ONE WEEK LOAN

The Sensation Novel and the Victorian Family Magazine

The Sensation Novel and the Victorian Family Magazine

Deborah Wynne
Keele University
Staffordshire

P4

palgrave

First published 2001 by
PALGRAVE
Houndmills, Basingstoke, Hampshire RG21 6XS and
175 Fifth Avenue, New York, N.Y. 10010
Companies and representatives throughout the world

PALGRAVE is the new global academic imprint of
St. Martin's Press LLC Scholarly and Reference Division and
Palgrave Publishers Ltd (formerly Macmillan Press Ltd).

ISBN 0–333–77666–6

A catalogue record for this book is available
from the British Library.

Library of Congress Cataloging-in-Publication Data
Wynne, Deborah, 1963–
 The sensation novel and the Victorian family magazine /
 Deborah Wynne.
 p. cm.
 Includes bibliographical references (p.) and index.
 ISBN 0–333–77666–6 (cloth)
 1. English fiction—19th century—History and criticism.
 2. Sensationalism in literature. 3. Periodicals, Publishing of—
 –Great Britain—History—19th century. 4. Books and reading–
 –Great Britain—History—19th century. 5. Serial publication
 of books—History—19th century. 6. English periodicals–
 –History—19th century. I. Title.

 PR878.S44 W96 2001
 823'.809353—dc21
 00–054524

10 9 8 7 6 5 4 3 2 1
10 09 08 07 06 05 04 03 02 01

Printed in Great Britain by Antony Rowe Ltd, Chippenham, Wiltshire

for Andrew and Henrietta

Contents

List of Plates ix

Acknowledgements x

1 Tantalizing Portions: Serialized Sensation Novels and Family Magazines 1
The 'sensation' formula 4
Serialization 10
Family magazines and their readers 14
All The Year Round 22
Once A Week 28
The Cornhill 31
The New Monthly Magazine 34

2 Wilkie Collins's *The Woman in White* in *All The Year Round* 38
Preaching to the nerves 38
The essential thing is to keep moving: Collins's narrative strategies 39
Strange family stories 41
Life in danger: sensationalizing health and safety 43
Self-help and helping yourself: the rise of the gentleman criminal 50
Interchangeable figures: criminals, detectives and spies 54

3 Ellen Wood's *East Lynne* in the *New Monthly Magazine* 60
East Lynne and its readers 60
Women's writing in the *New Monthly Magazine* 62
The professional woman writer 64
Bourgeois fantasies of ascendancy 66
Idle and ideal men and women 69
Ouida's *Granville de Vigne* 74
The maternity debate 76
The bigamy theme 79

4 Charles Dickens's *Great Expectations* in *All The Year Round* 83
Dickens: novelist as editor 83
Seizing a place in the economy of nature: discussions of natural selection in *All The Year Round* 84

We were unhealthy and unsafe	87
'So contaminated did I feel': *Great Expectations* and the problem of origins	91
Wolf-men	93
Problematic parentage	95

5 Wilkie Collins's *No Name* in *All The Year Round* — 98
Representing the female outsider	98
Holding converse with monstrosities: reviews of *No Name*	100
Out of the house of bondage	102
Magazine serialization and literary red herrings	106
From the harem to the convent	107
Working women	111

6 Mary Elizabeth Braddon's *Eleanor's Victory* in *Once A Week* — 114
Validating the sensation novel	114
The value of Dutch-metal and spangles: Braddon's defence of sensationalism	117
Eleanor's Victory: a labyrinth of textuality	121
Once A Week: foregrounding fictionality	125

7 Charles Reade's *Very Hard Cash* in *All The Year Round* — 132
Reade's 'Matter-of-Fact' romance	132
The problems of perpetual suspense	135
From magazine serial to book: Reade's revisions	140

8 Wilkie Collins's *Armadale* in *The Cornhill Magazine* — 145
Generic collisions in *The Cornhill*	145
Realism and sensationalism	148
Dual heroines	150
Fairytales, secrets, and lies	153
Containing and exploiting sensationalism	158
Illustrating the sensational	161

Conclusion: Victorian Novels and the Periodical Press	166
Appendix	169
Endnotes	170
Bibliography	188
Index	196

List of Plates

1 (Unknown), illustration to 'Once a Week', *Once A Week*, I, 2 July 1859.
2 (Unknown), title page illustration to 'Paul Garret: Or, The Secret', *Once A Week*, IX, 27 June 1863.
3 George Du Maurier, illustration to *Eleanor's Victory*, *Once A Week*, VIII, 4 April 1863.
4 George Du Maurier, illustration to *Eleanor's Victory*, *Once A Week*, IX, 3 October 1863.
5 'The Celibate Consoled' and George Du Maurier's illustration to *Eleanor's Victory*, *Once A Week*, VIII, 2 May 1863.
6 Frederick Waddy, Portrait of Charles Reade, *Cartoon Portraits and Biographical Sketches of Men of the Day* (London: Tinsley Bros., 1873).
7 Details of typographical diversity from *Very Hard Cash* in *All the Year Round*, 11 July 1863 and 19 December 1863.
8 Mary E. Edwards, illustration to *The Claverings*, *Cornhill*, XIII, February 1866.
9 Mary E. Edwards, illustration to *The Claverings*, *Cornhill*, XIII, February 1866.
10 Mary E. Edwards, illustration to *The Claverings*, *Cornhill*, XIV, October 1866.
11 George Du Maurier, illustration to *Wives and Daughters*, *Cornhill*, XII, November 1865.
12 Augustus Leopold Egg, *Past and Present* No. 1, 1858. (copyright Tate Gallery, London 2000)
13 George Thomas, illustration to *Armadale*, *Cornhill*, XII, December 1865.
14 George Thomas, illustration to *Armadale*, *Cornhill*, XII, October 1865.
15 George Thomas, illustration to *Armadale*, *Cornhill*, XIII, May 1866.
16 George Thomas, illustration to *Armadale*, *Cornhill*, XIII, February 1866.

Acknowledgements

The research for this book was initially funded by two British Academy awards covering the periods 1993 to 1994, and 1994 to 1997, for which I am very grateful. I also thank the staff at the various libraries where I did research: Birmingham Public Reference Library, Birmingham University Library, British Library, Keele University Library, Liverpool University Library, and the National Library of Wales.

Anthea Trodd provided excellent advice and encouragement through all stages of this project and I would like to thank her for helping to make my graduate studies at Keele University so rewarding. I would also like to thank John Bowen and Jenny Bourne Taylor for their perceptive comments and helpful suggestions on earlier drafts of this book. The anonymous reader at Palgrave also deserves thanks for a thorough analysis which helped clarify my ideas. Any faults which remain are, of course, my own responsibility. I also wish to thank Mair Evans, who introduced me to the work of M.E. Braddon and the pleasures of Victorian sensationalism. My greatest debt, however, is to Andrew and Henrietta, to whom this book is dedicated with love and gratitude.

A version of Chapter 4 appeared as an article, 'We Were Unhealthy and Unsafe: *Great Expectations* and *All The Year Round*'s Anxiety Stories', in the *Journal of Victorian Culture*, 5.1 (Spring 2000) and I thank the editor for permission to use this material. I am also grateful to the Tate Gallery for permission to use Augustus Egg's *Past and Present*, and to Ian Jackson at the University of Liverpool Library for permission to reprint the illustrations from *Once a Week*. Some of the ideas in this book were first aired at the Victorian Studies Forum at Keele University and at conferences, the Subversive Pleasures conference, University of Leeds (1997), and Victorian Genres conference, University of Liverpool (1998), and I would like to thank all participants.

1
Tantalizing Portions: Serialized Sensation Novels and Family Magazines

Popular magazine discourse during the mid-Victorian period was designed around the concept of the family as a domestic group bound together by shared literary tastes. Whereas today the target audiences for magazines tend to be stratified along gender and generational lines, editors of Victorian family magazines attempted to obviate such divisions by assuming that once within the home, individuals became subsumed into the group identity of 'the family'. This image of an 'ideal' unified family as a readership group was crucial not only to the development of the periodical press, but also to the form and dissemination of Victorian novels, many of which were first published serially in cheap family journals. In the 1860s an unprecedented range of new magazines appeared on the market featuring novels by authors who designed their fiction with the middle-class family audience in mind.

Many of these new literary miscellanies established themselves by serializing popular sensation novels, a genre based on representations of the disruptive forces of crime and secrets upon genteel domestic life. Horrified Victorian reviewers complained of a 'dumbing down' of middle-class literature, although this did nothing to stop readers eagerly buying, or borrowing from circulating libraries, 'respectable' magazines (that is, those directed at a middle-class rather than working-class readership) in order to read instalments of novels saturated with the excesses traditionally associated with working-class melodrama and 'shilling shockers'.[1] The sensation novel became legitimate reading for the middle classes largely *because of* its magazine context, where readers were addressed as educated and domestic family members, rather than sensation-seekers after cheap thrills. It was this ability on the part of magazine editors to combine the 'respectable' and 'scandalous' which made the emergence of literary sensationalism in the early 1860s so controversial.

Middle-class sensationalism made its first major impact in 1859 with the serialization of Wilkie Collins's *The Woman in White* in *All The Year Round*, Dickens's successor to *Household Words*.[2] This conjunction of cheap magazine and exciting serial novel based on the themes of crime, imposture, and false incarceration in a madhouse, presented in weekly instalments designed to keep readers at a fever-pitch of suspense, set the agenda for many of the emerging family magazines of the period. 'Sensation' writing, however, was not limited to fiction; magazines presented non-fiction which also discussed sensational topics such as crime, female transgression, insanity, and violence. The popular mix of sensational fiction and non-fiction within magazines established literary sensationalism as the dominant discourse of the 1860s. Indeed, the craving for the genre was so overwhelming that even the staunch practitioners and defenders of the domestic novel, Margaret Oliphant and Charlotte M. Yonge, were forced at the height of the craze to offer their readers sensational novels featuring murders and mysteries.[3]

The sensation genre worked with the new wave of middle-class family magazines to inject innovative developments into the Victorian novel, expanding the boundaries of domestic fiction to encompass a broader range of themes and styles. The work of nineteenth-century French authors, particularly Balzac and Flaubert, had opened up the novel's potential to represent sexuality, and the British sensation novel offered a sanitized version of their representations of dysfunctional or illicit sexual relationships. The fact that the sensation genre and the cheap middle-class magazine emerged together as 'modern' forms sharing the same cultural space is scarcely coincidental. The discourse which was forged by this partnership was useful to both serial novelists and journalists as a way of articulating the problems of modernity and in order to appreciate its cultural impact, the sensation novel needs to be read as an important signifier of social change during the mid-Victorian period.[4]

In a stimulating account of nineteenth-century reading practices, Patrick Brantlinger argues that the sensation novel was the most controversial middle-class genre of the period because of its tendency to cater to feelings of self-indulgence, 'intended mainly to produce thrilling sensations in readers with few if any philosophically, socially, or morally redeeming features [. . .] thus anticipat[ing] today's mass market thriller'.[5] Reading sensation novels in book form can readily lead to the view that the invoking of titillating 'sensations' was the genre's primary function. However, an examination of sensation novels within their magazine contexts indicates that such 'sensations' were not empty of meaning but constituted an important response to the issues of the day, particularly

anxieties surrounding shifting class identities, financial insecurity, the precarious social position of single women, sexuality, failed and illegal marriages, insanity and mental debilitation, fears of criminality, and perceptions that modernity itself was undermining domestic life. These topics were obsessively repeated throughout many middle-class family magazines in sensational serial novels, short stories, and articles, forging a discourse of sensationalism which not only permeated the literature of the period, but also the form of the middle-class periodical itself.

Victorian readers were invited by editors to adopt an intertextual approach to magazines by reading each issue's texts in conjunction with each other, encouraging the making of thematic connections between the serial novel and other features through the power of juxtaposition. The common assumption that Victorians read popular family magazines mainly for the serialized novels by well-known authors needs to be qualified. While the serial novel may have been a major incentive to buy a particular magazine, once bought it was unlikely to be discarded with most features unread. Indeed, the relative scarcity of cheap entertainment for the middle classes, coupled with the care and attention given by editors in shaping their magazines intertextually, meant that readers were likely to have read most, if not all, of a magazine's contents. When an instalment of a novel depicts forgery, or insanity, and is immediately followed by an article on forgery or insanity, one can safely assume that editors were 'interpellating' their readers, making a deliberate attempt to draw out the themes and ideas of the serial novels in ways which would enhance reading pleasure and generate debate. Meanwhile, the process of serialization itself also worked to heighten the impact and influence of a genre which has in recent years been identified as a powerfully subversive force within Victorian literary culture.[6]

The Sensation Novel and the Victorian Family Magazine considers the dramatic convergence of sensation novels and middle-class family magazines during the 1860s by means of seven case studies based on popular sensation novels and their host magazines. Each is explored in terms of the intertextual connections between the instalments of the novels and their accompanying articles and stories. This introductory chapter charts the reasons for the development of literary sensationalism and its relationship to the expanding popular periodical press of the mid-Victorian period. It also considers how the processes of serialization affected the impact of the new genre, and examines how new reading practices were brought about by the intertextual strategies developed by magazine editors.

The 'sensation' formula

she's behind it all

A distinguishing feature of the sensation novel is its concern with mysteries and secrets, a characteristic which has led Kathleen Tillotson to define the genre as 'the novel-with-a-secret'.[7] Sensation fiction usually centres on mysteries, often based on crimes and scandals, which disrupt the domestic lives of the property-owning classes. Wilkie Collins's *The Woman in White*, the first sensation novel, depicted sinister aristocrats plotting against a beautiful titled heiress. Subsequent sensation novelists developed variations on Collins's formula. Mrs Henry Wood's *East Lynne* presents a murder-mystery plot complicated by the actions of an adulteress, Lady Isabel Vane who, disguised as a governess, returns from the 'dead' to educate her own children. Mary Elizabeth Braddon's *Lady Audley's Secret* pushes sensationalism one step further with its focus upon the crimes of the beautiful, childlike murderess, Lady Audley.[8] The appearance of Collins's, Wood's, and Braddon's novels made it obvious to reviewers that the sensation novel was a distinctly new type of literature. They responded in the highbrow periodicals with various attempts to define, analyse and, more frequently, condemn the new phenomenon.

Many reviewers found themselves best able to discuss sensation novels in terms of the consumption of food. In an *Athenaeum* review of Collins's *The Moonstone*, Geraldine Jewsbury likened the reading of the serial instalments to the torment of hunger eventually relieved by the pleasure of satiation. She wrote:

> When persons are in a state of ravenous hunger they are eager only for food, and utterly ignore all delicate distinctions of cookery; it is only when this savage state has been somewhat allayed that they are capable of discerning and appreciating the genius of the *chef*. Those readers who have followed the fortunes of the mysterious *Moonstone* for many weeks, as it has appeared in tantalizing portions, will of course throw themselves headlong upon the latter portion of the third volume, now that the end is really come, and devour it without rest or pause; to take any deliberate breathing-time is quite out of the question.[9]

Jewsbury images serialization in terms of a carefully regulated food supply, regarding sensation novels as a tasty alternative to the bland fare of the domestic novel. Serialization, Jewsbury suggests, serves out a sensational narrative in delectable portions, although only the final portion is designed to offer the 'ravenously hungry' reader satisfaction. This

satisfaction was intended to be short-lived as family magazines regularly offered new 'tantalizing portions' of sensational novels.

Not all reviewers shared Jewsbury's enjoyment of serialized sensation fiction. Although domestic novels were often viewed as deliciously sweet (Thackeray maintained they were like raspberry tarts, and thus especially suited to the 'mental palates' of women and young people), sensation novels were considered by many reviewers to be too spicy.[10] Some complained that the new genre was addictive, even poisonous.[11] As women were presumed to be the principal consumers of novels, the popularity of the sensation novel suggested to some reviewers that the moral sanctity of the middle-class home itself was under attack. The zest of sensationalism became more acceptable, however, if it was tempered by the plain cooking of domestic fiction. One *Spectator* reviewer, for example, considered the novels of Mrs Henry Wood (one of the milder sensationalists) to be a harmless mixture of piquant incident and wholesome food, of 'murders and mutton, suicides and rice pudding, stolen cheques and thick bread-and-butter; and, as she never fails to say an emphatic grace over each heavy meal, she satisfies alike the appetite, the taste, and the conscience of her readers'.[12]

Whether highly spiced or tempered by wholesome ingredients, the new feast of sensationalism was usually disapproved of by most Victorian critics. In 1870, at the end of the genre's reign, Leslie Stephen complained in his essay, 'The Decay of Murder', that the weakness of the sensation novel was its 'unnatural' attempt to mix strong passions and crime with 'the milk-and-water commonplace of society'.[13] H.L. Mansel, writing in the *Quarterly Review* in 1863, exhibited an extreme disgust with sensation novels, considering them in serial form to be dangerously addictive. Readers of such stimulating literature, he asserted, resembled 'dram drinkers' in the grip of 'perpetual cravings'.[14]

Another source of alarm for Mansel was the genre's covert references to real-life crimes and scandals. Sensation novelists often looked to contemporary events and newspaper reports for inspiration for their plots.[15] Having condemned the addictive qualities of the genre, Mansel considers sensation novelists and their readers to possess a 'ravenous appetite for carrion, this vulture-like instinct which smells out the newest mass of social corruption, and hurries to devour the loathsome dainty'.[16] This tendency to draw upon recent murders and other crimes, along with divorce cases and scandals, was not only considered pandering to 'low' tastes, but also an attempt to align the novel (by now well established as a legitimate art form) with journalism, particularly the sensationalism of the popular penny press. Once actual crimes and misdemeanors had

received initial exposure in the newspapers, sensation writers reworked them, suitably disguised and embellished, into their fictional plots. The fact that so many sensation novels were serialized in magazines appeared to confirm a link between middle-class literary tastes and the working-class periodical press. This use of real-life 'sensations' was particularly marked in relation to female criminals, especially if they came from well-to-do homes. Constance Kent (a middle-class adolescent who confessed to the murder of her young brother), Madeleine Smith (another genteel young lady, accused of poisoning her lover), and Madame Rachel Leverson (a famous London beautician later imprisoned for blackmail and brothel-keeping), were among the many notorious women who inspired characters in sensation novels.[17]

As well as drawing upon scandal, the sensation novel, as its name suggests, was also designed to stimulate the senses; whether in the form of entertaining thrills or heavy doses of addictive arousal depended upon one's point of view. Analogies with tasty food and addictive drugs formed only part of the critical responses to the sensation novel. The genre was also discussed for its modernity, reviewers relating it to a variety of technological developments, ranging from the mass production and easy availability of the fiction itself to the up-to-the-minute plots which frequently made reference to the speed and anonymity of the railway and telegraph systems.[18] Another aspect of the sensation genre's modernity was its reference to the 'nervous' debilitation which the genteel classes, forced to keep up with the 'frantic' pace of modern urban life, were believed to be experiencing. Arthur Helps in 1859 suggested erecting a statue to 'Worry' in London which would symbolize 'the marks of haste, anxiety, and agitation' which characterized the age.[19] Sensation fiction became a symbol of an anxious age and Mansel, mixing his metaphors, likens its effects to 'galvanic batteries [...] which carry the whole nervous system by steam', suggestive of a drastic therapy for overwrought patients.[20] Many characters in sensation novels, whether villains or heroes, are depicted as wracked by the mental and physical torments arising from the shocks and worries involved in either perpetrating crimes and mysteries or suffering as victims. Readers were also kept in a heightened state of suspense which took its toll upon the nerves.

These specifically modern worries about the bodies and minds of the urban genteel classes were brought into sharp focus in Wilkie Collins's third sensation novel, *Armadale* (1864–66), where Dr Downward, a rather dubious medical practioner who works under the alias Dr Le Doux, argues that 'we live in an age when nervous derangement (parent of insanity) is steadily on the increase', and he sets up a Sanatorium for the cure of

'shattered nerves'.[21] He locates his asylum in a bleak, half-built suburb south of Hampstead, sending out invitions to the local inhabitants on open days, presuming that the surrounding villas will provide him with a regular supply of nervous patients. With its secret panels and hidden locks, Downward's Sanitorium offers a suitably sinister environment for the anti-heroine Lydia Gwilt's attempts to poison her enemy (XIII, 576). W.J. McCormack has recently argued that the sensation genre had its roots in modern domestic locations, 'emerg[ing] from the anxious imagination of suburbia'.[22] Indeed, the newly-developed suburbs housed a considerable body of readers for the sensation novel: the leisured middle-class wives and daughters at home, along with the husbands, fathers and brothers who may have whiled away their daily journeys to work by reading sensational magazines or 'railway novels'.[23] As *Armadale* indicates, the expansion of urban centres and suburbs during the mid-Victorian period, along with their associated problems of anonymity and alienation, created a new landscape for representation, where crimes and mysteries tested the already frayed nerves of the inhabitants.

It is the sensation genre's attempt to attack the body of the reader by means of surprising plots and representations of jangled nerves which has attracted the attention of many twentieth-century critics. Perhaps the most influential of recent reassessments is D.A. Miller's discussion of the genre as 'one of the first instances of modern literature to address itself primarily to the sympathetic nervous system'.[24] However, the 1860s sensation novel was not the first example of a literary genre to affect readers' bodily responses. The eighteenth-century novel of sensibility, also functioning as a direct attack upon the nerves, forced readers into an 'ever-varying emotional response [...] an experiential self-surrender'.[25] Gothic novelists like Ann Radcliffe and 'Monk' Lewis also expected readers to be thrilled and shocked in direct physical responses to their writing. The 1860s sensation novel owed much to these genres, particularly in its drive to thrill and entertain, rather than educate. Where it differed was in its rejection of supernatural appearances, promoting instead a realism in line with the middle-class domestic novel.

The sensation novel's improbable plots were always carefully presented as plausible. Some authors used prefaces to the volume editions of their novels in order to quote 'authorities', such as newspaper sources and medical evidence, as a defence against accusations of improbability.[26] Sensation novelists worked within the dominant discourses of realism, claiming to accurately represent modernity in their depictions of the unusual and aberrant which highlighted the dangers undermining contemporary British domestic life. Such dangers were represented in

the form of unscrupulous imposters, hidden secrets from the past, and sinister crimes. The supernatural and exotic landscapes which featured so prominently in Gothic fiction and stage melodrama were modified by sensation writers who rejected the primeval forests, ruined castles, monasteries, and exotic foreign locations in favour of country estates in the Home Counties, lonely stretches of parkland, seaside holiday resorts, city streets, suburban villas, and isolated villages.[27] The ordinary became tinged with sensational possibilities.

Why did the new sensationalism, with its odd mixture of implausible, excessively labyrinthine plots and domestic realism, develop so prolifically during the late 1850s and 1860s? A major reason was, as Helps's statue to 'Worry' indicates, the widespread perception of the period as an 'anxious' age. The peace and stability which had popularly been associated with British society at the time of the Great Exhibition of 1851 had given way to a more insecure outlook by the end of the decade. In 1859 David Masson, editor of the newly-formed *Macmillan's Magazine*, described the period since the revolutions of 1848 in terms of 'an epidemic of political irritability throughout Europe'.[28] Masson also indicated a sense of insecurity at home, insisting that 'Britain must make *herself* safe. That is her first duty [. . .] to keep the silver seas clear between her and the rest of the world'.[29] The feeling of national insecurity was exacerbated by an economic depression which plagued Britain throughout the 1860s, along with the tendency towards reform which generated considerable anxiety among some members of the educated classes.[30] In 1859, Charles Darwin published his *On The Origin of Species*, a book which sent shock waves through the nation as his evolutionary theories (often more or less distorted) were discussed throughout the periodical press, ranging from the prestigious quarterlies to the popular 'family' miscellanies.[31] Alarm was also registered at the 'everyday' sensationalism of life; three randomly picked issues of the *Illustrated London News* from the early 1860s reveal, in the brief extracts of the week's news, what many readers must have considered disturbing undercurrents of crime and violence in society. The headlines include, 'Ex-Magistrate Charged with Felony', 'Mysterious Murder', and 'Death by a Lion at Astley's', while the reports detail a servant-girl's murder of her master by poisoning his gruel, numerous railway accidents, opium-related robberies in London, and the suicide pact of two young women 'of respectable families'.[32] If the popular press offers an indication of the mood of the times, the 1860s were clearly *felt* to be unsafe, and this belief played a part in the receptivity of literary sensationalism as an articulation of modernity.[33]

Sensation novelists offered highly effective responses to the need for imaginative representations of such anxieties, and the most successful writers were distinguished by an ability to adapt traditional popular genres into exciting stories of modern life for middle-class consumption. The new genre developed as a mixture of melodrama, the gothic, sensational reportage, penny dreadfuls, the 'Newgate' novel and domestic realism, and it succeeded because it sanitized those aspects of working-class culture which were offensive to middle-class tastes, offering an alternative to the bland stories and 'prudish conventionalities' of the respectable novel.[34] A major influence upon the sensation novel was G.W.M. Reynolds, whose serialized novel, *The Mysteries of London* (1845–48), offered an extended tale of modern life using the gothic 'secret' to 'express the terrors of the city'.[35] He appealed to an enormous audience of working-class readers, depicting a metropolis undermined by the mysterious forces of crime and vice. *The Mysteries of London*, however, remained 'unrespectable' reading, roundly rejected by a middle-class family audience who were suspicious of fiction intended to excite feelings to 'a very high pitch', and whose readers were identified as including 'low' characters, 'spreeing young men [. . .] who go to taverns, and put cigars in their mouths in a flourishing way'.[36] Yet the 'accessible version of Gothic literature' which Reynolds offered to working-class readers was also fascinating to the middle classes.[37] Middle-class domestic fiction of the 1840s and 1850s did not usually represent modern urban life threatened by dark intrigue, although Dickens's work, while presenting all of the middle-class domestic virtues, is exceptional in its sense of urban chaos and hidden mysteries. R.C. Maxwell has drawn perceptive links between *Bleak House* and *The Mysteries of London*, arguing that Dickens's novel 'is a melodrama as labyrinthine as anything in the Mysteries tradition'.[38] The work of Reynolds and Dickens presented readers with similar themes but from opposite sides of the respectability divide. A bridge was clearly needed in order to satisfy middle-class cravings for sensationalism while minimizing the risk of disturbance to any sense of propriety, and this was skilfully provided by sensation novelists who took great care not to offend readers in their adaptations of risqué genres.

An important influence for sensation novelists was the popular Newgate novel of the 1830s and 1840s by writers such as W. Harrison Ainsworth and Edward Bulwer-Lytton. These were based on the violent crimes of the lower classes and located in the seedy criminal underworld of London.[39] The sensation novel modified this formula by representing the crimes of 'respectable' men and women in genteel domestic settings. The crudity of the crimes and passions represented in popular Sunday

newspapers, and the fictional versions in 'penny dreadfuls', was toned down considerably in the sensation novel.[40] This new formula led a reviewer in *Fraser's Magazine* to state that for modern novelists and readers 'a book without a murder, a divorce, a seduction, or a bigamy, is not apparently considered worth either writing or reading'.[41] Bigamy, imposture and forgery were, on the whole, the favoured crimes of the educated classes, and sensation novelists such as Mary Elizabeth Braddon, Mrs Henry Wood, and Charles Reade based many of their plots around these transgressions. Sometimes crime played a minor role; instead the focus was on the mysteries and secrets surrounding questions of insanity, illegitimacy, sexual transgression, or mistaken identity.

The sensation novel's debts, however, were not limited to the popular culture of the working class. Its success also depended upon its reworking of popular domestic novels. As Winifred Hughes has said, it attempted to balance 'the opposing realms of romance and domesticity'.[42] Sensation writers retained an important point of contact with the domestic novels of popular authors such as Charlotte M. Yonge and Margaret Oliphant, both of whom worked within (and helped shape) the 'cult of domesticity' which characterized the 1850s.[43] Mrs Henry Wood in particular promoted middle-class domesticity as an ideal to be protected, while even the more radical sensationalists, Collins, Braddon, and Reade, invariably resorted to closing their novels with a triumphant middle-class family surviving all attacks. Despite such concessions to the cult of domesticity, these writers succeeded in raising readers' awareness of the fragility of the domestic ideal, highlighting the dangers which could assail family life in a modern urbanized, increasingly anonymous, society. Their depiction of a threatened social order is often ambiguous, a feature which led some Victorian critics to attack the genre because it appeared to promote 'sympathy with crime'.[44]

Serialization

The sensation novel has recently been described by Nicholas Daly as an 'anxious accommodation of modernity [...] a machine for the production of suspense'.[45] However, the genre not only represented worrying aspects of contemporary society, but also reached its audience via the latest technologies of mass publishing. During the early Victorian period a number of developments in printing techniques opened up the possibility of cheap mass-produced literature, and by the 1860s the widespread availability of serialized fiction was threatening to debase the novel as a literary form, particularly at a time when middle-class readers were

turning their attention to the sensation novel.[46] The commodification of literature was not lost on contemporary reviewers, one of whom, writing in the prestigious *Edinburgh Review* in 1864, discussed the 'sensation novel' as 'the regular commercial name for a particular product of industry for which there is just now a brisk demand'.[47] If the sensation novel was a 'product', then serialization presented that product in a way guaranteed to maximize sales by extending its powers of suspense through the 'Scheherazade effect', the enforced deferment of narrative satisfaction.[48]

Serialization then, like the sensation novel, carried a distinct flavour of commercialism. Although serial fiction had been available since the late seventeenth century, its large-scale commercial potential was first exploited during the 1830s when publishers sought to maximize sales by offering cheap literature to the newly-literate, upwardly-mobile classes.[49] Dickens's early novels belonged to this revival of serial publishing, and he was fortunate in being able to exploit the part-issue format without being tarnished by the image of the hack writer. Dickens played an important role in raising the status of serial fiction and, in spite of its initially low image, serialization became the dominant publishing form during the nineteenth century. Roger Hagedorn has drawn connections between the commodification of literature and the significance of serial narratives:

> In a social system which perpetually defers desire in order to promote continued consumption, and whose mass media represent a major form of commercial enterprise, the serial emerges as an ideal form of narrative presentation under capitalism.[50]

Sensation novelists of the 1860s were seen by critics as producers of a popular 'commodity' presented in instalments, inevitably associated with the commercial exploitation of the latest literary craze, rather than producing work of artistic merit.[51]

Serialization has been widely discussed in recent years as a crucial factor in understanding the way Victorian literary culture worked. Jennifer Hayward in *Consuming Pleasures: Active Audiences and Serial Fictions from Dickens to Soap Operas* has suggested that the 'defining quality of serial fiction' is its reader friendliness: it suited 'an age increasingly wishing to consume small doses of reading matter at frequent intervals', possessing a unique ability to 'respond to its audience while the narrative is still in the process of development'.[52] Like Hagedorn, she explores the way publishers used the form to 'mobilize suspense and desire in highly profitable ways'.[53] The sensation novel, with its labyrinthine plots of crime and

mystery lending themselves to the generation of suspense, exploited to the full the commercial possibilities of serialization. Virtually all sensation novels originally appeared as serials, designed to prolong readers' pleasurably anxious engagements with the plots. The ability of serial narratives to capture and retain the attention of a wide readership results in the formation of a 'community of readers', a phrase used by Hayward and other scholars of serial narratives.[54] Serialization fostered communal reading; most magazines came out on Saturdays, a half holiday for many working people by the 1860s, becoming part of the weekend entertainment for thousands of people, many of whom would have heard an instalment of the latest novel read aloud within the home.[55] Hayward views the communal reading of serials during the Victorian era as having a parallel in the watching of television serials in the twentieth century, both forms of reception having socially binding functions which result in 'collaborative interpretations'.[56]

Hayward concentrates upon the commercial strategies and popular pleasures of serialization in both nineteenth- and twentieth-century formats. L.K. Hughes and M. Lund in *The Victorian Serial*, on the other hand, view the serial as 'more than an economic strategy', arguing that the extended timescales and enforced gaps of serial narratives echoed Victorian perceptions of social, cultural and natural developments.[57] They stress the length and bulk of Victorian serial novels, emphasizing the way readers needed stamina and commitment in order to get through to the end (they employ marriage and other family relationships as a metaphor for this).[58] However, it is difficult to fit the serialized sensation novel into this model of dutiful perseverance; such fiction was usually presented in the form of snappy, lively, reader friendly sections of narrative designed to make readers long for the next exciting instalment. As Geraldine Jewsbury's enthusiasm for *The Moonstone*'s 'tantalizing portions' indicates, Victorian readers of serialized sensation novels were more likely to have enjoyed them as a treat rather than an educational duty, as an extended series of weekly or monthly pleasures eventually leading to a satisfying denouement.

Even before the sensation novel appeared on the literary scene, reviewers were disturbed by the idea of the 'sensational' effects of serialized novels fostering in readers a 'delirium of feverish interest', as an anonymous reviewer in the *North British Review* suggested in 1845.[59] When novels were specifically designed to be sensational their serialization was considered particularly deleterious to readers. Margaret Oliphant, in a *Blackwood's* review of 1862, argued that middle-class morals were in danger of being eroded by the 'violent

stimulant of serial publication – of *weekly* publication with its necessity for frequent and rapid recurrence of piquant situation and startling incident'.[60] C.H. Butterworth, writing in the *Victoria Magazine* in 1870, identified a particular danger to those readers who consumed the miscellaneous texts which go to make up newspapers and popular magazines. Butterworth asks:

> How can a well-regulated mind skip with sobriety from the 'Latest Discovery of Gold-Fields in Sutherlandshire', to the 'Extraordinary Confessions of a Witch in Devonshire' [...] and the 'Roasting of a Missionary in the Sandwich Islands'. What mind is not is not [sic] likely to be thrown into a state of nightmare and ferment by this dancing among disconnected items of temporary intelligence, this hurrying at lightning speed from one part of chaos to another, without one interval to arrange one's thoughts or sift all these strange stories into their proper places?[61]

Such critics assumed that serialized novels and magazines would be read at a dizzy speed, each instalment offering so many shocks and thrills that over-stimulated readers would become easily addicted. Furthermore, as Butterworth suggests, magazines and newspapers serve to engender a sense of disorientation; readers are, he implies, overloaded with too much diverse textual excitement.

Not all critics, however, reacted with alarm to serial novels. E.S. Dallas, in a *Times* review of *Great Expectations*, outlines how the unfavourable reception of serial novels earlier in the century eventually gave way to a widespread acceptance of the form. He writes, 'most of the good novels now find their way to the public in the form of the monthly dole', going on to argue that the serial form 'has forced English writers to develop a plot and work up the incidents' in skilful and entertaining ways.[62] He particularly praises *All The Year Round*'s experiment with the weekly serialized novel, a form usually associated with popular penny fiction for the working classes, concluding that 'the weekly form of publication is not incompatible with a very high order of fiction'.[63] Dallas and Butterworth, despite their very different opinions, recognize the cultural significance of serialization in the context of the middle-class magazine. The emergence of numerous fiction-carrying magazines during the 1860s changed the reading practices of the middle classes by offering supplementary texts alongside an instalment novel, all intended to arouse excitement. To borrow Butterworth's terminology, the 'sobriety' which critics from the weighty reviews associated with reading novels in

book form was collapsing before a tendency among middle-class readers to 'dance', 'skip', and 'hurry' through the lively pages of new magazines with their stimulating instalments of sensation novels, popular journalism, and short stories.

The sensation novel was the first middle-class Victorian genre to conspicuously retain aspects of its 'low' origins in melodrama and penny fiction while still appealing widely to 'respectable' readers. Indeed, an important feature was its appeal to a wide cross-section of readers from different classes; as Kathleen Tillotson has said, 'What seems so unusual about the 1860s is that the *same* novel was so often read in library, drawing-room and kitchen'.[64] The extensive, indeed unprecedented, distribution of sensation novels among middle-class readers was largely brought about by their appearance in the new family magazines designed to appeal to a broad class base.

Family magazines and their readers

When Robert Browning was considering the possible publishing formats for his poem in twelve volumes, *The Ring and the Book* (1868–69), he wrote to William Allingham of his reluctance to serialize within a magazine because he did not 'like the notion of being sandwiched between Politics and Deer-Stalking'.[65] Browning was clearly nervous of the power of juxtapositioning within a magazine to subvert the effect of a text. However, the prestigious magazines he had in mind for *The Ring and the Book* offered precisely the wrong sort of context for a sensational text based on murder, violence, and mental debilitation. The cheap middle-class family magazine which, unlike the more highbrow journals avoided politics and rarely discussed aristocratic pursuits, was a much more favourable environment for literary sensationalism. If Browning's poem had appeared serially in such a magazine he may have been surprised to find its instalments sandwiched between discussions of contemporary murder trials and recent cases of bigamy.

As a recognizable component of the middle-class periodical press, sensationalism was a relatively recent development. Before the 1850s, middle-class readers had been largely neglected in so far as few cheaply priced magazines catering to their needs were available. Working-class readers, on the other hand, had since the early 1840s been able to choose from numerous penny and half-penny family magazines. The titles of these low cost weekly periodicals indicates their suitability for family consumption within the home: *The Family Herald* (established in 1843), *The People's Periodical and Family Library* (1846), *The Family Friend* (1843),

The Home Circle (1849), *The Home Friend* (1852), and *The Family Treasu* ,
Sunday Reading (1859).[66] These cheap weeklies were criticized by the
moral guardians of the day for their 'vulgar' mix of household hints,
'receipts for making Bath buns, tooth powder, cleaning out ink spots', and
'highly coloured' fiction 'which, if weighed in the balance of strict
Christian principle, would be found miserably wanting'.[67] In a *Household
Words* article, Wilkie Collins estimated an extensive readership of three
million readers for this sort of periodical, arguing that this 'unknown
public' (unknown because middle-class literary culture had traditionally
taken no account of it) was 'the largest audience for periodical literature'.
He envisaged a future when 'the readers who rank by the millions will be
the readers who give the widest reputations, who return the richest
rewards'.[68] Was Collins thinking of this 'unknown public' when he
turned his attention to his next novel, *The Woman in White*? It seems
likely that he made a deliberate attempt to broaden the readership of the
middle-class novel by grafting aspects of the 'highly-coloured' fiction of
cheap journals onto novels of genteel domestic life. Although Collins and
his fellow sensation novelists failed to reach all of the semi-literate
'unknown' millions, they successfully used the new family magazines to
extend the audience of the 'respectable' novel to include more working-
class readers.

Before 1859, however, there was a marked divide between 'respectable'
and 'unrespectable' fiction, a divide which was reflected in the publishing
formats of the novels: middle-class readers tended to borrow books from
circulating libraries, or buy novels in monthly part-issues; working-class
readers, on the other hand, consumed novels as serials in cheap
magazines.[69] Middle-class readers who did not enjoy, or could not afford,
the respectable monthlies such as *Fraser's* or *Blackwood's*, had very little in
the way of entertaining magazines equivalent to the working-class *Family*
and *Home* titles. *Household Words*, Dickens's twopenny weekly whose title
is redolent of its even cheaper counterparts, was one of the few magazines
of this kind acceptable to the middle classes.[70]

The years 1859 and 1860, however, marked an important turning-point
in the development of the Victorian periodical press, when many new
family magazines of a 'respectable' nature appeared on the market:
Dickens's *All The Year Round* (1859); Bradbury and Evans's rival illustrated
paper, *Once A Week* (1859); *Macmillan's Magazine* (1859), a branch of
Macmillan publishing house; *The Cornhill* (1860), whose first editor was
Thackeray, was owned by George Smith, from the publishing firm Smith,
Elder & Co.; and *Temple Bar* (1860) edited by George Augustus Sala. A few
years later came *The Argosy* (1865), edited by Mrs Henry Wood from 1867;

Belgravia (1866), edited by Mary Braddon; and *Tinsley's Magazine* (1867), edited by Edmund Yates. These new periodicals all offered serialized novels, many of them sensation novels. Some also presented woodcut illustrations by well-known artists, such as John Everett Millais, William Holman Hunt, John Tenniel, and George Du Maurier.[71]

This burgeoning of magazines during the early 1860s was a direct result of the demands made during the previous decade by opponents of the 'taxes on knowledge', when Parliament was vigorously lobbied for a reduction in the cost of newspapers and journals. In 1855 the Newspaper Tax was repealed, while six years later came the repeal of the Paper Tax, both reforms leading to a swift reduction in the costs of producing newspapers and other periodicals. This in turn brought about the availability of a wider range of new titles to an increasingly literate population. R.D. Altick has argued that this 'conjunction of a greatly expanded mass audience and lower costs threw the publishing and printing trades into a happy uproar', while technological innovations made the production of newspapers and magazines 'one of the most highly mechanized of all English mass-production industries'.[72] William Tinsley, a publisher who had jumped rather late on the new periodical bandwagon with *Tinsley's Magazine* in 1867, complained that 'There were more magazines in the wretched field than there were blades of grass to support them'.[73] Editors were at this period hard pressed to maintain reader loyalty and competed with each other to recruit the latest popular authors in order to maintain sales.

The editors of the new family magazines shared one feature: all presupposed a general family readership. Recent critics have maintained that the 'family' reader is synonymous with the female reader, suggesting that men were marginalized as readers of family magazines.[74] This was not the case: editors attempted to integrate the contents of their magazines to appeal to all family members, although whether they were successful or not is open to debate. Each editor adopted an integrated approach to magazine design, making no divisions into sections specifically directed at particular readers (for example, Victorian family magazines usually contained no 'woman's page', or sections devoted to male readers, or children). Although features occasionally appeared which were more likely to appeal to one gender or age group than another, they were usually presented in such a way as to be intelligible to other family members.

While female readers had long been positioned by editors as belonging to the domestic sphere, new magazines attempted a similar positioning with male readers who were invariably addressed in their domestic roles as

fathers, grandfathers, uncles, husbands, brothers, and sons, rather than as professionals, public figures, or working men. An article by James Hannay in *The Cornhill* in February 1865, 'Bohemians and Bohemianism', offers a good example of this attempt to position male readers as 'family' men. In this discussion of the alienation of 'Bohemian' men from family life, Hannay directly addresses his male readers as 'experienced Magazine-readers', presuming them to be family men in a shared world of domestic respectability, making 'formal calls' on neighbours, going to church, giving daughters away in marriage, and becoming godfathers to children.[75] Hannay presents himself as a family man, sharing his readers' amusement in the antics of those who cannot conform to society's mores, especially in their inability to maintain wives and children. Hannay is careful in detailing these outsiders' lives not to embarrass female readers or puzzle children. While this article apparently addresses the 'master' of the house, other family members are also invited to be entertained by the 'absurdities' of non-family, 'Bohemian' men.

Although contributors to magazines often addressed readers directly in their roles as mothers, wives and sisters, fathers, husbands and brothers, editors rarely announced their presence or indicated their positions of authority by means of editorials; similarly, none of the new family magazines published letters from readers. This lack of editorials or readers' comments meant that the family magazine was shifted away from the controversy and debate associated with newspapers, offering itself as a product designed largely for relaxation and entertainment. This 'silent' editorial style, however, did not apply to the two major novelist-editors, Dickens and Thackeray, who occasionally addressed readers from the platform of their magazines.[76]

The up-to-the-minute discourse of sensation novels had much in common with journalism, and editors used this to establish a 'modern' tone for their magazines. In 1863 *Punch* parodied the close links between popular journalism and the sensation novel with a spoof advertisement for an imaginary new magazine, 'The Sensation Times: A Chronicle of Excitement'. The advertisement claims that:

> No class of sensational record will be neglected, and readers may rely upon receiving the most graphic accounts of all Crimes with Violence, merciless Corporal Punishments (especially in the case of children), Revolting Cruelties to Animals and other interesting matters.[77]

Despite the obvious exaggeration, *Punch* had succinctly put its finger on the pulse of the literary culture, where the sensation genre had risen from

the ranks of the popular press with its 'sensational' headlines to suffuse the middle-class novel.

The sensationalism of the 1860s has most frequently been discussed in terms of novels.[78] However, magazines in which sensation novels first appeared in serial form frequently utilized a sensational discourse for their non-fiction features, just as the novels themselves drew upon styles of popular sensational journalism for their themes. Andrew Blake in *Reading Victorian Fiction* has emphasized the fact that there was 'no strict dividing line between any form of journalism and the writing of novels'.[79] In fact, virtually all sensation novelists also wrote as journalists, many of them, such as Wilkie Collins, working as paid staff members on the board of popular magazines. Mary Braddon and Ellen Wood, two of the most prominent sensation novelists, worked as journalists before editing and contributing to their own magazines.[80] Sensational journalism became a significant form within middle-class Victorian literary culture: Arthur Conan Doyle in *A Study in Scarlet* (1887) has Dr Watson detailing Sherlock Holmes's knowledge of sensational literature as 'Immense. He appears to know every detail of every horror perpetrated in the century.'[81] Holmes, we later discover, contributes 'sensational' journalism to the periodical press, articles based on his insider knowledge of crime and detection. Christopher Kent has argued that while Victorian periodicals were often marked by a 'visual sobriety', this type of sensational writing frequently dominated the contents, which focused on:

> extensive details about sensational court cases – murders, indecent assaults, breaches of promise, 'criminal conversations', bankruptcies, or libels. Not unreasonably it has been suggested that although the crime story is a preeminently English creation, it is more particularly the creation of the English editor and journalist.[82]

Sensation novels emerged directly from these journalistic discourses.

The magazine publication of sensation novels led to an intensification of what was in itself an emotionally intense genre, reinforcing the tendency towards excess which had begun to characterize much of the literary culture of the 1860s. Magazine editors were often prepared to offer large fees to secure novels from the leading sensation novelists, Wilkie Collins, Mary Elizabeth Braddon, Mrs Henry Wood, and Charles Reade, as well as a host of minor novelists who practised the genre. The most enterprising among them attempted to design the issues of their magazine around a successful serial, providing readers with supporting articles, stories and poems which dealt with similar 'sensational'

themes, and this form of intertextuality characterized a number of popular magazines.

Recent discussions of intertextuality have tended to focus on the way the weight of texts from the past bears down on newly-written texts in the form of influences from the various 'voices' of earlier writers and readers.[83] Sensation novelists were obviously indebted to former popular writers: Dickens was clearly a major influence for many of them, along with the works of Edward Bulwer-Lytton, William Harrison Ainsworth, the Brontës, Sir Walter Scott, as well as the eighteenth-century Gothic novelists.[84] Sensation novelists of the 1860s also drew upon each other's work. Collins's *The Woman in White* influenced Braddon's writing of *Lady Audley's Secret*. She once admitted, 'I owe "Lady Audley's Secret" to "The Woman in White". Wilkie Collins is assuredly my literary father'.[85] This process of influence went both ways, however, for Collins clearly learned from Braddon the value of using an erring, transgressive heroine for sensational effect. After *The Woman in White*, with its 'good' victimized heroines, Collins explores the possibilities of the beautiful but bad heroine, derived from Braddon's model in *Lady Audley's Secret*, in his subsequent novels, *No Name* and *Armadale*. This type of intertextuality was complicated by a different level of intertextuality within the periodical discourse of the 1860s, when magazines and serial novels converged in dramatic ways, offering readers textual juxtapositions which stimulated new reading practices.

How historical readers actually read, however, remains a problem. In 1992 Jonathan Rose insisted that the reading practices of the historical 'common reader' could be recovered if the necessary sociological investigation was applied; however, there have been few scholars willing to rise to his challenge.[86] The difficulties of finding a 'common' enough Victorian reader are virtually insurmountable. Recently Patrick Brantlinger, in *The Reading Lesson*, has insisted on 'the ultimate unknowability of the common reader', adding that:

> [N]o sociology of readers can fathom exactly how actual readers responded to texts. Neither, however, can a strictly rhetorical approach get at real readers reading: the two approaches must complement each other, and even then can only approximate readerly experience.[87]

Rose has in mind the self-taught working-class autobiographer as a source of information about the 'common reader'. Yet even sifting through autobiographies and letters will glean little about how 'common' readers responded to magazines. Apart from the odd mention in passing of such

periodicals as *Household Words* or *The Cornhill*, those Victorian readers who have put pen to paper have tended not to discuss *how* they read magazines. The ephemerality of the periodical has meant that most of its features, other than serial novels and journalism by well-known authors, have dropped out of the cultural consciousness long ago. As Margaret Beetham has written of the readers of nineteenth-century women's magazines, 'There is a dearth of specific information about who historically read [magazines] and how. [...] All this makes it difficult to discuss the question of readers' engagement', particularly as the magazine 'encourage[s] the possibility of diverse reading'.[88] We can only assume that Victorian readers may have read 'diversely' or 'laterally', although making such an assumption is, of course, unsatisfactory. Readers today, like historical readers, are invited by editors to read each magazine in a specific way. No doubt Victorian readers could potentially (and probably did) resist this invitation. However, one advantage for those reading Victorian periodicals today in following editorial guidance is that we can gain important insights into the way magazines were structured, thus offering us access to the unique qualities of magazines as a component of Victorian literature.

Periodicals exist as sites of simultaneity in that they present a cluster of apparently unrelated texts at the same point in time and space, all having the potential to be read in relation to each other. The major question which arises from this is: did readers sample all the different texts on offer, or did they single out one or two features and ignore the rest? According to one anonymous writer in 1866 in the *Publisher's Circular*, many readers 'notoriously buy a periodical only for the sake of some story in it by a favourite author, and are wholly indifferent to the remainder of its contents'.[89] This is clearly the opinion of a professional, working either as writer or publisher, an educated person who finds reading matter easy to come by. Other readers, less educated, less well-off, must have viewed periodicals differently. Magazines, shared by all members of the family, or colleagues in the workplace, would have had more than the serial novel to offer the majority of readers in search of cheap entertainment. Even if the serial novel was the main lure for most readers, it is dangerous to assume that once this was read the issue would be thrown away. The culture of thrift and recycling which underpinned Victorian middle- and lower-class life must have played a part in attitudes towards the periodical press. Newspapers and magazines were perused more intently by people lacking the distractions of other media forms, and it is safe to assume that the level of ennui experienced by the *Publisher's Circular* contributor and his/her acquaintances was not shared by a less demanding audience of readers

who wanted the short stories, poems, humorous sketches and articles which, at no extra cost, surrounded the instalments of novels.

Given, then, that most readers of novels in magazines would have read most of their contents, we need to relate Victorian novel-reading practices specifically to the invitations offered by the periodical press. W.J. McCormack has suggested that Victorian magazine readers practised 'reading laterally', moving from one item to another:

> in a complex of dependent relations: [the instalment of a novel] is only part of an implicit, larger whole, the completion of which lies inaccessibly in the future; it is only one of numerous items [. . .] which (unlike the other instalments of the same fiction) impinge immediately on its readers, permitting them to read on (or back) from fiction into political commentary or lyric poem or into (seemingly) different fiction.[90]

It should be added that advertisements also encroached into the magazine reader's 'lateral reading', all of which offered a different experience from reading a novel in book form, where little in the way of adjacent 'outside interference' affected the reader's response. Editors were sensitive to the possible connections which could be made between the novels serialized in their magazines and the various texts which made up each issue. This was the 'dancing among disconnected items' which Butterworth deplored, except that often items were not necessarily disconnected thematically; readers of magazines were able to make comparisons between the novel and other related features. This supplemented and intensified the experience of reading, something which is denied to those who do not engage in the 'lateral' reading offered by the periodical press.

Each magazine had its own particular audience, along with its own particular form and style. The overlap of texts *within* each magazine was complicated by the overlap *between* magazines, where editors borrowed ideas and styles from rival periodicals, while novelists jumped from one magazine to another. For example, during the 1860s, Charles Reade wrote for *Once A Week* then for *All The Year Round*; Wilkie Collins wrote for *All The Year Round* then *The Cornhill*, then for *All The Year Round* again; Mrs Henry Wood launched herself from Harrison Ainsworth's *New Monthly Magazine* before writing two serials for *Once A Week*, then editing her own magazine, the *Argosy*, where she serialized her subsequent novels. Unpicking the complicated tangle of influences, overlaps, and borrowings in sensation serials and their host magazines is crucial to identifying the major trends which make up the context of the sensation novel and

Table 1.1 A breakdown of selected family magazines, 1859–1865

	AYR	OAW	Cornhill	NMM
No. of pages	24	28	126	124
Novels*	36%	25%	45%	22%
All fiction*	47%	62%	53%	32%
Poetry*	2%	2%	0.4%	2%
Non-fiction*	51%	36%	46.6%	66%
No. of features per issue	6	9	7.5	11.5
Signatures	None	Some	Some	Some
Illustration	No	Yes	Yes	No
Circulation§	70 000	60 000	68 000	–

Abbreviations:
AYR: *All The Year Round*; *OAW*: *Once A Week*; *NMM*: *The New Monthly Magazine*

* percentage of each issue
§ Average per issue
Sources: *Wellesley Index to Victorian Periodicals*, E.A. Oppenlander, A. Sullivan, A. Ellegard. NB, no reliable figures are available for *NMM* for the 1860s.

highlight its significance within mid-Victorian culture. This enables us to assess the sort of pleasures which were available to readers of popular magazine serials. Jewsbury's notion of consuming 'tantalizing portions' of narrative is one way we can usefully understand the reading experience of a large number of Victorians during the 1860s, as they eagerly awaited the next weekly or monthly issue of their preferred magazine(s), 'devouring' each new instalment of the serial novel, then, pleasured but unsatisfied, beginning the wait for the next issue to appear. A cycle of pleasure and torment, consumption and hunger. A combination of good marketing tactics and exciting serialized novels placed the family magazine firmly at the centre of Victorian literary culture. It is doubtful whether sensation novelists would have reached so many readers on the margins of 'respectability' if they had not published in magazines, the issues of which appeared in thousands of newsagents shops and on railway stalls at relatively affordable prices, as well as being available from the major circulating libraries. The final part of this chapter briefly outlines the major features of the four magazines discussed in this book, while Table 1.1 presents a summary of the make-up of each one.

All The Year Round

Charles Dickens's *All The Year Round* inhabited the borderland between 'highbrow' literary culture, represented by prestigious quarterlies and

monthlies such as the *Quarterly Review* and *Blackwood's*, and the popular literature enjoyed by readers of 'lowbrow' weekly penny magazines. This borderland became an increasingly important territory as the century progressed when a broadening middle-class audience sought magazines which were entertaining and cheap without being 'low'. Dickens had been one of the first editors to address a middle-class family readership with *Household Words* (1850–59), a popular weekly miscellany which attracted readers with a mix of entertaining fiction (usually in the form of short stories and novellas) and social commentary.[91] Dickens envisaged a political role for *Household Words*, specifically designing the magazine to bring about a 'general improvement of our social condition'.[92] In 1859, following a disagreement with Bradbury and Evans, the publishers and part-owners of the magazine, Dickens abandoned *Household Words* in order to set up a new weekly miscellany, *All The Year Round*.[93]

As 'Conductor', or editor, of both magazines, Dickens designed each to suit the climate of the times. *Household Words* belonged to the spirit of the 1850s, a voice calling for reform and social justice in the wake of the poverty and unrest of the 1830s and 1840s.[94] This is reflected in the magazine's serialization of the major 'social problem' novels of the period, Dickens's own *Hard Times* (1854) and Elizabeth Gaskell's *North and South* (1855). The novels were supported by articles on related themes such as the problems of poverty, dangerous working conditions, and industrial unrest.[95] *All The Year Round*, on the other hand, was organized as a vehicle for entertaining literature, where the serialization of popular novels, rather than social issues, was the magazine's priority. After the final instalment of *A Tale of Two Cities*, the magazine's first serial, Dickens stated that:

> We purpose always reserving the first place in these pages for a continuous work of fiction [...] It is our hope and aim, while we work hard at every other department of our journal, to produce, in this one, some sustained works of imagination that may become a part of English Literature.[96]

Although the first few issues of *All The Year Round* echoed the format of *Household Words*, with features attacking social and political abuses, the new magazine swiftly developed its own distinctive pattern, offering a long instalment of a novel, followed by a selection of features which became increasingly dominated by sketches, travel writing, and short stories, rather than current affairs articles.

By consistently foregrounding high quality serialized novels, *All The Year Round* was presenting itself as a new type of weekly magazine.

E.S. Dallas, writing in *The Times* in 1861, commended Dickens for enticing working-class readers away from the cheap thrills of the penny magazines towards 'quality' literature.[97] *All the Year Round* devoted on average 36 per cent of each issue to the instalments of a novel, in contrast to its main rival, *Once A Week*, where serialized novels formed only 25 per cent of the overall contents.[98] Dickens was also unusual in making the novel central to its overall design by placing the instalments on the first pages of each number, and often allowing its themes to dominate an issue in a way which would have been unthinkable in the context of *Household Words*.[99] As this implies, *All The Year Round* relied heavily on the serial to generate sales, the articles and stories were intended to create a supporting context.

Its drab, unillustrated double-columned format made *All The Year Round* closer in appearance to a newspaper than a magazine. Dickens was aware that exciting serial novels were necessary to compensate for the visual sobriety and 'cheap' image. Although the magazine did not offer illustrations, readers were occasionally presented with a sort of typographical trickery intended to relieve the monotony of the closely printed columns. During the serialization of *The Woman in White*, for example, Gothic print was used to signify the inscription on Laura's tombstone, while the serialization of Charles Reade's *Very Hard Cash* led to an intensification of this typographical diversity because of Reade's propensity to use bold type, reduced print, four columns in place of two, and musical notations.[100]

An extraordinarily successful novelist, Dickens also had a talent for arranging texts within his magazine in ways which would maximize appeal for readers. Knowing his middle-class readership very well, he calculated to a fine degree how far they were prepared to go in accepting controversial topics. This ability to steer a safe course between conservatism and unacceptable excess was largely the result of Dickens's rapport with readers. Philip Collins has suggested that Dickens's success as an editor was owing to the fact that he 'sincerely adopt[ed] and reflect[ed] the average outlook of his contemporaries'.[101] He was adroit at packaging potentially 'dangerous' material in acceptable forms, allowing readers the pleasures of sensationalism without disturbing received ideas of what was 'proper'.

With *All The Year Round* Dickens straddled the roles of editor and contributor, two of his novels making their first appearance in the magazine. By launching *All The Year Round* with *A Tale of Two Cities*, the magazine was immediately established as a top quality weekly. Dickens's next serial, *Great Expectations*, was published from 1860 to 1861. Chapter 4 discusses the ways in which Dickens shaped *All the Year Round* during the

serialization of *Great Expectations* to intensify the novel's impact, and how its magazine context led to contemporary perceptions of the novel as a leading example of the sensation genre. Chapters 2, 5, and 7 also discuss *All The Year Round* serials: Wilkie Collins's *The Woman in White* and his second sensation novel, *No Name* (1862–63), and Charles Reade's *Very Hard Cash* (1863), later published as *Hard Cash*. While Reade's novel was not particularly successful in serial form (the reasons for this are outlined in Chapter 7), both of Collins's serials boosted *All The Year Round*'s sales. Dickens made Collins's sensationalism appear credible by means of supporting features indicating that 'real' life was as bizarre and dangerous as *The Woman in White* and *No Name* suggested. Even articles on such topics as railway travel and microscopes, which appear remote from the new sensational discourse, lapse into details of murders, mysteries, and crimes in ways which mirror the preoccupations of sensation fiction.

All The Year Round, like *Household Words*, subject to Dickens's powerful editorial control, developed a distinctive house style based on a combination of melodrama and sensationalism, imaginative 'fancy' and pathos, to which contributors of all articles and short stories were obliged to conform. Some critics found the style rather cloying, 'like a highly-flavoured sauce, which will disguise any kind of meat, and it is almost a mechanical trick which anyone might be taught'.[102] Dickens's ownership of *All The Year Round* guaranteed his autonomy as an editor; indeed, 'Charles Dickens's Own' had been one of the titles he had considered using.[103] His demand that contributors remain anonymous was an imposition complicated by the prominence of Dickens's own name on each page, where the words 'Conducted by Charles Dickens' implied his 'ownership' of each feature. Every contribution was subject to Dickens's 'corrections', and he insisted on a right to alter, even extensively rewrite, articles and stories to suit the magazine. Some regular contributors, such as G.A. Sala, found this enforced anonymity detrimental to their careers. Sala was particularly grieved whenever one of his better pieces was discussed in the press as though Dickens himself had written it.[104] During the 1860s, the issue of anonymity in the context of the periodical press was becoming the focus of considerable debate.[105] Many new magazines, principally *Macmillan's Magazine* and *The Fortnightly Review*, were proclaiming their use of signatures as a sign of intellectual honesty. Dickens, however, rejected the issue of signature outright. He was prepared to accept the burden of responsibility for everything published in his magazines, and remained insensitive to the anxieties of those contributors who feared being submerged by his name. While he did not feel able to take liberties with the work of serial novelists, he was always

ready to offer advice and suggestions, accompanied by various degrees of persuasion.

All The Year Round worked well because Dickens sought out the most popular and highly regarded novelists of the day, persuading them to produce the sort of fiction which would appeal to large numbers of readers. As Barbara Quinn Schmidt has said, 'Dickens demanded tight, self-contained narratives, often autobiographical novels about crime'.[106] The 'tightness' was important because of the problems of sustaining a long novel in short weekly bursts where each instalment must advance the plot and offer excitement and suspense. Many novelists found this form of weekly publication extremely demanding and potentially damaging. When Dickens tried to recruit George Eliot to write a novel for him, she refused on the grounds that providing short sections of narrative to be published at weekly intervals would compromise her integrity as an artist.[107] Wilkie Collins, on the other hand, like Dickens himself, was able to write good serial novels despite the magazine's intense pressures, and no doubt his brand of suspense and mystery narrative was more conducive to the weekly format than the intricate and subtle detailing of Eliot's realism.

From *All The Year Round*'s inception Dickens displayed a commitment to serializing sensational fiction, from the violent melodrama of *A Tale of Two Cities*, to the domestic sensationalism of *The Woman in White*. Subsequent sensation novels serialized in the magazine were *Great Expectations* (received by reviewers as an example of the genre), Wilkie Collins's *No Name* and *The Moonstone*, Charles Reade's *Hard Cash*, and Elizabeth Gaskell's sensational novella, *A Dark Night's Work*.[108] While some magazines only occasionally incorporated sensation novels, often as a deliberate ploy to boost flagging sales, or as a temporary flirtation with the latest literary craze, *All The Year Round* was relatively consistent in its presentation of sensation novels and adoption of a sensational discourse, making it an ideal literary space for the germination of the new genre. Dickens's journal provided readers with a focus for their anxieties. It was undoubtedly the provision of a controlled release valve at a time of rapid social change which made the magazine so popular with a readership which has recently been described as 'solid' and 'frankly bourgeois'.[109]

All The Year Round's first two years were undoubtedly the most popular, when readers were presented with *A Tale of Two Cities*, *The Woman in White*, and *Great Expectations*, along with innovative journalism. Only one serialized novel appeared at any one time. The only exception to this was during the serialization of *Great Expectations*, when Dickens published the novel to rescue his magazine when Charles Lever's unpopular *A Day's Ride*

sent sales plummeting. This was the only occasion when the magazine presented readers with two novels simultaneously.[110] As with most family magazines of the period, *All The Year Round* attempted to balance the contents to appeal to the widest possible audience; most of the fiction and articles attempted to cross gender and generational divides. The short stories, like the novels, were frequently sensational, with mystery plots or confessional narratives, often detailing violent crimes and horrific situations. A significant proportion of the non-fiction was educational or informative, usually written by 'experts' who attempted to describe in entertaining ways such things as the working of the electric telegraph, the history of Roman Catholicism, travels abroad, and British coal reserves.

Arguably the most interesting item, apart from the serialized novels and short fiction, was the regular appearance of serial reportage based on the observations of a 'roving' reporter. During the serialization of *The Woman in White*, Charles Allston Collins, Wilkie Collins's younger brother, contributed his 'Eyewitness' series, descriptions of his strolls through the London streets. The 'Eyewitness' was possibly the inspiration for Dickens's 'Uncommercial Traveller', another 'roving' gentleman who not only travelled in search of interesting sights, but also to stimulate memories and emotions. This type of journalism owes much to the *Spectator* of the eighteenth-century, although Dickens and Charles Collins present their reporters as *flâneurs* strolling, spectating, gazing, and witnessing the city sights. The *Uncommercial Traveller* essays often encroached into sensationalism, detailing drowned and murdered bodies in the Paris morgue, shocking conditions in the workhouse, morbid emotions generated by walking at night, and childhood terrors. Some issues of *All The Year Round* featured both the 'Eyewitness' and 'Uncommercial Traveller'. For example, on 10 March 1860, an instalment of *The Woman in White* was followed by a travel article, an *Uncommercial Traveller* feature, 'Mercantile Jack', an article on France and free trade, and the Eyewitness visiting the poorer districts of London. At twopence per issue, *All The Year Round* offered a diverse range of high quality literature very cheaply.

Philip Collins has argued that *All The Year Round* was 'inferior to its predecessor'.[111] However, this view does not take into account the first-rate sensation novels which appeared in the magazine along with the important innovations in reportage presented in the *Uncommercial Traveller* essays and the 'Eyewitness' accounts. Collins's disparagement may have something to do with the denigration of sensationalism which characterized some accounts of popular culture at the time he was writing in the late 1960s. This book attempts to reassess *All The Year Round*, too

frequently dismissed as inferior to *Household Words*, in the light of its major contributions to the sensation genre of the 1860s, both in terms of its promotion of sensation novels, and also in its use of a discourse of sensationalism for non-fiction and short stories. Dickens's second weekly family magazine was crucial to the development of the sensation novel, playing a vital role in shaping the genre and promoting it as an exciting new force within the literary culture.

Once A Week

Bradbury and Evans had launched *Once A Week* after Dickens abandoned *Household Words* to set up *All The Year Round*.[112] A lavishly illustrated weekly, *Once A Week* was designed with the hope of enticing readers away from Dickens's rival magazine. While *All The Year Round* was visually drab, *Once A Week* carried in each issue several illustrations by well-known artists. The magazine defined itself as an 'Illustrated Miscellany of Literature, Art, Science, and Popular Information', claiming to give prominence to 'serial tales by Novelists of Celebrity'.[113] This promise, however, was reneged on; serialized novels formed only a small proportion of the magazine's overall contents and rarely featured as the first item. Indeed, pride of place was usually given to short stories and novellas, often by anonymous or minor writers; this shorter fiction formed on average 37 per cent of each issue's contents. So although the magazine was dominated by fiction, it was largely short fiction rather than the top quality serial novels which Bradbury and Evans had promised. Among the novelists whose work was published in *Once A Week* were George Meredith, Charles Reade, and Harriet Martineau. Each issue carried at least three illustrations, some of them three-quarter or half a page in size and, as R.A. Gettmann has said, '*Once A Week* is now recognized as a mine of wealth in the black-and-white work which made the 'sixties so notable a period in the history of book illustration'.[114] This reliance on illustrations by well-known artists at the expense of serialized novels meant that Bradbury and Evans had difficulty in establishing the magazine at a time when readers expected exciting serial novels. *Once A Week* was priced at threepence per issue, making Dickens's rival weekly at twopence, with its prominent placing of serial novels by 'big name' novelists, appear better value for money to many readers.

The first issue of *Once A Week*, edited by the former *Times* literary critic, Samuel Lucas, opened optimistically with a light-hearted illustrated poem by Shirley Brooks which imagined the impact the new magazine was

going to have on the lives of its readers, a readership which Alvin Sullivan has argued comprised 'middle-class, liberal-minded readers of a fair educational standard'.[115] Brooks imagines in his poem this type of reader, when he refers to lawyers, businessmen, and doctors; all, however, are united by their position within the middle-class family. The magazine, as the poem makes clear, was designed to be read during periods of leisure within the family circle. The poem's three illustrations depict a young lady at the opera who, Brooks suggests, will be guided in her musical tastes by *Once A Week*; a businessman in his garden, just returned from the office, his daughters rushing towards him with slippers, cigars, and the latest copy of *Once A Week*; and the third illustration shows a family at the seaside, a lady reading the magazine aloud to her husband and children (see Plate 1). The final stanzas of Brooks's poem suggest that *Once A Week* hoped to brighten the lives of the less well-to-do members of society:

> Nor to the rich alone, or those who're striving
> Upward for riches, is our sermon read;
> To other thousands nobly, humbly, hiving
> Their little stores for winter it is said.
> Far easier than they dream is the transition
> From the dull parlour, or the garret bleak,
> To fields and flowers – a beatific vision
> Devoutly to be pray'd for ONCE A WEEK.[116]

This intention to reach out to the successful middle classes *and* the 'humble' labouring classes, offering entertaining (but educational and 'moral') leisure-time reading resembles Dickens's aims with his journals. The similarities between *Once A Week* and *All The Year Round* were at first embarrassingly obvious: Bradbury and Evans insisted on launching the magazine with an historical novel, Charles Reade's *A Good Fight* (published in volume form as *The Cloister and The Hearth*), against their editor's advice, echoing the launch of *All The Year Round* with *A Tale of Two Cities*. Dickens was scornful about his former publishers emulating his magazine, writing, 'What fools they are! As if a mole couldn't see that their only chance was in a careful separation of themselves from the faintest approach or assimilation to *All The Year Round*'.[117] While Bradbury and Evans followed Dickens's blueprint for a family magazine, they added illustrations in the hope of outselling their rival. Their plans for *Once A Week* were undermined, however, by their choice of editor; Lucas envisaged a highbrow weekly miscellany, rather than a popular periodical catering to the latest literary tastes.

Lucas, an Oxford educated man who had abandoned the law for journalism in the early 1850s, was a respected literary critic for the *Times*. As editor of *Once A Week* he received a salary of five hundred guineas which, while meagre compared to the £2000 Thackeray received initially as editor of *The Cornhill*, was a respectable sum which reflected his high standing as a man of letters.[118] Lucas intended *Once A Week* to be a weekly equivalent to the shilling monthlies, such as *Macmillan's Magazine* and *The Cornhill*, in contrast to Bradbury and Evans who envisaged the magazine as more lowbrow, catering to broad popular tastes. Lucas's editorship began ominously with a major disagreement with Charles Reade, who responded by pulling out of *Once A Week* after only fourteen of the forty instalments of *A Good Fight* had appeared. Lucas disliked sensation fiction, which he considered to be cheap 'thimblerigging'.[119] While Bradbury and Evans wanted to serialize the sort of sensation novels which were making *All The Year Round* popular, Lucas favoured 'the sober strength and adherence to probability' which characterized the work of major realist writers, such as George Eliot.[120] After Reade's departure, Lucas recruited George Meredith to produce the next serial novel. Meredith's *Evan Harrington* (1860), however, proved unpopular with readers and sales declined. Bradbury and Evans intervened, insisting on the serialization of sensation novels, which at this period were becoming the focus of considerable controversy and a guarantor of increased sales.

Despite the difficulties of competing in an overcrowded marketplace, *Once A Week* maintained a steady circulation of 60 000 during its first five years, although after 1865 it steadily declined until it finally folded in 1880.[121] According to Alvin Sullivan, the reason for the decline was a lack of 'pointed purpose and characteristic tone'.[122] However, under Lucas's editorship *Once A Week* was a lively, often sophisticated literary miscellany which focused on discussions of art and culture. Unlike many magazines of the early 1860s, signatures were used for most of the features published. This, along with its outstanding illustrations, established *Once A Week* as more upmarket than its rival, *All The Year Round*. *Once A Week*'s main problem was the tension between the owners and editors: the sensation novels favoured by the former did not sit comfortably with the educated tone established by the latter. Another damaging factor was its tendency to favour short stories rather than long serialized novels. The major literary miscellanies of the period depended upon novels to generate sales, and Lucas's ambivalence about popular novels meant that likely readers of cheap weekly magazines were not attracted in large numbers to *Once A Week*.

The first concession Lucas made towards 'thimblerigging' sensation fiction came with the serialization of Mrs Henry Wood's popular murder mystery with a bigamy theme, *Verner's Pride* (1861–62), following on from *Evan Harrington*. Bradbury and Evans were gratified to find the circulation figures increasing significantly. This success was followed up by a novel by Mary Elizabeth Braddon, who had recently risen to fame with *Lady Audley's Secret* and *Aurora Floyd*. *Eleanor's Victory* (1863) offered readers a sensational story of forged wills, suicide, mysteries and secrets. Chapter 6 discusses Braddon's use of *Once A Week* as a 'respectable' platform for *Eleanor's Victory*, from which she launched her defence of sensationalism. This chapter also illustrates the ways in which Braddon designed *Eleanor's Victory* to fit into the sophisticated tone of *Once A Week*. Having faced critical opprobrium with her first sensation novels, she fought back with a spirited attempt to justify her brand of sensational literature, juggling *Eleanor's Victory's* melodramatic plot with a witty commentary on the pleasures of melodrama. Part of this pleasure, she suggests, is a knowledge that melodramatic sensationalism can be absurd, as well as entertaining and emotionally satisfying. Braddon, aware that Lucas attracted a number of prestigious contributors to *Once A Week*, including G.H. Lewes and Harriet Martineau, believed that her novel's proximity to such respectable literary figures would help rescue her reputation from the image of the hack writer with which she had been burdened. As one of the biggest new names in the 'sensation' field, Braddon was encouraged by Bradbury and Evans, but she found that the unsympathetic Lucas pushed her novel into the background. Harriet Martineau's *The Hampdens: An Historiette* was positioned as the first item during the crucial early weeks of the serialization of *Eleanor's Victory*. Braddon was content at this stage of her career to rub shoulders with the likes of Lewes and Martineau, knowing that her novel's representations of the theatre, literature, and Pre-Raphaelite art were supported by *Once A Week*'s intelligent discussions of cultural formations, thus adding credence and legitimacy to her work as a 'sensation' author.

The Cornhill

The Cornhill occupied the sort of exalted position within mid-Victorian periodical publishing which the ambitious Lucas never attained for *Once A Week*. Founded by the publisher, George Smith in January 1860, *The Cornhill* was intended 'to give the public both the contents of a general review and the entertainment of first-class fiction at the unheard of price of a shilling'.[123] Smith, at considerable cost, recruited Thackeray as editor, and together they developed a successful journal based on the provision

of 'respectable middle-class family reading of the highest quality, a mixture of good serial novels and intelligent instructive articles on noncontroversial subjects'.[124] Determined to offer readers high quality fiction (Smith appears to have been cavalier about costs during the early years), Thackeray launched *The Cornhill* with the joint serialization of Anthony Trollope's *Framley Parsonage* and his own *Lovel the Widower*. The first issue sold slightly under 100 000 copies, making it an outstanding success for a newly launched monthly, although within four years it had declined to circulation levels of around 40 000 per issue.[125]

The Cornhill adopted the unusual policy of serializing two illustrated novels in each issue and many of the major authors of the day, including George Eliot, Harriet Beecher Stowe, Anthony Trollope, and Elizabeth Gaskell, contributed serialized novels. *The Cornhill* presented itself as a family magazine intended to offer entertaining literature for leisure time reading, which distinguished it from its rival monthly, *Macmillan's Magazine*, which focused heavily on political and social commentary. Mark Turner has recently suggested that because it addressed a family audience, *The Cornhill* was 'gendered female', a view which is supported by Thackeray's policy to 'avoid controversy and assume a female reader'.[126] This 'feminization' of the family magazine centres on the traditional linkage of novel reading and domesticity, where the home and family circle (traditionally, the woman's domain) became a major focus for recreation and shared 'family' pleasures. Thackeray, an upholder of this ideal of the feminized home, deliberately excluded articles on politics and religion in order to banish the competitive 'masculine' world of controversy and discord from the leisure time pursuit of domestic reading.

The Cornhill, however, while it worked to appeal to women, was not directed solely at a female readership. Many features, on history, social commentary, discussions of art and literature, were carefully designed to appeal to educated readers of both genders and, like most of the new family magazines, to cross generation divides by appealing to children and young people as well as adults. As Thackeray stated in his general letter to potential contributors, 'We hope for a large number of readers, and must seek, in the first place, to amuse and interest them.'[127] Within the context of mid-Victorian, middle-class leisure pursuits, entertainment was increasingly intended to be domestic and family orientated. Thackeray described the sort of readers he hoped to attract to the forthcoming journal as:

A professor ever so learned, a curate in his country retirement, an artisan after work hours, a school-master or mistress when the children

are gone home, or the young ones themselves when their lessons are over, may like to hear what the world is talking about, or be brought into friendly communication with persons whom the world knows.[128]

Thackeray wanted contributors to be 'lettered and instructed men who are competent to speak' on their chosen topic, as long as they assume that 'the ladies and children are always present'.[129] In other words, contributors (presumed by Thackeray to be male) must speak to the whole family, a general requisite imposed on contributors to all of the new middle-class magazines.

Like *All The Year Round* and *Once A Week*, *The Cornhill* set out to appeal to everyone who could read; yet, as Thackeray's words indicate, his magazine was more likely to attract educated readers, or those struggling to educate themselves and rise socially. Few could say of *All The Year Round*, for example, what Sir Edward Cook said of *The Cornhill*, that it represented 'the spirit of humane culture'.[130] *The Cornhill*'s articles during its first decade indicate its commitment to engaging in cultural debates; for example, there are regular discussions of such topics as art exhibitions, charities, education, and literary developments, while an impressive profile of regular non-fiction contributors, Matthew Arnold, Harriet Martineau, John Ruskin, J.A. Symonds, and Anne Ritchie (Thackeray's daughter), established the intellectual tone. Serialized novels in *The Cornhill* tended to be domestic novels by well-known writers. Wilkie Collins's virulent third sensation novel, *Armadale*, was not the sort of serial *The Cornhill*'s readers had come to expect.

Chapter 7 focuses on *Armadale*'s serialization alongside Elizabeth Gaskell's *Wives and Daughters* and Trollope's *The Claverings*, highlighting the clashes generated by this unprecedented juxtapositioning of the genres of sensation fiction and domestic realism in one periodical. The publication of *Armadale* in *The Cornhill* was in some ways an 'accident' at this point in time: George Smith, aware of the excitement caused by *The Woman in White*'s publication in 1860, asked Collins to write a serial for his new magazine, offering £5000, a remarkably high payment at the time. Collins, however, was already engaged to write *No Name* for serialization in *All The Year Round*, although he promised to produce a new novel by December 1862. Collins's poor health, however, delayed progress on the novel and *Armadale* began serialization in November 1864, three years after the original contract had been signed.[131] When Smith had approached Collins early in 1861, he was unaware that the critical acclaim for *The Woman in White* would turn into a general hostility for *No Name*. With this second sensation novel, Collins had moved

towards a more polemical sensationalism and Smith found he had secured, at considerable expense, a highly controversial writer who was intent on raising issues which were in danger of alienating *The Cornhill's* middle-class readers. *Armadale's* 'heroine', the seductive Lydia Gwilt, is a forger, blackmailer, and murderess, and she horrified critics who considered her to be a vivid and unacceptable portrait of female depravity. *The Cornhill's* readers were not enthusiastic about *Armadale*, for the circulation declined during the novel's run from 41 000 to 32 000.[132] Ironically, the controversial Collins was one of the highest paid novelists recruited by Smith, his £5000 matched only by the £7000 offered to George Eliot for *Romola*. Elizabeth Gaskell's popular *Wives and Daughters* earned her only £1400 from *The Cornhill*.[133]

 The Cornhill, then, was not the most likely space for a novel like *Armadale* to be found. Its failure with *The Cornhill's* readers highlights the tensions which existed within middle-class literary culture at that period. Readers' preference for *Wives and Daughters* and other domestic novels suggests that the sensation novel offered only a limited appeal to well-to-do Victorians. The less secure middle classes and upwardly mobile working classes, those who did not enjoy social or financial security, tended to prefer sensation novels and chose magazines in which they were serialized. This readership was attracted to Dickens's *All The Year Round*, in which Collins's first two sensation novels were serialized. Although *Armadale*, with its powerful depiction of the gentry undermined by imposters, was misplaced in *The Cornhill*, its sandwiching between Gaskell's and Trollope's domestic novels offers an excellent opportunity to examine the ways in which sensation fiction and domestic realism fed off each other, and Chapter 7 examines not only the conflicts between the genres, but also the areas in which the two overlap.

The *New Monthly Magazine*

Few of the new monthlies were as upmarket as *The Cornhill*, although many of the old style monthlies, such as *Blackwood's* and *Fraser's Magazine* with their Tory roots, retained a gentlemanly dignity in the face of the new competition. Some of the older monthlies, however, had been declining even before the onset of the new wave of periodical publishing in the late 1850s. The *New Monthly Magazine* was one of these. It had been launched in 1814 by the magazine entrepreneur, Henry Colburn as a Tory mouthpiece, flourishing during the first decades of the century. In 1837, the practice of serializing novels was introduced and its title was changed to the lighter *New Monthly Magazine and Humorist*. In 1847, when the

journal was at the height of its success, William Harrison Ainsworth, a popular author who had enjoyed considerable success with his Newgate novels during the 1830s and 1840s, took over as owner and editor. In its heyday it rivalled *Blackwood's* and boasted a list of contributors which included Thackeray, Leigh Hunt and Bulwer-Lytton.[134] Ainsworth, however, was not particularly talented or even perceptive as an editor. By the 1850s, a decline had set in, and the 'new' magazine appeared to readers as decidedly 'old', becoming rapidly overshadowed by newer, more exciting rivals. Ainsworth, who also ran and owned *Bentley's Miscellany*, was not attuned to the changing literary culture, remaining unaware of the emergence of new readership groups among the expanding middle class. Throughout the 1850s the magazine declined into a 'decidedly second rank publication'.[135] Ainsworth sold the magazine in 1870, and it continued a 'feebly languishing existence' until it finally folded in 1884.[136] The *New Monthly Magazine* was unable to survive the advent of other shilling monthlies, such as *Macmillan's* in 1859, and *The Cornhill* and *Temple Bar* in 1860, and many of Ainsworth's readers defected to these more exciting periodicals. The readers who did remain loyal to the magazine tended to be the conservative bourgeoisie.

The *New Monthly's* contents were characterized by a distinct gender divide: the non-fiction, usually based on the lives of 'great' men, military campaigns, and detailed reports of national and international affairs, was designed to appeal to men, while the fiction, depicting pure and virginal heroines suffering the pangs of unrequited love, or young wives neglected by thoughtless husbands, was designed for female readers. Stories with such titles as 'The Fatal Chain' and 'The Belles of the Island' were set alongside articles such as 'Commercial and Industrial Reform in France', 'A New Solution to the Religious Question', and 'Marine Artillery'. Each issue of the *New Monthly* devoted on average 66 per cent of its contents to non-fiction, while only 22 per cent was allotted for serialized novels. The emphasis on non-fiction based on 'masculine' topics was detrimental at this period to a monthly magazine, when readers sought entertaining reading for the whole family. The fiction in Ainsworth's journal effectively became the equivalent of the 'woman's page', a marginal section within the magazine which Ainsworth viewed as frothy sentimental nonsense which 'ladies' liked to read.

This denigration of women's (or, if Ainsworth only knew it, the family's) pleasure in fiction was exacerbated by his view of female authors as cheap workers, content only to see their writing in print without being paid, producing on demand fiction which was 'good enough' for the female reader. Mrs Henry Wood's son Charles recorded that for ten years his mother:

wrote without renumeration, out of love for her work. Popular as [her short stories] were, Mr Ainsworth made no pecuniary return. At length she declared her unwillingness to continue these contributions month after month and year after year without acknowledgement, and the payment of a small yearly sum was arranged; so small that the old agreement could scarcely be said to have altered.[137]

Numerous other women writers were exploited in this way by Ainsworth, including Ouida who, like Wood, began her career as a sensation writer in the pages of *The New Monthly Magazine*. Ainsworth was at first reluctant to publish novels by Wood and Ouida, presuming that if he did so he would be expected to pay them the going rate. Eventually, they threatened to publish their short stories elsewhere if he did not serialize their novels. Charles Wood maintained that Ainsworth feared losing his cheap (frequently unpaid) contributors, 'unwilling to run the risk, [he...] only yielded when Mrs Wood at length refused to write any more short stories for his magazines'.[138] After Wood won the Scottish Temperance League's competition in 1859 with her first novel, *Danesbury House*, Ainsworth reluctantly accepted *East Lynne* for serialization.

Ainsworth's acceptance of Wood's novel was the best editorial move he could have made for his ailing magazine, for it enjoyed a temporary upturn for the next six years. The enormous popularity of *East Lynne* boosted sales, as did Ouida's first novel *Granville de Vigne* (although she, too, had had to bully Ainsworth into accepting it). The two novels ran side by side for several months. *East Lynne* was followed by Wood's *The Shadow of Ashlydyat*, a sensational ghost story, while *Granville de Vigne* was followed by Ouida's next bestseller, *Strathmore*. Chapter 3 examines the serialization of *East Lynne* in the uncongenial environment of Ainsworth's monthly magazine, demonstrating how Wood, and her fellow sensationalist Ouida, brought the *New Monthly Magazine* into prominence, turning attention away from the editor's focus on politics by forcing attention upon its serial novels. They achieved what Ainsworth failed to do: a repositioning of the periodical within the ranks of the new family magazines. Readers began to buy the *New Monthly* for the exciting instalments of novels based on middle-class transgression and aristocratic excess. The magazine had moved from being a stuffy, conservative journal with one eye fixed nostalgically on its prosperous past, to become host to shocking, sensational tales which were engendering considerable critical controversy. However, Ainsworth never quite understood what was happening and continued to present readers with bulky articles on Japanese foreign policy and French military hardware, scarcely suitable

supporting features for *East Lynne* and *Strathmore*. Ainsworth had unwittingly stumbled on two bestselling authors and his editorial skills were not up to adapting his magazine to provide a suitable environment for their novels. He learned no lessons from the more integrated approach developed by editors of new magazines like *The Cornhill, All The Year Round* and *Once A Week*. This was the main reason why his magazine failed, despite its presentation of popular sensation novels. When Wood and Ouida found better deals elsewhere and withdrew from the *New Monthly Magazine*, many of Ainsworth's readers ceased to be interested in the magazine.[139]

The Sensation-Novel and the Victorian Family Magazine examines the impact of literary sensationalism on the mid-Victorian periodical press through a number of sensation novels and the magazines in which they were serialized. In order to highlight how fiction and non-fiction developed in relation to each other within the family magazine, each case study is presented chronologically. The chapters based on the *All The Year Round* serial novels seek to demonstrate the ways in which the novel and periodical worked successfully together to promote the new literary sensationalism. However, Chapter 7 explores an exception, examining the failure of Reade's *Very Hard Cash* to offer a suitable style of sensationalism in serial form. An examination of this failure is valuable in highlighting the form and function of serialized sensation novels in middle-class magazines. The chapters on *East Lynne* in the *New Monthly Magazine* and *Eleanor's Victory* in *Once A Week*, on the other hand, indicate how the power of the new sensationalism had the potential to subvert 'respectable' middle-class periodical discourse. Both Wood and Braddon manipulated the space available to them within the family magazine as a way of establishing themselves as important practitioners of the sensation novel. The chapter on *Armadale* in *The Cornhill* takes its focus from the tensions raised by the serialization of a popular sensation novel alongside two domestic novels, indicating the convergences and divergences of competing genres, made starkly evident by their simultaneous presentation within the same periodical. The next chapter, however, reveals the dramatic configuration of sensation novel and family magazine, discussing the serialization of the first sensation novel, *The Woman in White* in *All The Year Round*, and how Dickens as editor supported its instalments with related 'sensational' features.

2
Wilkie Collins's *The Woman in White* in *All The Year Round*

Preaching to the nerves

Victorian reviewers who condemned the sensation novel did so on the grounds that it 'preached to the nerves' rather than to the reasoning faculties.[1] The first example of the genre, Wilkie Collins's *The Woman in White*, was designed to elicit a 'nervous' response from readers through a mystery plot based on the schemes of gentlemen criminals and the wrongful confinement of people in lunatic asylums. Collins's technique for generating 'sensation' was to unsettle his readers by focusing on two major areas of middle-class anxiety: the vulnerability associated with poor physical and mental health, and the encroachment of crime into the genteel home. In *The Woman in White* Collins presents an array of physically and mentally debilitated characters who struggle against the devious plots of educated criminals. His style of literary sensationalism proved extremely effective and sales of *All The Year Round*, the magazine in which the novel was first serialized, soared throughout its run. Collins's success caused a 'sensation' itself, and various entrepreneurs exploited this by marketing 'Woman in White' merchandise, products such as cloaks, bonnets, and perfumes.[2] This sort of commercial exploitation of the novel, along with its appearance as a serial in a popular weekly magazine, helped to establish an impression of the new genre as a type of commodity, rather than as a legitimate form of 'respectable' literature.

This chapter illustrates how the interaction between Collins's novel and *All The Year Round*'s journalism intensified the impact of the new sensationalism. Dickens's editorial skills ensured that *The Woman in White*'s instalments were accompanied whenever possible by articles and stories which echoed its themes of crime, danger, and 'nervousness'. Editors generally placed what they considered to be the magazine's most

The Woman in White 39

important item first, and in *All The Year Round* the serialized novel was always placed as the leading feature. However, although the novel was privileged by its prominent positioning, the accompanying articles, poems, and short stories, were important and not simply randomly chosen to make up the requisite number of columns. Reading the instalments of *The Woman in White* as a magazine serial highlights the careful planning which was made by Dickens and his sub-editor, William Henry Wills, to provide suitable support for Collins's novel in order to enhance its 'sensational' qualities.

All The Year Round was launched with the serialization of *A Tale of Two Cities*, its graphic descriptions of the violence of the French Revolution establishing the magazine's credentials for sensational writing. *The Woman in White* took over in November 1859 as the second serial, presenting readers with a more up-to-date sensationalism which proved even more popular than Dickens's historical focus. The success of the magazine's sensationalism established a popular discourse which dominated its pages throughout the first five years of publication. In relation to other middle-class magazines of the period, an unusually high proportion of *All The Year Round*'s contents, both fiction and non-fiction, dealt with 'sensational' topics such as crime (especially murder and forgery), disasters, war, historical atrocities, accidents, incurable diseases, mental illness, imposters, gambling, suicide, bankruptcy, and violence. The most commonly occurring themes during *The Woman in White*'s run were crime, health and safety, and it is no coincidence that articles and stories dealing with such issues were clustered around those instalments of the novel which foregrounded revelations of crime and worrying instances of debilitated health. Collins's development of a successful literary sensationalism was the culmination of a number of experiments with magazine publication during the 1850s whereby he had formulated a genre designed to suit the tastes of the middle-class reading public and the requisites of the weekly periodical.

The essential thing is to keep moving: Collins's narrative strategies

From 1850 to 1860 there was a marked shift in middle-class reading tastes. The 'social problem' and domestic novels of the 1850s were falling out of favour as readers sought more exciting plots which represented insecurity and danger temporarily disturbing the genteel home. Dickens and Collins, both of whom knew the market for middle-class fiction well, worked together during *The Woman in White*'s serialization to cater to the

new taste for sensational narratives. The unusually intense relationship between serial novel and host magazine can be explained by Dickens's and Collins's close friendship and working partnership. Collins had developed his expertise as a writer during his years as a *Household Words* staff member. From 1852 he had regularly contributed articles and short stories, collaborating with Dickens on popular Christmas numbers and other literary projects, and becoming a salaried staff member in 1856.[3] In 1859 Collins's major break came with *The Woman in White*, when *All The Year Round* presented him with the opportunity to reach a mass audience. With this novel, he became a household name, his style of sensational writing influencing many authors of the period.

Collins was excited by the potential offered by the family magazine to reach a mass audience, although he was also aware of the potential pitfalls of serialization. In 1857 his novel, *The Dead Secret*, had appeared in weekly instalments in *Household Words*.[4] Like *The Woman in White*, *The Dead Secret* was also a mystery story with sensational elements, although unlike the latter novel, it was not particularly successful in serial form, being largely devoid of suspense. Collins's main mistake was the revelation of the mystery in the first instalment, clearly an unsuitable strategy for sustaining the reader's interest in a novel over a number of months. When he came to write his next serial novel for *All The Year Round*, he was careful to avoid this mistake. *The Woman in White*'s success as a serial depended upon skilfully shaping a long mystery story into carefully crafted instalments, each suited to the demands of magazine readers for surprise and suspense. Collins rose to the challenge, constructing a plot which, he once argued, was designed 'to create maximum suspense and mystifica-tion' over the nine months of serialization.[5] With *The Woman in White* Collins knew that to avoid the disappointing reception of *The Dead Secret* he '*must* stagger the public into attention, if possible, at the outset'.[6] This time, Collins made the instalment form work for him, rather than against him, by providing numerous secrets and plot complications which allowed him to 'stagger' readers on a weekly basis.

Collins's success in shaping *The Woman in White* into instalments meant that the exigencies of the serial form itself became responsible for many of the distinctive generic features of the sensation novel, and new writers (all of whom serialized in magazines) incorporated similar narrative devices in each instalment.[7] The serial form inclined sensation novelists to develop a fast paced plot designed to capture and retain the reader's attention over the months of serialization. This was noted by G. H. Lewes in an article in *The Fortnightly Review*, where he argued that the main characteristic of the sensation novel was its 'breathless rapidity of

movement; whether the movement be absurd or not matters little, the essential thing is to keep moving'.[8] Lewes's objection to the accelerated pace of the sensation novel, however, was precisely the grounds for readers' pleasures in the genre. The proliferation of secrets and shocks, all of which accumulated on a weekly basis, was clearly popular with the readers of serials.

As a seasoned journalist, then, Collins was familiar with the characteristics of the publishing space in which *The Woman in White* appeared. While Dickens offered his colleague generous editorial support, Collins reciprocated by developing his novel with *All The Year Round*'s readers in mind. There were particular advantages to publishing in *All The Year Round*. Collins's long-standing professional connection with Dickens and his journals gave him the opportunity to write non-fiction features which could be published alongside the instalments of his novel. One of the most important examples of this was when Collins's two-part article on Vidocq, the French criminal-turned-policeman, appeared alongside the novel's most climactic instalments, the episodes in which Sir Percival Glyde's 'secret' (his illegitimacy and forgery) is disclosed.[9] The provision of an appropriate environment for the instalments of *The Woman in White* meant the inclusion of other features by a range of authors on the topics of crime, detection, health, and safety, matching the novel's preoccupation with these issues. Dickens added his own contributions to support Collins's serial. No doubt stimulated by the success of earlier *Household Words* collaborations with Collins on Christmas numbers, such as *The Perils of English Prisoners* and *A House to Let*, and the account of a walking tour of 1857, *The Lazy Tour of Two Idle Apprentices*, Dickens was keen to publish his own work alongside some of *The Woman in White*'s instalments.[10] His *Uncommercial Traveller* essays made regular appearances, while the two-part story, 'Hunted Down', an exploration of the theme of the gentleman criminal, was significantly positioned alongside the final instalments of Collins's novel.[11] This intervention on Dickens's part offers further evidence that he envisaged *All The Year Round* as an organic whole, intended to be read in its entirety, rather than solely as a vehicle for a serialized novel by a well-known author with the accompanying texts as 'disposable' added extras.

Strange family stories

By deliberately generating suspense in each instalment, Collins set a brisk pace for his narrative. He 'staggered the public into attention' by thrilling readers at the outset with plenty of dramatic incident to suggest a

long-term future for his novel. This is particularly evident in the first instalment, where Collins not only builds up suspense and mystery but also creates a magazine within a magazine, borrowing from *All The Year Round*'s format in order to present his narrative as a series of 'documents' or stories, echoing the fragmented structure of the family magazine. Walter Hartright, the novel's main narrator, positions himself as the 'editor' of various first person testimonies, a self-imposed task which extends his professional role as an illustrator for a range of journals. He begins his career working 'for the cheap periodicals', and later goes on to produce illustrations for a more upmarket current affairs paper.[12] In the 'Preamble' to the novel, Hartright presents the story of the conspiracy against Laura Fairlie and Anne Catherick in the style of journalism: 'This is a story of what a Woman's patience can endure, and of what a Man's resolution can achieve' (II, 95), a 'headline' statement which resembles the openings of many of *All The Year Round*'s non-fiction accounts of unusual 'cases' which are brought to the public's attention.[13] Walter's recounting of what he calls 'this strange family story' (11, 96) matches the numerous other 'strange family stories' which Dickens presented to readers of his family magazine. The novel's documentary framework is established by Walter's address to readers, 'the story is left to be told, for the first time, in this place' ('this place', of course, being the novel's initial appearance in Dickens's magazine). The 'factual' basis for the story is implied by the use of courtroom procedures, 'As the Judge might once have heard it, so the Reader shall hear it now.' (II, 95) This beginning has seemed rather odd to some critics; D.A. Miller, for example, has wondered 'why and for whom does this story need to be thus told?'.[14] The answer is obvious: Collins wrote his novel for a magazine audience used to features outlining 'strange family stories', accounts of bigamy, insanity, and dramatic falls from middle-class comfort to poverty in the workhouse. Within this context, the instalments of *The Woman in White* offer readers yet another odd and disturbing story. This attempt to recreate the procedures of *All The Year Round*'s journalistic practice is used by Collins as a way of lending an air of verisimilitude to an improbable mystery story.[15]

Hartright's opening narrative provides an abundance of mysteries largely suggested by the atmosphere of unease and vague forebodings which he maintains until the novel's final instalments, creating a suitable sense of anticipation in readers. Miller has indicated that this is a typical device of the sensation novel, where 'in order to make us nervous, nervousness must first be represented'.[16] Yet Hartright's fears are never explained. Indeed, the very lack of explanation for his initial agitated state

· of mind and poor health (he is aware of only a 'small pulse of life within', II, 96) serves to generate nervousness in readers. Hartright's unexplained depression affects his response to the offer of a lucrative post as a drawing-master to two young ladies at Limmeridge House, presenting readers with a mystery at the outset: why cannot Hartright rid himself of his 'unreasonable disinclination to go to Limmeridge House' (II, 100)? This mystery functions simply to unnerve readers and project them towards a future when Hartright's fears will be realized and his early reluctance appear in the light of a premonition of the plot wrought against Laura and Anne. The dramatic encounter with the 'woman in white', which swiftly follows his 'disinclination to go to Limmeridge', appears to explain his forebodings. Walter (like the readers Collins intended to 'stagger') is 'staggered with astonishment' (I, 103) when the mystery woman unexpectedly refers to Limmeridge House, while her refusal to explain her connection with the House, along with her strange fear of an unnamed Baronet, serves to heighten the sense of mystery. The doubt cast on her sanity at the close of the first instalment leaves plenty of unanswered questions to motivate readers towards future instalments of the serial.

Collins's techniques as a serial novelist, while popular with the 'common' reader, were not always appreciated by the critics. The lack of immediate explanation for an apparent mystery was a major device employed by Collins in *The Woman in White*. This, however, was a source of irritation to Anthony Trollope, who probably read the novel in book form rather than as a serial. He wrote in his *Autobiography* that Collins:

> seems always to be warning me to remember that something happened at exactly half-past two o'clock on Tuesday morning [...] One is constrained by mysteries and hemmed in by difficulties, knowing, however, that the mysteries will be made clear, and the difficulties overcome by the end of the third volume.[17]

Most readers, however, (if the relative unpopularity of *The Dead Secret* is anything to go by) felt reassured by a mystery plot which suggested a clarifying revelation in the final instalments.

Life in danger: sensationalizing health and safety

Collins's use of pointed warnings and forebodings, along with his numerous representations of nervousness and anxiety, were meant to be contagious.[18] As Margaret Oliphant suggested, the sensation novelist

'thrills us into wonder, terror, and breathless interest, with positive personal shocks of surprise and excitement'.[19] In *The Woman in White* the issues of poor health and nervousness are linked, many of the characters fall ill, usually as a physical response to their disordered states of mind on being wracked by fear, guilt, anger, or worry. Virtually all of the characters in the novel are at some point ill, and the novel's preoccupation with illness and 'nervousness' was supported by discussions of health in *All The Year Round*. Fictional and factual accounts of nervous disorders and poor health intersected in *All The Year Round*, apparently confirming contemporary medical theories which suggested that the pace of modernity was rendering the middle classes nervous and weak, 'unfit' to survive the pressures of the 1860s.

The Woman in White's concern with poor health, particularly poor 'nerves', can be read as a response to Victorian medical theories which suggested that both mind and body suffered from the turbulance and disorder of modern life. There was a widespread perception that the 'disorder of the outer world was paralleled by [...] bodily fragility within'.[20] Nervous disorders were increasingly being viewed as symptoms of an advanced state of civilization, 'diseases of affluence, the symptoms of over-indulgence, idleness, and excess of the civilised refinement of the upper classes of both sexes'.[21] Medical experts of the period were divided about the causes of this condition. The American neurologist, G. Miller Beard, argued that 'nervousness' was inevitable in technologically advanced societies, and that professional men in particular (or, to use his term, 'Brain-workers') were becoming 'nervous' because of new pressures to succeed within a demanding and stressful workplace. Others, such as B.A. Morel the French medical theorist, postulated that increased nervous debility was actually the result of the biological degeneration of the human species. Alongside these theories, popular representations of modern nervous complaints (such as the sensation novel) further highlighted confusion as to whether 'nerves' were a signal of 'genteel' sensibilities in the face of a debased age or of poor moral and physical heritage.[22]

Evidence of this confusion emerges in *The Woman in White*, where the 'nervous' aristocratic men, Glyde, Fosco, and Fairlie, are associated with the degenerative theories of nerves, while the virtuous and bourgeois Walter Hartright suffers only temporarily from a bout of genteel 'nerves' before he regains his composure to engage in demanding detective work. His recovery is, Collins implies, a sign of his good moral and physical heritage. Collins is also sympathetic towards the nervous illness of another bourgeois professional character, the lawyer Mr Gilmore – typical

of Beard's Brain-workers – who suffers an apoplectic fit as a result of over work. A more negative view of 'nervousness' is offered in the figure of the chronic invalid, Mr Fairlie, whose wealth, over-refinement, and shattered 'nerves' indicate both his modernity and degeneracy. Marian sums up contemporary confusion about nervous disorder when she describes Mr Fairlie's condition:

> I don't know what is the matter with him, and the doctors don't know what is the matter with him, and he doesn't know himself what is the matter with him. We all say it's on the nerves, and we none of us know what we mean when we say it. (II, 119)

Collins, a chronic 'nervous' sufferer himself, was aware of developments in medical practice and theories surrounding the psychosomatic maladies which were plaguing the middle classes during the mid-Victorian period, and his personal engagement with the modern preoccupation with health and sickness permeates *The Woman in White*. Collins's obsession with health undoubtedly stemmed from his own search for a cure for his 'gout' and various 'nervous' ailments.[23] He was not alone in his obsession with health, for the prominence of the subject of illness and its treatment in *All The Year Round* indicated Dickens's awareness of the subject's popularity. Readers of the magazine during *The Woman in White*'s serialization frequently received double doses of anxiety, for the novel's depictions of ill and nervously debilitated characters were supported, as we shall see, by articles discussing the precarious health and safety of the middle classes.

Besides Mr Fairlie, the majority of Collins's characters are mentally and physically debilitated in some way at some point of the narrative and display physical signs of their 'nervousness'. Hartright responds to his midnight encounter with Anne Catherick with 'every drop of blood in [his] body [...] brought to a stop' (II, 101), while Anne herself later displays 'maniacally-intense' facial expressions (II, 217), with 'nervous, uncertain lips' (II,101). Her half sister, Laura, has lips which 'trembled visibly' (11,167), and Walter himself displays at one stage 'a momentary nervous contraction [which] quivered about the lips and eyes' (II, 288). Sir Percival Glyde suffers from a 'wearisome cough' (II, 382) and is 'worn and anxious' (II, 336). Glyde's poor physical heritage may, Collins suggests, be the result of his father's weak health, his 'painful and incurable deformity' (III, 219). Characters in the novel are in turn unhealthily pale or flushed; Laura first 'turned pale and trembled violently' (II, 333), then later has 'a feverish flush in her cheeks' (II, 336), eventually becoming 'pale' (III, 102) and debilitated with her 'weakened,

shaken faculties' (III, 173). Anne, suffering from a fatal aneurism, is 'pale and thin and weary' (II, 502), eventually becoming a 'ghastly white' colour (III, 124). Madame Fosco displays a 'ghastly whiteness' at one point (II, 528) and has unhealthily 'dry white hands (so dry that the pores of her skin look chalky)' (II, 383). Glyde also turns to an 'awful whiteness' and, during a moment of crisis, 'great beads of perspiration broke out' on his forehead (III, 101). Fosco, despite his masterly criminal plotting, is also plagued by bad 'nerves', he 'starts at chance noises' and is 'scared' and 'dazed' (III, 126) by Anne's inconveniently premature death. Marian, so robust and hearty at the beginning of the novel, succumbs to typhus fever and is left 'worn and wasted' with 'Pain and fear and grief written on her as with a brand' (III, 128). Mr Gilmore's partner, Mr Kyrle, is a 'pale, thin, quiet' man (III, 193) who appears in danger of succumbing to the poor health which afflicts Brain-workers. Even Mr Dawson, the doctor who attends Marian, also suffers 'ill health' (III, 146). By the end of the novel, most of the characters are either dead or in worse health. Only Walter, who experiences a brief bout of 'nerves', overcomes his ill health by an 'adventure cure' in the colonies where danger taught him 'to be strong, [his] heart to be resolute, [his] mind to rely on itself' (II, 373). This allows him, unlike the other characters, to shake off the debilitating effects of the 'nerves' which, according to Victorian theorists, were inextricably linked to modern, technologically advanced societies.

The debilitations of modern middle-class life were discussed in an article, 'The Breath of Life', which appeared in the same issue as the episode of *The Woman in White* where Marian displays the first symptoms of typhus fever.[24] She suddenly (and at this point inexplicably) becomes too feeble to rise from the sofa. In the instalment where Marian lies helpless, readers also encountered the heated debate between the doctor, Mr Dawson, and Count Fosco on the proper treatment of her fever. This very debate formed part of the strategically placed article, 'The Breath of Life', based on a recently published book by Dr Thomas Inman, *A Foundation for a New Theory of Medicine*, appearing immediately after the instalment in which Marian displays the first signs of her illness. Collins uses the argument between Fosco and Dawson to raise topical debates surrounding old-style ideas about 'lowering' a fever (that is, purging the patient in order to reduce the temperature) and the new 'fortifying' regime of plying the patient with alcohol and other stimulants. Dawson subscribes to the traditional remedy while Fosco, who boasts of his medical studies at 'the gigantic centres of scientific activity – Paris and London' (III, 73), wins the day by insisting that Marian is treated with 'alcohol, ammonia and quinine'. At this point, readers have reason to

believe that Fosco wants to harm Marian, yet Fosco's argument is actually supported by 'The Breath of Life', where the reviewer of Inman's book maintains, 'The wholesome rule of the profession now, is, to use wine, quinine, and whatever can support the patient's strength.' (II, 484)

'The Breath of Life', while summarizing some of the theories outlined in *A Foundation for a New Theory of Medicine*, offers a series of sensational anecdotes, presented as 'strange family stories', outlining the diseases and debilitations which afflict the genteel classes. The title of the article refers to the vital force which each individual must nourish and protect, for the least shock or over exertion may extinguish it. Although no overt links are made between mental and physical states, the numerous examples of debilitation and sudden death imply that 'nervousness' may render 'the breath of life' extremely fragile; the most ordinary aspect of middle-class life, the least exertion, is shown to be potentially fatal. The examples are presented in the form of alarming narratives of middle-class breakdown. One lady became inexplicably 'bloodless and weak, required food half-hourly, she was unfortunately allowed to sleep too long, and she awoke only to die' (487). Similarly, 'Miss E', recovering from influenza, 'sat up in bed chatting actively, ate heartily of chicken, and died when she laid her head back on the pillow' (487). Another lady died during a fit of laughter, while another expired on a walk which her doctor ordered her to take. A mother, 'suddenly depressed by a shock of profound terror', put her baby to her breast and 'at the first draught of milk its limbs become rigid and it dies' (484).

These cases, illustrating the dire results of over exertion or emotional strain, are not limited to middle-class women, for 'gentlemen' are equally prone to debilitation (interestingly, the article offers no examples of working-class sufferers). The writer describes a gentleman walking to a concert, 'and for three days afterwards his life was despaired of' (487). An 'active man of business' became suddenly enfeebled and developed 'a distressing impediment of speech' (187), while a surgeon abandoned his work because of the 'wild visions' which haunted him (485). Other 'Brain-workers' suffer habitual vomiting (486) and mental instability (487). These cases indicate a physical response to psychological trauma, although this is not a feature of the discussion. In fact, the suggested 'cures' are intended to soothe the body rather than the mind. At the first signs of a flickering 'breath of life' the patient is advised to consume food 'liberally' and take 'plenty of rest on the sofa [...] read[ing] novels for a week' (487). Whether the new sensation novels were recommended as therapeutic reading for nervous patients is, unfortunately, not stated.

Readers' 'nervous' and 'hysterical' responses to sensation fiction were particularly intensified in the issue of *All The Year Round* where 'The Breath of Life' appeared.[25] The descriptions of debilitated patients are mirrored by Marian's inexplicable decline which leaves her exhausted and vulnerable. Jenny Bourne Taylor, in *In The Secret Theatre of Home*, a discussion of Collins's sensation novels in relation to Victorian psychology, outlines the debates during the nineteenth century surrounding women's mental and physical well-being. Many medical experts, she argues, viewed 'both energy and lassitude' in female patients as 'explicitly morbid'.[26] Women were considered to be prone to hysteria because they naturally possessed little energy and were unfitted for mental and physical exertion.[27] In the novel both Marian's energy and Laura's lack of it point towards adverse medical consequences. After her recovery from typhus, Marian's exhaustion (undoubtedly read by contemporary readers as the result of her 'unnatural' expenditure of energy earlier in the novel), is ultimately overcome when she leaves the 'man's' work of detection to Hartright. Miller aptly points out that Marian, an unusually energetic and forceful woman, is eventually cured by domestication, becoming the '"good angel" of the Victorian household'.[28] While Marian is 'cured' by confinement within the home, her half-sisters, Laura and Anne Catherick are confined in a lunatic asylum.

All The Year Round published numerous articles on the care and treatment of insanity, reflecting a general taste for graphic descriptions of insanity in novels and periodicals. Madness, like criminality, was now represented by means of textual display (whether produced by novelist, journalist, or medical expert), a 'civilized' displacement of the earlier taste for voyeuristic outings to Bedlam or Newgate.[29] In his representations of Laura's and Anne's incarceration in a lunatic asylum, Collins was playing with common fears regarding the boundaries between insanity and sanity and the legitimate confinement of those presumed to be insane. *Household Words* had devoted considerable space to this subject, even though Dickens felt a 'responsibility' to avoid 'awakening a slumbering fear and despair' in readers who lived under the shadow of hereditary insanity.[30] He found it difficult to pursue this non-alarmist policy in *All The Year Round*, however, when readers demanded sensational features and many of his contributors were keen to exploit the taste for representations of the horrors of the madhouse.[31]

Collins's exacerbation of readers' fears of insanity and false incarceration was counteracted by Dickens's inclusion in *All The Year Round* of a rosy account of life in Bedlam written by a former inmate. This article, 'Without a Name', appears immediately after Mr Gilmore's description of

his interview with the 'nervous' Mr Fairlie.[32] At this point, the mysterious links between Glyde and the escaped lunatic, Anne Catherick, have been emphasized, and Hartright's meeting with her in Limmeridge churchyard has indicated that Glyde may be guilty of wrongfully incarcerating her. Into this atmosphere of uncertainty Dickens inserts 'Without a Name', the title referring to the fact that he considered this to be an unclassifiable feature (hence the inability to give it a proper title) because it has not been written by a journalist. Dickens's note informs the reader that this is a letter 'addressed to the Conductor of these pages [. . . who has] published it exactly as he received it, and without even giving it a title' (291). *All The Year Round* usually published no letters from readers, so this move was very unusual. The writer, described by Dickens as an 'educated and delicate woman', describes how she left her home to find a better one in Bedlam, explaining how domestic life left her depressed, 'silent and moody'. In Bedlam, however, 'everything was done to amuse and interest her' (291). This article probably offered little reassurance to readers who feared the horrors of false incarceration in a lunatic asylum, not only because *The Woman in White* was powerfully suggesting that sane people could be wrongly confined, but also because a three-part novella, *The Black Tarn*, serialized alongside Collins's novel, describes another land-owning husband who tries to incarcerate his wife as insane. The fact that he murders her instead, while his second wife, on discovering the fate of her predecessor, swiftly loses her sanity and dies, scarcely allays readers' fears.[33]

The issue of poor health was raised in *All The Year Round* during *The Woman in White's* run in other ways than through references to debilitated nerves and full-blown insanity. Dickens's magazine also liked to remind readers that the bodies of middle-class people were equally vulnerable to attack. Collins's sensational representations of nervous shocks, palpitations, and anxieties was supplemented with other features designed to elicit similar responses from readers in relation to accidents. For example, 'Life in Danger', published on 24 March 1860 drew attention to the dangerous state of the Serpentine in Hyde Park, where the calm surface conceals 'the real depths of [the water's] character', where 'treachery, and poison, and death' (in the forms of mud and pollution), lurk to entrap unwary pleasure-seekers.[34] An earlier article on the same topic of watery dangers, 'Man In!', warns against skating on thin ice, and is narrated by a person who has narrowly escaped death by drowning. Ignoring a 'Danger' notice, he plunges into the water, where he experiences the sensation of cold 'arresting the very life within me. Am I going to die?'.[35] These two 'disaster' articles, with their emphasis on the

hidden dangers of middle-class leisure pursuits, alerted readers to *The Woman in White's* own depiction of danger in a genteel pleasure-ground: Blackwater Park, Sir Percival Glyde's estate in Hampshire, containing a gloomy lake which looks 'black and poisonous'. Laura and Anne, the two threatened heroines, put their lives in danger when they meet at the boathouse alongside the lake. Readers already had reason to be wary about this sinister spot, for earlier Marian had discovered Mrs Catherick's dying dog, and Count Fosco referred to the lake when he outlined his alarming theories on crime. 'Life in Danger' follows closely on Marian's account of Laura's meeting with Anne at the Blackwater Lake (by now firmly associated in the reader's mind with death and crime), fuelling fears of the possibility of a dreadful fate for the two women.

Self-help and helping yourself: the rise of the gentleman criminal

Sensational representations of nervous debilitation and disaster in *The Woman in White* and *All The Year Round* were matched by images of crime. Middle-class anxieties about criminality focused upon fears of the outwardly respectable criminal infiltrating and undermining the genteel home. Collins's novel, like all subsequent sensation novels, was structured around 'the interaction of crime and family life'.[36] The criminals of sensation fiction were rarely from the working class; usually they were educated, upwardly-mobile 'impostors'. This literary type was a relatively recent innovation, indicative of the changes in the way criminality was being represented during the nineteenth century. As Michel Foucault has argued in *Discipline and Punish: The Birth of the Prison*, crime literature's traditional popular representation took the form of the 'gallows speech', a condemned criminal's published 'confession', often heavily embellished, and frequently a fictional account.[37] Early Victorian 'Newgate' fiction incorporated the 'gallows speech' into the genre of the novel, and later in the century the more sophisticated formula of the detective novel offered further developments in terms of narrative styles and themes. Foucault has charted this transition from the confession of the criminal hero in popular broadsides to the elaborate plots based on the educated super criminals of detective fiction in which, 'crime is glorified, because it is one of the fine arts [. . .] [T]here is a whole aesthetic rewriting of crime, which is also the appropriation of criminality in acceptable forms.'[38] This new crime literature focused not upon the conflict between the people and powerful, often oppressive authorities, a traditional element of many 'gallows speeches', but upon the 'struggle between two

pure minds – the murderer and the detective'.[39] The Victorian novel's claim to represent social realities became, along with newspapers and journals, a new arena for representing crime, its detection, and the punishment of the offender.

Henry James, reviewing Mary Elizabeth Braddon's work in 1865, drew attention to the way sensation novelists were representing criminality as a symptom of modernity, 'Modern England – the England of today's newspaper – crops up at every step'.[40] As James suggests, the sensation novel and the newspaper had converged as the demand for the criminal to be publicly displayed shifted from the carnivalesque spectacle of public torture and execution to the private 'civilized' voyeurism of the text. The exposure of middle-class (rather than more 'ordinary' working-class) crime was fascinating to newspaper and novel readers, who relished stories of clever criminals encroaching on the supposedly safe world of the genteel family and its sources of finance. Indeed, Franco Moretti has identified a connection between the development of detective fiction and the growth of impersonal modern capitalism based on complex systems of investment and banking.[41] The sensation novel, like its offshoot the detective novel, addressed common anxieties about the difficulties of regulating a rapidly expanding urban society whose wealth was dependent on the mysterious processes of an anonymous capitalist marketplace. Middle-class family life was usually made possible by the income from investments in stocks and shares, and could be drastically undermined by criminal activities on the financial markets.[42]

During the 1860s the press foregrounded forgery and other financial irregularities as a disturbing social problem. Glyde's forgery symbolizes a general unease about the gentleman criminal, an unease which was also registered by Dickens in his story, 'Hunted Down', published alongside the final instalments of *The Woman in White*. These fictional accounts of the activities of gentlemen criminals were supplemented by articles on financial crime which employed a sensational discourse to analyse the issue of social survival. Surviving within a modern competitive, money-based society was, from the middle-class reader's perspective, as problematic as suffering from poor mental and physical health. The inability to engage in the 'universal struggle' to survive in the modern workplace particularly generated fear of failure.[43] November 1859, the month in which *The Woman in White* began serialization, also saw the publication of Samuel Smiles's *Self-Help*.[44] Smiles's influential guide book appeared at the height of a scandal surrounding a series of forgeries, where English businessmen had 'helped themselves' to an extra share of their employers' profits. *All The Year Round*, by means of articles on financial crime, made

explicit links between *The Woman in White's* themes and the controversial ideology of self-help. At the same time, readers were invited to link Glyde's criminal activities to Smiles's theories. *All The Year Round* connected the doctrine of self-help to the recent cases of forgery, strategically placing its discussions not in the months immediately following the publication of *Self-Help*, but when Glyde's forgery is sensationally exposed in *The Woman in White*.

One of these articles, 'Convict Capitalists' by John Hollingshead, a regular contributor to the magazine, appeared a month before the instalment where Glyde is unmasked. Hollingshead discusses recent cases of fraud involving large sums of money, viewing Smiles's *Self-Help* as a guidebook for aspiring criminal businessmen. The self-help ideology, he sensationally suggests, presents a temptation to 'convict-capitalists', the recent forgers who:

> started from very humble positions – were born with no directorial silver spoons in their mouths – were quick to discover the weakest point of the trading system in which they were placed and, with one exception, almost ended by becoming convict millionaires.[45]

Although Collins's forger, Glyde, was born with a 'silver spoon in his mouth', his criminal resourcefulness links him to the aspiring gentlemen forgers whose social rise is brought about by 'keenness and industry' (203), the money they gain from crime allowing them to live in the style of traditional gentlemen, a way of life which Glyde is determined to maintain.

Hollingshead inverts the language of *Self-Help* to describe the City forgers as men who 'helped themselves' (203). In 'Convict Capitalists' he discusses one forger, Walter Watts, who 'became the proprietor of two theatres, and lived an intensely gay life during the hours that remained to him before ten o'clock in the morning and four in the afternoon' (203). Watts, a parody of the conscientious self-made man, obeys the exigencies of capitalist working practices during the day in order to become a 'gay' aristocrat at night. Another forger, Leopold Redpath, is described as the 'aristocrat' of fraud, reaching 'the top of the criminal tree as the most eminent among all modern men of this kind' (203). Another aspirant to the gay life of the gentleman is the swindler, George Pullinger, who speculated 'on the turf or the Stock Exchange [by] keeping money back from his employers' store at the Bank of England, in order to gamble like a capitalist, or a sporting lord' (204). These City criminals are represented as daring class imposters, encroaching upon a respectable society which

frequently failed to distinguish between self-made men and men who 'helped themselves'.

Hollingshead envisages a forger of the future who extends the self-help ethos by recognizing no barrier to his social ascent, buying up shares in his employer's company with his fraudulent 'earnings' 'until he stands sole proprietor of the establishment, secure from any civil or criminal prosecution. The bank will be his, the clerks will be his, the books and documents will be his' (204). This type of crime was possible, Hollingshead suggested, because educated criminals could employ the behaviour and manners of 'gentlemen' (no doubt with the help of suitable guidebooks, such as *Self-Help*) as a mask to deflect attention away from their explorations of the weak points of an expanding capitalist marketplace. A second article by Hollingshead, 'Very Singular Things in the City', focuses on the rise of Redpath, tracing his career from 'ambitious costermonger' to his notoriety as the 'aristocrat of fraud'.[46] Redpath used forged signatures to issue share certificates of the Great Northern Railway Company (where he held a position of trust as a manager). After being arrested on charges of defrauding the company, Redpath took 'a lofty tone about his means and position "as a gentleman"' (325).

'Convict Capitalists' and 'Very Singular Things in the City' highlight the problems inherent in the doctrine of self-help, exposing the ways in which criminals use fraud to fund their tastes for the luxuries and freedoms associated with gentlemen of leisure.[47] This exposure of imposture had surfaced in *The Woman in White* in the figure of Glyde. The forgery of his parents' marriage details in the parish register, a capital offence until 1832, conceals his illegitimacy, the 'Secret' which motivates the plot. Glyde is typical of the criminals of sensation fiction. The idea of the crime comes 'on the spur of the moment' (III, 491) although, being an educated criminal, he makes meticulous plans, taking 'some time getting the ink the right colour (mixing it over and over again in pots and bottles of mine) and some time, afterwards, in practicing the handwriting' (III, 492). The climactic revelation of the forgery is swiftly followed by Glyde's punishment, an unofficial execution, as he burns to death in the vestry of Old Welmingham Church in an attempt to obliterate all traces of his crime. This spectacular finale to Glyde's villainy is presented as an act of God, the public authorities remaining in ignorance of his forgery.

By emphasizing the connections between Glyde and the 'gentlemen' forgers, *All The Year Round* was able to draw the reader's attention to the cultural debates surrounding Smiles's doctrine of self-help. This ability to pick up the news of the day and relate it to the sensation novel via magazine journalism was a characteristic of Dickens's editorial style

during the early years of *All The Year Round*. *The Woman in White*'s serialization was punctuated by connecting links between the novel's instalments and cultural debates. Dickens was particularly skilful at making such connections as a way of enhancing the novelty and impact of the new sensation genre. These links to *All The Year Round*'s journalistic discourse, which blurred the boundaries between fiction and the real world, also made *The Woman in White* appear dramatically up-to-the-minute. As well as the links to current debates surrounding health, safety, and self-help, Collins's novel was also related to high profile discussions on the problems of crime and attempts to develop efficient processes of detection, a major preoccupation of the mid-Victorian period. Collins's depiction of his gentleman forger, however, formed only one of the novel's criminal plots. The other villain, Count Fosco, is a much more dangerous threat to society, his theories on crime and contempt for the police heighten *The Woman in White*'s sensationalism, making important connections to the current debates on the effective policing of modern Britain.

Interchangeable figures: criminals, detectives and spies

Representations of imposture in *All The Year Round*, appearing at a time when some respectable businessmen were turning to financial crime were, like sensation fiction itself, intended to play upon readers' anxieties. Set against such educated criminals are the police, a sadly incompetent lot according to Hollingshead (who disturbingly echoes Fosco's low opinion of the efficacy of the British police). Instead, Hollingshead and Fosco (Collins's mouthpiece on this occasion) put their faith in the solitary clever detective, whether an amateur or skilled professional working privately.[48] Collins provides *All The Year Round* with two examples of clever detectives capable of outwitting smart criminals: Hartright in *The Woman in White*, who becomes an amateur detective solely to help Laura regain her 'stolen' identity, and Vidocq, the real-life French detective, who features in a two-part article, 'Vidocq: the French Detective', which appeared in July 1860.

Hartright's adoption of the role of detective does not compromise his position as a gentleman. As Anthea Trodd has argued, the introduction into the nineteenth-century novel of the policeman as a representative of social control was highly problematic, for policemen did not enjoy a 'gentlemanly' status and their intrusion into family secrets and scandals registered a note of alarm among the genteel classes.[49] In *The Woman in White*, criminal acts remain remarkably free from state intervention.

Glyde's forgery is never revealed officially to the authorities and the only representatives of the law Collins presents are the Fairlie's family lawyers who are incapable of preventing or exposing the criminal plots. While this lack of effective state control of crime allows Hartright the freedom to pursue the villains, he is saved from the 'ungentlemanly' act of handing the culprits over the police, for both Glyde's and Fosco's violent deaths occur without him directly intervening. The problems of social control, particularly the policing of domestic life, are conveniently elided in Collins's novel, where the amateur detective work, along with the processes of punishment and reward, is firmly fixed in the private realm of family secrets.

The appearance of Collins's article on Vidocq alongside two instalments of *The Woman in White* indicates one of the main advantages of magazine publication for novelists: the opportunity to explore themes simultaneously through fiction and non-fiction. Novelist–editors, such as Dickens, Thackeray, Braddon, and Trollope frequently made full use of the opportunity to write fact and fiction to be read together. Collins, as Dickens's close friend, was also privileged in his use of the periodical's space. The first part of 'Vidocq; the French Detective' appeared in the same issue of *All The Year Round* as the revelation of Glyde's crime and Hollingshead's article on Redpath's fraud.[50] By juxtaposing three related texts in this way, the Victorian family magazine could be used to explore a theme across a range of genres within a single periodical issue, thus intensifying the experience of reading a magazine. Collins's discussion of the career of Vidocq was particularly well-timed. In the instalment of the novel which precedes 'Vidocq: the French Detective', Glyde had been consumed in flames in the vestry as he attempted to cover his criminal tracks. Hartright, having reached a dead-end in his investigation, turns his attention to Count Fosco, the mastermind behind Glyde's plot against Laura. Readers of the serial needed their attention to be redirected from the dead Glyde to the active and dangerous Fosco, who had not featured in the story for several instalments. Collins timely piece of journalism offered this reminder because, as readers of the article would have seen, Vidocq was clearly a model for Fosco.

Vidocq's career was fascinating to the British middle classes.[51] In the early years of the nineteenth century, theatres had staged Douglas Jerrold's popular play, *Vidocq, the French Police Spy*, notable as one of the first plays to feature a detective.[52] In 1860 a new edition of Vidocq's *Memoirs* (originally translated into English in the 1820s) was published, and Collins's article directed readers' attention to the Frenchman's remarkable life of crime and espionage at a point when *The Woman in*

White was focusing attention on Fosco as the only surviving villain. The main similarity between Vidocq and Fosco is their chosen profession of spy, the former becoming a police spy as part of a bargain to secure a pardon against a conviction for forgery. As part of this bargain, he created the 'secret' department of Sûreté. He spent his youth engaging in various criminal activities and, like the eighteenth-century British criminal hero, Jack Sheppard, became notorious for his remarkable escapes from police custody. He felt no qualms about betraying his former criminal associates, and Collins was surely thinking of his own Fosco when he described Vidocq as 'glory[ing] in the name of spy; treachery brought no shame to his cheek' (334). While pretending to still be a thief, Vidocq infiltrated the criminal underworld of Paris, moving easily between the positions of criminal, police official and respectable member of society. He also had a lucrative sideline as a private investigator, 'hunting up debtors; the surveillance of married and unmarried women [...] the highest families unhesitatingly [applied] to him under the most delicate circumstances' (358). He aspired to the position of a gentleman, using his earnings to live in 'easy circumstances' (360).

Collins's Count Fosco also occupies positions in the supposedly mutually exclusive worlds of respectability and crime. This ability to straddle social divides is matched by Vidocq's and Fosco's shared ability to transcend gender roles. The former loved to dress up, 'assum[ing] whatever stature, gait, physiognomy, age and accent best suited to his purpose [....W]hen he was more than sixty years of age, his favourite disguise was to dress himself in female attire' (III, 332). Fosco's love of fine, colourful clothes and bons-bons suggest similar feminine tastes. As Marian says, 'his movements are astonishingly light and easy. He is as noiseless in a room as any of us women [...] he is as nervously sensitive as the weakest of us' (II, 384). There are other similarities which Fosco and Vidocq share. Fosco is also an expert in disguise, altering his whole body in order to escape the retribution of the Italian brotherhood be has betrayed, 'The shaven face [...] might have been covered by a beard in Pesca's time; his dark brown hair might be a wig; his name was evidently a false one.' (III, 434) Even his immense corpulence is contrived in order to mask his identity. Like Vidocq, Fosco is unconcerned about his treachery, describing his role as a spy in terms of 'diplomacy' and 'delicate political missions' (III, 457). An Italian aristocrat, Fosco's punishment takes the form of being stripped of his social identity, dying in the role of a working man, an appropriate punishment for a man who supported an oppressive aristocratic rule and attempted to rob others of their nationhood, and Laura and Anne of their identities.

Fosco is an early example in English fiction of the 'super-criminal', an educated genius whose cunning plots must be unravelled by an equally clever detective. His theories on crime exist as a legacy for subsequent fictional super criminals.[53] When the dull-witted Sir Percival considers the lake at Blackwater Park to be 'just the place for a murder', Fosco's logic rejects the idea: 'The water is too shallow to hide the body; and there is sand everywhere to print off the murderer's footsteps' (II, 407). He goes on to distinguish between two types of criminal, 'the fool's crime is the crime that is found out; the wise man's crime is the crime that is not found out' (II, 408). The relationship between the criminal and the detective, according to Fosco, is a 'trial of skill': 'when the criminal is a resolute, educated, highly intelligent man, the police, in nine cases out of ten, lose' (II, 409). His theories struck at the heart of middle-class insecurities about crime, playing on fears that society was rife with clever criminals who elude capture, capable of imposing themselves upon unwary respectable people as 'gentlemen' and 'ladies'. Clearly, the divine punishments meted out to the criminals of sensation fiction work to subdue such fears by suggesting that crime always brings about its own punishment. However Collins, despite his use of providential punishments for his villains, actually shared Fosco's views on crime, admitting that his 'theories concerning the vulgar clap-trap that murder will out, are my own'.[54] Although he maintained that his Italian villain was not modelled on any one figure, the similarities between Fosco and Vidocq suggest that Collins did (perhaps unconsciously) incorporate many of the French detective's traits into his creation of his own 'ingenious' Italian.

Collins's two-part article on Vidocq was placed alongside instalments of *The Woman in White* in a way which invited readers to draw parallels between the flamboyant Count Fosco and Vidocq. This juxtaposition was meant to suggest that the novel's representation of flamboyant criminals and spies was neither excessive nor 'unreal'. Dickens incorporated other examples of sensational journalism and short fiction to alert readers to the novel's modernity. 'Ardison & Co.', for example, is an article which discusses the career of an Italian businessman, brought to trial in March 1859 for hiring assassins to eliminate his rivals.[55] Other supporting features include discussions of the current political turmoil in Italy, which helped to put Fosco's and Pesca's involvement with the Italian 'Brotherhood' into a contemporary context for original readers.[56] A sensational short story, 'Written in My Cell', narrated by a murderer awaiting execution, further explores the figure of the gentleman criminal. The condemned man is outwardly respectable (and interestingly a contributor of sensational short stories to the popular press) who, in a fit of sexual

jealousy, murders the sixteen-year-old daughter of a family friend.[57] Another sensational story, *The Black Tarn*, in three instalments, features a female counterpart to Sir Percival Glyde, an illegitimate imposter. However, she is eventually murdered by her husband, an outwardly respectable member of the landed gentry.[58]

Dickens himself also entered the debate about gentlemen criminals which featured so prominently in *All The Year Round* during *The Woman in White*'s run. His short story, 'Hunted Down', appeared in the 4 and 11 August 1860 issues alongside the climactic instalments of *The Woman in White* when Hartright's investigations are finally coming to fruition and Fosco dies at the hands of a member of the Brotherhood he has betrayed. 'Hunted Down' concerns the criminal plot devised by an educated 'gentleman', Mr Julius Slinkton, whose suave and respectable appearance conceals his criminal propensities. Just as an avenging Walter Hartright hounds Sir Percival Glyde to his destruction in *The Woman in White*, Dickens also uses an amateur detective driven by the desire to avenge a loved one to bring about Slinkton's exposure and death. Slinkton combines fraud with murder, insuring the lives of his victims then slowly poisoning them. He was based on a former acquaintance of Dickens's, the forger and poisoner Thomas Griffiths Wainewright, a contributor to highbrow periodicals, who was executed in 1847.[59] Dickens, however, must also have had in mind a more recent poisoner, William Palmer, the Staffordshire doctor who insured his victims' lives before murdering them, and who had been tried and found guilty in 1856.[60]

Dickens borrows for 'Hunted Down' various Collinsian touches; for example, Hartright's discovery of Glyde's secret by stumbling upon an apparently irrelevant detail (the unusually cramped entry in the marriage register) is matched by Dickens's statement in 'Hunted Down' that 'some apparently trifling thing' may turn out to be 'the clue to the whole mystery. A hair or two will show where a lion is hidden. A very little key will open a very heavy door.'[61] This short story is notable mainly for its positioning alongside Collins's sensation novel, suggesting that Dickens was keen to try his hand at the new style of sensationalism embodied by *The Woman in White*. Collins, however, may have in turn been influenced by 'Hunted Down', whose villain, Slinkton keeps a diary (in cipher) of his crimes, a feature, which Collins uses in his third sensation novel *Armadale* (1864–66), with Lydia Gwilt's sensational diary outlining her wicked plots and crimes.

Sensation novels were usually based on the activities of flamboyant criminals, in contrast to the often insipid heroines and heroes of domestic novels. Dickens's Slinkton and Collins's Fosco were early examples of this

type of criminal. Margaret Oliphant, in her review of *The Woman in White* in 1862, singles out Fosco as 'the most interesting personage in the book [...] So far from any vindictive desire to punish his ill-doing, we cannot understand how Hartright, or any other man, finds it in his heart to execute justice upon so hearty, genial and exhilirating a companion'.[62] The moral function of the domestic realist novel, considered to lie in its ability to convey guidance about how best to conduct genteel family life, appeared to be crumbling with the advent of the sensation novel. Readers now preferred stories with prominent, and often appealing, villains. Among the gentlemen criminals who appeared in the sensation fiction of the 1860s are the dandy murderer, Sir Francis Levison, in *East Lynne*, Compeyson the swindler in *Great Expectations*, the corrupt banker, Mr Alfred Hardie, in Reade's *Hard Cash*, and the double-dealing philanthropist, Godfrey Ablewhite in Collins's *The Moonstone*. The sensation novel also offered readers criminal gentlewomen: the blonde Lady Audley, capable of assuming a new identity at a moment's notice in *Lady Audley's Secret*, and the passionate, auburn-haired murderess, Lydia Gwilt, in Collins's *Armadale*. Sensation novels also presented a host of erring ladies such as Lady Isabel Vane, Aurora Floyd, and Magdalen Vanstone.[63] While all of the major sensation novels appeared as magazine serials, only some of them received the special support which *All The Year Round* offered. Mrs Henry Wood's *East Lynne*, for example, did not enjoy the sympathetic support of a magazine editor. Despite this disadvantage, however, her novel was enormously popular, and its sensational discourse dominated the *New Monthly Magazine* in which it first appeared. The development of her career as a magazine contributor, along with her unique brand of melodramatic sensationalism will be discussed in the next chapter.

3

Ellen Wood's *East Lynne* in the *New Monthly Magazine*

East Lynne and its readers

In 1862 a young Englishman touring Egypt declined an invitation to join his travelling companions on an expedition to the tombs, choosing instead to finish a particularly engrossing novel. When his friends returned to the camp they found him still reading, and he later insisted that they read it too. The young man was Queen Victoria's eldest son, Edward, and the novel was Mrs Henry Wood's *East Lynne*. The Prince of Wales went on to organize an 'East Lynne' evening, and one of the company, Arthur Penryn Stanley, Professor of Ecclesiastic History at Oxford, later boasted, 'I came off with flying colours, and put one question which no one could answer – with whom did Lady Isabel dine on the fatal night?'[1] The 'fatal night' in question is when Isabel, the novel's erring heroine, runs away from her respectable bourgeois husband to join a dissipated aristocrat. Disfigured by a railway accident and regretting her hasty action, she returns to East Lynne disguised as a governess to suffer the emotional torments of witnessing her husband with his new wife, and having to educate her own children without acknowledging that she is their mother.

Since its serialization in W. Harrison Ainsworth's *New Monthly Magazine* from 1860 to 1861, *East Lynne* has had a complex history. It became one of the most enduringly popular novels among subscribers to circulating libraries following its appearance (with minor revisions) in three volumes. The novel's popularity continued well into the twentieth century. It was adapted for the stage shortly after the three-decker was published and for decades theatre audiences on both sides of the Atlantic flocked to hear Lady Isabel's heart-rending line as she watches her son die: 'Dead! And never called me mother!' Popular film versions of *East Lynne* appeared in

1916 and 1925.[2] However, by the mid-twentieth century *East Lynne* had declined into a joke, a tired Victorian melodrama which was no longer capable of generating emotion. More recently feminist critics have rescued the novel from obscurity, largely because of its powerful representation of the maternal melodrama and its articulation of the constraints of proper Victorian femininity.[3]

East Lynne is today considered the archetypal woman's novel, its mixture of sentiment and sensation forming a model for later examples of popular romantic fiction.[4] Indeed, Wood's famous direct address to the reader as 'Lady–wife–mother', an exhortation to women to bear any burden in the cause of domestic unity, appears to firmly establish *East Lynne* as 'women's' fiction.[5] However, as Prince Edward's and Professor Stanley's enthusiasm make clear, *East Lynne* was also received as an exciting novel by men as well as women. Indeed, during its serialization in the *New Monthly Magazine* Wood directly addressed male readers, although she chose to exclude this from the subsequent volume text. In the original serial, in Chapter 5, the reader is invited to witness the hero lawyer, Archibald Carlyle, at work. Wood describes his 'noble' tendency to smooth over his clients' disputes by promoting a spirit of reconciliation, rather than profiting by their disagreements. She imagines the male readers of Ainsworth's magazine 'sneering' at Carlyle's virtuous working practices, directly addressing them with the words, 'No, rest you assured, sir, that when business is conducted upon honest and sincere principles, it must and does prosper.'[6] This interjection indicates that Wood expected her novel, at least in its original serial form, to attract male readers as well as women; indeed, the *New Monthly Magazine*'s preference for political and military articles suggests that most readers of the magazine were men. One of Wood's major concerns, as this direct address to the 'sneering' male reader indicates, is her championship of businessmen and entrepreneurs. This type of middle-class hero dominates her fiction and is consistently displayed as a 'gentleman', despite his need to earn a living. Indeed, as Wood insists, the more gentlemanly the businessman the greater his profits, and this ethos is a significant feature of *East Lynne* and subsequent novels.

Here, we examine *East Lynne*'s origins as a magazine serial in order to show that the sad maternal sob story which has dominated the focus of recent criticism is not the only story embedded in Wood's novel. *East Lynne* appeared in fragmented form over nearly two years, each instalment surrounded by a variety of other texts all addressed to a specific magazine readership. This context complicates any reading which suggests that the maternal melodrama forms the only dynamic of the

plot. Indeed, the month by month unfolding of the magazine serial highlights the fact that Lady Isabel's emotional yearnings for her children occupy only the final third of the novel. Other themes emerge as equally important. For example, Wood foregrounds the conflicting interests of the bourgeoisie and the upper classes, identifying the qualities which, she believes, constitute an 'ideal' style of masculinity. Such themes were consistently foregrounded in Wood's subsequent work, while the maternity motif of *East Lynne* is not particularly conspicuous in most of the later novels. Indeed, the major theme she pursued throughout her career was class conflict, her favoured plots depicting a righteous bourgeoisie asserting their values over an enfeebled, yet corrupt, aristocracy and infantilized, occasionally troublesome, working class.[7]

East Lynne's concern with class conflict, idealized middle-class men, and maternity are echoed in a novella which was serialized alongside three of *East Lynne*'s instalments, Mary Ann Bushby's *Why Is She An Old Maid?*. Ouida's first novel, *Granville de Vigne* (published in three volumes as *Held in Bondage*), also appeared alongside many instalments of Wood's novel, offering a contrasting fantasy for the magazine's middle-class readers.[8] Bushby's story shares a number of *East Lynne*'s concerns, such as feminine revenge strategies, the promotion of middle-class values, and an exploration of what constitutes an ideal masculinity. Bushby also considers the nature of maternity, adding a wider dimension to Wood's debate about the 'true' role of the mother. Ouida's serial, on the other hand, presented readers of the *New Monthly Magazine* with an opposing set of values, her heroes are dashing, moustache-twirling, irresponsible high born men. While female readers were dosed with sombre warnings against such men from Wood and Bushby, Ouida shamelessly promotes the pleasures and glamour of aristocratic excess, with no references to either maternity or middle-class domesticity. This chapter charts the mixed messages surrounding class and gender offered by the *New Monthly Magazine*'s female writers as they worked with the new sensationalism in their fiction.

Women's writing in the *New Monthly Magazine*

East Lynne's first appearance in the pages of a middle-class family magazine complicates later impressions of Wood's novel as a sentimental melodrama. The *New Monthly Magazine*'s main focus was politics and social comment presented in substantial articles intended to be informative rather than entertaining. Serialized novels made up only 22 per cent of the contents of each issue of the magazine. Ainsworth, by including fiction, hoped to reach a family readership (or at least some

women readers), but by positioning fiction on the margins he made it clear that he considered his male readers to be more important. Wood's archetypal 'woman's' novel, then, entered the literary culture in the margins of what was ostensibly a 'man's' magazine (although Ainsworth would have undoubtedly described it as a 'family' magazine).

The *New Monthly Magazine* was in decline during the 1850s, Ainsworth having done little to boost its popularity. He frequently relied on contributors whose services were cheap; indeed, he was often prepared to accept work from unknown writers as long as they did not expect to be paid. Ellen Wood had made her debut as an author in the magazine, her first (unpaid) piece had appeared in 1851 called 'Seven Years in the Life of a Wedded Roman Catholic'.[9] During her early days as a journalist, Wood contributed sketches rather than stories, because the 'manly' tone of the magazine appeared to demand this. R.S. Surtees's tale of hunting and gambling, *Mr Sponge's Sporting Tour*, had been serialized from January to December 1852 and set the magazine's tone for the next few years. Aware of this jaunty masculine bias, Wood contributed a series of articles about a soldier's life at the front during the Crimean War, 'Stray Letters From the East', which she signed 'Ensign Pepper'.[10] According to her biographer, Charles Wood, these were accepted as a genuine account of the comic exploits and hardships of war experienced by soldiers in the British Army by the magazine's readers.[11] Wood used a male voice later in her career in her 'Johnny Ludlow' stories, narrated by a schoolboy. Wood wrote from the male point of view for Ainsworth's magazine on a number of occasions, until in the late 1850s she persuaded him to accept her preferred style of fiction, tales of female suffering and disappointment, far removed from sketches of masculine enterprise on the battlefield. After a decade of seeing her work published but never receiving any money for it, Wood then tried to persuade Ainsworth to not only accept a full-length novel for serialization, but also to pay her for it. Ainsworth was reluctant, but was dependent upon her provision of regular, free articles and stories. Wood now felt the time was right to insist he serialize her new novel, especially as her first, *Danesbury House*, had won the Scottish Temperance League's competition of 1860. Ainsworth, who was easy-going if reluctant to pay up, felt he had little choice but to take a risk with *East Lynne* and Wood's career as a popular novelist duly became established.

Ainsworth's own career as a popular novelist had long been in decline.[12] His heyday during the 1830s and 1840s had been characterized by novels of masculine bravado. *Rookwood* (1834) featured the highwayman, Dick Turpin, while his later Newgate novel, *Jack Sheppard* (serialized in *Bentley's Miscellany* from 1839 to 1840, its first instalments running in

tandem with the final parts of *Oliver Twist*), was based on the career of the eighteenth-century thief and prison breaker, Jack Sheppard. Ainsworth's own brand of popular historical literature depended on plots of adventure, violence, and metropolitan low-life, and he clearly devalued the sort of fiction which Wood was offering, with its focus on the middle-class female concerns of motherhood, marriage, and the qualities which characterized the 'ideal' husband and father. While he grudgingly accepted *East Lynne* as a serial, he did nothing to foreground the novel in his magazine, always tucking its instalments away after the leading political or cultural features.

Ainsworth also devalued the fiction of other female contributors. He rigidly divided his magazine into 'manly' fact and 'feminine' fiction, hoping by this method to please all his readers. However, the new family magazines were promoting serial novels as suitable reading for the whole family, attempting to cut across gender and generational divides. Ainsworth failed to understand the increasing importance of serialized fiction as the centrepiece of the family magazine, and was not capable of managing the rise in popularity brought about by *East Lynne*. He failed to adapt the magazine to support Wood's compulsive instalments of bigamy, adultery, and crime, which were often surrounded by dry articles on military tactics or foreign news.[13] Editors of rival magazines, meanwhile, were supporting their popular serial novels with considerably more flair.

Wood specifically designed *East Lynne* with Ainsworth's magazine's audience in mind. As the product of a conservative, rather old-fashioned magazine, *East Lynne*, despite its use of the new sensationalism, promoted views which blended comfortably with the magazine's 'house' style. This was no hardship, however, for Wood already subscribed to the conservative values of domestic management for women and thrusting entrepreneurship for men. Her son indicates her politics in his biography with the contradictory comment, 'In politics she took no part, beyond being a strong Conservative. Inequality she recognized as a Divine law.'[14] Unfortunately, the main source of information about Wood is her dutiful son's unsatisfactory biography, a narrative which obscures and mytho-logizes one of the most prolific writers of the Victorian period. However, it is possible to glean from his account something of the Ellen Wood who lived in the shadow of Mrs Henry Wood.

The professional woman writer

Charles Wood's *Memorials of Mrs Henry Wood* was published in 1894, seven years after his mother's death. Her last illness and funeral, along

with the letters of tribute sent by well-wishers and admiring readers, occupy a substantial portion of the biography. Dates are almost entirely omitted, along with important details such as the number of her children and some of the places in which she lived. Charles Wood spends much time in rhapsody over his mother's virtues, depicting a perfect angel in the house. She was 'more a beautiful shadow than a human being',[15] who avoided contact with 'the outer world [from which] she shrank with the sensitiveness of extreme refinement and physical helplessness'.[16] Devoted to her duty as a wife, she always 'yield[ed] to her husband's wishes when it was possible and falling in with his plans as good wives do'.[17] Mr Henry Wood, on the other hand, emerges from Charles Wood's account as an obscure and volatile character whose 'temperament [contained] the possibilities of future danger';[18] in fact, he 'possess[ed] a mind a little wanting in ballast'.[19]

While Charles Wood says as little about his father as possible, he works to represent his mother as perfectly passive at all times. Even when he describes her only adventure (as a newly-wed wife she went on a midnight excursion to a French monastery disguised as a monk), she is depicted as entirely free of responsibility for her act of transgression. When her husband (who was fond of practical jokes) offered her an unusual brown cloak with a heavy cowl, Mrs Henry Wood presumed it was to keep out the cold. This 'perfect' lady became a passive transvestite as she wandered through the forbidden male space of the monastery. When she emerged, she was unsure whether the experience has given 'her pleasure or pain. A nervousness had come upon her in the midnight gallery she never liked to recall.'[20] Wood's relationship to the transgressive continued to be 'nervous'. While other sensation novelists, particularly Braddon, Collins, and Reade, lived unorthodox lives and delighted in representing transgression, Wood's sensationalism was rarely more than a mild flirtation with crime, bigamy, and adultery.

Conservative, passive, nervous, and domestic: this is the image Wood attempts to create of his mother. However, in the *Memoirs* another picture struggles to emerge of a self-promoting, hard-working writer and editor, and his systematic idealization of his mother repeatedly stalls when he refers to her career. Although from 1867 to her death twenty years later she edited the popular magazine, *The Argosy*, also producing nearly forty novels and over three hundred short stories, this is not presented as work, but in terms of a relaxing hobby. The period when she wrote her novels is described as 'full of rest and repose',[21] while her role as middle-class lady supersedes the other roles she adopted:

It has been said of many literary people that they are not domesticated. It was not so with Mrs Henry Wood. No one ever looked more earnestly to 'the ways of her household'. The happiness of those about her was ever her first thought and consideration. Her house was carefully ruled, and order and system reigned. Nothing ever jarred; the domestic atmosphere was never disturbed [...] No home duty was ever neglected or put aside for literary labours.[22]

Ellen Wood's housewifely façade concealed a determined ambition to succeed and a business acumen which resembled that of her father, a successful glove manufacturer, whose factory formed an important part of the economy of Worcester. Wood recognized the importance of assuming a frail, lady-like persona as a way of disguising her 'unfeminine' traits of literary ambition and business management skills. She was part of the new generation of literary women that Elaine Showalter identified in *A Literature of Their Own*, 'The business skills and unflagging energy of this generation made them formidable competitors, and their popularity, as well as their aggressiveness, antagonized many of their male con-temporaries'.[23] Ellen Wood, unlike younger contemporaries such as Mary Braddon, sought to disguise her energy and aggression. However, as a reading of *East Lynne* in the context of the *New Monthly Magazine* indicates, energy and enterprise were central to Wood's representation of middle-class characters, both male and female.

Bourgeois fantasies of ascendancy

Wood's middle-class characters, like Wood herself, also use a respectable façade to disguise their hunger for property and power. *East Lynne* asserts Wood's allegiance to a recently consolidated middle-class hegemony as her plots depict bourgeois men and women ousting and replacing the tired, incompetent (frequently dissipated) upper classes. The middle-class ideal is represented in the novel through the figures of Archibald Carlyle and Barbara Hare, who quietly ascend the social ladder without appearing ambitious for power. Wood shared the social outlook of her *New Monthly* readers, most of whom were likely to have depended upon some form of paid employment to maintain their middle-class status. These readers undoubtedly struggled to keep up genteel appearances, and may have secretly resented those who enjoyed the benefits of wealth and status without having to work for them. Wood's main achievement in her fiction is her adaptation of a certain brand of popular melodrama for middle-class consumption, transforming and toning down the traditional

working-class plot based on the downfall of the rich and mighty into a middle-class form.[24] She drew upon this melodramatic tradition in order to address the fantasies of class usurpation enjoyed by her middle-class readers, and her success in submerging fantasies of power within her plots has meant that many critics today have failed to read this aspect of her work.[25]

Recent feminist critics have almost invariably focused on the figure of Lady Isabel as offering a (melo)dramatic illustration of the tensions and restrictions associated with Victorian codes of femininity. E. Ann Kaplan, in a psychoanalytic study of the popular appeal of melodrama and representations of maternity, has argued that Isabel, an over devoted mother, is the focus of Wood's 'woman's melodrama', serving to warn female readers against the potential excesses of maternal feeling.[26] Ann Cvetkovich has also focused on the emotional satisfactions of melodrama, describing *East Lynne* as a 'drama of affects' which 'transforms a narrative of female transgression into a lavish story about female suffering that seems to exceed any moral or didactic requirement that the heroine be punished for her sins'.[27] Cvetkovich indicates the problems surrounding Isabel's excessive 'punishment', assuming that Wood views her heroine's adultery as an unforgivable sin and that *East Lynne*'s sensationalism 'has as much to do with its capacity to make its audience cry as it does with its capacity to generate mystery or suspense'.[28] Another critic who views the novel as a melodramatic weepie is Laurie Langbauer, who goes so far as to suggest that all the female characters in the novel 'cry hysterically throughout it',[29] although she fails to register the hard-nosed Cornelia Carlyle and Afy Hallijohn as exceptions. I would argue that for original readers, part of the novel's sensational appeal consisted less in Wood's capacity to generate tears in characters and readers alike, and more in opening up the possibility for enjoyment in Barbara's triumph and Isabel's humiliation. Isabel's adultery gives Wood and her middle-class readers a pretext to gloat over the downfall of an aristocratic lady. Wood sneakily convinces the unwary reader that her project as a novelist is to make us weep, engendering 'pure' emotional responses which are depoliticized and ahistorical, a tactic which has led to the assumption that her plots are limited to sentimental melodrama. *East Lynne*, however, contains other plots based on crime, revenge, property accumulation, and power which are equally important to the story of Lady Isabel's dramatic fall.

Recent critics have also tended to ignore the significant fact that Wood chose to call her bestseller *East Lynne* and not *Isabel Vane*, after her sinning and suffering heroine. The novel takes its title from a country house, a

property which early in the narrative is transferred from a dissipated, undisciplined aristocrat, Lord Mount Severn, to the hard-working, upwardly mobile lawyer, Archibald Carlyle. This transfer of property consolidates Carlyle's power and influence in the nearby town of West Lynne. Wood's project is to show Carlyle morally, physically, and economically outstripping his aristocratic rivals. By the end of the novel he has been elected to Parliament as West Lynne's representative, his power extending beyond the provinces to achieve national influence, constituting an overthrow of aristocratic privilege. Wood's own class, by means of discipline, determination, and disarmingly genial manners, inherit the power, property, and status of a class group she (and, no doubt, her original readers) publicly emulate, but secretly envy and despise.

East Lynne opens with a warning to middle-class men in the shape of the Earl's history. He began life as a hard-working barrister, 'industrious and steady', until at the age of twenty-five he succeeded to the earldom and became 'the most reckless of the reckless' (CXVIII, 28). The narrator significantly remarks, 'It had been well for him had he lived and died plain William Vane.' (CXVIII, 28) The gradual ruin of the Earl from industrious barrister to decadent aristocrat is carefully outlined before we are introduced to his visitor, Archibald Carlyle. The latter is described as 'a very tall man of seven-and-twenty, of remarkably noble presence.' (CXVIII, 29) Despite his innate 'nobility', he does not seem to pose a threat to the gouty Earl, for he has a habit of 'stooping his head when he spoke to anyone shorter than himself', a 'bowing habit' (CXVIII, 29) which makes Carlyle appear respectful towards Lord Mount Severn. For Wood's quiet revolution to take place it is necessary that her middle-class heroes and heroines remain outwardly deferential towards the class they mean to usurp. We learn that Carlyle 'received the training of a gentleman' (CXVIII, 29) at both Rugby and Oxford, and is well-equipped to meet the upper classes on their own territory.

Carlyle intends to appropriate the territory of the upper classes quite literally, by purchasing East Lynne, the house and land which the Earl has inherited. Lord Mount Severn laughs when Carlyle, a country lawyer, says he has the means to buy the property. However, Carlyle explains that his income is extensive, both because of his 'first-class' business and because his mother's fortune allowed his father 'to speculate successfully.' (CXVIII, 30) In Wood's system of values, fathers and husbands work as professionals or businessmen, while women transfer property through marriage, thus consolidating a capitalistic system of wealth creation which favours bourgeois interests. East Lynne is, for Carlyle, an 'investment', he eschews extravagance and display for their own sakes,

and has lived a life of domestic sobriety under the management of his older half-sister, Cornelia. Unlike her upwardly-mobile brother, she is unable to adapt her old-fashioned notions of prudence and thrift as her income expands to encompass a more imposing display of social power. Carlyle, however, does not intend to stay a small-time country lawyer. His plan of buying East Lynne leads to a desire to appropriate another attractive symbol of wealth and power: an aristocratic lady. Carlyle, meeting the beautiful Lady Isabel, admires her 'light, graceful, girlish form', which is 'decorated with pearls, and a flowing dress of costly white lace.' (CXVIII, 32) The movement from Isabel's body to her jewels and expensive dress is scarcely perceptible, yet signals Isabel's role as part of the transference of money and power from one social group to another. The narrator points out that Isabel appears to Carlyle to belong to 'a fairer world than this.' (CXVIII, 32) Wood is extremely critical of the drive on the part of middle-class men to marry aristocratic women; throughout her fiction she stresses that for all their attractive outward forms and refinement, such women carry the seeds of their 'doomed' class within them.[30]

The exchange of East Lynne takes place in secret, ostensibly to avoid the Earl's creditors getting wind of the deal, but really to lessen the impact of Carlyle's 'presumptious' step in becoming the owner of so grand a property. Wood makes much of the fact that East Lynne secretly belongs to Carlyle and Lord Mount Severn stays on temporarily only as his guest: 'East Lynne's guest! that was what the Earl was, at present.' (CXVIII, 279) Carlyle, however, does not abandon his middle-class values of prudence and thrift; he makes a mental note of the Earl's 'unnecessary profusion of splendour' (CXVIII, 279), while the narrator, worried that her hero may be taken in by the dangerous glamour of wealth (which, as we have seen in the example of the Earl's downfall, can lead to relative poverty and powerlessness), directly warns him, 'Very unnecessary were the attractions that day [....] Take care of your senses, Mr Carlyle.' (CXVIII, 279) Carlyle's acquisition of East Lynne is complete when he marries Isabel, its former mistress. His lack of caution is emphasized by Wood, who spends much of the rest of the novel promoting the 'superior' qualities of the middle-class Barbara Hare.

Idle and ideal men and women

Barbara, with her bourgeois values of prudence and propriety, eventually replaces the frail, childlike Lady Isabel. Although the reader is encouraged to feel sympathy for Isabel's dilemmas, Wood's focus upon her suffering,

particularly the obvious delight she takes in detailing her mutilated body and agonies of remorse, suggest that both she and her readers experienced a range of complex responses to Isabel, including a covert satisfaction in witnessing the downfall of an aristocratic lady. Barbara's social rise, on the other hand, offered a more straightforward focus for readers' identifications. Charles Wood reinforces this idea when he describes Barbara as 'a gem [. . .] who presents exactly the qualities which Lady Isabel wanted'.[31] Samuel Lucas, whose review of *East Lynne* in the *Times* was influential in introducing the novel to an audience beyond the *New Monthly*'s readership, also admired Barbara, seeing Isabel as 'a frail reed for such a weight of woe'.[32] When *East Lynne* appeared in volume form and became the most popular novel in the circulating libraries, it reached a considerably wider audience than the original magazine readers.[33] Later readers, coming to the novel from diverse class and cultural standpoints, usually responded more generously to Isabel. Margaret Oliphant, for example, made it clear where her sympathies lay when she argued that:

> When [Isabel] returns to her former home under the guise of the poor governess, there is not a reader who does not feel disposed to turn her virtuous successor to the door, and reinstate the suffering heroine, to the glorious confusion of all morality.[34]

To assume that all readers felt this way is misleading. While I am not trying to deny that Wood's depiction of Isabel's suffering does work to evoke strong feelings of sympathy, I particularly want to draw attention to the text's ambiguity which conceals other, less sympathetic, emotions surrounding Isabel's plight. The sub-text which indicates Barbara's triumph over Isabel, and Carlyle's triumph over Levison and all other upper-class men, is a powerful one frequently overlooked by later readers; yet this held a potential source of covert enjoyment to readers of the serial.

It is significant that Barbara, the middle-class girl initially rejected by Carlyle in favour of the aristocratic Isabel, eventually becomes both mistress of East Lynne and the *employer* of her former rival. Her triumph over the ideal/idle lady opens up the possibility of anger and rivalry between women which many feminist critics have been reluctant to explore. Helena Michie is one recent exception. She argues that 'contemporary feminists need themselves to provide rhetorical and political room for the expression of female difference, for anger and mistrust between and among women'.[35] Lyn Pykett's discussion of *East Lynne*, for example, fails to address the novel's representation of feelings

of rivalry and revenge among women. She discusses Isabel's sufferings on watching her son die as 'masochistic', arguing that this 'masochism of the text is clearly an important source of its pleasures for the middle-class reader', pleasures which, she goes on to say, consist in 'the opportunity of spectating feelings of anxiety, separation, loss and claustrophobia which arise from middle-class women's experience of motherhood and domesticity'.[36] Such 'masochism', however, existed alongside an equally strong sadistic impulse of identification with Barbara's triumph. Barbara herself, unaware that Madame Vine the governess is really her husband's first wife, is allowed no unladylike feelings of revenge or satisfaction in her rival's humiliation. However, in the secret rapport which Wood had established with her loyal *New Monthly* readers, such hidden and unladylike emotions were allowed to come into play. Indeed, a considerable proportion of the magazine's fiction depicted middle-class heroines triumphing over female rivals (usually upper-class women or 'low' imposters).

While some recent critics have been aware of Wood's championing of the middle classes and have drawn attention to her representation of bourgeois values, many of them display a confusion about the nature of *East Lynne*'s class struggles. Pykett argues that the novel depicts a society in transition, characterized by the 'renovation (of the aristocracy) and incorporation (of the bourgeoisie)'.[37] Similarly, Elaine Hadley sees *East Lynne* as offering evidence that Wood 'harboured an uncloseted if complicated nostalgia for a deferential culture in which aristocrats played their roles well'.[38] Kaplan, too, fails to grasp Wood's class antagonism when she writes that *East Lynne*'s bourgeois, 'solid families [. . . are] prey to exploitation from the immoral aristocrats'.[39] There is little evidence in the novel to suggest nostalgia or desire for the 'renovation' of the aristocracy. The main aristocrats, Isabel, her father, and Sir Francis Levison, the villain who seduces Isabel then abandons her, are all depicted as morally unfit for power and responsibility. This is in sharp contrast to her bourgeois characters who, far from being 'exploited' by aristocrats, as Kaplan suggests, are depicted as capable of undermining traditional class structures by wresting power (discreetly and politely, of course) from the upper class. Wood is concerned with the triumph of her class group, portraying the middle class not as vulnerable, but as victorious. The heroes of many of her later novels are manufacturers who use the money made from business to buy power and influence, frequently appropriating the grand houses and land of the decaying aristocracy.[40] Seen in the light of this class struggle, Barbara's role as Lady Isabel's employer takes on a special significance.

In *East Lynne* the celebration of middle-class superiority is nowhere more apparent than in the depiction of the election at West Lynne, where Archibald Carlyle stands against Sir Francis Levison. Wood's depiction of the election is less about politics than sex, as she displays her two opposing versions of masculinity. The contest is between Levison, the 'wicked coward' (CXXI, 420), representing the upper classes, and Carlyle, 'that noble man' (CXXI, 34), representing the bourgeoisie. Wood does not name the political parties the two men represent, neither does she hint at their policies. The election episode is simply a means of offering Wood an opportunity to depict her hero and villain in combat, her intention being to thoroughly humiliate Levison. He and his agents 'sneaked about the town like dogs', while Carlyle and his supporters constitute 'a stately crowd: county gentry, magistrates, Lord Mount Severn' (CXXI, 423), the latter being the more responsible successor to Isabel's father. Wood utilizes certain minor aristocratic figures to support Carlyle's acceptance as a member of the nation's élite. However, her more fully drawn portraits of aristocratic men, Levison and Isabel's father, constitute an attack upon the values of their class group and the style of masculinity they represent.

Samuel Lucas's review of *East Lynne* in *The Times* focuses upon Wood's representation of Sir Francis Levison, rather than on Lady Isabel's story. Lucas argues that this is one of the better sensation novels, yet is puzzled as to why Wood should heap so much ignominy on Levison's head:

> [H]e is hated and despised by all his acquaintance, not excepting even the woman he espouses [....]. All this crime and retribution for an ordinary performer who is merely up to the standard of a walking gentleman is excessively onerous, and we know of few cases in fiction of such rigorous treatment as that of Sir Francis Levison.[41]

One expects Levison to be punished for his seduction of Isabel, yet the extensive list of humiliations he faces before he finally ends his days in prison is, as Lucas suggests, unusual in fiction. Lucas goes on to point out the problems surrounding Levison's trial for murder, where any good lawyer would have argued that a 'conspiracy' existed against him. Indeed, there is a 'conspiracy' against Levison as Wood scapegoats him in her vitriolic attack against upper-class men.

Wood's strategy in perpetrating this attack has to be devious, for her middle-class heroes cannot be seen to take an active role in overthrowing the aristocracy. During the election campaign, this act is done symbolically by means of a working-class 'mob' of 'stout-shouldered labourers'. These

men 'naturally' support the ever popular Carlyle. In their indignation against Levison, they duck him in a pond, voicing the rage of their 'betters':

> Let's give him a taste of his deservings! What do he, the scum, turn up at West Lynne for, bearding Mr Carlyle? What have he done with Lady Isabel? Put up for others at West Lynne! West Lynne don't want him: it have got a better man: it won't have a villain. (CXXII, 32)

The election episode in *East Lynne* becomes a contest to prove the 'fittest', the man who most conforms to an ideal masculinity. It also becomes an added punishment for Isabel, reminding her of her 'sin' in preferring the smartly dressed aristocrat to the sober lawyer. Early in the novel Isabel muses, 'I do not love Mr Carlyle, but I fear I do love, or very nearly love, Francis Levison' (CXIX, 96). This fatal error is brought home to Isabel repeatedly. During the election, Cornelia and Barbara (now Mrs Carlyle), persistently assert Carlyle's superiority over Levison, much to the disguised Isabel's distress, for she now bitterly regrets losing so 'noble' a man. Cornelia says to her:

> You see him; my brother Archibald? [...] And you see *him* that pitiable outcast, who is too contemptible to live? Look at the two, and contrast them [....] The woman who called that noble man husband, left him for the other! Did she come to repentance, think you? (CXXII, 34)

Later, Barbara has an opportunity to assert her moral superiority over Isabel when 'Madame Vine' asks her why Carlyle invited Levison to stay at East Lynne immediately before his wife's elopement. Barbara triumphantly replies:

> Did I hear you aright, Madame Vine? Did Mr Carlyle know he was a reprobate? And if he had known it, was not Lady Isabel his wife? Could he dream of danger to her? If it pleased Mr Carlyle to fill East Lynne with bad men tommorrow, what would that be to me? – to my safety; to my well-being; to my love and allegiance to my husband? (CXXII, 52)

Barbara, taking the moral high ground, is allowed to crush Isabel without appearing to do so because she fails to perceive the identity of the governess. Barbara's covert power to torment her aristocratic rival may have had an appeal for the 'solid' middle-class readership of the *New Monthly Magazine*.

Carlyle's attractiveness to women is, during the election, shown to surpass Levison's charms. While the latter can only rely upon the sympathy of his working-class mistress, Afy Hallijohn, Carlyle is surrounded (as a member of Levison's party puts it) by 'a galaxy of beauty', 'How the women rally round him!' (CXXII, 165). Levison's own wife recognizes Carlyle's superiority to her own husband, considering Isabel 'mad', saying, 'I could understand a woman flying from Francis Levison for love for Mr Carlyle; but, now that I have seen your husband, I cannot understand the reverse.' (CXXII, 395) To complete Levison's humiliating downfall, Wood denies him the 'dignity' of death when he is found guilty of murder. She condemns him (significantly) to hard labour: 'The gay Sir Francis Levison working in chains with his gang! Where would his diamonds and his perfumed handkerchiefs and his white hands be then?' (CXXIII, 38). Carlyle, on the other hand, unopposed, goes on to become West Lynne's Member of Parliament. Lady Isabel, at the pinnacle of her jealous torments, reflects that 'she had flung away Archibald Carlyle' for a murderer (CXII, 55). The novel closes with the death of Isabel; Carlyle and Barbara stand alone as the undisputed owners of East Lynne, Carlyle's final comment reflecting the confidence and power of the rising middle class: 'Every good thing will come with time that we earnestly seek.' (CXXIII, 50)

Ouida's *Granville de Vigne*

Before *East Lynne* had completed its serial run in the *New Monthly Magazine*, Ouida's very different sensation novel, *Granville de Vigne: A Tale of the Day*, began serialization in January 1861, running for nine months alongside Wood's novel.[42] Wood and Ouida became equally popular novelists during the nineteenth-century, reaching similar audiences, yet catering to very different fantasies. Readers of the *New Monthly Magazine* were presented in each issue with representations of opposing styles of masculinity. While Wood offers a fantasy of bourgeois advancement, championing the respectable middle classes, represented in her 'perfect' professional gentleman, Carlyle, Ouida offers the same readers a different fantasy: a total escape from the limiting respectability of middle-class life. Ouida does not even bother to represent middle-class people and values; instead she focuses on the glittering social lives of upper-class men and women who break society's codes of propriety with impunity. While Wood depicts an aristocracy defeated on all sides by a powerful middle class, Ouida's aristocrats are vulnerable to attack only from low-class imposters.

Ouida, like Wood, found Ainsworth willing to accept her short stories for publication in his magazines, but reluctant to accept a novel. Eventually, he was persuaded to publish her first novel *Granville de Vigne* in *The New Monthly*, although he offered only a very small fee.[43] The popularity of *East Lynne* may have influenced his decision. It is clear that Ouida must have been following *East Lynne*'s progress because she borrows the names of some of Wood's aristocratic characters. Lady Isabel Vane's name is given to Ouida's narrator, Arthur Vane Chevasney, while her villain is Lord Vane Castleton. A minor character, Jimmy Levison, shares the surname of Sir Francis Levison. Although Ouida draws upon *East Lynne* for names and the bigamy theme, the borrowings stop here, for *Granville de Vigne* centres on the intensely masculine world of its hero, Granville, an officer in the 'Dashers' and wealthy womanizer who does just as he pleases. Ouida strikes back against Wood's championship of the middle class by promoting the aristocracy as an ideal. Readers of the magazine faced a dilemma over what style of masculinity was most to be admired, for Granville, Ouida's hero, resembles Wood's villain, Levison. Such contradictions within popular fiction for middle-class consumption indicate some of the anomalies which existed within middle-class culture generally. Questions such as how far do ambitious bourgeois men and women emulate the aristocracy, or how much freedom from social constraint should wealth bring, or how far middle-class values of thrift and prudence need to be modified in order to display new-found wealth and power, emerged in the popular fiction of the day. The difficulty of finding answers to such questions helps to explain the fact that the readers of one magazine could enjoy two opposing representations of 'ideal' social conduct at the same time.

Ouida gained popularity by allowing her readers a chance to vicariously escape into a world of wealth, leisure and excess, while Wood catered to readers' fantasies of working within a middle-class value system of restraint and self-control to triumph over traditional élites. Ouida's narrative of bigamy and imposture centres on Granville's downfall at the hands of a beautiful, but brash, working-class woman. As a schoolboy, Granville seduces Lucy Davis, a factory girl, who is outraged when he abandons her. She concocts a plan of revenge, disguising herself as a 'lady' with the help of the wicked old Lady Fantyre (who had herself once been an orange-seller). Lucy transforms herself into 'the Trefusis', a beautiful vamp who lures Granville into marriage. The reader is not meant to identify with Lucy, but her triumph over the arrogant and irresponsible Granville may have appealed to many of the *New Monthly's* female readers who, as we have seen, had a penchant for stories about arrogant aristocrats

brought low. A sub-plot of Ouida's novel concerns Granville's friend, Colonel Sabretasche (a brilliant artist, outshining the Pre-Raphaelites, and a splendid soldier), who is also tricked into marrying a low-born woman. Having abandoned his wife, he wreaks his vengeance on the female sex by breaking their hearts. The two heroes eventually rid themselves of their working-class wives: Lucy turns out (conveniently) to already have a husband, and Sabretasche's wife, now begging on the streets, dies in her husband's arms, he generously forgiving her for luring him into marriage. The novel ends with a warning to young men not to marry commonplace girls. While Wood warns middle-class men away from the dangerous allure of aristocratic ladies, Ouida warns dashing young men away from the voluptuous charms of working-class imposters. Only women who are well-born artists are, according to Ouida, worthy of marriage.

For the nine months when both serials ran side-by-side (a significant period, perhaps, considering the emphasis on maternity made by some of the female contributors to the *New Monthly Magazine*), readers of Ainsworth's journal were offered confused messages about class and gender from a trio of conservative female authors writing from rather different (although ultimately related through their catering to middle-class fantasies) standpoints. The conservatism of Wood and Ouida meant they were unwilling (despite their representations of bigamy and adultery) to promote social transgression. The style of domestic melodrama which Wood employed was typical of much of the *New Monthly's* fiction. Mary Ann Bushby, a regular contributor of short stories in this style, published a three-part novella, *Why is She an Old Maid?* from June to August 1861. This appeared alongside those instalments of *East Lynne* where Isabel watches her son die, and the pathos of the maternal melodrama is at its height, and those chapters of *Granville de Vigne* where 'the Trefusis' dramatically reveals herself to be the wronged Lucy Davis. The exciting plot developments in both serial novels were matched by the sensational plot of Bushby's story, with its focus on female suffering, surrogate mothering, and 'passive' revenge.

The maternity debate

Mary Ann Bushby's style is closer to Ellen Wood's than Ouida's. Like Wood, she uses the figure of the suffering heroine to focus the reader's attention, raising images of maternity designed to demarcate the role of the middle-class mother. At the same time Bushby, like Wood, presents a plot based on crime and deceit derived from the newly emerging genre of the sensation novel. Bushby's stories usually have non-European settings,

frequently depicting West Indian and North American life. However, as she states at the beginning of *Why is She an Old Maid?* her stories 'might as well have taken place anywhere else', because they are more about white middle-class female experience than any specific national culture or social system.[44] In her novella the heroine, Arabella Stuart, a perfect young lady, grows up in the West Indies on her rich father's plantation. The man she hopes to marry, Harry Vaughan, jilts her when he erroneously believes she is not a wealthy heiress, and is then lured into marriage by a working-class imposter, Eudora. Arabella, like Barbara Hare in *East Lynne*, is allowed to benefit from her policy of patient suffering, for at the end of the story she enjoys (a discreet) triumph as she learns that Harry's disloyalty has led him into ignominious poverty. The formulaic fiction offered by Wood and Bushby consists of conventional exhortations for passivity and sacrifice on the part of women, yet allows a space for fantasies of revenge against oppression. Such revenge avoids any descent into 'masculine' aggression, and is usually achieved on a moral plane, where the persecutors and wrong-doers end up suffering humiliation and loss. In Bushby's story, Harry's eventual humiliation is similar to the punishment meted out to Levison, far in excess of usual representations of villainy punished in nineteenth-century novels. This doubling of themes in Wood's novel and Bushby's story suggests that readers of the *New Monthly Magazine* were particularly inclined towards representations of women enjoying triumphs over others, as long as outward ladylike appearances were preserved. Barbara's triumph over Lady Isabel is disguised by the fact that she is unaware of Madame Vine's identity, and only the reader knows the full extent of the pain she causes Isabel. Arabella's rescue of a degraded and dying Harry, and her adoption of his neglected daughter, offers a similar fantasy of 'ladylike' revenge.

When Harry realizes he has married an illegitimate swindler who is descended from a long line of fallen women, the reader is offered the emotional satisfaction of seeing Arabella 'well avenged' (325). Harry's situation has a parallel in Ouida's serial, where the 'low-born' imposter, Lucy Davis, dupes Granville into marriage. The female imposter is presented in both stories as the dark double of the angelic refined heroine, and female readers were invited to identify with both figures. While the former embodies the unladylike qualities of violence, deviousness, and ambition, the latter is a model for fantasies of suffering, but righteous, femininity.

The final section of Bushby's trilogy, like *East Lynne*, focuses upon representations of motherhood. Just as readers of the *New Monthly Magazine* were presented with opposing versions of masculinity in

Wood's and Ouida's serials, they were also offered contrasting models of maternity in *East Lynne* and *Why is She an Old Maid?*. Eudora's children, according to her husband Harry, are 'ill-fed, ill-clothed creatures, quite neglected by their mother' (429). Eudora dies from alcoholic poisoning, having killed one daughter by pushing her down the stairs and heartlessly leaving her sons to die from measles. When Arabella discovers Harry in a debtors' prison, she arranges his release and rescues his one surviving daughter. In contrast to Eudora, who was 'one of those unnatural beings [...] a mother without the slightest affection or regard for her offspring' (437), Arabella, the ladylike spinster, fulfills all of the criteria for the ideal mother as she adopts Henrietta Vaughan as her own daughter. Bushby's depiction of Eudora's neglect appeared alongside the instalments of *East Lynne* when Isabel's agonies of frustrated maternal longing were reaching their climax as William, her son, dies. Isabel is an over emotional, unstable mother who identifies herself unhealthily and destructively with her children.[45] Eudora, on the other hand, is an 'unnatural' mother who works in conscious ways to destroy her children. While Isabel dies of frustrated maternal desire, Eudora actually kills three of her children by means of violence and neglect. Readers of the *New Monthly Magazine* were also presented with examples of good mothering. In *East Lynne*, Barbara understands the need to control maternal excess, while Bushby's Arabella also provides a controlled environment in which to exercise her maternal duties. Barbara, famously, gives voice to the theories of the day on the correct role of the mother:

> [T]oo many mothers pursue a mistaken system in the management of their family [....] They are never happy but when with their children [....] They wash them, dress them, feed them; rendering themselves slaves [....] The children are noisy, troublesome, cross [....] Let the offices of the nurse, be performed by the nurse [....] Let her have the *trouble* of the children [....] But I hope I shall never fail to gather my children round me daily, at stated periods for higher purposes: to instil in them Christian and moral duties; to strive to teach them how best to fulfil life's obligations. *This* is a mother's task. (CXXI, 278–9: emphases in the original)

To be successful, maternity, Barbara suggests, needs to be controlled; a mother should train her children socially and morally, rather than physically nurture them. However, Isabel's fear that Barbara denies her stepchildren the maternal love they need complicates this view of maternity, where the middle-class mother needed to tread a fine line

between guiding children, commanding their respect, and offering love and tenderness. Isabel's powerfully emotional response to her children's plight highlights the difficulties of controlling maternal impulses in order to become an 'ideal' mother. Of course, Barbara's doctrine could only be put into practice by those families who could afford servants to take on the 'troublesome' aspects of childrearing.

This episode of *East Lynne* appeared in the March 1861 issue of the *New Monthly Magazine*. Just four months later, readers were offered further evidence to suggest that 'controlled' mothering was an ideal for all women. In the final section of *Why Is She an Old Maid?* Harry dies of 'a softening of the brain' (422) and Arabella strengthens her resolve to remain an 'old maid'. Although she rejects marriage, she views herself as a mother to Harry's child:

> Henrietta Vaughan was the light and hope of her life. To bring her up with strict moral and religious principles, to teach her to control her temper and cultivate good dispositions, to superintend her education, and make her useful as well as accomplished, were Arabella's sedulously cherished occupations, forming a self-imposed duty to which she devoted all the energy of her mind. (444)

Arabella, like Barbara, sees the mother's role as a devotion to forming children into well-adjusted adults and Christian subjects. To do this successfully, the mother needs to maintain an emotional detachment in order to avoid using her children as a way of filling an emotional vacuum.

The bigamy theme

Within the formerly male-orientated space of the *New Monthly Magazine*, Wood, Ouida, and Bushby explored the issues of class mobility, maternity, and the problems of recognizing both a 'real' lady and 'perfect' gentleman, issues which were important to their middle-class readers. All three writers use sensational plots of mystery, crime, imposture and bigamy, and the connecting link between the three stories is an overriding concern with the institution of marriage. The wrong choice of wife or husband forms the dynamic of all three sensational plots. This depiction of marriage as a potential form of imprisonment was a major feature of the sensation novel and the subject of numerous articles in magazines. Jeanne Fahnestock has identified 'a contemporary disillusionment with the institution of marriage and thus a fascination with escape' which characterizes the fiction of this period.[46] Bigamy was a particularly

interesting theme to middle-class readers, for the state of the marriage laws during the 1860s was the subject of continuing discussion, as the recently passed Matrimonial Causes Bill of 1857 meant that only the wealthy could afford to divorce. In *East Lynne* this theme is touched upon in Wood's bizarre situation of having Carlyle marry Barbara when he hears Isabel has died, to later find that his first wife has returned in disguise as his children's governess. *Granville de Vigne* has a female bigamist and two men unable to marry the women they love because of earlier marriages. In *Why is She an Old Maid?* Harry tries in vain to free himself from his hasty marriage to the imposter, Eudora. Against these fictional representations of shaky marriages, the *New Monthly Magazine* intervened with a particularly controversial discussion of matrimony.

In March 1861 there appeared an article, 'The Mormons and the Country They Dwell In', exploring further the issue of matrimony raised in all three serials. This anonymous article was written in response to a recently published book on Mormonism by the French traveller, Jules Rémy. The taboo subject of polygamy surfaced in many magazines at this period; Dickens, for example, wrote on Mormonism in his *Uncommercial Traveller* series.[47] The Mormon religion was fascinating to Victorians because it brought the practice of polygamy from the 'exotic' and 'corrupt' East into the West. The bulk of the *New Monthly* article outlines the practice of polygamy, whereby Mormon men are encouraged to take more than one wife, the anonymous writer making clear his disapproval and condemning polygamy as 'carnal'.[48] He depicts Mormons as 'imposters' who set out to infiltrate and undermine British society:

> The imposters from the Valley of Salt are ever coming over to this land of credulity to prey upon the ignorance that is unfortunately to be met, especially among the females of the lower orders, and they delude them away by their corrupt babble [...] to add to the numberless victims already writhing in mental and corporeal agony in the city which must necessarily be cursed by God. (267)

Wood was clearly influenced by this article, using its details in her next novel, *Verner's Pride* (which was serialized in *Once A Week* from 1862 to 1863). One of the novel's subplots concerns the appearance of a Mormon missionary in an English village and the mass exodus of its working-class inhabitants to Utah. Two servant girls look forward to finding husbands, but are less than happy when they have to share the same one. As a companion says, 'the two took to quarrelling perpetual. It was nothing but snarling and fighting everlasting.'[49] The article, like *Verner's Pride*,

focuses on the experience of female Mormons, forced to suffer 'the shame, the vexation, and the misery' of sharing husbands (267). Asking why these women endure the 'terrible tyranny' of polygamy (270), the writer presumes the answer lies in their maternal feelings: they 'wish to fly from the odious chains, but their maternal love carries the day, and they die in harness' (268). Again, maternity is explored as a potentially dangerous area of women's experience, where mothers break moral codes because of their love for their children. However, the apparent lack of jealousy and sense of rivalry among women who share one husband is puzzling to the writer of 'The Mormons and the Country They Dwell In': 'Mr Hyde says he once asked a Mormon lady if she was not jealous, "I was at first," she said, "but I soon ceased to trouble myself about my husband."' (268)

In the same issue of the *New Monthly Magazine* as this article, the instalment of *East Lynne* depicts Isabel's guilty presence in the home of her former husband and his new wife. Carlyle's *ménage à trois* is emphasized by Isabel's awareness of her anomalous position which, 'galled and fretted her spirit: but she bowed in meek obedience.' (CXXI, 287) She not only endures the torment of being with her children and unable to acknowledge that she is their mother, but also has to endure witnessing Carlyle's displays of affection towards Barbara. Isabel's 'jealous eyes' watch them exchanging 'passionate, lingering' kisses (CXXI, 282). At times, Isabel doubts the ethics of returning to East Lynne in disguise, knowing herself to be:

> an interloper; a criminal woman who had thrust herself into the house; her act, in doing so, not to be justified, her position a most false one. Was it right, even if she should succeed in remaining undiscovered, that she and Barbara should dwell in the same habitation, Mr Carlyle being in it? (CXXI, 298)

Carlyle is placed in the position of an unwitting polygamist, a sensational situation which is barely defused by his innocence. When at the end of the novel he recognizes Madame Vine as his first wife, 'The first clear thought that went thumping through his brain was, that he must be a man of two wives.' (CXXIII, 42) Such thrills were the stuff of sensation novels, where respectable men and women found themselves unwittingly placed in unrespectable, often criminal, situations.

Before *East Lynne*'s serialization Ainsworth's magazine had not been inclined towards the discussion of sensational topics. However, the tide of sensation fiction had swept the *New Monthly* into new channels engineered by his female contributors. While some magazines delighted

in the sensational topics of polygamy, bigamy, adultery and crime, Ainsworth tended to be uneasy about representing such themes. 'The Mormons and the Country They Dwell In' is an unusual example of the magazine's non-fiction complementing its serial fiction. Ainsworth preferred his contributors to confine controversial subjects like insanity, middle-class crime, and bigamy, within fictional plots of domestic melodrama. Ainsworth viewed his female contributors' stories as a minor, even trivial, aspect of his magazine which, he believed kept female readers happy. This lack of judgement about the best way to handle the enormous popularity of Wood's and Ouida's novels was, however, fatal for the magazine. When both writers ceased to write serials for him, a steady decline in sales was inevitable.

Other magazines of the 1860s were not so coy in their relationship to the new sensation genre and were more in tune with what modern readers demanded from their magazines. The next chapter shows how Dickens's *All The Year Round* was committed to representing sensationalism in its serial novels as well as in its journalism and short fiction. Middle-class readers were by no means an homogeneous group, as the very different styles of magazines and serial novels indicate. While the *New Monthly* uneasily titillated its readers with sensation fiction, *All The Year Round* was using sensationalism as a way of forging a new style of magazine discourse designed to address contemporary issues.

4
Charles Dickens's *Great Expectations* in *All The Year Round*

Dickens: novelist as editor

The relationships between Victorian magazine editors and their con-
tributors could be fraught with problems. On the one hand editors had a
tendency to view readers as quick to take offense at material which
overstepped the bounds of 'propriety', while on the other hand serial
novelists frequently resented interference on the part of editors. As editor
of *Household Words* and *All The Year Round*, Dickens had on a number of
occasions found himself in disputes with contributors. During the
serialization of *North and South* in *Household Words*, for example, he was
at loggerheads with Elizabeth Gaskell over the length and instalment
divisions of her novel.[1] In 1863, when Charles Reade's *Very Hard Cash* was
serialized in *All The Year Round*, Dickens was alarmed by Reade's violent
polemic against the Lunacy Commissioners, and he published a
statement in the magazine disclaiming any agreement with Reade's
opinions.[2] When Wilkie Collins contributed a novel or article, Dickens
worried about his colleague's enthusiasm for shocking the middle
classes.[3] Such editorial nightmares were dispelled, however, when he
serialized one of his own novels. Attuned to his readership, he could trust
himself never to unduly offend and, being emotionally dependent upon
readers' loyalty and enthusiasm, he tended to respect their judgement.[4]
While some Victorian editors, such as Leslie Stephen, who edited *The
Cornhill* from 1871 to 1882, complained of being a 'slave' to 'popular
stupidity', Dickens did not see his readers operating as a check upon the
type of fiction or magazine he wanted to produce.[5]

This rapport with his audience has been interpreted as the result of a
vein of 'mediocrity' within Dickens's personality; Philip Hobsbaum, for
example, argues that he never went 'beyond the popular and accepted

view of things', while Philip Collins states that he wholeheartedly 'reflect[ed] the average outlook of his contemporaries'.[6] Whether we subscribe to this view of Dickens or not, in his roles as editor and novelist he appeared to have an unusually intense sympathy with readers whether in terms of their pleasures in comedy and melodrama, or their preoccupations and anxieties. With the advent of the sensation novel, the popular cultural mood moved away from domestic fiction towards fiction which blatantly exploited contemporary anxieties. Dickens was one of the first magazine editors to be aware of the swing from domesticity to sensation, organizing *All The Year Round* with the new literary genre in mind. After the successful serialization of *The Woman in White*, Dickens attempted to sustain within his magazine the novel's popular sensational discourse. However, the next serial, Charles Lever's *A Day's Ride: A Life's Romance*, devoid of sensational plot or themes, was unpopular with readers and sales rapidly declined. In order to save *All The Year Round*, Dickens realized that the best guarantee of retrieving lost readers was to publish his next novel, *Great Expectations*, as yet in the planning stages, in the magazine. The circumstances surrounding the writing of *Great Expectations* have been well documented.[7] Briefly, Dickens rapidly reorganized his plans, converting the novel's divisions from long instalments intended to be published monthly into shorter sections suitable for weekly serialization. While many critics have noted the fact that Dickens had to reshape his novel and quicken his pace in writing it, few have explored the implications of this radical change of plan. Anny Sadrin proclaims that 'in less than a year one of the greatest works in the English language came to be conceived and delivered'.[8] What needs to be added is that *Great Expectations*, received by contemporary reviewers as another example of the sensation genre, also owes a debt to the sensationalist discourse of the popular weekly magazine in which it first appeared.[9] Dickens designed *All The Year Round* to support his serial, and his choice of accompanying texts reveals those themes in the novel which he particularly wanted to emphasize. This chapter demonstrates how the magazine context of *Great Expectations* reveals the novel's engagement with common fears surrounding biological degeneracy, fears which had been set in motion by the newly unleashed obsession with origins.

Seizing a place in the economy of nature: discussions of natural selection in *All The Year Round*

With *The Woman in White*, Dickens had been aware of the value of linking a popular serial novel to his magazine's journalism as a way of

exploring contemporary events and debates. This strategy gave the novel an immediacy and social relevance which proved popular with readers. By the time *Great Expectations* appeared in *All The Year Round*, the controversies surrounding Darwin's *On The Origin of Species* were generating intense debates. Darwin's book was first published in November 1859, although it took several months for the full implications of evolutionary theory to filter down to most readers. Sensationalism appeared to Dickens to be an ideal discourse with which to respond to the popular mood of anxiety and alarm surrounding the concept of natural selection. Although the new evolutionary theories were not widely discussed in the magazine's non-fiction, the ideas of animal origins, biological degeneracy, and struggles for survival surfaced dramatically in both *Great Expectations* and many of *All The Year Round*'s short stories. Dickens, as novelist–editor, again used *All The Year Round*'s 'voice' to extend a novel's range by positioning it in relation to current debates, in this instance presenting readers with powerful, if covert, responses to prevailing scientific theories. While Dickens expected his novel to survive beyond its magazine publication and take its place as 'Literature', he was also a businessman who needed to rescue his magazine from impending economic disaster. By tapping into the latest cultural shock waves, he could achieve both, producing an enduringly powerful novel *and* a serial which spoke immediately to its original readers on the news of the day.

By the time *Great Expectations* began serialization, Darwin's work had already received a very high profile. His *Origin of Species* had been widely discussed in both the highbrow and popular press and the prevailing debates on evolutionary theory were now made available to the general magazine reader. The popular press in particular succeeded in drawing the public's alarmed attention to the animal origins of humans. Popular interpretations of evolutionary theory played a key role in highlighting fears of national and individual decline, and many Victorian commentators contemplated the possibility of a reversion to animal form, anticipating an era of crisis for the human species or, what was perhaps even more alarming, the survival of the British 'race'. Other scientific theories from the 1860s, particularly the works of Bénédict-Augustin Morel on degeneration and Jacques-Joseph Moreau de Tours on deviancy, had also filtered down to non-specialist readers by the early 1860s.[10] The vast timescales which Darwin opened up were frequently lost in the popular press to a sense of immediate danger. In July 1860, *All The Year Round* featured an article called 'Natural Selection' which sensationalized evolutionary theory, the anonymous author stating:

Although some species may be now increasing more or less rapidly in numbers, all cannot so increase, for the world would not hold them. [. . . .] As a consequence, the weakest goes to the wall; it is a race for life, with the deuce taking the hindmost. A grain in the balance will determine which individual shall live and which shall die: which variety or species shall increase in number, and which shall decrease, or finally become extinct. [. . . F]or as all organic beings are striving, it may be said, to seize on each place in the economy of nature, if one species does not become modified and improved in a corresponding degree with its competitors, it will soon be exterminated.[11]

The words 'rapidly', 'race for life', 'will soon be', suggest a fast approaching crisis, while the language of *laissez-faire* economics implies that random forces (like market forces) can sweep away those individuals and species who cannot maintain the necessary level of 'fitness'.

While fears of degeneration and the decline of families had long been represented in folklore and literature, developments in biology and psychology during the late 1850s foregrounded such fears in a particularly dramatic way. The eugenics movement, an extreme response to fears of social and national degeneration resulting from allowing the 'unfit' to reproduce, was first formulated in the 1860s. During the first years of the decade the issue of racial degeneration had been debated in the correspondence columns of *The Lancet*, and by the late 1860s strategies were being developed by some medical theorists to guarantee the long-term health of the nation.[12] In 1868 an influential article by William Rathbone Greg, 'On The Failure of "Natural Selection" in the Case of Man', appeared in *Fraser's Magazine*, where Greg complained that 'unfit' individuals were being allowed to pass on their 'incapacities to numerous offspring', leaving British society in a state of biological degeneracy which could only be checked by a programme of selective breeding.[13] The eugenics movement is commonly associated with the late-nineteenth century. However, an examination of *All The Year Round* during the early 1860s reveals a panic response to theories of natural selection and degeneration which was manifested most strongly in the magazine's short stories, many of which foregrounded the theme of reversion. These form a substratum of the sensation genre, articulating anxieties about violence, deformity, and insanity which other middle-class literary forms tended to elide.

There has been considerable interest recently in the ways in which Darwin's controversial text intersected with Victorian literary culture.[14] Two essays, both presenting a similar argument, have discussed

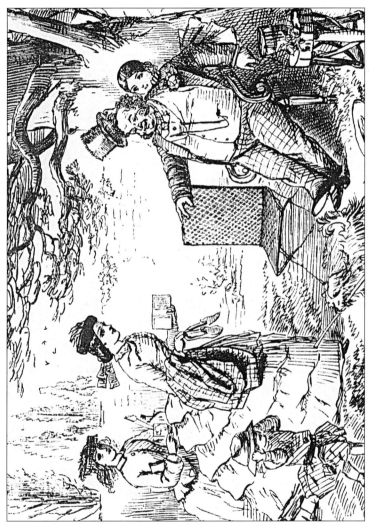

1 (Unknown), illustration to 'Once A Week', *Once A Week*, I, 2 July 1859.

2 (Unknown), title page illustration to 'Paul Garrett: Or, The Secret', *Once A Week*, IX, 27 June 1863.

3 George Du Maurier, illustration to *Eleanor's Victory*, *Once A Week*, VIII,
4 April 1863.

4 George Du Maurier, illustration to *Eleanor's Victory, Once A Week*, IX, 3 October 1863.

5 'The Celibate Consoled' and George Du Maurier's illustration to *Eleanor's Victory*, *Once A Week*, VIII, 2 May 1863.

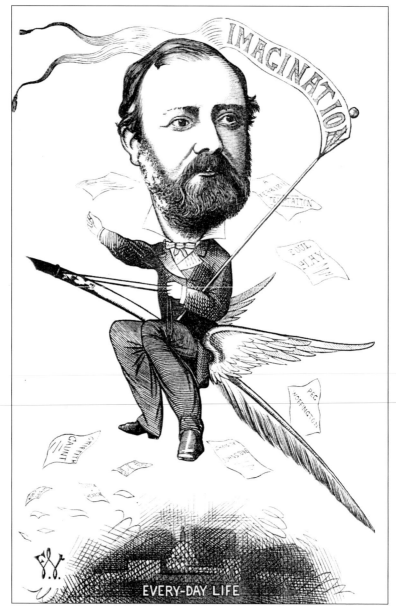

6 Frederick Waddy, Portrait of Charles Reade, *Cartoon Portraits and Biographical Sketches of Men of the Day* (London: Tinsley Bros., 1873).

7a Detail of typographical diversity from *Very Hard Cash* in *All The Year Round*, 11 July 1863.

7b Detail of typographical diversity from *Very Hard Cash* in *All The Year Round*, 19 December 1863.

8 Mary E. Edwards, illustration to *The Claverings, Cornhill*, XIII, February 1866.

THE
CORNHILL MAGAZINE.

FEBRUARY, 1866.

The Claverings

CHAPTER I.

JULIA BRABAZON.

HE gardens of Clavering Park were removed some three hundred yards from the large, square, sombre-looking stone mansion which was the country-house of Sir Hugh Clavering, the eleventh baronet of that name; and in these gardens, which had but little of beauty to recommend them, I will introduce my readers to two of the personages with whom I wish to make them acquainted in the following story. It was now the end of August, and the parterres, beds, and bits of lawn were dry, disfigured, and almost ugly, from the effects of a long drought. In gardens to which care and labour are given abundantly, flower-beds will be pretty, and grass will be green, let the weather be what it may; but care and labour were but scantily bestowed on the Clavering Gardens, and everything was yellow, adust, harsh, and dry. Over the burnt turf towards a gate

9 Mary E. Edwards, illustration to *The Claverings*, *Cornhill*, XIII, February 1866.

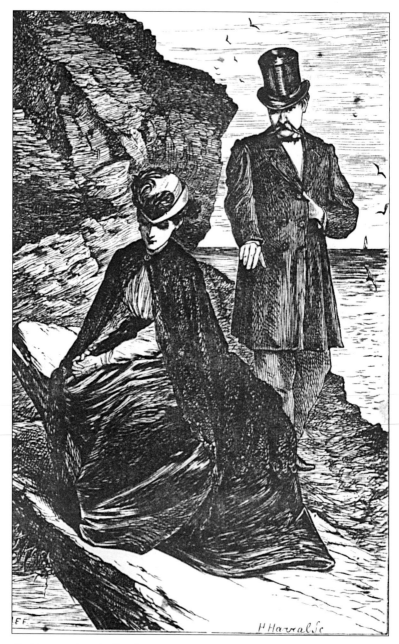

10 Mary E. Edwards, illustration to *The Claverings*, *Cornhill*, XIV, October 1866.

11 George Du Maurier, illustration to *Wives and Daughters*, *Cornhill*, XII, November 1865.

12 Augustas Leopold Egg, *Past and Present* No.1, 1858 (copyright Tate Gallery, London 2000).

13 George Thomas, illustration to *Armadale*, *Cornhill*, XII, October 1865.

14 George Thomas, illustration to *Armadale*, *Cornhill*, XII, October 1865.

15 George Thomas, illustration to *Armadale, Cornhill,* XIII, May 1866.

16 George Thomas, illustration to *Armadale*, *Cornhill*, XIII, February 1866.

Great Expectations in the light of Darwin's theories, suggesting that Dickens used his novel to refute the idea of heredity as the primary influential factor in shaping human experience. Kate Flint, in her 1995 essay, 'Origins, Species, and *Great Expectations'*, argues that the novel exposes 'the irrelevance of placing too much weight on origins', illustrating 'how one's way in the world should be dependent on one's own efforts, rather than on the status, power, even struggles of one's predecessors'.[15] In a later essay, 'Meditating on the Low: A Darwinian Reading of *Great Expectations'*, Goldie Morgentaler presents a similar view, arguing that Dickens's novel 'jettisons heredity as a determining factor in the formation of the self'.[16] She goes on to claim that 'Dickens's initial reaction to Darwin was to blot out heredity altogether from his conception of human development and to replace it with the formative effects of environment'.[17] Reading *Great Expectations* within its magazine context, however, makes this argument difficult to sustain. Dickens, as both novelist and editor, certainly reacted to Darwin's book, if not directly, then to its sensational public reception; his reaction, however, was linked to popular (often irrational) panic responses to evolutionary theory. Both *Great Expectations* and *All The Year Round* register considerable alarm at the consequences of poor biological inheritance upon physical and mental health. This alarm was at its most intense in a cluster of anonymous short stories (which I have termed 'anxiety stories') published immediately before, during, and after the serialization of Dickens's novel.[18] If we read these anxiety stories intertextually alongside both Darwin's *Origin of Species* and the instalments of *Great Expectations*, aware of Dickens's total editorial control over his magazine, the novel can be read as containing an anxious questioning about the implications of biological degeneracy, particularly reversion to animal form. Examining *Great Expectations* in this way, however, requires an effort to (temporarily) remove the novel from its canonical status in order to reposition it as a magazine text.

We were unhealthy and unsafe

In an unfavourable review of the novel in *Blackwood's*, Margaret Oliphant argued that *Great Expectations* 'is a sensation novel [in that] it occupies itself with incidents all but impossible, and in themselves strange, dangerous, and exciting', adding that Dickens 'manages to impress distinct images of horror, surprise, and pain on the mind of his reader'.[19] Oliphant was especially puzzled by the novel's episodes of violence, which for her formed unpleasant disruptions to the narrative. She was

particularly disapproving of the 'gratuitous' nature of one 'sensation episode' where Pip is imprisoned and tortured by the murderous Orlick. She concludes that this scene, unaccountable to readers of the volume text, was 'perhaps acceptable to weekly readers as a prick of meretricious excitement'.[20] Oliphant here suggests both the power of the serial form to intensify Dickens's 'strange and dangerous' story, and the magazine's provision of an exciting sensational context for the novel. *All The Year Round*'s anxiety fiction was available as supplementary reading to original readers of the novel. Linked to the sensation genre, these stories push its discourse towards the contemporary fears of degeneration, employing the voices of anxious, tormented narrators who fear they pose a biological threat to the rest of the community. This fiction serves a similar function to *fin de siècle* tales of gothic horror in exploring the possibility of degeneration; they are forerunners of tales of biological terror, such as Robert Louis Stevenson's *The Strange Case of Dr Jekyll and Mr Hyde* (1886) and Bram Stoker's *Dracula* (1897).[21] While this later fiction is a relatively sophisticated registering of popular concerns, the 1860s anonymous anxiety stories were crude attempts to offer an immediate response to cultural fears.

All The Year Round's anxiety stories focused upon a new sense of a collapse of the apparently God-given divide between animal and human. The first person narrators feel themselves to be 'unfit' and, therefore, disposable. Aware of their threat to society, they use the intimate, confessional form of the autobiography to depict extreme situations, such as suicide, terror, insanity, inexplicable physical decay or transformation, and violent crime. The narrator usually attempts to trace back the origin of some trauma in an attempt to explain its devastating effects in the present. This first person voice is, in this context, reminiscent of the voice of the analysand in psychoanalysis. The reader, like the analyst, is asked to accept the burden of the narrator's anxious words, a process which, like psychoanalysis, offers an opportunity to voice emotional responses which can usually only be articulated indirectly, through a labyrinthine narrative which appears on the surface to be excessive and confused. If the anxiety story offered readers any pleasure, it was the pleasure of articulating what was feared to be unspeakable. Not surprisingly, the anxiety story depends upon the gothic to frame the narrator's confession, where gothic landscapes of desolation and decay are invoked, usually the lonely house or neglected garden, to suggest both the isolation and the tortured mental state of the narrator. In some stories, the private space of the bedroom is used as the scene of violence, a place where encounters with the homicidal and insane occur.

Two anxiety stories which appeared during the serialisation of *Great Expectations*, 'The Family at Fenhouse', published alongside chapters 6 and 7 in the 22 December 1860 issue of *All The Year Round*, and 'My Father's Secret', which appeared on 9 March 1861 alongside chapters 23 and 24, foreground the consequences of 'bad' genetic inheritance for the survival of family lines. 'The Family at Fenhouse' is narrated by the middle-class Miss Jane Erfurt, a woman who is physically deformed and mentally damaged by some unspecified hereditary condition. She opens her narrative with a bleak outline of her family's unfitness for survival:

> My poor mother had been insane for many years before her death; one of my brothers was deaf and dumb, another was deformed, while none of us showed either health or vigour. In a word, there was no escaping the fact that we had the seeds of some terrible disease sown thickly among us, and that, as a family, we were unhealthy and unsafe.[22]

Jane supports herself as a paid companion to the barely animate, 'slightly deformed' (261) wife of Mr Brand, a brutish man who lives at the desolate village of Fenhouse. Mrs Brand is only 'half alive' (262), while her son by a former marriage is a 'lumpish being, with a face devoid of intelligence [. . .] scarcely raised above the level of a dog or a horse' (262). Living as one of the family, Jane despairs that she makes one of 'an unwholesome, unnatural circle' (262). The crisis of the story occurs when Jane witnesses Mr Brand murdering his stepson. She says, 'Pale, heavy, motionless on the bed lay the youth [. . . .] The sheets were wet with blood – red – the light of the candle glistening upon a small stream that flowed over the side of the bed, on to the floor beneath. At a little distance stood Mr Brand, wiping a knife on a handkerchief.' (264) Jane finds herself accused of the murder, her story closing with an admission that she is still on the run from the police, her tenuous links with humanity severed further as she is now 'a wild being hunted' as 'a murderess and a maniac.' (264)

'My Father's Secret' also foregrounds the themes of insanity, animality, and bloodshed in the bedroom. The narrator describes his childhood fear of undergoing transformation into a wolf. This is brought into being by his father's unexplained, but persistent, surveillance which continues until the boy awakes one night to find a madwoman in his bedroom; she obsessively washes her hands and fingers his throat. We later discover she is his mother, confined to a disused wing of the isolated mansion, whom the boy believed to be dead. Like so many characters in the anxiety stories, she is an outcast from her species, her face wears 'the stamp of something that seemed to me not to belong to humanity. There

was a sort of mingled wildness and vacancy in the expression of the pale lips, of the troubled eyes.'[23] The obsessive surveillance of the father is explained by his fear that the mother's insanity may emerge in their son. Her madness is not hereditary, however, but was brought about by a traumatic and bloody encounter with a young suicide in a hotel bedroom. The dying man, his throat cut, is imaged as non-human, a 'thing', as he crawls into the pregnant woman's room in order to seek help; 'there was a struggling and writhing on the floor at the bedside, as if the *thing* was striving to clamber up on it' (518: emphasis in original). The woman:

> put forth her hand, as if to repulse the thing, and felt it come into contact with something hot and wet, that clung stickily to her fingers [...] a man in the agonies of death with his throat gashed, and the blood welling from it, saturating the bedclothes, and crimson on my mother's hand (518).

Other anxiety stories were equally bloodsoaked and dealt with the vulnerability of pregnant women. 'An Incident in the Tropics', set in Jamaica, describes the shooting of a black plantation worker by a pregnant white woman. Having been 'deluged and blinded by [the] hot, thick, crimson rain' of the dying man's blood, the woman later gives birth to a red baby, an 'unnatural' child who is quietly killed before the mother and her husband return to England. The story closes with the birth of their healthy white offspring.[24] Another story which raises the issue of racial difference, 'Out of the House of Bondage', describes the discovery by the daughter of a cotton plantation owner in one of America's southern states that her mother was a black slave. The narrator is made to fear 'the drop of black blood' within her which, a male relative tells her, could dangerously destabilise her mental balance. Once she has knowledge of her origins, the girl is regularly beaten by her father.[25] An early anxiety story, 'Written in My Cell', is narrated by a middle-aged man, a writer of sensational features for popular magazines, whose hideous ugliness precludes the possibility of marriage. He develops a passion for the teenage daughter of a friend and when she spurns his advances, he shoots her. His narrative is presented in the form of a 'gallows speech', a confession made immediately before his execution, where he proclaims his own unfitness to belong to humanity and the pressing necessity for his death.[26] These stories portray characters who foreground the instability of their biological heritage, and each narrative is punctuated with vivid descriptions of violent acts: murders, suicide, and beatings.

Ellen Miller Casey, in her discussion of *All The Year Round*'s serial novels, focuses upon violence as a major feature in the magazine. She argues that the numerous descriptions of violence served as a substitute for sex, a subject which was taboo in the context of the family magazine. Casey states, 'It is true that there is no explicit sex and a great deal of explicit violence', adding that 'sex is replaced with blood'.[27] This assertion needs to be qualified in the light of the themes which emerge around the magazine's depictions of violence, where the insistent themes of degeneration, animality, and reversion suggest that the anxiety story was more worried about reproduction, particularly the transmission of healthy genes, than with sexual desire. Both 'My Father's Secret' and 'An Incident in the Tropics' make explicit the vulnerability of women as carriers of offspring. It is the problem of 'inappropriate' breeding, with its implications for the long-term future of the human species, which underpins the anxiety story. The genre was excessive in its means of articulating fears of biological, racial, and social decline, indicating how 'unhealthy' parentage may send the whole species back down the evolutionary slide into animality.

The uncompromisingly agonising form of the genre allows the reader no sense of distance or relief, often even no point of resolution or closure. This refusal to offer comfort suggests why the genre was unable to survive as a popular form. In later stories of biological terror, anxieties tend to be shifted onto a supernatural plane. *Dracula*, for example, offers a closure which eventually restores characters and communities to order after the threat of the vampire has passed; while *Dr Jekyll and Mr Hyde*'s depiction of the destructive, but limited, influence of weird drugs was clearly easier to accept than the anxiety story's more mundane biological terrors, where the mentally and physically unfit remain at large within society, threatening the long-term health of the nation.

'So contaminated did I feel': *Great Expectations* and the problem of origins

Great Expectations brought the themes and procedures of these marginal magazine stories into the cultural foreground by reworking the genre's motifs. This reworking is most clearly seen through an examination of *Great Expectations*'s imagery and the novel's relationship to the fairytale nightmare of the anxiety stories. The narrative of the troubled Pip resembles (in less virulent form) those of the narrators of the anonymous stories, while the landscape of desolation recurs in the form of Satis House, with its neglected rooms, the convict-haunted marshes, and the gloomy

buildings and streets of London. Dickens's novel carries all of the anxiety story's motifs: reversion to animality, contamination (from blood, from criminality, from madness, and from poor genetic stock), and the use of the troubled and troubling voice of a guilty, anxious autobiographer. *Great Expectations* is, of course, more than an anxiety story; however, its relationship to this substratum of sensationalism is significant and needs to be explored in the light of the novel's original publication as a magazine story.

In *Great Expectations*, Pip has visited Newgate with Wemmick, and he awaits Estella's arrival in London with an acute sense of uneasiness:

> I consumed the whole time in thinking how strange it was that I should be encompassed by all this taint of prison and crime; [...] While my mind was thus engaged, I thought of the beautiful young Estella, proud and refined, coming towards me, and I thought with absolute abhorrence of the contrast between the jail and her. I wish that [...] I might not have had Newgate in my breath and on my clothes. I beat the prison dust off my feet as I sauntered to and fro, and shook it out of my dress, and I exhaled its air from my lungs. So contaminated did I feel, remembering who was coming, that the coach came quickly after all, and I was not free from the soiling consciousness of Mr Wemmick's conservatory, when I saw her face at the coach window and her hand waving to me.
>
> What *was* that nameless shadow which again in that one instant had passed?[28]

Pip's response to 'prison and crime' appears excessive, as though Newgate were radioactive, exuding some invisible but harmful contaminant. Throughout *Great Expectations* Pip fights a hopeless battle against criminality, which to him is equated with low status and animality. His consideration of his own and the prisoners' debasement is interrupted by the arrival of the coach, at the window of which he sees Estella, prompting the insistent question, 'What *was* that nameless shadow which again in that one instant passed?' The mature narrating Pip knows that the 'nameless shadow' is the physical resemblance Estella bears to her mother, Molly. Estella, even more directly than Pip, is 'contaminated' by criminality, her mother being a murderess and her father a transported convict. She does not conform to Pip's fantasy of an 'unsullied' Estella who exists outside the fall-out zone of 'prison and crime'.

Convicts, according to Pip, are condemned to 'lowness'; their removal from the rest of humanity suggests to him a disturbing animality, and

animal imagery is used to describe the two convicts who ride behind Pip on the coach. They have a 'coarse, mangy, ungainly outer surface, as if they were lower animals', and are even pervaded by a convict smell, 'that curious flavour [...] which attends the convict presence' (IV, 557). A 'flavour', as though Pip can taste their contaminatory exudation. The boundaries between the human and animal are remarkably unstable throughout *Great Expectations*. Pip's childhood is punctuated with references to his own animality; his sister, Magwitch, and other adults think of him as a 'young dog', a 'dog in disgrace' (IV, 169), and a 'squeaker' or pig (IV, 195). Magwitch describes himself as a 'warmint', having a 'savage air that no dress could tame' (V, 173), a 'hungry old dog' with 'fangs' (V, 170). Bentley Drummle is imaged as both a 'spider' (IV, 532) and an 'uncomfortable amphibious creature' (IV, 529), while Orlick considers Mrs Joe to be 'a bullock' (V, 339) and Pip a 'wolf' (V, 338–9). Conversely, Pip describes Orlick as a 'tiger' (V, 339), while Molly is a 'wild beast' (IV, 510).

Readers are most likely, however, to consider Orlick as the novel's most fully drawn representation of bestiality; his 'loose-limbed' body 'always slouching', 'his eyes on the ground' (IV, 363), and his behaviour appearing to be removed from human rationality. Stupid, but cunning, his home is on the marshes, along with the convicts and other 'primitive' life forms. Orlick has been a difficult character for some critics to explain. Peter Brooks writes that he is 'not convinced Orlick "works" as a character: his evil appears so total and gratuitous that he at times appears too easy a device for deflecting our attention from Pip's more hostile impulses'.[29] Yet readers of *All The Year Round* would have recognized Orlick as a relation of the frightening, animal-like degenerates in the anxiety stories who threaten middle-class security and, more sinisterly, the future of the human species. Orlick becomes a focus for the violence and anxiety which trouble Pip, representing the dark possibility of reversion which had been recently introduced into the popular consciousness.

Wolf-men

The most chilling example of Orlick's lack of 'humanity' occurs when he tortures Pip at the limekiln, the scene which Oliphant singled out as particularly disturbing. It is interesting, however, that Orlick persists in seeing Pip as the animal, or degenerate, calling him a 'wolf' seven times during the attack. This multiple usage echoes Orlick's earlier attempt to frighten him by insisting that 'it was necessary to make up the [forge] fire, once in seven years, with a live boy, and that [Pip] might consider

[himself] fuel' (IV, 363). Seven, of course, is a magical number, associated with fairytales, folklore, and religions, and Pip himself (to reinforce Dickens's focus on the number) is a seventh child. As Freud indicates in his 'Material from Fairytales in Dreams', the number seven is significant to the analysis of his famous patient, the 'Wolf-Man', whose neurosis was eventually traced back to a terrifying childhood dream about seven wolves, an animal which, Freud argues, was only available to him through fairytales and picture books.[30] The power of fairytales and myths also surfaces in the anxiety stories. Pip reads his life through the distorting medium of the fairytale, with Miss Havisham as his fairy godmother (although later she takes on witch-like characteristics for him), Estella becoming the captive princess, while he sees himself as 'the young knight of Romance' (V, 1). Orlick fits into Pip's fantasy as the ogre, or troll, who tries (unsuccessfully) to destroy the hero. The mature Pip comes to see this fantasy as his 'poor labyrinth' (V, 1), a twisting, but false plot which leads him nowhere. Yet even when Pip is young and most vulnerable to his illusions, he wavers alarmingly between seeing himself as the handsome prince and the wicked wolf. After his fight with Herbert, when he sheds this genteel boy's 'gore', Pip considers himself 'a species of savage young wolf, or other wild beast' (IV, 318).

Pip's association with the wolf, through his own fears and Orlick's taunts, is suggestive to readers familiar with the cultural significance of wolves. The anxiety story, 'My Father's Secret', has a narrator who describes how, as a young boy, he was haunted by a fear of lycanthropy:

> Sometimes I fancied it would be gradual, and I should see and feel the slow blending of the human and bestial natures, till the former should be swallowed up in the latter, and I should become, for the time being, at all events, a real wolf [...] that from a boy, I should suddenly spring into a raging ravening monster [... and] with bloody fangs, rush howling, an object of hatred and terror to all, into the dark woods [...] (515)

The wolf, as Carlo Ginzburg has argued in his recent reinterpretation of the Wolf-Man Case, has a more complex mythical significance than Freud's reference to 'The Wolf and the Seven Little Goats' would suggest.[31] The werewolves of folklore, the wolves of fairytales and fables, as well as the secret lives of real wolves hidden in the dark primeval forests of Europe, all work together as part of a fearful cultural heritage for people in the West. Both Pip and the narrator of 'My Father's Secret' use their wolf fantasies as ways of transforming themselves from powerless, passive, troubled children into creatures who are powerful and terrifying.

Great Expectations moves the fear of 'low' animal origins into the realm of monstrous, unnatural origins when Pip borrows the image of the monster from Mary Shelley's *Frankenstein* as a model for Magwitch.[32] Pip, now tied to his 'second father' (V, 147), sees himself as '[t]he imaginary student pursued by the misshapen creature he had impiously made' (V, 173), inverting the *Frankenstein* analogy by insisting the father/creator is the monster who seeks to destroy him. Magwitch represents, within the biological agenda set by the anxiety story, the fearful origins which contain the power to disrupt not only the future of direct offspring, but also the future of the human species. Banished to the colonies, just as Victor Frankenstein tries to banish his monster from his own 'civilized' territory, Magwitch insists on returning. His project, to turn Pip into a gentleman, exists largely as a desire to wreak revenge on an unjust society, while his refusal to accept the law which consigns him to Australia is matched by a stubborn refusal to look anything other than the outcast convict/monster which Pip so fears:

> The more I dressed him and the better I dressed him, the more he looked like the slouching fugitive on the marshes. This effect on my anxious fancy was partly referable, no doubt, to his old face and manner growing more familiar to me; but I believe too that he dragged one of his legs as if there were still a weight of iron on it, and that from head to foot there was Convict in the very grain of the man.
> The influences of his solitary hut-life were upon him besides, and gave him a savage air that no dress could tame [...] (V, 173).

Pip's discovery of his monster–father resembles the discoveries made by some of the narrators of anxiety stories about their parentage. Pip's worst fears about Magwitch concern the fact that he is impossible to hide or transform. As he attempts to disguise Magwitch as an 'ordinary' member of society, Pip confesses that 'awful was the manner in which everything in him that it was desirable to repress, started through that thin layer of pretence, and seemed to come blazing out of the crown of his head' (V, 173). As *Great Expectations* and the anxiety stories stressed to *All The Year Round*'s readers, 'unsafe' parentage inevitably creates a traumatic legacy for offspring.

Problematic parentage

Wolves and monsters emerge in *All The Year Round* during the early 1860s as tropes for the anxieties surrounding 'unsafe' origins. It is against these

fears that we need to read Dicken's original (rejected) ending for his novel, which stresses the impossibility of a marriage between Estella and Pip. David Trotter argues that, 'it doesn't really matter whether Pip marries Estella'.[33] In literary or social terms this is probably the case. However, in biological terms a marriage between the two would be highly problematic. Pip's poor genetic inheritance is emphasized at the outset. Both of his parents are dead. He comes to 'a childish conclusion' (based on the letters of the tombstone) that his 'mother was freckled and sickly' (IV, 168). This 'sickliness' must have been transmitted to his five brothers, all of whom 'gave up trying to get a living exceedingly early in the universal struggle' (IV, 168). Pip's only surviving relative, his sister, is almost certainly infertile, while her appearance does not suggest perfect health, being 'bony' with 'a prevailing redness of skin' (IV, 171). As Anny Sadrin has indicated, Pip is extremely keen to distance himself from his biologically unsuccessful family by using 'the circuitous phrase, "my father's family name" [. . .] when a plain statement, "my family name", would do just as nicely'.[34] Sadrin calls Pip 'Dickens' disinherited boy'; however, Pip's real problem is that he inherits too much from his parents in biological terms. His rather devious attempts to distance himself from poor genetic stock lead him to attach himself to an equally 'unsafe' parent, the mentally unstable Miss Havisham, while the 'monstrous' Magwitch insists on becoming his 'second father'.

Estella also shares this 'parentage', Miss Havisham being her foster mother, and Magwitch her biological father. Her biological mother is equally 'unsafe' within the economy of natural selection. Molly is violent and, once 'tamed' by Jaggers' discipline, clearly suffers from anxieties based on her fear of him. Molly is the original trauma which sets in motion Pip's 'poor labyrinth', the convoluted road he takes towards knowledge of his and Estella's origins. Estella, the refined and cold beauty, is the offspring of parents who led a 'dark wild' life together (V, 293) and thus carries within her a potential for their dangerous wildness. Like the mad mother in 'My Father's Secret', Molly has to be hidden away from her offspring. She is a 'jealous woman, and a revengeful woman' (V, 293), whose violence and threats contradict Victorian conceptions of 'natural' femininity. While Magwitch is banished to the outer space of Australia, Molly is confined in the inner domestic space of Jaggers' home, hidden away from a society which, but for the lawyer's skilful intervention, would have had her executed. However, like a 'wild beast tamed' (IV, 510), she is displayed to a select audience (namely Pip and his friends) as proof of her taming. Jaggers 'kept down the old wild violent nature whenever he saw an inkling of its breaking out, by asserting his power over her in the old

way' (V, 315). Molly's 'unnaturally' powerful wrists, 'disfigured' and 'scarred' (IV, 533), signify her aberrant femininity, enabling her to attack those who appear physically stronger than herself. It is, of course, Estella's physical resemblance to Molly which so disturbs Pip.

Reading *Great Expectations* as a sensational anxiety story is limited in that it fails to take into account the emotional investments and interlacing themes which make the novel so rich and, unlike the anonymous magazine stories, guarantee its survival outside its magazine context. However, this reading was possible, even probable, for readers of the serial who were likely to have been aware of (and perhaps disturbed by) Darwin's *Origin of Species* published in the previous year and still widely discussed in the press, along with other theories which suggested that atavism existed as a potential threat to the future of the human species. Original readers of *Great Expectations* were able to consume *All The Year Round*'s stories depicting instances of courtship and marriage slipping out of the realm of love into an anxious questioning of physical and mental fitness. The anxiety story highlighted the ethics of producing 'unhealthy and unsafe' offspring who may go on to 'contaminate' the nation and ultimately the whole species.

Reading *Great Expectations* in conjunction with the supporting short fiction which Dickens selected highlights his concern with the issue of biological inheritance. Dickens may not overly stress the point, yet readers of the magazine serial would have recognized the links between the magazine's fiction and the evolutionary theories which were dominating the headlines. A knowledge of this linkage presents the rejected ending of the novel in a new light. Dickens, in the original ending of the novel, emphasized the impossibility of Pip and Estella, each burdened with 'unsafe' parentage, marrying and producing offspring. He depicts Estella, married to a doctor (without, it is implied, children from this union), encountering Pip holding the hand of a 'pretty child', the son of Joe and Biddy. She wrongly presumes the child to be Pip's son. This ending suggests that both will remain childless. The revised ending, which Dickens produced on the advice of Edward Bulwer-Lytton, who considered the original too gloomy, leaves the issue of marriage vague, hinting that there will be 'the shadow of no parting' between them (V, 437). Clearly, Dickens's first instinct was to end his serial with a parting rather than a mating, and this is consistent with *All The Year Round*'s panic response to the possibility of biological degeneracy for the future of the human species.

5
Wilkie Collins's *No Name* in *All The Year Round*

Representing the female outsider

In 1861, the year following the publication of *The Woman in White*, Wilkie Collins found himself contending with two female rivals, Mary Braddon and Ellen Wood, who had recently emerged as the latest bestselling sensation novelists. They brought new themes to the sensation formula, most notably the introduction of the erring heroine. Wood's *East Lynne* offered Lady Isabel's adultery and imposture, while Braddon's *Lady Audley's Secret* depicts a wicked heroine straying into the realms of violent crime. While *The Woman in White* depicted male criminals preying on vulnerable women, Collins's next novel, *No Name*, focused on the active and transgressive Magdalen Vanstone. Collins contributed to the new sensationalism a type of heroine who, in the words of Winifred Hughes, has 'more intelligence and daring' than the 'typical female lead in Victorian literature, even at its most sensational'.[1] *No Name* relates Magdalen's social and moral downfall and eventual rehabilitation. On the death of her parents, she discovers she is both illegitimate and disinherited and attempts to retrieve her lost fortune and social position by becoming first an actress and then a swindler. She adopts a false identity in order to lure her cousin, the legal inheritor of her fortune, into marriage. Her schemes entail an impersonation of her own governess and a parlour maid. However, her clever plots ultimately fail, leading her eventually to destitution and the prospects of the pauper hospital and the workhouse. Magdalen, more forceful than Wood's Lady Isabel and more conscience-stricken than Braddon's Lady Audley, takes her place as one of the more complex and likeable heroines of sensation fiction.

No Name made its first appearance in *All The Year Round* from March 1862 to January 1863 and both Collins and Dickens were eager for a

repetition of *The Woman in White*'s success. Collins planned *No Name* during the summer of 1861, aware that he must offer his readers a novel which, while still 'sensational', was significantly different from both *The Woman in White* and the new work of Braddon and Wood. He realized that 'the first element of success is not to repeat the other book'.[2] Although he had touched upon the representation of the marginalized woman in his depiction of the victimized Anne Catherick, he chose to focus his next two novels upon female outsiders who were spirited and actively defiant of the law. Lydia Gwilt, the heroine of *Armadale*, as we shall see in Chapter 8, is considerably more transgressive than Magdalen Vanstone.

Collins's intensification of the sensation formula met with Dickens's approval, for he was relying on *No Name* to boost sales of *All The Year Round* after a slump in 1861 with the serialization of Bulwer-Lytton's unpopular novel, *A Strange Story*. From the planning stages, Dickens took an interest in *No Name*, even suggesting possible titles (all of which Collins rejected).[3] When Collins's health deteriorated, he offered to help with the final instalments, writing, 'I will come up to London straight, and do your work. I am quite confident that with your notes, and a few words of explanation, I could take it up any time and do it'.[4] Dickens reminded him of their previous literary collaborations and his familiarity with Collins's style, insisting that readers would be unable to discover that he had helped out. Collins, needless to say, did not take up the offer. His biographer, Kenneth Robinson, sees Dickens's 'generous and timely gesture' as a 'demonstration of true friendship'.[5] However, another reason for this offer was Dickens's anxiety to keep *All The Year Round*'s successful serial afloat to the end.

In his letters to Wills, Dickens frequently instructs him as to which articles and stories should be placed alongside the instalments. In one letter, Dickens reassured Collins, 'I am bent upon making a good No. to go with *No Name*'.[6] Judging by the fact that the make up of each issue took place approximately two weeks before publication, the issue to which Dickens refers appeared on 18 October 1862, where the instalment of *No Name* depicts Magdalen making a loveless marriage to her repulsive cousin, Noel Vanstone. One of the features specially chosen to comple-ment this instalment was an article by Eliza Lynn Linton on the plight of young pauper girls, 'The Girl From the Workhouse', a feature which was particularly relevant to *No Name*, for both texts explore the condition of young women who live outside the shelter of a respectable family. Other features in this issue include, 'Blind Black Tom', an alarmist discussion of race and theories of degeneracy, and 'The Story of Major Strangeways', an

historical story of violent crime and punishment. As with *The Woman in White* and *Great Expectations*, Dickens juggled texts in such a way as to encourage intertextual readings. While he was aware of the importance of variety in both novels and magazines, and that unremitting echoes of the serial novel in *All The Year Round*'s accompanying features could potentially alienate readers, he also understood the effectiveness of providing regular support for the serial's themes. During *No Name*'s serialization an unusually high proportion of features appeared on the topic of female outsiders, chiming in with Collins's exploration of women's social and economic vulnerability. Articles and stories outlined the experiences of homeless women, criminal women, working women, and others who did not live as dependents within a middle-class family. As testimony to the success of Dickens's intertexual strategy, *All The Year Round*'s sales increased steadily during the serialization of *No Name*. When the novel was issued in book form on 31 December 1862, the first edition of 4000 copies sold out immediately.[7]

Holding converse with monstrosities: reviews of *No Name*

The reviewers of *No Name*, both hostile and friendly, testified to its power as a compulsive read. An anonymous reviewer in *The Reader* had followed the novel in serial form:

> Since it began, thousands of English households have studied its progress with unfailing interest [.... I]t is no small triumph to have constructed a story which, week after week, for nearly a year defied the divining powers of the most acute of novel readers, and surprised everyone at the end.[8]

H.F. Chorley, reviewing the novel in the *Athenaeum*, also read the magazine serial, arguing that '*No Name* [...] for some nine months past has fixed and retained curiosity in no uncommon degree' adding that it placed considerable emotional demands on readers by means of Collins's efficient 'maintainance of suspense till the final hour of relief'.[9] These reviewers confirm the power of the magazine serial to generate readers' interest, acknowledging Collins's skill in shaping a narrative to meet the form's criteria.

Reviewers who admitted to reading *No Name* as a magazine serial tended to produce favourable reviews of the novel, while those who waited to read the volume edition were more condemnatory. One of these latter critics, Alexander Smith, writing in the conservative *North British Review*,

complains that 'so long as you have the book open, you are spell-bound; whenever you close it, you feel you have been existing in a world of impossible incidents, and holding converse with monstrosities'.[10] These apparent impossibilities did not appear so blatant to readers of the magazine serial, however, for the accompanying articles and stories on similar themes tended to confirm and add credence to the issues raised in the novel. Readers would not have limited their interest to *No Name*'s instalments, and were likely to have read many, if not all, the related accompanying features.

Collins remained sensitive to the possibilities and limitations of his serial's publishing space, developing further some of the narrative strategies he had first introduced in *The Woman in White*. Once again, he shunned the straightforward use of an omniscient narrator, and although *No Name* uses a third person narrative voice, he regularly interrupted it with other narratives made up of letters, newspaper clippings, and journal entries. Deidre David, viewing Collins's subversion of patriarchy alongside his rejection of the formal conventions of the realist novel, argues that *No Name* exhibits 'an intense dialogism'.[11] This dialogism is not, however, restricted to the novel's internal structure, but spills over into an interaction with its host magazine. Each instalment of the novel, fractured by its various narrative voices, exists within the textual diversity of *All the Year Round*. As *The Woman in White* presented itself as a magazine within a magazine, its 'strange family story' repeated in the other 'strange family stories' of *All The Year Round*'s journalism, so *No Name* echoes the structure of its magazine context. Sometimes Collins deliberately blurs the boundaries between fiction and journalism, such as when Captain Wragge, Magdalen's unscrupulous accomplice, writes in his private journal about her disguises. Here, the interaction between novel and magazine becomes particularly complex as Wragge writes:

> Hundreds of girls take fancies for disguising themselves; and hundreds of instances of it are related year after year in the public journals. But my ex-pupil is not to be confounded for one moment with the average adventuress of the newspapers.[12]

This passage works as a playful reference to the fictionality of the text (of course Magdalen should not be 'confounded' with 'the average adventuress of the newspapers'; she is a fictional character who does not 'belong' in the 'real' world of newspaper reports). It is also a reminder that as a fictional character, Magdalen can transcend the 'average' and be larger than life. On another level, however, the passage also insists on the

realism of Magdalen's story; if 'hundreds of girls take fancies for disguising themselves' and their behaviour is discussed in the public press, then Magdalen's career as an imposter is neither exceptional nor unreal. Similarly, the accounts of women's extraordinary lives outside the middle-class family which dominated *All The Year Round* throughout the serialization of *No Name* make Magdalen's story, by implication, appear plausible. If a sensation heroine like Magdalen Vanstone has real-life counterparts, then Smith's view of the novel as a 'world of impossible incidents' and 'monstrous' characters appears inaccurate.

Magdalen Vanstone's 'impossible' trajectory, from sheltered lady to workhouse inmate, supported by *All The Year Round*'s articles and stories on life for women outside the middle-class family, helps to move *No Name* beyond the 'impossibility' of sensation fiction towards realism. Lifted out of this supporting context the novel inevitably loses some of its power. Yet *No Name*, like other sensation novels, shares many features of the realist novel. As Deidre David has indicated, the novel is 'thick with the inherited themes of Victorian fiction – marriage, family, money, female desire, male governance'.[13] According to H.L. Mansel, writing in the *Quarterly Review* in 1863, the main theme of *No Name* is 'a protest against the law which determines the social position of illegitimate children'.[14] This 'protest', he argues, encourages a dangerous moral relaxation towards unmarried parents. Through the concept of illegitimacy Collins explores the status of the economically and socially disadvantaged woman whose very need to earn a living was itself considered aberrant. The image of the 'redundant', or unmarried, woman featured widely in the literature of the period. During *No Name*'s serialization there appeared in highbrow journals two influential articles which raised the issue of the social and economic position of 'surplus' women. W.R. Greg's article, 'Why Are Women Redundant?', appeared in the *National Review* in 1862, arguing that unmarried women were 'unnatural', while Frances Power Cobbe, in response to Greg's argument, published 'What Shall We Do With Our Old Maids?' a few months later in *Fraser's Magazine*.[15] The theme of Collins's novel was, then, already the subject of debate within the pages of the periodical press, although *All The Year Round* and its serial were unusual in representing the figure of the woman without the shelter of a family through the exciting filter of a sensational discourse.

Out of the house of bondage

In *No Name* Magdalen is the focus of the novel's sensationalism as she slips through the social frameworks of respectability to lead an

adventurous, if risky, life. While some sensation heroines, such as Wood's Lady Isabel, are represented as passive victims, Magdalen Vanstone actively works to avoid the position of victim as she sets out to recover her lost social identity and fortune. Her sister, Norah, follows an orthodox path by resigning herself to becoming a governess, following in the footsteps of her former governess, Miss Garth, upon whom 'the hard handwriting of trouble had scored [her face] heavily' (VII, 1). *All The Year Round* responded to Collins's theme of the dispossessed heroine by publishing features exploring the vexed question of where women should turn when the support of family or marriage is not available to them. These articles and stories depicted women in an extraordinary range of diverse roles; as nuns, workhouse inmates, prisoners, witches, labourers, slaves, and harem wives, all of which suggested, ironically, the paucity of choices open to women unable (or unwilling) to spend their lives as dependents within the middle-class family. Like Collins, *All The Year Round* preferred to explore the aberrant, an approach which served to highlight the problems and limitations faced by women outside the respectable family.

The most significant link between Collins's novel and *All The Year Round* is made by means of a short story, 'Out of the House of Bondage', which appeared in the 26 April 1862 issue alongside an early instalment of *No Name*. This depicts Magdalen's home broken up by the death of her parents, the lawyer, Mr Pendril, hinting that the two sisters are for some mysterious reason disinherited. Working with Collins's image of dispossessed women, 'Out of the House of Bondage' charts the collapse of a young woman's social and racial identity and its gradual reconstruction. While Collins depicts the family as a safe refuge for women and its loss a source of danger and humiliation, 'Out of the House of Bondage' emphasizes the problematic and precarious identity of the dependent female within the family. Like *No Name*, the heroine of this short story discovers that her parents were unmarried, although illegitimacy is only part of her problem, for the discovery reveals that her mother had been a slave on her father's cotton plantation. No longer the secure white middle-class girl she believed herself to be, Clara finds herself first marginalized and ultimately excluded from her family.

This sensational story's publication during *No Name*'s serialization gave readers an opportunity to consider the social position of women in relation to the issue of slavery, an issue foregrounded in the frequent newspaper reports at this period on the development of the American Civil War. Margaret Oliphant, in her 1862 *Blackwood's* article, 'Sensation

Novels', makes a direct link between the new fashion for sensation novels in Britain and the War, comparing the British reader's need for literature which offered 'a supply of new shocks and wonders' to the American way of 'procuring a new sensation' by means of engaging in civil war.[16] 'Out of the House of Bondage' illustrates Oliphant's linkage of American political unrest, based around the issue of slavery, and the British reading public's craving for a sensational discourse. This story also resembles the slave narrative, a genre much in vogue during the 1850s. Audrey A. Fisch links this appetite for stories narrated by slaves to the appetite for sensation fiction, arguing that the slave narrative offered Victorian readers a 'politically correct' way of enjoying 'graphic scenes of torture, murder, sexual violence, and the thrill of escape'.[17] 'Out of the House of Bondage', like the slave narrative, foregrounds the issues of slavery and violence, but is unusual in its depiction of a white, middle-class girl's discovery of her mother's slave status. Clara's loss of identity as a white girl and her removal from her family is reflected in Magdalen's loss of identity on the discovery of her illegitimacy and her subsequent exile from sheltered family life.

'Out of the House of Bondage' opens with Clara, secure within her home as the daughter of a wealthy slave-owner. Although she tries to be liberal and 'advanced', she admits she views the slaves as 'lower animals'.[18] The first signs of unease occur when Clara's cousin from the north, Abel Duncan, makes a visit, displaying towards her an inexplicable 'repugnance', and taking delight in pointedly asserting 'the inferiority of the African race [...] they could only be ruled by fear' (157). Abel also insists that a black skin is mysteriously aligned to insanity, an aberration which has the power to destroy white races. Clara says, 'I recollect with what diabolical ingenuity he used to compare the drop of black blood to insanity lurking in the frame.' (157). When she eventually discovers her parentage, she feels the shame of 'the debased race' (157). However, on leaving her father's plantation and settling in 'brave England' this 'shame' eventually gives way to a new 'feeling of self-respect and self-confidence', as well as a political awareness of, and identification with, the women her father 'owns' (162). Before she leaves her father's home, she loses her privileges; her father makes her new position chillingly clear:

> He finally told me with great sternness that although I was free [...] my future destiny depended upon my own behaviour [...] he would at least have a return for the money spent upon me. I should amuse him, read and play to him as heretofore, and arrange the household affairs; I should suffer for it if I failed. (160)

Clara's 'freedom' is, of course, no freedom at all. Her knowledge of her parentage has destroyed her father's fantasy that she is a white daughter, and he now views her as a slave he has 'bought' dearly and expects a greater 'return' from. Like the dutiful Victorian daughter, Clara's role is to 'amuse' her father, although she now has not even the pretence of the affection of family bonds. She no longer feels able to 'command' her father's slaves, and is beaten for this dereliction of duty. Like Magdalen Vanstone, Clara discovers on her father's death that she has been disinherited in favour of a cousin. Abel inherits his uncle's property (including, of course, all the slaves), while Clara is left with 'a moderate competence only' (162). This story invites readers to link racial oppression with the oppression of women, echoing Collins's concern with the marginalized and dispossessed Magdalen and Norah.

A literal 'house of bondage' featured in the 2 August 1862 issue of *All The Year Round* with Eliza Lynn Linton's 'Gone to Jail', a review article based on the anonymous, recently published *Female Life in Prison. By A Prison Matron*. Linton opens with a description of the 'female waifs and strays' who end up in jail, outlining their various responses to imprisonment. Some women, according to Linton, are 'at home' in prison, conforming there to an ideal of domestic, submissive femininity. Two poverty-stricken women, a mother and daughter imprisoned for murder, are 'grave, pious and well-conducted' and the prison matron believes them to be 'quite, half-stultified, simple-minded beings [...] but they were not murderesses'.[19] Their lives of domestic durdgery outside the prison are simply replicated inside, except that they now have enough to eat. Another well-behaved prisoner, 'Granny Collis', at over seventy years of age, preferred prison to the workhouse. Each time she was released from Milbank she would commit another petty crime in order to return to jail, 'where she found a happier home, and a more liberal one, than in the union' (490).[20] Other prisoners display different aspects of femininity, such as Mary Anne Ball, whose love of 'coquettish dress' led her to defy the imposition of a drab prison uniform. A resourceful dress designer and 'bold, handsome girl', she used the cords from her mattress to make a frame for a crinoline, and tore out the window wires, not to escape, but to create a pair of stays, transforming her 'dull brown serge' prison gown into 'a fashionable flowing robe' (491). 'Gone to Jail', like many of *All The Year Round*'s features, is put to work to add realism to Collins's serial by suggesting that women, like Magdalen, were often forced to inhabit a region beyond the safety of the respectable home.

Magazine serialization and literary red herrings

The magazine's intertextual format, however, did more than foster a sense of realism in the serial fiction. It also helped to suggest more than was actually stated in a novel. While the novelist could hint at developments in future instalments which may never actually come to fruition, the texts surrounding each instalment could strengthen such hints, thus raising false expectations in readers. These literary 'red herrings' could add to the thrills and shock value of a novel, setting readers speculating on the probable outcomes of the plot. An example of this strategy on the part of Collins and his host magazine occurs in the same issue where 'Gone to Jail' appeared. The instalment of *No Name* shows Magdalen apparently planning to murder her husband-to-be, Noel. The accompanying article on women in prison provides a strong hint to the reader that Magdalen will actually commit this crime and end up in jail. When she proposes a scheme to trap Noel into marriage, Wragge, her accomplice, is nervous about the possibility of being implicated in murder. The narrator informs us that he 'dimly discerned, through the ominous darkness of the future, the lurking phantoms of Terror and Crime, and the black gulfs behind them of Ruin and Death' (VII, 486). While readers of the complete text may place little significance on Wragge's fears, or simply forget them as the narrative progresses without evidence of Magdalen's murderous intentions, readers of the serial no doubt had the words made 'significant' (even though they are not) by Linton's article on women and crime. Serial readers had to wait for many more instalments before they were unequivocally informed that Magdalen never actually intended to murder Noel.[21]

In 'Gone to Jail', the disruptive female prisoners are described as 'breaking-out women' who, 'though not necessarily the worst in nature, are the most difficult to deal with' (489). In *No Name*, Collins is keen to show that his 'breaking-out' woman is not irredeemably bad, but misguided. The territory mapped out for women is, Collins suggests, a restricted zone to those who attempt to venture beyond familial and domestic roles. Novelists, however, found plenty of sensational potential in the 'breaking-out' heroine; indeed, she was usually the main focus of readers' interest. As Florence Nightingale stated in 'Cassandra', women's lives within the genteel family were not the stuff exciting novels were made of, arguing that one of the main 'charms' of novels is the fact that 'the heroine has *generally* no family ties'.[22]

The bottom line for women without financial support was the workhouse, and *All The Year Round* featured a second article by Linton

called 'The Girl From The Workhouse'. This, as I mentioned earlier, appeared on 18 October 1862, in the issue which had been especially made up by Dickens to reassure Collins of his support. Linton, echoing Dickens's own well-known views, argues that young women in prison experience better conditions and educational opportunities than girls in the workhouse. Pauper girls have committed no crime other than being 'destitute of means', yet they are ignored by a society more intent on reforming criminals than creating justice for the poor.[23] Linton calls for schools where pauper girls can be trained to cook, sew, and do household tasks, acquiring skills which would allow them to be incorporated into family life (albeit as servants in other people's families). The illegitimacy of most workhouse girls means they have little conception of what 'family life' means, and this, Linton argues, may lead them astray. The sort of temptations they face are darkly hinted at, although adult readers would have understood that prostitution was being referred to. Although the women's prison and workhouse were discussed as institutions which housed disadvantaged and deviant women, *All The Year Round*, during *No Name*'s run, made no reference to the refuge for fallen women, despite the fact that Dickens, in conjunction with the wealthy philanthropist, Angela Burdett-Coutts, was involved in the running of such a home, Urania Cottage. As with the prison and workhouse, Urania Cottage was designed to reposition 'breaking-out' women back into domestic life, although in this case they were sent out to the colonies as servants.[24] The magazine's silence about prostitution is made more evident by Collins's false clue in calling his heroine Magdalen, a name associated with the prostitute in Luke, 7:37. Just as Magdalen Vanstone does not resort to murder, neither does she resort to prostitution. However, Collins was able to darkly hint at both transgressions without having to take his heroine too far into the realms of the forbidden.

From the harem to the convent

The majority of *All The Year Round*'s female readers would have neither lived in the workhouse nor the prison, yet the threat of such places no doubt existed. In *No Name* and 'Out of the House of Bondage', both heroines consider themselves secure in their respectable well-to-do homes, yet both are unexpectedly plunged into the insecure social positions of 'outsiders'. The security of dependent females could, the novel and its host magazine suggest, be tenuous. However, while the workhouse and the prison existed as remote and fearful possibilities for the majority of readers, life in the harem was outside most Western

women's experience altogether. The family groupings of the Middle East, with many wives sharing the same husband, were fascinating to Western readers. While men, denied access to the harem, had produced their sexualized fantasies in written and visual representations, Western women who visited harems presented a much less lush account.[25]

All The Year Round, during the serialization of *No Name*, featured an article by a Western woman called 'Mrs Mohammed Bey "At Home"'.[26] According to the author, the harem is a place where women are free to behave in outrageously amusing ways, entertaining each other with jokes, naughty songs, and slapstick comedy. 'Mrs Mohammed Bey "At Home"', a reference to a young bride entertaining the female wedding guests within the harem, anticipates the title of Magdalen's stage act, 'A Young Lady At Home' where, as a professional actress, she acts a variety of female domestic roles for her audience. The irony of both 'at homes' is that the harem and the stage are tabooed spaces for middle-class Western women. The connotations of 'home' are undermined in Collins's serial, where the disinheritance of Magdalen and Norah literally leaves them homeless, and in Norah's case, with little choice but to serve (in the capacity of governess) those who do have a home. The harem as home is equally contentious, although the writer of the article attempts to fit the harem into her preconceived ideas of what a respectable home should be. A guest at the wedding, she describes the uproarous, even indecorous, behaviour of the harem women, in the midst of which sits Mrs Mohammed Bey, displayed in her wedding finery for the benefit of the guests, a 'glittering image or idol [...] very beautiful [...] a show, a sight, a thing on which to hang gorgeous jewels.' (104–5) She sits perfectly passive, with a 'cold handsome scornful weary face', suggesting to the writer 'the struggles between the external and internal life' which Eastern women must overcome 'before they settle down into the usual routine of harem existence.' (105) Yet, as readers of *No Name* were about to discover, Western women could also contract loveless marriages and regale their beauty 'coldly' as brides. When Magdalen marries the repulsive Noel, Collins describes the marriage ceremony in a way which may have reminded readers of the bride in 'Mrs Mohammed Bey' when he writes, 'The one person present who remained outwardly undisturbed was Magdalen herself. She stood with tearless resignation in her place before the altar – stood as if all the sources of human emotion were frozen up within her.' (VIII, 125)

Another link between *No Name* and the harem article is an emphasis on women's clothes and appearance. Much is made of Magdalen's ability to transform herself from an innocent girl 'at home' into an actress on the

stage, and later into an imposter out to trap a man into marriage. Magdalen's cynical use of clothes and cosmetics offers Collins an opportunity to comment on the instability of society's constructions of femininity. He undermines the apparent innocence of feminine behaviour by representing Magdalen's talent for mimicry (which she first puts to use early in the novel when she takes part in private theatricals) as part of her ability to 'swindle' people into believing she is something she is not. Jenny Bourne Taylor suggests that Collins used her premeditated 'swindling' as a comment on women's adoption of a constraining role and a pleasing appearance to be socially acceptable. Taylor argues that Magdalen's 'conscious assumption of a role becomes a more "honest" dissimulation than the reality on which it is based'.[27]

This theme of feminine appearances and dissimulation resurfaces in an *All The Year Round* article on cosmetics, 'Paint, and No Paint', which appeared on 9 August 1862 alongside the instalment of Collins's serial where Magdalen stands before the mirror, wondering whether or not to apply make-up. The article prompts readers to view Magdalen's decision in the light of current fashions. As she scrutinizes herself in the mirror, she asks, 'Shall I paint? [. . .] The rouge is still left in my box. It can't make my face more false than it is already.' (VII, 509) 'Paint, and No Paint' shows that Magdalen's use of 'paint' is shared by numerous women, the article referring to Madame Rachel Leverson, a popular beauty therapist for the rich who sold cosmetics under the slogan 'Beautiful For Ever'. Leverson was to later gain notoriety when she was exposed as a con-woman and proprietress of a brothel. Collins used her as a model for Mrs Oldershaw in his next novel *Armadale*, the procuress and beautician who helps Lydia Gwilt in her schemes to catch a rich husband.[28] 'Paint, and No Paint' discusses the importance of make-up in the theatre, describing the ability of actresses to alter their appearance by its use, giving credence to Magdalen's talent in altering her face to create new roles for herself on the stage, as well as her use of convincing disguises outside the theatre. Magdalen's question as to whether it is expedient to paint her face is shown in this article to be quite typical for many young ladies, the writer states, 'the age of no-paint has not yet arrived'.[29] While readers expected the actress to be skilled in the art of cosmetics, some may have been surprised to learn that respectable young ladies were perfectly capable of applying make-up:

A streak of black under the eyes (borrowed from the land of Egypt) and the timidest ideas of red may, to this day, be detected on the cheeks of ladies, to whom no suspicion of enamelling need attach. When you see

a pair of piquant eyes surmounting a faint blush under the half-veil
[. . .] you may conclude that the pencil and the tinting-pad have been at
work. (521)

Cosmetics, the writer claims, allow women to alter their faces, yet still pass
them off as 'natural'. Magdalen's deceptive strategies to adapt and disguise
her appearance are, in the light of this article, not so much a characteristic
of the sensation novel's heroine but a normal part of feminine behaviour.

'Paint, and No Paint' also draws attention to the less than beautiful raw
materials which help create beautiful faces. The secret arts of femininity
are disturbingly linked to refuse, where 'the sympathetic blush is
produced from a chemical substance called alloxan' (520), derived from
the foetal membranes of animals. The writer goes on to say that 'the vilest
garbage supplies to the gold, silver, and crystal cases of fashion an
exquisite and reviving perfume', having their source in 'bones and from
coal-tar, [and] the refuse from gas-works.' (520) Like the dust-heaps
transformed into money in *Our Mutual Friend*, society's waste undergoes a
transformation, creating the beautiful surface of fashionable ladies' faces.
Readers of this article and *No Name* would have also been aware of the
darker side of cosmetics surfacing in the most sensational criminal trial of
the period, that of Madeline Smith, a young lady from a genteel home
who was accused of poisoning her lover with arsenic. When questioned as
to why she possessed the poison, she replied that she used it to improve
her complexion. This prompted George Eliot to speculate as to who may
be 'the victim of the next experiment in cosmetics'.[30]

Outside the safe domestic space of the respectable home Victorian
women could apparently stray into any strange situation, whether it be
the worlds of the theatre, the workhouse, or the prison. *All The Year Round*,
during *No Name*'s representation of Magdalen's disastrous career, also
explored the convent and the coven as possible options for women who
could not, or would not, belong to respectable families. 'Worse Witches
Than Macbeth's', an article which appeared immediately after the first
instalment of Collins's novel, reviews Eliza Lynn Linton's history of
witchcraft, *Witch Stories*. The article emphasizes the dangers women faced
if they did not conform to established domestic roles. Derided as aberrant,
marginalized women who grouped together prompted fearful speculation
about their participation in the sisterhood of the coven, where 'unnatural'
knowledge, such as 'useful secrets of roots and herbs' were shared.[31]
Linton's research into the cases of persecution and torture faced by female
outsiders highlights both the dangers and restrictions faced by women
who held no legitimate place in society. A later article, 'The Polite World's

Nunnery', depicts a much less dangerous, but typically restrictive, refuge for women outside the family: the convent. This feature is written by an inhabitant of a German Protestant convent, 'a sort of fashionable almshouse for unmarried ladies of high rank'.[32] The convent women are assigned 'play' work, of the sort familiar to many leisured Victorian women. One, for example, is given the role of 'Lady of the Gloves', her task being to knit a set number of gloves for Christmas presents. This comfortable institution, where religious observance is a mere formality, appears far removed from the prison or workhouse, yet resembles them in the fact that the inhabitants are confined and removed from conventional family life.

Working women

Women's work, work which enables a woman to support herself in relative comfort, is not discussed in *All the Year Round* at this period. Although *No Name* represents Magdalen successfully earning her own living as an actress, this work is devalued in the novel as unsuitable for a well-brought-up middle-class woman. As she is about to make her first appearance on the stage, Magdalen is acutely aware of the 'shame' of working as an actress. She breaks down 'sobbing and talking like a child. "Oh, poor papa! poor papa! Oh, my God, if he saw me now!"' (VII, 339). Norah's work as a governess is similarly (although of course to a much lesser extent) seen as demeaning, an ill-paid profession full of humiliations for a woman brought up within the shelter of a middle-class home. The necessity for women to work was seen ultimately as the failure of the father (or husband) to support his female dependents. Alongside Magdalen's and Norah's plight as middle-class young women left without the support of a family, Collins presents other examples of women forced to earn their own living. Mrs Lecount, an impovershed widow who works as housekeeper for Noel Vanstone, resorts to wiles and deceptions in order to gain a competency from her selfish employer. Louisa, Magdalen's servant is an unmarried mother who teaches her mistress to act the role of parlour maid, while she temporarily takes on Magdalen's role. She is helped by Magdalen to start a new life in Australia with the father of her child. Mrs Wragge is a working-class woman whose dreary life as a waitress, serving meals at a frantic pace to men whose orders buzzed in her 'poor head like forty thousand bees' (VII, 290), fails to be ameliorated by her marriage. She continues in a similar position of exploited servitude, telling Magdalen that Captain Wragge married her when he discovered she had received a small inheritance, he 'took care of me and my money.

I'm here, the money's gone' (VII, 291); she now works as cook, valet, and maid-servant to her demanding husband. Deidre David sees Matilda Wragge as 'somewhat like Magdalen, a woman deprived of her identity as inheriting daughter and disciplined by laws that legislate legitimacy and correct irregularity'.[33]

All The Year Round also raised readers' awareness of the lives endured by working-class women in a two-part article, 'Pinchback's Cottage', which appeared immediately after the second instalment of *No Name*. The article begins with a description of the theatre's idealized images of female agricultural labourers, where 'that maypole dancing-girl Annette, who comes on stage in an exceedingly short gown' bears no resemblance to an actual working woman who, in reality, 'wears old top-boots of the squire's, and her father's great-coat, and goes out from seven am to five pm stone-picking in the fields'.[34] The positioning of 'Pinchback's Cottage', which combines a discussion of working people with a call for cheap theatres, is particularly significant. The first section of the article appears immediately after the second instalment of *No Name*, where Magdalen persuades her father to allow her to act the part of Lucy, the maid-servant, in an amateur performance of Sheridan's *The Rivals*. The article then draws the reader's attention to the discrepancy between stage versions of working women and the harsh reality of their lives, highlighting the instalment's depiction of Magdalen, the sheltered, spoilt young lady, who will only 'pretend' to be a servant. This instalment, and 'Pinchback's Cottage', foreshadow Magdalen's later transformation from lady into servant.

All The Year Round's readers were shown, through *No Name*'s instalments and their supporting features, the ease with which some ladies could slide down the social scale into poverty and insecurity. As novel and magazine progressed, readers found themselves increasingly enlightened as to the difficulties faced by women who were denied the support and protection of a family. The slippage from lady to servant is suggested when Magdalen reassures Louisa that she can easily pretend to be the mistress, 'Shall I tell you what a lady is? A lady is a woman who wears a silk gown and has a sense of her own importance' (VIII, 270). That 'sense of importance', *No Name* and *All The Year Round* showed readers, could be easily destroyed by a society which was all too ready to devalue unmarried or unsupported women as 'redundant'. While *No Name* is a sensation novel in the conventional sense of presenting devious plots and the 'shocking' themes of illegitimacy and female transgression, it is also sensational in its exposure of women's insecurity and vulnerability through its story of a 'lady' transformed into a destitute and homeless woman.

The most sensational element for Victorian reviewers, however, was not Magdalen's fall but her rise. Instead of punishing her for her transgressions, Collins allows Magdalen to regain her lost social identity by marrying an old admirer, Captain Kirke. Margaret Oliphant complained that 'after all [Magdalen's] endless deception and horrible marriage, it seems quite right to the author that she should be restored to society, and have a good husband and happy home'.[35] While Braddon's Lady Audley had been punished for her wickedness by incarceration in an asylum and a premature death, and Wood's Lady Isabel had suffered for her adultery with mutliation and premature death, Collins left his transgressive heroine at the end of the novel wiser and in good health, kissing her husband-to-be and reflecting on those 'poor narrow people' who 'would fasten on [her] sin, and pass all [her] suffering by' (VIII, 439). In his next sensation novel, *Armadale*, Collins was to develop the transgressive heroine further. Lydia Gwilt's crimes and schemes are more heinous than Magdalen's. However, it was only with *No Name* that he allowed his 'breaking-out' sensation heroine the possibility of redemption.

6

Mary Elizabeth Braddon's *Eleanor's Victory* in *Once A Week*

Validating the sensation novel

Mary Elizabeth Braddon wrote her third sensation novel, *Eleanor's Victory*, as a defence of her role as a popular writer. Alongside a melodramatic tale of an orphan's revenge, she provided her readers with an insider view of cultural production, emphasizing the skill needed to entertain audiences. In the novel she promoted the value of 'lowbrow' forms such as melodrama, exposing the reductionist cultural categories of 'high' and 'low' which were used by critics to maintain artificial divisions between élite and working-class forms. Her complicated mystery plot is enriched by references to a wide range of other texts, both literary and visual, as Braddon provides her readers with an informed commentary *about* melodrama and its pleasures.

Eleanor's Victory was designed for serialization in *Once A Week*, appearing from March to October 1863. Many of its instalments were accompanied by woodcut illustrations by George Du Maurier which emphasized the novel's themes of theatricality and melodrama. *Once A Week*, established in July 1859, is one of the few weekly Victorian family magazines to have received scholarly attention, mainly because of its use of high quality illustrations which offer an exciting visual appeal.[1] Indeed, Gleeson White, writing at the end of the nineteenth century, argued that *Once A Week*'s first series can 'be ranked as one of the few artistic enterprises of which England may be justly proud'.[2] The magazine's appeal extends beyond its illustrations, however. During its early years, its content and style resembled that of a high quality monthly journal. *Eleanor's Victory*'s spirited defence of melodrama and sensation fiction was in some ways well placed in *Once A Week*, for the magazine adopted a sophisticated approach towards cultural analysis in its discussions of

literature, art, and the theatre. Braddon, who had previously written for less prestigious magazines, such as the *Sixpenny Magazine* and *Robin Goodfellow*, viewed the serialization of *Eleanor's Victory* in *Once A Week* as an opportunity to validate her own particular style of fiction to an audience of educated middle-class readers.

The first editor of *Once A Week*, Samuel Lucas, sought to develop a 'genteel standard' along the lines of respectable monthlies like *The Cornhill*.[3] Alvin Sullivan has argued that *Once A Week*'s 'writers were among the finest of those contributing to any popular Victorian periodical'.[4] The well-known contributors Lucas recruited included G.H. Lewes, Harriet Martineau, and George Meredith, while among the regular illustrators were artists such as John Millais and John Tenniel. *Once A Week*'s owners, Bradbury and Evans (who were also the owners of the satirical weekly paper, *Punch*) disagreed with Lucas's attempt to create an elevated tone for the magazine. They had envisaged *Once A Week* as a popular rival to Dickens's *All The Year Round*.[5] While Lucas, an admirer of the work of George Eliot and Thackeray, preferred to serialize the more esoteric novels of writers like Meredith, Bradbury and Evans wanted to boost sales with sensation novels.[6] From Braddon's point of view, Lucas was not a particularly sympathetic editor. He did nothing to foreground *Eleanor's Victory* in the magazine; indeed, Harriet Martineau's *The Hampdens: An Historiette* was always placed in first position during the crucial early stages of the novel's serialization. However, always a pragmatic businesswoman, Braddon made the most of her proximity to such a writer as Martineau, hoping that within the 'respectable' context of *Once A Week*, her novel would appeal to the educated reader and boost her reputation as a writer. By combining a sensational plot designed to please Bradbury and Evans (who were concerned to increase sales following a drop during the serialization of *Evan Harrington*), along with a sophisticated cultural analysis designed to fit in well with *Once A Week*'s intellectual style, Braddon used this opportunity to win a place for herself as a 'serious' writer of popular middle-class fiction. *Eleanor's Victory* marked the beginning of her campaign to justify her work to critics and reach a wider readership through the periodical press.

Solveig C. Robinson has argued recently that Braddon, on becoming editor of *Belgravia* in 1865, used the journal's non-fiction 'to legitimize her own creative work by elevating "light literature" to genuine literary endeavour'.[7] Braddon's need to defend her sensation fiction had first arisen from the critical opprobrium brought upon her by the publication of her sensational bestsellers, *Lady Audley's Secret* and *Aurora Floyd*.[8] While these have recently received considerable critical attention, Braddon's

numerous subsequent novels have suffered almost complete neglect.[9] Yet Braddon's appeal for Victorian readers extended well beyond *Lady Audley's Secret* and *Aurora Floyd*, and she eventually achieved her goal of attracting an extensive middle-class audience. Indeed, some eminent Victorians confessed to an interest in her work: Queen Victoria herself enjoyed her novels, while in 1868 Tennyson wrote to the young son of a friend, admitting, 'I am simply steeped in Miss Braddon. I'm reading every book she ever wrote'.[10] Henry Sidgwick (later a professor of moral philosophy at Cambridge), wrote to his sister from Margate, 'I subsist chiefly on a kind of fish called Margate Dabs [...] and on Miss Braddon. Yes, I have decided [her novels] really are more improving to the mind than Mrs Henry Wood's'.[11]

Lady Audley's Secret appeared on the literary scene shortly after the serialization of Wood's melodramatic tearjerker, *East Lynne*, and throughout the 1860s Braddon's and Wood's sensation novels were invariably compared and contrasted. While Braddon was the more literate writer, reviewers tended to prefer Wood's novels as more 'genteel' and 'proper'. Wood's conservatism and cautious handling of sensational material earned her a grudging approval from the reviewers, while Braddon's cleverness and wit did nothing to save her from condemnation for her tendency to deal with topics usually considered out of bounds to ladies, such as representations of 'low' life, the world of the theatre, and the behaviour of men when no women were present. Braddon was especially threatening to critics because of her ability to present sensational plots in fluent, correct English. Some Victorian reviewers saw popular female authors as inferior writers, often considering 'errors as one sign of a woman's hand'.[12] In an 1863 review article on the novels of Wood and Braddon, an anonymous reviewer in *Littell's Living Age* spent four pages ridiculing Wood's 'slipslop style and bad grammar', yet viewed her novels as ultimately preferable to those of Braddon because she 'bases her fiction on a womanly notion of right'.[13] Braddon disturbed preconceived notions of gender and popular writing, for she presented sensational and melodramatic plots in witty, stylish prose which ranged beyond the world of genteel female experience.

Braddon gained a knowledge of 'low' life as a young working woman living on the margins of respectability. The daughter of a solicitor whose extravagance had left the family in poverty, she embarked on a career writing for the periodical press in 1856, aged twenty-one. When this didn't pay she became an actress and earned a moderate income working in comedy and melodrama in the northern provincial theatres. By 1860, having rejected her dead-end stage career, Braddon was living alone in

London, determined to make her fortune as a writer.[14] She contributed serial fiction to a wide range of cheap magazines, among them the working-class *Reynolds's Miscellany*, the *Welcome Guest*, and the *Halfpenny Magazine*. As a young professional based in London, Braddon was just one of a considerable band of penny-fiction writers who struggled to make a living. Nigel Cross in *The Common Writer* states that the majority of 'penny' writers were men, 'journalists, radicals, out of work actors, gamblers', going on to add that they inhabited:

> a particularly cut-throat world in which women writers, outnumbered by at least twenty to one, had to fight twice as hard as men to avoid being swindled by unscrupulous publishers. Another reason why so few women entered the field of penny fiction was that most of it catered to a male appetite for sex and violence.[15]

Braddon's survival within this 'cut-throat world' resulted in the acquisition of an 'unladylike' knowledge which allowed her to transform her experiences of the theatre and Grub Street into racy fiction for a male audience.[16] She also put this knowledge to use in her middle-class sensation novels; as Henry James, an early admirer of her work stated, Braddon offered readers 'the exact local colouring of Bohemia'.[17]

James also noticed that in all her writing, 'the grim determination to succeed is apparent in every line'.[18] Braddon's determination to succeed was reinforced when she met the magazine entrepreneur John Maxwell. She not only wrote for his journals, but moved in with him, despite the fact that his wife was still living, albeit confined in a lunatic asylum. Braddon bore him five children before they eventually married. Maxwell's financial difficulties led her to write at a frantic pace in order to make money, and she directed her attention to the emerging genre of the sensation novel, adapting for middle-class consumption the criminal plots of the penny serials she had written for working-class audiences. In a matter of weeks she wrote the novel for which she is best known today, *Lady Audley's Secret*, a sensational tale of female criminality disrupting the polite world of the landed gentry.

The value of Dutch-metal and spangles: Braddon's defence of sensationalism

Braddon continued throughout the early 1860s to pursue her lucrative sideline as a writer of anonymous penny-fiction, describing this work to her literary mentor, Edward Bulwer-Lytton, as 'the most piratical stuff, &

would make your hair stand on end, if you were to see it. The amount of crime, treachery, murder and slow poisoning, & general infamy required by the Halfpenny reader is something terrible.'[19] Braddon was well-placed to observe both the mainstream culture of the educated classes and the more robust cultural forms favoured by the majority of people, understanding that middle-class readers also delighted in plots based on crime and infamy, except they preferred such plots packaged in the acceptable form of a three-volume novel, or respectable magazine serial, rather than within the pages of a badly printed penny pamphlet. In *Eleanor's Victory* Braddon was at pains to show that despite such differences in packaging, high and low cultural forms frequently shared similar themes and imagery and she set about educating her 'educated' readers on the delights of penny dreadfuls and the pleasures of melodrama and pantomime. At the same time, she offered her less privileged readers access to information about more élite cultural forms, such as Shakespeare's plays, Turner's paintings, and the novels of Scott. Braddon extended her didactic role in attempts to educate women about men and men about women. Her female readers were provided with forbidden knowledge about the private world of masculinity, while her male readers were shown hidden aspects of femininity. Like George Eliot, another unmarried woman living with her male partner, Braddon was denied access to 'respectable' female society: however, there were certain freedoms to be gained from this ostracism in that both writers (in their very different ways) felt able to use their experiences of marginality to reclaim the woman's novel from its exclusive concern with the world of femininity associated with the 'ladylike' fiction of Jane Austen. Braddon's extraordinary knowledge of both sides of the culture, class, and gender divides was the secret of her success: whatever the class group or gender of her readers, there was always something worth knowing to be learnt from her novels.

Sympathetic Victorian reviewers recognized that Braddon's appeal lay in this ability to educate readers in unorthodox ways. In the *Saturday Review* in 1863, an anonymous reviewer stated that:

> Miss Braddon gives us something more than a cunning plot cunningly worked out, and a story in easy, flowing and lively English. She gives us something peculiar to herself and given by no one else. She alone can write of women's things like a woman and men's things like a man. She can talk of gussets, and seams, and dress, and all manner of music; and she can also talk of theatricals and little Paris dinners, and brandy-and-water, and grisettes, and horses, and dogs. The mixture is piquant.[20]

In a later review in *The Nation*, Henry James also delighted in Braddon's 'piquant mixtures', although he concentrated on the way her representations of an 'illegitimate' Bohemian male world were made interesting to female readers, 'She knows much that ladies are not accustomed to know, but they are apparently very glad to learn'.[21] Both reviewers, however, fail to mention the less shocking aspects of Braddon's didactic project: her ability to teach readers to enjoy and appreciate pantomime and the Pre-Raphaelites, Tennyson and transpontine theatre, sensation novels and Shakespeare. She opens up the 'illegitimate' world of popular culture to her readers, as well as promoting the pleasures of the 'legitimate' world of high culture.

The defence of popular culture which Braddon makes in *Eleanor's Victory* is in sharp contrast to her presentation of herself as a novelist in her letters to Bulwer-Lytton, where she derides her role as a popular writer, apologizing for catering to the demands of her mass readership before considering the issue of artistic integrity. Bulwer-Lytton himself, despite Braddon's flattering portrayal of him as a great artist, had also pursued popularity by catering to numerous phases of literary fashion throughout his career. As Anthea Trodd has argued, 'as a novelist [he] had only one indisputable talent, his ability to anticipate what genre would next be popular'.[22] Braddon overlooks Bulwer-Lytton's own mass market appeal when she describes herself to him as a victim of the literary marketplace, 'a patcher up of sham antiquities as compared to a Grecian sculptor: a dauber of pantomime scenes, all Dutch-metal, glue, and spangles, as compared to a great painter'.[23] As we shall see, Dutch-metal, a cheap copper–zinc alloy used in the theatre to create the illusion of gold, assumes a significant role in Braddon's way of thinking about cultural formations.

The self-deprecatory tone she assumes in her letters is transformed in *Eleanor's Victory* into a confident assertion of the pleasures and importance of popular cultural forms. Borrowing her own words to Bulwer-Lytton, Braddon puts them into the mouth of one of her characters, Richard Thornton, a skilful scenery painter and translator of French melodramas. He defends his work to Launcelot Darrell, a young artist with 'highbrow' pretensions, insisting that 'scene-painting isn't *all* done with Dutch-metal and the glue-pot: we're obliged to know a little about perspective, and to have a slight knowledge of colour. Some of my brotherhood have turned out tolerable landscape-painters, Mr Darrell'.[24] Richard's use of the term 'brotherhood' would have suggested to contemporary readers the Pre-Raphaelite Brotherhood, whose art Braddon discusses elsewhere in the novel.[25] Her point is clear: that popular art forms, to be executed successfully, need skilful artists, sensitive to the

needs and pleasures of their audiences, and that high art sometimes borrows from this world of Dutch-metal to add sparkle and thrills which would otherwise be lacking. Braddon's apologetic letter describing herself as a 'dauber of pantomime scenes' is offset in *Eleanor's Victory* by the promotion of the specific pleasures pantomime scenes offer. This defence was directed towards those critics who suggested there was no skill involved in the writing of sensation novels or other forms of popular literature, and only crude pleasures to be had from reading them. Braddon uses her serial novel in *Once A Week* as a platform from which to launch her attack against such critics, interweaving her assertion of the value of melodrama and sensationalism within the novel's mystery plot. Some of the magazine's features also engaged in this debate, analysing a variety of cultural formations and the pleasures they offer, providing readers of Braddon's serial with an opportunity to further explore the issues she raises.

Most Victorian reviewers, however, were hostile to Braddon's attempt to combine high and low culture in her fiction. W.F. Ray, writing in the *North British Review* wrote that:

> The notoriety she has acquired is her due reward for having woven tales which are as fascinating to ill-regulated minds as police reports and divorce cases [. . . .] Others before her have written stories of blood and lust, of atrocious crimes and hardened criminals, and these have excited the interest of a very wide circle of readers. But the class that welcomed them was the lowest in the social scale, as well as in mental capacity. To Miss Braddon belongs the credit of having penned similar stories in easy and correct English, and published them in three volumes in place of issuing them in penny numbers. She may boast without fear of contradiction, of having temporarily succeeded in making the literature of the Kitchen the favourite reading of the Drawing-room.[26]

Another reviewer, referring to Braddon's 'literary curry', complains that such 'coarse fare is now sought by the dainty'.[27] Braddon's abilities to offer a 'cunning plot' in 'lively English' allowed her to align the popular novel with educated literature, forcibly demonstrating that a symbiotic relationship existed between the 'literature of the Kitchen' and more respectable cultural forms. From her earliest novels Braddon had incorporated a wide range of references to literature, theatre, and art, her fluent style appealing to readers of different educational abilities. For example, in *Lady Audley's Secret*, she represents her wicked heroine,

Lucy Audley, in ways which resemble the villainesses of stage melodrama (a figure recognizable to most theatre-goers), as well as drawing upon French literature, Shakespeare, and the poetry of Tennyson (all meaningful to her more educated readers). Similarly, *Aurora Floyd*'s allusions to high art and poetry exist side by side with references to popular theatre, contemporary murder trials and the slang of the race track.

Eleanor's Victory: a labyrinth of textuality

In *Eleanor's Victory*, Braddon toned down her sensational narrative (the bigamy and murder of the earlier novels are transformed to false suspicions of adultery and suicide), in order to put more of an emphasis upon her commentary about the role of cultural formations in people's lives. As a background to her plot of revenge and mystery, readers were offered a detailed map of contemporary forms of literature, art and drama, whereby the similarities rather than differences between élite and popular culture are emphasized. Braddon balances her melodramatic storyline, based on the formulaic model of an orphan's attempt to avenge her father's death, with a debate about the value of melodrama and the nature of its fictionality. She incorporates many of the motifs of stage melodrama: a beautiful young heroine, Eleanor Vane and her spendthrift but affectionate father; a mysterious villain who provokes Mr Vane's suicide; and comedy in the form of Eleanor's flighty young friend, Laura. Eleanor's father, a compulsive gambler living in Paris in shabby retirement, is cheated out of the money intended for Eleanor's education. Unable to bear the shame, he commits suicide. The rest of the novel follows Eleanor's quest to find and punish the villain, helped by her friend, Richard Thornton. They eventually track down the culprit, a spendthrift artist called Launcelot Darrell, although despite having gathered the necessary evidence against him, Eleanor is prevented from enjoying her 'victory' by his doting mother's prayers for forgiveness. Overcome by the power of Mrs Darrell's maternal devotion, Eleanor abandons her 'unnatural' scheme of vengeance. Interwoven with these melodramatic and sensational elements is a preoccupation with other texts and other forms of representation. All of the characters read books and magazines and talk about them, discuss paintings, and music, and visit the theatre. Some characters, such as Richard and Launcelot are actively involved in cultural production, while Eleanor hovers on the brink of earning her living as an actress before she becomes the paid companion of Laura.

A good example of how Braddon introduces other texts and raises the reader's awareness of the power of fiction is when Eleanor, alone in her father's shabby apartment, anxiously awaits his return. She passes the time by reading a novel by the French sensationalist, Paul Féval:

> There was an awful mystery in those greasy tattered pages: a ghastly mystery about two drowned young women, treacherously made away with, as it seemed, upon the shore of a dreary river overshadowed by willows. There were villains and rascals paramount throughout this delightful romance; and there was murder and mystery enough for half a dozen novels. But Eleanor's thoughts wandered away from the page. The dreary river bank and the ghostly pollard-willows, the drowned young women, and the ubiquitous villains, all mingled themselves with her anxious thoughts about her father; and the trouble in the book seemed to become a part of the trouble in her own mind, adding its dismal weight to her anxieties.
>
> There were splotchy engravings scattered here and there through the pages of Monsieur Féval's romance, and Eleanor fancied by-and-by that the villain in these pictures was like the sulky stranger who had followed her father. (VIII, 382)

This mingling of two fictional worlds draws readers into a labyrinth of textuality: we encounter a heroine in a sensation novel reading the 'greasy tattered pages' and 'splotchy engravings' of another sensation novel. Throughout *Eleanor's Victory* Braddon illustrates her heroine's development as a reader and consumer of cultural productions. The adolescent Eleanor's reading of Féval's novel is too personal; she sees nothing but her own troubled situation in the story and illustrations. Richard (Braddon's alter-ego) complains that Eleanor frequently 'talk[s] as if life was a melodrama' (VIII, 497), seemingly unable to distance herself from her favourite fictional forms and basing her conduct on 'the numerous novels she had read, in which the villain was always confounded in the last chapter' (VIII, 437). This outlook, based on her over reliance on fiction, leads her to overuse the language and gestures of melodrama to express herself.

Eleanor is helped in her journey from naive girl reader to discerning woman by Richard's warnings against a too-close identification with fiction; he insists 'life is not a three-volume novel or a five-act play, you know, Nelly. The sudden meetings and strange coincidences common in novels are not very general in our everyday existence' (VIII, 467). Yet with enormous irony, Braddon frequently makes her plot creak under the

weight of 'strange coincidences' as if to emphasize her novel's fictionality. Braddon's project is divided between a utilization of the emotional energy of melodrama in her representation of Eleanor and a deflation of melodrama's excessive emotion by means of an ironic commentary on the part of Richard. His discourse on the inappropriateness of melodrama to everyday life serves to distance the reader from Eleanor's own naive reliance on fiction. To Richard, melodrama is work: a popular and entertaining fiction which meets emotional needs in audiences, but which belongs on the stage, or between the covers of a book, or the frame of a painting. Richard can laugh at melodrama's excesses while at the same time appreciating its appeal. Eleanor, on the other hand, always blurs the boundary between her own life and the story.

Eleanor's dependency on fiction has its comic echo in the figure of Laura Mason, who has completely and ludicrously submerged her identity in the world of Byron's poetry and other literature popular with Victorian young ladies. Laura enjoys viewing herself as a victimized heroine who dotes on dashing heroic men. When she becomes engaged to Launcelot, she finds numerous fictional models for their relationship: while he is the Corsair, she sees herself as Medora (IX, 74); later he resembles the 'hero of a dreadful French novel' and Laura imagines herself as the overworked seamstress in Hood's 'Song of the Shirt' (IX, 101–2). Laura's wholesale acceptance of fiction as a model for life leaves her vulnerable, as Braddon is at pains to show; she is like 'Red Ridinghood, simple enough to be deluded by the weakest-minded of wolves.' (IX, 18) In her next novel, *The Doctor's Wife*, a reworking of Flaubert's *Madame Bovary*, Braddon depicts a similar vulnerable young woman, Isabel, who 'wanted her life to be like her books; she wanted to be a heroine'.[28] This outlook holds particular dangers for women, a point which Flaubert also argues in his novel. Emma Bovary is drawn into adultery by uncritically consuming the 'wrong' sort of fiction. In *Eleanor's Victory*, Braddon hints at the possibility of adultery for Eleanor as the outcome of her fantasies based on fiction when she depicts her, by now married to Gilbert Monckton, falsely suspected of adultery. Unlike Laura (and Emma Bovary), Eleanor gradually frees herself from her desire to be a 'heroine', admitting that her reliance on fiction 'had been wrong altogether.' (IX, 296) The never-never land of fiction, Braddon suggests, is not the best place for women to spend their time: they may 'stray' or get trapped and become as vulnerable a 'Red Ridinghood' as Laura.

Although she highlights the dangers of fictionality, Braddon also indicates the pleasures which both popular and 'respectable' fictions can offer audiences. Towards the end of *Eleanor's Victory*, Launcelot abandons

his life of crime and aimlessness to turn his energies to art. After studying in Italy he returns to England to pursue a career as a popular artist, basing his first successful painting, 'The Earl's Death', on a poem by Tennyson. This depicts a woman standing over a man, the Earl whom she has just murdered. The narrator explains that:

> although the picture was ugly, there was a strange weird attraction in it, and people went to see it again and again, and liked it, and hankered after it, and talked of it perpetually all that season; one faction declaring [. . .] the murderess of the Earl the most lovely of womankind, till the faction who thought the very reverse of this became afraid to declare their opinions, and thus everybody was satisfied. (IX, 413)

Launcelot's painting is based on Tennyson's 'The Sisters', a poem depicting a woman avenging her sister's seduction and death by luring the wicked Earl responsible to his destruction. By drawing the reader's attention to this sensational poem of sex, revenge, and violence, Braddon indicates that sensationalism was not exclusively the province of 'low' cultural forms like melodrama. She suggests that these themes straddle a wide cultural spectrum, and that images of transgression and emotional excess are interesting to everyone, except perhaps the professional critics who, in *Eleanor's Victory*, are satisfyingly silenced by the sheer force of public opinion.

Braddon's discussion of cultural forms argues for the skill which is needed to produce popular art likely to appeal to a wide audience. One reviewer in the *Saturday Review* also recognized this skill, stating that sensational plots are highly valued by readers, yet devalued by critics, going on to add that 'most clever people who tried to work out a plot like that of *Eleanor's Victory* would find at once that they had no control over their materials'.[29] Braddon must have been grateful for this reviewer's recognition of her skill in developing complicated plots, particularly when the majority of critics were glibly dismissing her work as unskilled and improbable.

Bulwer-Lytton once stated that Braddon's '[p]ublic is a large one and comprises intellectual readers'.[30] The educated readership of *Once A Week* would have understood her allusions to Tennyson and the work of the Pre-Raphaelites, aware of the argument she was sustaining throughout *Eleanor's Victory*: that high culture does not exist in a vacuum, but sometimes borrows themes and images from popular cultural forms. Braddon's less educated readers, however, were placed in positions to explore her references if they chose to do so, for she always refrained from esoteric allusions. Kate Flint has discussed Braddon's extensive allusions

and quotations from the work of other writers, along with her references to art movements and genres. This approach, Flint argues, 'encourage[s] her consumers not just to take cultural references as part of the social backcloth, but to enter into an active process of interpretation'.[31] Braddon's didactic project in *Eleanor's Victory* works in two ways: alongside her tendency to allude to mainstream writers and artists, she also attempts to educate her readers to appreciate popular cultural forms (if they do not already do so). While her novel abounds with references to Byron, Scott, Shakespeare, Tennyson, Balzac, Flaubert, Millais, Holman Hunt, Turner, Raphael, and Beethoven, it also reverberates with references to the *roman feuilleton*, 'Jack Sheppard', 'Wagner, the Wehr Wolf', pantomime, 'God Save the Queen', Scottish ballads, melodrama, fairy-tales, and the sensation novels of Paul Féval and Fréderic Soulié. Braddon presents all these cultural forms as pleasurable and worth engaging with. This promotion is supplemented, however, by a warning to young women about the dangers of being passive consumers of culture in the figure of Eleanor, who rejects her over dependence on melodrama and eventually abandons her impractical notions of 'a stern classical vengeance' (IX, 414). Braddon offers female readers of *Eleanor's Victory* a critical framework with which to enjoy all forms of literature, art and theatre without becoming involved in a too-close identification with oppressive fictional role models. Such readers are encouraged to distance themselves from fictionality by questioning (as well as enjoying) all forms of representation.

Eleanor's Victory emphasizes textuality: everyone either reads, or visits the theatre (usually both); torn letters and forged wills provide the dynamic of the plot; even the minor French villain, Launcelot's accomplice, has 'tattered novels' strewn around his apartment, which just happens to be situated in the same building as 'the office of a popular bi-weekly periodical' (IX, 380). *Once A Week* also presented readers with a number of texts which either playfully disrupt fictionality, or discuss the painful experience of fictionality disrupted, or assert the pleasures of refusing to draw distinctions between fiction and reality. Some of the illustrations serve to extend this theme, providing visual jokes which distance the reader from the text by highlighting its fictionality.

Once A Week: foregrounding fictionality

Once A Week's 'implied' readers were positioned as highly sophisticated in their approach to fiction compared to Laura Mason and Eleanor Vane. During the serialization of *Eleanor's Victory* they were offered a number of features which echoed the novel's self-referentiality. Emma Traherne's

sensational bigamy story, 'Paul Garrett; Or, the Secret', was published during the serialization of *Eleanor's Victory* with an illustration by C. Green.[32] The story concerns Winifred, an elderly woman secretly married to a much younger man who disappears shortly after their marriage. She later discovers that he has made a second bigamous marriage to a woman of his own age. Winifred finds herself unable to convince anyone that she really is married. Green's illustration (see Plate 2) depicts Winifred reading a letter (which the story reveals is from a private detective, informing her of the whereabouts of her runaway husband), while a younger woman, her niece, stands behind her, staring worriedly out towards the reader, as though sharing some secret with us. This illustration forms a visual joke against Winifred, appearing to confirm the niece's belief that her 'spinster' aunt is mad. The suggestion of a collusive gaze between the figure of the younger woman and the reader provides a minor disruption to the illusions generated by fiction. The supposedly mutually exclusive worlds of the characters and the reader temporarily meet over the head of a fictional character oblivious to this rapport.

In the accompanying instalment of *Eleanor's Victory* there is a chapter called 'The Testimony of the Sketchbook' where Darrell's sketches are ludicrously presented as evidence of 'real life'. Eleanor and Richard (who believe that 'a man's sketch-book contains a record of his life', IX, 19), surreptitiously search through Darrell's Paris sketchbook for evidence of his 'crime' against Mr Vane. They discover a sketch, conveniently dated, showing Eleanor's father losing at cards. Here, Braddon pushes probability to extremes, as though to emphasize the ease with which her characters can become confused about the boundaries between fiction and reality.

The cross-over point between fiction and reality is also addressed in an earlier *Once A Week* article, 'My Neighbour At The Theatre'. Here, the writer despairs about the difficulties of maintaining a division between fictionality and the real world at the theatre. The writer complains that he cannot enjoy the pleasures of the play because he is 'always annoyed by [his] neighbour'.[33] He objects to people in the audience who comment on the play during the performance by asking questions of their neighbour, laughing obtrusively, following the action on stage by constantly referring to a copy of the play, borrowing an opera-glass, or refusing to laugh and smile during the amusing sections. He gives a sample of the version of *Hamlet* he experiences at one theatre:

> *Hamlet*: A little more than kin and less than kind.
> *Box keeper*: Party for box 12, four seats in the front row – (Bang, bang, go the seats) – Will you take a book of the play, sir? (573)

His pleasure is destroyed by the fact that as the play progresses he becomes more and more engaged with the behaviour of the audience than with the actions on the stage. The article suggests that for textual pleasure to be experienced, a certain gap between fiction and audience is necessary. Images of the theatre also pervade *Eleanor's Victory*. Eleanor 'had seen a good deal of the English drama', and 'the Parisian theatres seemed delightful' (VIII, 354) to her. Her first thought is to become an actress after her father's death, and although she never becomes a professional actress, she retains a propensity for regularly creating dramatic tableaux with herself at the centre.

Du Maurier's illustrations to Braddon's novel also draw upon the theatre for inspiration, incorporating the motifs of the stage, the actors and the audience, within domestic settings. One illustration depicts the moment when Eleanor, having read for the first time her father's suicide note, falls back on her experience of stage melodrama in order to arrange an emotional scene: 'falling on her knees, she clasped her hands, and lifted them towards the low ceiling of the little chamber.' (VIII, 415) Du Maurier's illustration (see Plate 3) shows Eleanor standing by a window with the crumpled note in her raised hand, while on her knees before her, with her arms clasped around Eleanor's waist, is Richard's aunt, begging her to abandon her plan of revenge. Richard, who has his back to the reader, leans against a chair, separated from the two women and watching their 'performance'. His detachment from their emotional postures suggests both his position as spectator to a drama, and his role as a behind-the-scenes worker at the theatre.

Braddon provides an echo of this scene towards the end of the novel, when the tableau is recreated in a different context, Du Maurier providing an almost identical framework for the illustration (see Plate 4). This accompanies the penultimate chapter, 'The Day of Reckoning', where Eleanor, armed with the necessary 'evidence', confronts Launcelot with the language of stage melodrama: '[A]t last I can be true to the lost father whose death was your cruel work [. . .] Cheat, trickster, and forger; there is no escape for you now.' (IX, 411) Her 'victory', however, is short-lived because her desire for vengeance cannot withstand the excessive maternal devotion of Launcelot's mother. Mrs Darrell, like Eleanor, also adopts the postures and language of melodrama in order to save her wayward son:

The widow came suddenly forward into the centre of the room, and cast herself on her knees before Eleanor, and wound her arms about the girl's slender waist, pinning her to the spot upon which she stood, and

holding her there. The mother's arms were stronger than bands of iron, for they were linked about the enemy of her son. (IX, 412)

Du Maurier's illustration again places the emotional women at the centre of the tableau, with the repentant villain covering his face to the right of the picture, while the spectating men on the left form an audience, an arrangement which picks up in visual form the theatricality of Braddon's scene. The fact that this image is a repetition of the earlier one (Plate 3) invites readers to draw parallels between the two scenes, while the illustrations work with the text in suggesting the intense theatricality of Eleanor's vows of vengeance. The visual mirroring of the two scenes, depicting the heroine centre-stage making her vows of revenge, each image showing a kneeling older woman begging restraint and each with spectating men on the margins, tends to push fictionality to its limit by bringing the codes of the melodramatic theatre into the commonplace drawing-room world of the novel.

These images of theatricality in *Eleanor's Victory*'s plot and illustrations are not only foregrounded in 'My Neighbour at the Theatre', which complains about the commonplace world of the audience disrupting the fiction on the stage, but also in Dutton Cook's 'Lavinia Fenton', which provides similar instances of the collision between fiction and reality. Dutton Cook had himself published a sensation novel in 1861 called *Paul Foster's Daughter*, and in 1867 was to become the theatre critic for the *Pall Mall Gazette*. Cook here discusses the career of the eighteenth-century actress Lavinia Fenton, stating that she created a ' "sensation" (applying the word in a sense she never heard it invested with)'.[34] 'Lavinia Fenton', like *Eleanor's Victory* and its illustrations, explores the conventions of the theatre and its relationship to the world offstage. Fenton began her career acting in melodramas with titles like *The Orphan; Or the Unhappy Marriage*. She, like Eleanor, was adept at generating emotion in audiences: her voice ringing 'through the house in tones of deepest emotion, she fairly carried the whole audience away with her' (653). Cook goes on to discuss Hogarth's painting of Fenton in the role of Polly Peachum in *The Beggar's Opera*. The painting depicts the audience as well as the scene on stage and Cook describes how Fenton, as Polly, appears not to be acting to the other characters on stage, but to the Duke of Bolton in the audience, whose wife she was later to become. While the author of 'My Neighbour at the Theatre' depicts audience activity encroaching into the play, and Braddon and Du Maurier depict the actions of the stage in a middle-class domestic setting, Cook describes an instance of a play being played out between an actress on the stage and a member of the audience, the public and private

blending confusedly in Hogarth's image. All three texts deliberately disrupt those notions of verisimilitude by which critics of the period judged all types of Victorian cultural production.

A further instance of textual disruption appeared in *Once A Week* during the serialization of Braddon's novel in a poem called 'A Celibate Consoled'. This outlined one man's refusal to distinguish between fiction and reality. Just as Braddon hovers dangerously close to self-parody in *Eleanor's Victory* when she deflates her melodramatic plot with a commentary on the codes and joys of fiction, this poem plays directly with the world of fiction. The protagonist, a bachelor, has rejected real women in favour of the heroines of novels and poems. These fictional women are not words on a page, but are 'warm and real':

> I dream the poet's dream of bliss,
> The cream of prose I sip, too;
> The sweetest cheeks are mine to kiss
> That lover e'er put lip to.

> Unknown beloved of my heart,
> Fair queen of my ideal!
> I thank thine author for the art
> That frames thee warm and real.[35]

The 'Celibate' is a male version of Laura Mason, for she also sees romantic attachments in terms of the heroes from her favourite novels and poems. He, however, finds consolation in the positions of power and sexual domination he can enjoy over fictional women. The 'Celibate' praises Tennyson's 'Maud', Browning's 'Geraldine', as well as Thackeray's heroines. He is well up-to-date in his tastes in liking the fiery heroines of sensation novels:

> Each new sensationist I skim,
> Whose thrilling plots prevent your
> Forgetting life's a wayward whim,
> And love's a risky venture.

> The fastest heroine daren't deny
> My right to lord it o'er her,
> From Melville's wild Kate Coventry
> To Braddon's quaint Aurora.

He indicates the pleasures of his power fantasies over textual women, a power denied him in reality where, he complains, women run up bills and

fill the home with disruptive children. Another pleasure he experiences is the fact that desiring textual heroines allows him to abandon monogamy and indulge a taste for as many women as he likes:

> And, while I am the happy man,
> Such vivid fancies figure me,
> I need not tremble at the ban
> That disallows polygamy.

Fictional representations of women take on a magical life of their own, and words are transformed into 'reality':

> Beneath the subtle alchemy
> Glow thought and scene and diction,
> And blossoms of reality
> Burst from the buds of fiction.

On the page opposite to this tongue-in-cheek poem extolling the virtues of textual women (including one created by Braddon herself), there appears an instalment of *Eleanor's Victory*, along with a Du Maurier illustration showing Laura and Eleanor seated in Mrs Darrell's garden with the newly-returned Launcelot (see Plate 5). In the foreground lies an open book on the lawn and Laura sits with another book in her hand. In the chapter which accompanies this illustration the reader encounters Laura meeting Launcelot for the first time, and she later tells Eleanor that 'He looks just like the hero of a novel, doesn't he, Nell? dark and pale, tall and slender.' (VIII, 520) The lawn in the illustration is described by Braddon as 'the grassy little amphitheatre' (VIII, 521) where the scene of Eleanor's meeting with the man she intends to make pay the price for her father's death takes place. Theatre and textuality again mingle, for Eleanor's mistrust of Launcelot is 'instinctive' (in true melodramatic style), while Laura provides comic relief with her silly hero worship and belief that Launcelot organizes private theatricals and writes for amateur newspapers and magazines (VIII, 521). Readers of this issue of *Once A Week* were inundated with references to fictionality: 'A Celibate Consoled', praising fictional heroines as 'real', the books within the image (which being Laura's books, contain the sort of heroines admired by the 'Celibate'), and the serial instalment of the novel itself, all foreground fictionality. *Once A Week*'s readers were asked to tread a fine line between accepting the world of fiction *as* fiction and laughing at its conventions.

By publishing *Eleanor's Victory* in *Once A Week*, the first middle-class journal she had written for which was not owned by Maxwell, Braddon became aware of the possibilities of magazine discourse in establishing her literary reputation. In 1866 she extended this reputation through her editing of *Belgravia*, a monthly magazine priced at one shilling, which aimed to attract a genteel readership. Braddon did not, however, attempt to emulate the highbrow standards of *Once A Week* or *The Cornhill*; she was too canny a businesswoman not to know precisely where her particular market was to be found. Although she continued to complain to Bulwer-Lytton about her inability to take time out to write an artistic masterpiece, she continued to produce the exciting novels which she knew her audience would pay good money to read, justifying this to Bulwer-Lytton by stating that 'the shilling public can only be extracted by strong measure'.[36] Sensation fiction, or 'strong measure' was, Braddon realized, her speciality. The appearance of *Eleanor's Victory* in *Once A Week*, while offering Braddon the opportunity to defend her work and, metaphorically, sit alongside such respectable figures as Harriet Martineau (something she could not literally do) also alerted her to the fact that the magazine market was an extensive one. Her editorship of *Belgravia* allowed her to fully exploit the lucrative niche she called 'the shilling public'.

7
Charles Reade's *Very Hard Cash* in *All The Year Round*

Reade's 'Matter-of-Fact' romance

The nineteenth-century cartoonist Frederick Waddy executed a series of portraits in *Once A Week* called 'Men of the Day'. One of these depicts the sensation novelist and playwright, Charles Reade, sitting astride an ink-dipped pen with wings which soars above a murky representation of 'every-day life' (see Plate 6). Reade holds up a banner carrying the word 'Imagination', while the titles of his works cascade around him. The caption reads 'Something Like A Novelist'. This triumphant image signifies Reade's reputation as a manly, vigorous writer whose works transcended the encroaching 'feminization' of novels of 'everyday life'.

According to most of his contemporaries, Reade was a writer who would stand with Dickens and Thackeray as one of the greatest nineteenth-century novelists. Margaret Oliphant, for example, considered him 'a writer to whom we are disposed to assign one of the highest places in his art'.[1] Waddy, in the review which accompanied his cartoon portrait of Reade, argued that George Eliot was indebted to Reade's novels, although she lacked his 'magic spell' of 'genius'.[2] A further sign of Reade's high status as a novelist is Dickens's anxiety to sign him up for a serial novel, writing to *All The Year Round*'s sub-editor, Wills, that Reade is 'the best man to be got for our purpose'.[3] Reade's reputation as a 'powerful romanticist' appeared unassailable during the mid-Victorian period, continuing until well into the twentieth century.[4] While the sensation novels of Braddon and Wood suggested a 'feminization' of middle-class sensation fiction, Reade's 'nervous, vigorous, and masculine' style, was perceived as making the sensation novel acceptable even to 'the scholar and the man of culture'.[5]

However, Reade's position as a major Victorian novelist has not stood the test of time. Apart from *The Cloister and the Hearth* (1859), his historical

novel set in fifteenth-century Europe based on the lives of the parents of Erasmus, few of his works have been reprinted during the late twentieth century. Indeed, despite critical acclaim, some of his novels faced a mixed reception with middle-class Victorian readers. Readers did not always respond favourably to Reade's novels when they appeared as serials in magazines. *The Cloister and the Hearth* did little for the newly established *Once A Week*, not even completing its serialization because of Reade's disputes with the editor,[6] while his sensation novel, *Very Hard Cash* (published in two volumes as *Hard Cash*), brought about a decline in *All The Year Round*'s sales, although the novel's reappearance in book form was received more favourably.[7] This chapter explores the reasons for *Very Hard Cash*'s failure as a magazine serial, despite its location in the congenial 'sensational' environment of *All The Year Round*. Reade's inability to produce the 'tantalizing portions' of narrative which magazine readers demanded indicates the special skills which novelists needed to produce a successful magazine serial. Dramatic failures afflicted some novelists, such as Reade, Bulwer-Lytton and Charles Lever, when they published serials in *All The Year Round* without understanding the specificities of magazine serialization. Reade's insensitivity to readers' needs, particularly his obsession with offering high doses of suspense and violence, highlights the dangers writers faced if they attempted to overstep the boundaries of middle-class literary sensationalism. By examining *Very Hard Cash*'s failure as a magazine serial in the light of its success when, significantly revised, it appeared as a book, we are presented with a useful benchmark with which to judge the limits of middle-class tastes for 'sensation'.

Very Hard Cash was serialized from March to December 1863 and published in volume form a few weeks before the final instalment appeared in *All The Year Round*. With this novel, Reade intended to present his readers with 'a matter-of-fact romance; that is, a fiction based on truths'.[8] The 'truth' on which it was based was the practice of self-interested relatives incarcerating sane men and women in lunatic asylums, aided by a corrupt medical profession. Reade's representation of this 'truth' prompted considerable controversy, leading to a widespread condemnation of the novel by the medical profession.[9] One proprietor of a lunatic asylum in Salisbury, Dr J.S. Bushnan, published a letter of protest in the *Daily News* which Reade reprinted, along with his own reply, in his introduction to the first edition of *Hard Cash*. Bushnan had followed the novel's progress in *All The Year Round* and objected to Reade sensationalizing the laws concerning the confinement of lunatics. He made it clear that his protest was not an objection to the sensation novel itself; indeed,

he believed that the public's taste for novels like *Lady Audley's Secret*, where the 'heroine push[es] a superfluous husband into a well', was harmless. Bushnan draws the line, however, at Reade's particular brand of 'sensation', designed to send 'a thrill of terror [...] through the public mind', by suggesting that corruption lurks within the very fabric of British society.[10]

The novel's magazine context, where its instalments appeared alongside authoritative articles based on fact, seemed to Bushnan to be an exacerbation of Reade's dangerous message to a public ignorant of the law. Bushnan vociferously denies that corrupt officials deprive sane men and women of their freedom, going on to accuse Reade of 'offences against decency, good taste, and truth'.[11] Reade's defence (which, like Bushnan's letter, made its first appearance in the pages of the *Daily News*) is based on his own experience of sheltering for twelve months a sane man who had escaped from a lunatic asylum. Reade also cites his extensive research into the subject, giving specific examples of men and women who had suffered false confinement as lunatics.

The controversy surrounding *Very Hard Cash* also caused considerable unease among the staff of *All The Year Round*. Dickens, whose friend John Forster was a Commissioner in Lunacy, was embarrassed by Reade's wholesale condemnation of officials presiding over cases of false confinement. This led Dickens to add a footnote (in capital letters for emphasis) to the instalment of *Very Hard Cash* which appeared on 14 November, where he distances himself from Reade's opinions:

THE CONDUCTOR OF THIS JOURNAL DESIRES TO TAKE THE OPPORTUNITY OF EXPRESSING HIS PERSONAL BELIEF THAT NO PUBLIC SERVANTS DO THEIR DUTY WITH GREATER ABILITY, HUMANITY, AND INDEPENDENCE, THAN THE COMMISSIONERS IN LUNACY.[12]

This statement was followed by an even larger announcement in the magazine (again in capitals), signed by Dickens himself, placed immediately after the final instalment of Reade's serial, insisting that the 'Conductor', while taking responsibility for all of the articles, short stories and poems published, refused to take responsibility for the work of serial novelists.[13]

Because of its controversial subject, *Very Hard Cash* did not meet with widespread critical approval. A reviewer in *The Times*, for example, stated that 'Eccentric fact makes improbable fiction'.[14] Reade, however, fiercely denied that his novel was 'improbable', and in his Preface he cites his use

of 'pamphlets, journals, reports, blue-books, manuscript narratives, letters, and living people'.[15] Out of these miscellaneous sources of 'truth', Reade claims to retrieve the 'facts' which bind his narrative into a 'realistic' whole.

The problems of perpetual suspense

Despite Reade's claims, his serial novel failed to interest *All The Year Round*'s readers, for sales dropped steadily during its run. John Sutherland maintains that the novel 'shocked, alarmed, and eventually turned away readers' because Reade's descriptions of the conditions in asylums were too 'repulsive'.[16] As we have seen in Chapter 4, however, *All The Year Round*'s readers were not particularly squeamish and clearly enjoyed stories with violent scenes, yet Reade's perpetual use of violence, coupled with a serious generic instability in the novel, indicates his lack of sensitivity about the careful balancing act needed to produce a successful magazine serial.

Reade's position within Victorian literary culture is a difficult one to assess, for he consciously distanced himself from many of the literary strategies pursued by his contemporaries. The problem with *Very Hard Cash* was its failure to conform to either the codes of realism or sensationalism, both of which Reade maintained informed his work. While he intended to base his narrative on 'facts', his mixed generic approach failed to offer readers any sort of stability. A certain amount of mixing of genres was, of course, acceptable to readers; but Reade's alarming vacillation between a wide range of genres in one novel was not satisfying to a magazine readership. *Very Hard Cash* offers a courtship/marriage plot, a nautical adventure tale (complete with pirates and shipwrecks), a sensation plot based on forgery and secrets, the violent excess of anxiety fiction, and the current popular taste for athleticism (in the style of Charles Kingsley); added to these is a strong 'social problem' theme in the discussions of conditions in lunatic asylums. All of this in one serial may have been too rich a mixture for readers to take. As Richard Stang has said:

> Reade thought of the novel as a vehicle for exposé, and his own novels, aside from the reforming sections, usually consisted of a mélange of the most conventional material from Adelphi melodrama: stagy villains foiled at the last moment, hidden wills suddenly found, exciting encounters with pirate ships, and hair-breadth escapes. His formula was to crowd as much exciting incident as possible into one story so that his reader would be in a perpetual state of suspense.[17]

The keyword here is 'perpetual'. Reade offers his readers few respites in a narrative which depends upon a relentless sequence of disasters.

A good example of how his plots work occurs in *Very Hard Cash*, as a brief outline illustrates. The initial chapters detail the growing love between the athletic Oxford undergraduate, Alfred Hardie, and the sheltered middle-class Julia Dodd. Their plans to marry are mysteriously thwarted by Alfred's father, the wealthy banker, Richard Hardie. Once this situation is introduced, the reader is abruptly transported to the Far East to follow the fortunes of Julia's father, Captain Dodd, who is about to sail home with the fortune (in cash; Dodd suffers from a fatal mistrust of foreign banks, while possessing a blind faith in the safety of British banks) he has managed to build up for his children. Dodd's ship meets with an unbroken series of disasters, including storms and pirate attacks. Wounded after fighting pirates, Dodd finds his money stolen by a treacherous Indian servant, but eventually recovered by a loyal African servant. No sooner is it recovered than it is lost overboard in a storm, only to be found later floating in a bottle in the sea. Dodd reaches Europe (after encountering yet another life-threatening storm which finally wrecks the ship) with his money miraculously intact. On shore, he is immediately attacked by French robbers. He fights them and manages to save the money, only to lose it again when he returns to England and deposits it in Richard Hardie's bank, which, unknown to Dodd, is on the point of collapse. The unscrupulous Hardie steals the money and Dodd goes mad.

Reade's depiction of the series of dangers which beset Captain Dodd and his money leaves readers exhausted with suspense. A similar exhaustion is induced in the novel's other plot, where Alfred, confined against his will as a lunatic by his father (who has stolen his inheritance), makes numerous attempts to escape, all of them thwarted until his final escape when the asylum is set on fire. The escape–capture formula continues for many chapters, along with Alfred's hopeless attempts to convince numerous visiting officials of his sanity. Reade forces his readers into an almost constant state of suspense with no respite until the novel ends. This formula was not adopted by other sensation novelists who rightly assumed that continual suspense would frustrate readers rather than offer pleasure. While authors like Collins and Braddon understood the importance of suspense, they were also aware of the need for respite and the provision of a sense of progression, as well as tempering the shocks and thrills with moments of calm. Reade's approach to serialization was based on a narrative excess which alienated rather than satisfied *All The Year Round*'s readers.

The failure of *Very Hard Cash* in serial form was owing to Reade's lack of understanding about what the middle-class reader wanted from serial fiction. In *Very Hard Cash* he interrupts his story to address his readers directly:

> No life was ever yet a play: I mean an unbroken sequence of dramatic incidents. Calms will come: unfortunately for the readers, happily for the read. And I remember seeing it objected to novelists, by a young gentleman just putting his foot for the first time into 'Criticism', that the writers aforesaid suppress the small intermediate matters which in real life come by the score between each brilliant event, and so present the ordinary and extraordinary parts of life in false proportions. [...] The truth is, that epics, dramas, novels, histories, chronicles, reports of trials at law, in a word, all narratives [...] abridge the uninteresting facts as nature never did, and dwell as nature never did on the interesting ones.[18]

Here, Reade attempts to justify his approach to novel writing, but fails to see that his disproportionate focus on 'brilliant events' and the 'extraordinary parts of life' was not a popular strategy to pursue. The plot of *Very Hard Cash*, based on the physical torments of Captain Dodd at sea, and the physical and mental torments of Alfred in the lunatic asylums, is unrelieved by any 'small intermediate matters' which novel readers so enjoyed, even in sensation novels. Reade's preference for unremittingly exciting narratives blinded him to the tastes of most middle-class magazine readers.

To such readers, Reade was giving them short measures of narrative pleasure by excluding the banal, tea-table details which helped provide relief, as well as context, to the sensational events. Reade even goes so far as to admit to his readers that he is not going to bother with scenes of domestic realism, interrupting the narrative to add:

> Can nothing, however, be done to restore, in the reader's judgment, that just balance of 'the sensational' and 'the soporific' which all writers, that have readers, disturb? [...] I throw myself on the intelligence of my readers; and ask them to realize, that henceforth pages are no measure of time [...]. (II, 229)

In other words, readers must fill in for themselves those 'soporific' moments which separate 'the sensational' events. By throwing the burden of 'balance' onto the reader, Reade hopes to justify his emphasis on a

comprehensive and unremitting series of violent and disturbing events, presuming that readers will imagine, without the benefit of authorial guidance, the gaps which the narrative fails to cover. Judging by the declining sales of *All The Year Round* during *Very Hard Cash*'s serialization, Reade was unable to fob his readers off with pure sensation unrelieved by representations of 'soporific' domesticity.

This misunderstanding about the sensation novel, where Reade presumed that the genre was utterly devoid of domestic scenes, was not limited to novelists. H.L. Mansel in the *Quarterly Review* considered contemporary fiction to belong either to 'novels of the warming-pan' or 'of the galvanic-battery type'.[19] According to Mansel, domestic realist novels work on the 'warming-pan' system, while the sensation novel sends 'galvanic-battery' shocks into the reader. This analysis fails, however, to take into account the importance of sensational elements in domestic novels, as well as the debt sensation novelists owed to domestic realism.[20] Henry James, on the other hand, in his review of Braddon's novels, was aware of the importance of maintaining a sense of 'intense probability' in sensation novels. *Lady Audley's Secret*'s provision of a necessary verisimilitude depends on Braddon's depiction of the minutiae of everyday life, such as Lady Audley's 'dresses, her bedroom furniture, her little words and deeds'.[21] Other successful sensation novelists such as Collins and Wood also interwove such 'little' details into their sensational plots. Reade, however, despised this strategy. Even his most popular novel, *The Cloister and the Hearth*, was considered by some Victorian critics to be too fast-moving for comfort. One reviewer in the *Saturday Review* complained of an 'abundance of mere adventure, of chases with bloodhounds, of fighting of all kinds'.[22] Readers of Reade's novels in book form, however, were better placed to tolerate such excess, having the power to quicken their pace of reading in order to lessen the suspense, unlike readers of the serial, who found Reade's refusal to delineate moments of calm a source of irritation. To focus exclusively on violence, conflict, and conspiracy denied serial readers the slow build up of mystery and suspense which they expected from the instalments of a sensation novel.

Ellen Miller Casey has discussed the unbalanced nature of Reade's novels, but she argues that 'Reade makes us aware [...] that lack of balance need not destroy a novel, and that sensationalism and suspense are lesser crimes for an author than dullness and stupidity'.[23] However, the continous decline in *All The Year Round*'s sales during *Very Hard Cash*'s run suggests otherwise. For an author to succeed as a serialist he needed to 'balance' the sensation and suspense with the 'dull' (but necessary) details

of ordinary domestic life. As editor of *All The Year Round*, Dickens must have been aware that *Very Hard Cash*'s failure was owing to its unrelieved suspense along with a tendency to ramble on week after week with little sign of progress. *All The Year Round*'s usual policy of intertextuality had had to be abandoned, as Reade's serial swung alarmingly (and often incoherently) between pirates and madhouses. Dickens, in a desperate attempt to offer his magazine's readers some relief from *Very Hard Cash*, published Gaskell's short story, 'The Cage at Cranford' on 28 November 1863, at a point when Reade's serial looked as though it would never end. The charms of Miss Matty and the spinster community of Cranford, along with Gaskell's gently comic domestic scenes, were not in the usual *All The Year Round* style (*Cranford* had originally appeared as a serial in the less 'sensational' *Household Words*). However, the ceaseless 'galvanic-battery' shocks Reade was inflicting on readers needed to be offset by a cool 'warming-pan', which is perhaps why Dickens, for once, presented this odd juxtapositioning of disparate fiction in his magazine.

Reade's excesses as a novelist were not limited to his use of unremitting suspense. As one irritated reviewer of *The Cloister and the Hearth* complained, Reade takes 'a childish pleasure in the liberties of the press. When one of the personages of the story shouts, his words are expressed in gigantic capital letters; and when another whispers, the typography shrinks together with the volume of sound.'[24] A similar strategy is pursued in *Very Hard Cash*, where Reade introduces a number of visual variations to his text. Readers of *All The Year Round* were used to a certain amount of textual variation in the magazine, which no doubt helped to diversify the drab, unillustrated format. Collins, for example, introduced this device in his serial, *The Woman in White*, with the use of Gothic print and capital letters of various sizes to represent the text on Laura's gravestone. Reade, however, overused this device, often making digressions in the narrative simply to include a textual anomaly. For example, in the 16 May instalment, he presents two columns of dialogue which run simultaneously within one column of text, followed by the printing of the ballad 'Aileen Aroon'. The coupling of the rows of dialogue is meant to represent two conversations taking place at the same time, while the printing of the ballad in full does not serve the plot, but allows Reade an opportunity to vent his irritation on the 'adulteration' of 'a simple eloquent Irish song', attempting to persuade readers of the superiority of the original version. In another instalment, Reade prints the musical notation of a sailors' ditty (presumably to enable the reader to join in the song). A similar (though more relevant) disruption to *All The Year Round*'s format occurs in the 11 July issue, when an image of the handwritten receipt for £14 000 given

to Captain Dodd by Richard Hardie is illustrated. The same image reappears, looking dirty and crumpled, later in the serial.

Reade bombarded readers with text in bold type, reduced print, poetry, musical notations, extra columns, and other variations (see Plate 7). As with his policy of continual suspense, such unnecessary visual anomalies may have alienated readers. However, the most significant text variations to appear during *Very Hard Cash*'s serialization were the intrusion of Dickens' footnotes, where in one he disrupts one instalment by publicly distancing himself from the opinions articulated in Reade's novel, while the other asserts his confidence in the efficiency of the Lunacy Commissioners. As if to beat Reade at his own text-variation game, Dickens insisted that his statements appeared '*in rather larger type* than usual'.[25]

From magazine serial to book: Reade's revisions

Reade's novel failed as a serial, but because of his reputation as a controversial novelist who tackled social abuses he found a more responsive set of readers for the book. One factor which may have made *Hard Cash* more acceptable to later readers was the fact that Reade extensively revised his serial for volume publication. The main alterations are to the division and reordering of chapters. The serial has 58 chapters while the book has 54. Reade condensed the novel's opening chapters, so what appeared as eight chapters in the serial, each forming an individual instalment, became the first four chapters of the book. The serial's eight opening instalments barely move the plot forward, outlining details of a university boat race and extended descriptions of the hero and heroine. The novel's main themes, Alfred's incarceration in the asylum, Captain Dodd's perilous sea journey and subsequent insanity, and Mr Hardie's treachery, have not even been hinted at, a dilatoriness which lasted for nearly the first two months of serialization. This lukewarm beginning may have been one reason for the unpopularity of *Very Hard Cash*. The two-volume novel, on the other hand, with its greatly condensed opening, brings Reade's main themes to the reader's attention more swiftly.

Reade made other changes to his novel in the light of his different perceptions of *All The Year Round*'s readers and the buyers of books and subscribers to circulating libraries. He presumed that *All The Year Round*'s readers, fed on a diet of sensational serials, required continual suspense and shocks from week to week. After the initial sluggishness of his serial novel's opening instalments, Reade's narrative moved at a breakneck speed, where a week didn't go by without depictions of violent action and

complicated conspiracies. Reade's lack of a sense of proportion meant that he completely failed to take into account the subtleties which successful serialists knew were needed to balance the suspense and shocks with a qualifying proportion of 'soporific' realism. This point is illuminated by an examination of Reade's methods of generating suspense.

In *Very Hard Cash*, Reade closes the 29 August instalment with the scene where Julia Dodd, abandoned by Alfred on their wedding day, is escorted out of church weeping, asking her mother to hide her shame. The readers of the serial did not know at this stage why Alfred had not turned up for the wedding. The following instalment continues to leave readers in suspense about Alfred's whereabouts, outlining instead Edward Dodd's and Dr Sampson's failure to find him, and their investigation into the disappearance of Captain Dodd's money. *All The Year Round*'s readers were kept in further suspense the following week, when the private detective, Green, takes over the investigation to find the missing money. This instalment also details Julia's illness following Alfred's desertion, and a fatal attack by a madman on Alfred's sister. It was only in the 19 September instalment that readers of the serial discovered that Alfred had been lured into a lunatic asylum and confined against his will.

Reade assumed that the generation of suspense was a vital aspect of a serial, but less important in the book, where readers, if bored, might be tempted to skip sections of the narrative in order to get to the next exciting part. In *Hard Cash*, Reade reorders his chapters so that the episode describing Julia's desertion at the altar is immediately followed by the chapter revealing Alfred's imprisonment in the asylum. While the serial forces readers to wait during three intervening instalments which serve only to defer the vital information about Alfred's whereabouts, the book reveals the solution to the mystery in the next chapter. Reade ends his first volume here. If he had considered suspense necessary to readers of the book, he could have ended the first volume with Julia's desertion at the altar. This would have forced library readers to wait for the next volume before they found out why the heroine had been jilted. Instead, the volume ends with details of Alfred's imprisonment. Clearly, Reade came to the realization that keeping readers on perpetual tenterhooks was a bad policy, and this revision of his narrative offers an important clue as to why *Hard Cash* was more favourably received than *Very Hard Cash*.

Another significant change which Reade made when preparing his novel for volume publication was to excise a long paragraph which describes a fight between Alfred and a warder who is about to drug him. This is the paragraph which *All The Year Round* readers read in the 3 October instalment of the serial:

Cooper then sprang furiously on Alfred, and went kneeling up and down on him. Cooper was a heavy man, and his weight crushed and hurt the victim's legs; but that was a trifle; as often as he kneeled on Alfred's chest, the crushed one's whole framework seemed giving way, and he could scarcely breathe. *Cooper warmed to his work, and kneeled hard on Alfred's face. Then Cooper drew back and jumped savagely on his chest. Then Alfred felt his last hour was come: he writhed aside, and Cooper missed him this time and overbalanced himself; the two faces came together for a moment, and Alfred, fighting for his life, caught Cooper with his teeth by the middle of the nose, and bit clean through the cartilage with a shrill snarl. Then Cooper shrieked and writhed, and whirled his great arms like a windmill, punching at Alfred's head. Now man is an animal at bottom, and a wild animal at the very bottom. Alfred ground his teeth together in bull-dog silence till they quite met, and with his strong young neck and his despair shook the great hulking fellow as a terrier shakes a cat, still grinding his teeth together in bull-dog silence. The men struck him, and shook him in vain. At last, they got hold of his throat and choked him, and so parted the furious creatures: but not before Mrs Archbold and nurses Jane and Hannah had rushed into the room, drawn by Cooper's cries. The first thing the newcomers did was to scream in unison at the sight that met them. On the bed lay Alfred all but insensible, his linen and his pale face spotted with his persecutor's blood. Upon him kneeled the gory ruffian swearing oaths to set the hair on end.*[26]

In the later version of the novel, the section between each asterisk was deleted. Reade may have considered this passage too strongly sensational for the self-styled guardians of public morals in control of the circulating libraries, fearing that they would not allow such material on their shelves.

There is another possibility as to why Reade removed this passage from the volume text. He may have believed he was defeating his purpose in representing his young hero engaged in the behaviour of a 'wild animal'. The fear of degeneration, particularly the fear of reversion to animal form, as I indicated in Chapter 4, was raised in many forms in *All The Year Round* during the early 1860s. In *Very Hard Cash*, Alfred Hardie was intended to represent the sane, civilized gentleman, his athleticism proof of his genetic fitness. His health, intelligence, and strength underlined the horror of his father's conspiracy to confine him as a lunatic. Yet Alfred's frequent recourse to violence tends to undermine Reade's argument. In a later section of the novel he describes the 'bestial' behaviour of people who are actually mad:

[Alfred] was conducted by Hayes and Rooke through passage after passage, and door after door, to a wing of the building connected with the main part only by a covered way. As they neared it, strange noises became audible. Faint at first, they got louder and louder. Singing, roaring, howling like wolves. Alfred's flesh began to creep. [...] Here he was surrounded by the desperate order of maniacs he at present scarcely knew but by report. Throughout that awful night he could never close his eyes for the horrible, unearthly sounds that assailed him. Singing, swearing, howling like wild beasts. (X, 267)

Reade's representation of the insane as 'wild beasts' is not far removed from his earlier statement that 'man is an animal [...] a wild animal', which he offers as explanation for Alfred's violence. *Very Hard Cash*, like the anxiety story, attempts to erect a barrier between sanity and insanity, humanity and animality, without being able to successfully maintain this distinction. Reade suggests that 'degenerates' need to be separated from the 'healthy' community, yet it is the respectable, sane Oxford under-graduate who bites and shakes a man 'as a terrier shakes a cat'. Unwittingly, Reade suggests that the barriers between insanity and sanity, the human and the animal, are easily transgressed. This idea militates against the anxiety story (a genre which it is likely Reade encountered in *All The Year Round*) which insists that degeneracy is a recognizable physical trait, marking out the 'unfit' as people who should be eradicated for the good of the community. The implication in *Very Hard Cash* is that sane, civilized people carry within them the 'wild animal' heritage which they so fear. In revising the novel for volume publication, Reade was no doubt wary of emphasizing this point and had the contentious passage removed.

Although much of the violence in Reade's serial is associated with insanity, Reade also depicts violence in other contexts. Indeed, his reputation as a 'manly' novelist was based on this propensity to focus on scenes of action and violence. Reade's previous novels, *It's Never Too Late to Mend* (which depicts the torture of prisoners in British prisons) and *The Cloister and the Hearth* (which outlines many instances of violent conflict among soldiers, robbers, and corrupt officials) all testify to this preoccupation. In *Very Hard Cash* violence is an integral part of the pirate attack on Captain Dodd's ship, and Reade lingers on every bloodthirsty detail: the pirates 'raged and brandished their knives' (IX, 341). When Dodd's ship wrecks that of the pirates, their 'wild forms [...] were hacked to pieces', leaving in the sea 'a cluster of wild heads and staring eyeballs bobbing like corks' (IX, 345). Once back in Europe, Dodd is again attacked.

He defends himself by throwing a rock at one assailant, 'Thibout's face crashed; his blood squirted all round the stone', while another is crushed in Dodd's arms, his 'temples bursting, throat relaxed, eyes protruding, and livid tongue lolling down to his chin' (IX, 438). Violence encroaches into the English village scenes when a creditor, driven mad by the collapse of Hardie's bank, attacks Hardie's daughter, Jane, beating her to death in the street. Reade's representation of violence verges on the obsessive and *All The Year Round*'s middle-class readers may have found his repetitive emphasis offensive.

The focus on violence aligns Reade's serial with both *Great Expectations* and the anxiety story. However, Dickens balances the themes of violence, degeneracy, and criminality with a variety of other themes. *Very Hard Cash* fails to provide a similar balance. It seems likely that magazine readers could accept a one-off story which focused exclusively on the fearful topics of degeneracy and violence, but failed to respond to a novel which attempted to provide this every week for nine months. The failure of *Very Hard Cash* as a serial indicates two things about the magazine context of 1860s sensation novels: first, that too much suspense in the form of perpetual shocks and thrills did not offer the necessary narrative pleasure over the weeks and months of serialization; and second, for sensationalism to be acceptable to a middle-class readership it needed to be tempered by the inclusion of a domestic realist plot. The 'galvanic-battery' of the sensation plot needed to be alternated with 'soporific' moments. The next chapter continues to explore the issues surrounding the relationship between sensation fiction and domestic realism by examining *Armadale*, arguably Collins's most sensational novel, which appeared as a serial in *The Cornhill*, a magazine usually devoted to the serialization of middle-class domestic novels.

8

Wilkie Collins's *Armadale* in *The Cornhill Magazine*

Generic collisions in *The Cornhill*

In *The Maniac in the Cellar*, Winifred Hughes has argued that the 'primitive, troublesome vision' of the sensation novel 'collided sharply with that of the reigning domestic novel', going on to state that a gulf existed between the 'tame fare' of novels by Eliot, Gaskell, and Trollope, and the sensation novels of Collins, Braddon, and Wood.[1] This divide, however, was not always as sharp as Hughes suggests. Sensation novels and their domestic realist counterparts existed within Victorian culture at different points along a continuum, rather than as unrelated or opposite forms. The resemblances between the two genres frequently failed to register with Victorian reviewers, who condemned sensation fiction for its reliance on lowbrow forms, such as melodrama, while remaining blind to the fact that many domestic novelists also drew in various ways upon the melodramatic tradition.[2] Between 1864 and 1866, readers of *The Cornhill Magazine* were offered an unusual opportunity to compare the two dominant literary genres of the period when Collins's sensation novel, *Armadale*, was serialized alongside domestic novels by Elizabeth Gaskell and Anthony Trollope.

The Cornhill was an upmarket monthly magazine which from its inception had presented two serial novels in each issue. *Armadale*, described by one reviewer as 'a lurid labyrinth of improbabilities',[3] ran for over a year alongside Gaskell's *Wives and Daughters*, and when Gaskell's novel ended, Trollope's *The Claverings* took over as *Armadale*'s accompanying serial.[4] Collins's sensation novel and its domestic companions share numerous themes, such as the problems surrounding courtship and marriage (particularly the transmission of property through marriage), and the social and economic position of women, explored in all

three novels by means of dual heroines, one well behaved, the other more defiant of social constraints. Each novel represented middle-class domestic life in terms of its boundaries, tensions, and ideals. Their appearance in the same literary space is highly unusual, for family magazines which carried serialized novels tended to specialize in a particular genre.[5]

During the early 1860s *The Cornhill* specialized in domestic realism, largely rejecting the sensation fiction which dominated many other magazines of the period. For example, when readers of the *New Monthly Magazine* were presented with *East Lynne* in 1860, *The Cornhill* was serializing Anthony Trollope's *Framley Parsonage*, where a clergyman's problem with debt is the closest the novel comes to a sensational plot. Trollope's *The Small House at Allington*, George Eliot's *Romola*, and *Cousin Phillis*, by Elizabeth Gaskell were characteristic of *The Cornhill's* fiction. However, this emphasis on domestic fiction was twice disrupted; firstly by Frederick Greenwood's bigamy novella, *Margaret Denzil's History*, serialized from 1863 to 1864, and secondly by Collins's more spectacular sensation story, *Armadale*, a novel vividly focused upon the career of a female forger and murderess. Lydia Gwilt's plots for self-advancement were used by Collins to link the world of criminality to the respectable world of the landed gentry. By contrast, the accompanying serials by Gaskell and Trollope represent a relatively calm version of respectable society disrupted only by the trials and tribulations attendant on the finding of suitable marriage partners for (temporarily) wayward sons and daughters. These more obvious differences, however, mask the underlying similarities between the two genres, similarities which will be explored further in this chapter.

The juxtaposition of *Armadale* alongside *Wives and Daughters* and *The Claverings* was accidental in the sense that Collins submitted the manuscript of his novel to George Smith, *The Cornhill's* owner, much later than he had planned. The contract for the serial had been signed shortly after Collins's success with *The Woman in White*, when his reputation as a controversial novelist had not yet developed. As a novel written specifically for *The Cornhill*, *Armadale* appears particularly provocative, as though Collins had set out to challenge the magazine's comfortable, educated readership. He clearly felt called upon to assert the power of the new sensationalism by offering those readers who favoured domestic fiction a sample of an 'alternative' genre. Collins also set out to challenge the nineteenth-century realist tradition, as his Preface to the subsequent volume edition of *Armadale* indicates. He may have had *The Cornhill's* readers in mind, along with hostile critics, when he wrote that

some readers may be 'disturbed' – perhaps even offended – by finding that "Armadale" oversteps, in more than one direction, the narrow limits within which they are disposed to restrict the development of modern fiction'.[6] This provocative statement is undoubtedly a covert reference to *Armadale*'s companions in *The Cornhill*: *Wives and Daughters* and *The Claverings* were both well received by critics, and both within Collins's definition of the 'narrow limits' of domestic realism.

The Cornhill's overlapping of one sensation novel with two domestic novels complicates any investigation we may make into their original receptions. Without a knowledge of their magazine contexts, one may assume that all three novels first appeared as separate books intended for two distinct audiences: that Trollope's and Gaskell's readers would not be attracted to a sensation novel by Collins. Yet their close proximity in the same journal opens up a number of (unanswerable) questions: did most readers follow both serials, or choose to follow one? Were readers aware of the similarities between *Armadale* and its companion novels, or did they, like the reviewers, focus on their differences? Did readers find ways of negotiating around the overlaps and gaps between the two genres, enjoying both forms? While we lack the means of answering such questions, we can explore the issues they raise by examining *The Cornhill*'s development during the period from 1864 to 1867 when the three novels appeared. The 'accidental' proximity of Collins's, Gaskell's, and Trollope's serials offers an opportunity to explore two genres side by side in a way which is not an artificial juxtaposition brought about by critical curiosity (or expediency) but in a way which was available to the 'ordinary' reader of the time.

None of the three novels was privileged in editorial terms.[7] Each serial had its turn as *The Cornhill*'s leading item during the first part of its run, until the next serial was introduced and placed first. Thus *Wives and Daughters* enjoyed first place until *Armadale* came in and Gaskell's novel was relegated to forth or fifth position in the magazine. When *The Claverings* began serialization, *Armadale* suffered the same 'demotion' as *Wives and Daughters*. This was *The Cornhill*'s usual policy during the 1860s, the only exception was when George Eliot, the most prestigious new novelist of the period, serialized *Romola*, which kept its position as first item throughout its serialization.[8] The juxtapositioning of Collins's, Gaskell's and Trollope's novels indicates interesting thematic and formal overlaps, and in this chapter I will explore these across all three novels. The major similarity is the employment of dual heroines who highlight the disruptive forces of secrets on family life. Each writer adopted genre-specific narrative strategies to represent this disruption, offering an

indication of how the boundaries between sensation fiction and domestic realism could be unstable, prompting questions about the assertions of reviewers who claimed clear-cut distinctions between the two genres. This chapter also addresses the ways in which domestic novelists sought to disguise, or soften, the sensational aspects of their work.

Realism and sensationalism

Critical receptions of the three *Cornhill* novels indicate the contemporary sense of an unbridgeable gulf between domestic fiction and sensation fiction which characterized expectations of both genres. Victorian reviewers of *Wives and Daughters* and *The Claverings* insisted that both were refreshingly free of the taint of sensationalism. H.F. Chorley, writing in the *Athenaeum*, hinted that *Armadale*'s proximity to Gaskell's novel in *The Cornhill* had not 'infected' her serial with any generic virus. In a review of *Wives and Daughters* he argued that Gaskell's novel:

> constrained many to take up the periodical in which the quiet tale month by month unwound itself, – in contrast with fictitious matter to all appearance far more artful, and certainly in regard to spicery of incident, far more 'sensational' (as the word runs).[9]

Sensation novelists, on the other hand, were considered incapable of representing reality. Chorley was one of the first reviewers of *Armadale*, and he described it as 'a "sensation novel" with a vengeance', an extreme example of an 'ugly' literary trend:

> We are in a period of diseased invention, and the coming phase of it may be palsy. Mr Collins belongs to the class of professing satirists who are eager to lay bare the 'blotches and blains' which fester beneath the skin and taint the blood of humanity.[10]

Similarly, a reviewer in the *Saturday Review* considered *Armadale* to be 'a literary nightmare', making readers 'uncomfortable without letting them know why.'[11] This sense of discomfort, however, appeared to form no part of the experience of reading *Wives and Daughters* or *The Claverings*, both viewed as *anti*-sensational. One reviewer of Gaskell's novel asked, 'What is there out of the usual run of things? [...] Excitement, passion, intensity there is not: as to "sensation", there is not the faintest shadow of its existence.'[12] Trollope's serial elicited similar responses from critics, one of which refers to his ability to present a

'pleasant' story, in contrast to the 'discordant', 'uncomfortable' experience
of reading a sensation novel:

> [Trollope] has a wonderful faith in respectability, and he would think
> ill of himself if he should write anything to make one suppose that
> iniquity is ever triumphant. This may be another reason why his stories
> are so pleasant.[13]

The crux of reviewers' disapproval of *Armadale*, however, was Collins's
depiction of Lydia Gwilt, a 'creature' who, they argued, was a product of a
diseased imagination and could not possibly be a reflection of reality.
Reviewers were vociferous in their condemnation of Collin's villainess:
she was 'one of the most hardened female villains whose devices and
desires have ever blackened fiction.'[14] A 'waxwork figure displayed from
time to time in every conceivable sort of garish light.'[15] A theatrical
'monstrosity' who bears no relation to English life.[16] Indeed, it was Lydia's
English birth which led many critics to view her as an improbable
character. The Polish spy, Sophie Gordeloup, in *The Claverings*, is
represented by Trollope as a devious plotter prone to overblown language,
theatrical gestures, and violence, yet one reviewer exclaimed she was 'a
masterpiece [...] true to life and to human nature.'[17] Lydia, as an
Englishwoman, is an 'impossibility'; Sophie (a much less fully drawn
character), as a Pole, is 'true to life'.

Neither the 'true to life' *Wives and Daughters* nor *The Claverings*
represent the dark and dangerous aspects of existence which so
preoccupied Collins. He probed the underside of respectable domesticity,
laying bare its corruptions and areas of vulnerability, incorporating the
melodramatic in order to generate an emotional engagement in his
narrative. Sally Mitchell has argued that popular fiction is specifically
designed to cater to readers' daydreams, where 'forbidden feelings can be
pleasurably experienced.'[18] Realism, on the other hand, addresses readers'
fantasies in a rather more limited way. The realist novel, Mitchell argues,
'even when it exposes social injustice, is generally a novel of compromise,
with a solution that is necessarily conservative; existing society remains
unchanged.'[19] Although sensation novelists usually provided conserva-
tive solutions at the ends of their novels, their complex depictions of
subversive possibilities are prominently placed for most of the narrative,
suggesting alternatives without necessarily endorsing them. Realist
novelists, on the other hand, maintained that they both educated and
entertained readers by means of pictures of 'reality', namely stories of
middle-class domestic life. In his autobiography, Trollope insisted that

however much a writer wished to teach moral duty, his 'first necessity [is] to make himself pleasant.'[20] Reviewers considered his and Gaskell's domestic novels to be both 'pleasant' and accurate reflections of reality, while Collins's sensation novel, conversely, was neither pleasant nor accurate.

Dual heroines

Armadale's 'unpleasantness' permeates a complex plot which revolves around the lives of two Allan Armadales, one a social outcast who chooses to call himself Ozias Midwinter, the other a genial young fellow who inherits a country estate called Thorpe-Ambrose. Before their birth, Midwinter's father (also called Allan Armadale) had murdered the genial Armadale's father, sexual jealousy being the motive for this crime. When Midwinter learns of his father's crime, he becomes possessed of a strong feeling that Fate will bring about a repetition of this evil action in the next generation of Armadales. The agent of evil, however, turns out to be Lydia Gwilt, Allan's mother's former maid, a forger, blackmailer, and murderess who has been in prison for theft. Her plot to murder the wealthy Allan Armadale shocked and outraged reviewers. Collins contrasts the worldly Lydia, a red-haired siren in her thirties, with Neelie Milroy, the sixteen-year-old heroine who eventually marries Allan. This long and complicated novel has a narrative based on timeshifts, flashbacks, dreams, letters, and diaries, interspersed with a third person omniscient narrative.

While *Armadale* ranges over time from the 1830s to the 1860s and shifts over a wide geographical area (Germany, the West Indies, Italy, London, the Isle of Man, East Anglia, and Devon), Gaskell's *Wives and Daughters* is set in a provincial English town in the early years of the nineteenth century. *Wives and Daughters* follows the development from childhood to young womanhood of Molly, the only child of a widower, Dr Gibson. The story concerns her relationship with her new stepmother and stepsister, Cynthia, and Gaskell's plot is woven around the contrasting heroines, the virtuous Molly and the flighty Cynthia. Similarly Trollope's *The Claverings* also features a beautiful erring heroine and a more sober, well-behaved counterpart. The former, Julia Brabazon, rejects Harry Clavering because he is poor, marrying instead the rich but debauched Lord Ongar. Julia, returning to London a rich widow, is socially ostracized for 'selling herself' for a title and wealth. Harry, now engaged to Florence Burton, the stay-at-home daughter of an engineer, is unable to resist the newly widowed Julia's charms. Again, the main focus of the narrative is the contrast between the beautiful and worldly Julia and the staid middle-class Florence.

As these summaries make clear, all three novels focus on dual heroines: the badly behaved Lydia is offset by the sheltered Neelie; the wayward Cynthia is contrasted with the virtuous Molly; and the dangerous charms of Julia Brabazon are presented alongside the homely figure of Florence Burton.[21] The novels also depict characters who vacillate over the choice of a marriage partner: Allan Armadale briefly rejects Neelie in favour of Lydia; Harry Clavering cannot make up his mind between Julia and Florence; and Roger Hamley's heart is broken by Cynthia before it is mended by Molly, while Cynthia herself picks up then drops numerous fiancés. The problems of choosing a partner are attended in each novel by secrets and intrigue: the smooth running of domestic life is shattered by each love complication, only to be restored by the marriage, retirement, or death of the erring heroine.

The erring heroines are all characterized by a lack of 'Englishness'. In each of the three *Cornhill* serials, the well behaved English heroines, Molly, Neelie, and Florence, are firmly rooted in provincial towns and villages, protected by their families, and never travelling further than the next town, or a journey to the seaside. The 'flawed' heroines, on the other hand, are all English, yet have unorthodox family lives and dangerous associations with foreign countries. Cynthia appears to have learnt deceit and coquetry at her French school. Julia, brought up in Nice by her father, spends her married life with Lord Ongar in Florence, where she witnesses his debauchery. Lydia, like Cynthia, attends a French boarding school, and later lives a wandering life in Europe. As a child, she committed her first crime in Madeira. Even Allan's mother's otherwise blameless life is tainted by her deceit when she lives in the Canary Islands, although her return to rural Devon is marked by a selfless devotion to her son. A sojourn in a foreign country – readers of *The Cornhill* would be forgiven for thinking – was potentially damaging to the moral development of English girls.

However disapproving readers may have been of the more cosmopolitan heroines, this did not mean that there was a widespread interest in the lives of the stay-at-home heroines. Indeed, depictions of the sheltered lives of provincial middle-class girls, despite their presentation as 'ideal' figures, were often considered dull. Reviewers of both *Wives and Daughters* and *The Claverings* displayed most interest in the 'flawed' heroines. Henry James, in a review of Gaskell's novel, admitted he felt a 'fascination' for Cynthia Kirkpatrick, arguing that Molly 'commands a slighter degree of interest.'[22] Other reviewers found Cynthia 'fascinating',[23] and 'a pretty, captivating, ill-disciplined girl.'[24] Julia Brabazon elicited similar responses from the critics: one found her more 'fascinating' than Florence, despite

'her unwomanly sin in marrying such a man as Lord Ongar for rank and money',[25] while another considered her 'one of the most charming women.'[26] Even Margaret Oliphant, whom one would expect to defend the stay-at-home heroine, is scathing about Florence Burton, arguing that '[t]he only person whom we have any sympathy with [...] is the poor, faulty beauty, Julia.'[27] To another critic, Julia is attractive, although he considers Trollope right in having her 'punished just enough, and not more than enough, to vindicate the ways of society to women.'[28] This indicates one reason why the beautiful and faulty Lydia failed to please critics: women were interesting who erred in minor, 'forgivable' ways; who may be coquettish, using their beauty calculatingly and dallying with suitors, or harbouring designs (which never come to fruition) of escaping the constraints of family life. While Cynthia and Julia belong to this category of 'faulty' beauties, inhabiting the margins of middle-class respectability, Lydia is an outsider in every sense of the word.

In *Armadale*, Collins adapted the dual heroine device specifically to explore Victorian codes of femininity. The use of contrasting heroines was popularized by Thackeray in *Vanity Fair* (1847–48), where Becky Sharp's wickedness is contrasted with Amelia's self-sacrificing passivity. Collins, like Thackeray (but unlike Gaskell and Trollope), pushes this device to its extremes. Neelie is the silly, bouncing schoolgirl, whose poutings and naivety belong to a popular type of Victorian heroine. Her opposite, Lydia, is an experienced woman whose life has been one long transgression of the codes of feminine propriety. While many domestic novels employ dual heroines to demonstrate the potential pitfalls and rewards of feminine behaviour, *Armadale* lays bare many of the issues which remain buried in less sensational texts. As Barickman, MacDonald, and Stark have written:

> Collins turns away from the domestic setting of most Victorian fiction. Even his courtship plots are transformed into bizarre stories of fraud, crime, prostitution, murder, impersonation, and madness. [...] Collins thoroughly parodies the values and practices of the Victorian middle-class family. [...] He focuses on those who are outcasts of the family-centred system, who have broken with it openly, who manipulate it for their secret advantage, or who are victims of it.[29]

By foregrounding an outcast heroine in the figure of Lydia, a woman who has never experienced family life and has lived among criminals, Collins indicates a world beyond the respectable domesticity women were expected to inhabit. In *Wives and Daughters* and *The Claverings*, Cynthia

and Julia are ultimately contained by the values of middle-class respectability: Cynthia's proclivity for desiring many lovers is limited at the end of the novel to her 'normal' acceptance of one husband; while Julia's *open* flaunting of the terms of the marriage contract by pursuing a husband with a title and wealth, leads to her eventual acceptance of a 'punishment'; she must remain single in order to be reincorporated into genteel society.

There is no possibility for reincorporation for Lydia, however, for she was never incorporated in the first place. Unlike Cynthia and Julia, Lydia remains a disturbing figure because she rejects domesticity, refusing to be contained within the structures of respectable family life. Lydia is a social outsider who goes to extreme lengths to attain wealth and status. Her ability to disrupt the security of genteel life may have satisfied readers who struggled to maintain only basic appearances, 'the thousands of anonymous and dispossessed' identified by Catherine Peters as a major sector of the audience for sensation fiction.[30] That an audacious woman should so nearly succeed in her elaborate plot to murder Allan Armadale and become mistress of his estate, Thorpe-Ambrose, must have appealed to those readers of sensation fiction whose stake in society was tenuous and who faced the gulf of poverty and distress as a real possibility.

Fairytales, secrets, and lies

The power of Lydia's characterization lies in her telling her own story through her letters and diary. The reader's direct access to Lydia's inner life, her laudanum addiction, her schemes, and her crimes, generated considerable critical condemnation: she was dismissed as grotesque and improbable by Victorian reviewers, because of the ways in which she exceeded the bounds of the law and feminine propriety. By means of her 'secret' diary, a masterly strategy in heightening the sensationalism of the narrative, Collins reveals the usually hidden aspects of the private self. Hughes has suggested that 'more than any other sensation novel, *Armadale* depicts an entire populace down on its knees before its neighbours' keyholes'.[31] This 'Peeping Tom' quality extends to the reader, whose access to Lydia's private letters and diary (she calls the latter, 'this secret friend of my wretchedest and wickedest hours')[32] amounts to a collusion with the culture of spying and secrecy which pervades the novel. Lydia, as a writer, understands the power of language and the ways in which narrative can be used to play with readers' responses, and it is her ability to adopt a position of authority in relation to the reader which appears so disturbing. When she writes to Mother

Oldershaw, she adopts the role of the novelist playing with readers' desires for the revelation of secrets:

> Shall I trust you with his [Midwinter's] story? Shall I tell you his real name? Shall I show you [...] the thoughts that have grown out of my interview with him? [...] Or shall I keep his secret as I promised? and keep my own secret too, by bringing this weary long letter to an end at the very moment when you are burning to hear more! (XII, 603)

It comes as no surprise to learn that this ends an instalment of the serial. While Collins, as a serial novelist out to generate suspense, shares Lydia's ability to shape a narrative, readers of *Armadale* are uncomfortably aligned with Mother Oldershaw. Like a sensation novelist, Lydia is a skilful manipulator of plots, secrets, and suspense. When Midwinter (who wants to marry her) asks for details of her 'family misfortunes', she confides to her diary, 'I must rouse my invention, and make my little domestic romance' (XIII, 188). After she has fabricated a suitable story, she reinforces her link with the novelist when she writes:

> There was nothing new in what I told him: it was the commonplace rubbish of the circulating libraries. A dead father, a lost fortune, vagabond brothers, whom I dread ever seeing again; a bedridden mother dependent on my exertions [...].
> My lies came to an end at last. (XIII, 189)

Elaine Showalter has argued that 'the power of Victorian sensationalism derives [...] from its exposure of secresy as the fundamental enabling condition of middle-class life'.[33] Not only does Collins use *Armadale* to expose the secrets which undermine genteel family life, but he also uses Lydia as an accomplice; her letters and diary work in a similar way to the novel in revealing the hidden corruption existing within respectable society and feminine appearances. Lydia's dark, secret plotting appeared particularly disturbing to reviewers at a time when outwardly respectable young women, notably Constance Kent and Madeline Smith, were facing exposure in the courts and the press, accused of murder.

Lydia forms the centre of *Armadale*'s complex web of secrets. However, an emphasis on secrets was not limited to sensation novels; Gaskell and Trollope also represent middle-class domestic life as dependent upon concealment. Gaskell deals with the potential sensationalism inherent in a plot full of family secrets while managing to avoid the stigma which reviewers fixed on Collins. The world of *Wives and Daughters* is

constrained by secrets: Osborne is secretly married to a French servant, Mrs Gibson secretly plots to marry off her daughters, Cynthia is embarrassed by her secret liaison with Mr Preston, and Mr Gibson plots secretly to remarry. Cynthia, like Lydia, weaves a fabric of mysteries around herself, and in Gaskell's novel, as with most sensation novels, secrets are the result of sexual intrigue.

A major reason for Gaskell's immunity from accusations of sensationalism is her careful use of a third person omniscient narrator who steers the narrative carefully in order to avoid overtly shocking revelations. This narrator is skilled at storytelling and, like Lydia, particularly clever at manipulating readers' responses. *Wives and Daughters* opens with a harking back to the traditional narrative style of fairytales:

> To begin with the old rigmarole of childhood. In a country there was a shire, and in that shire there was a town, and in that town there was a house, and in that house there was a room, and in that room there was a bed, and in that bed there was a little girl [...][34]

Gaskell, setting her novel in the 1820s, the period of her own childhood, is self-consciously invoking the storytelling modes she experienced as a young girl. The 'fairytale' beginning lulls the reader into an expectation of the narrative satisfactions of childhood, the privileged access into the secret places of another world. This element of nostalgia for childhood storytelling is soon dropped in favour of the realist style Victorian critics accepted and approved of as accurate reflections of reality. The calm voice of Gaskell's omniscient narrator maintains an air of adult control, even at times when the narrative depicts conflict and confusion, by means of certain distancing strategies.

One of these strategies is the limiting of what is said. 'Sensation' is generated when a narrator or character is allowed to say *everything* (or, one could say, too much). This is melodrama's legacy of excess adopted by most sensation novelists. As Peter Brooks has said, 'The desire to express all seems a fundamental characteristic of the melodramatic mode. Nothing is spared because nothing is left unsaid.'[35] Realists like Gaskell found this strategy unsatisfactory: she was a storyteller who knew when the giants and ogres needed to be contained and not allowed to spill out into more dangerous forms of description. The repression which was essential to the smooth running of Victorian middle-class life depended upon disturbing emotions and experiences *not* being articulated, and Gaskell understood the need to keep such emotions at bay. In *Wives and Daughters* secrets emerge when characters cannot speak their emotions.

When Molly is devastated by her father's intention to remarry, she fails to reveal her emotional pain for fear of causing domestic disturbance. While Molly cannot speak, neither can Gaskell, who resorts to refusing the reader access to Molly's repressed, passionate anger:

> She did not answer. She could not tell the words to use. She was afraid of saying anything, lest the passion of anger, dislike, indignation – whatever it was boiling up in her breast – should find vent in cries or screams, or worse, in raging words that could never be forgotten. (X, 589)

Gaskell, whose narrator is reluctant to say what 'was boiling up' within Molly, tells us only what she did *not* say, indicating her anger, but distancing readers from it. If Molly chose words to express her 'passion and anger' in the way that Lydia chooses to, her image as a morally upright girl would be undermined. Containment is necessary for character and narrator to maintain appearances, both the appearance of 'reality' (well brought up girls like Molly do not openly express bitterness) and the appearance of conformity (girls like Molly do not rebel against their fathers). The pain is elided by a narratorial sleight-of-hand and *Wives and Daughters* receives critical acclaim as a 'pleasant' story. However, if Molly had screamed her rage, Gaskell's novel would have been pushed into the unacceptable realms of sensationalism.

Yet to some readers, such elision was clearly unsatisfactory. Sensation novelists attempted to articulate 'dark' areas of emotion, and this was one reason why sensationalists like Collins were seen as excessive. Lydia Gwilt's emotions are fully detailed (albeit through the language of stage melodrama) in her letters and diaries. Her hatred of Allan Armadale, for example, is actually voiced; a sensational strategy on the part of Collins which helped make his heroine seem monstrous in her lack of feminine restraint:

> I hate him for his mother's sake. I hate him for his own sake. I hate him for going to London behind my back, and making enquiries about me. I hate him for forcing me out of my situation before I wanted to go. I hate him for destroying all my hopes of marrying him, and throwing me back helpless on my own miserable life. (XII, 743)

While I am not trying to suggest that Collins is here more 'realistic' than Gaskell (clearly, the language of melodrama is hardly adequate to express a full range of emotional complexity), he does not allow the 'passion of

anger' to be silenced. Although there is occasionally a stilted quality to Lydia's writing of her 'secret' diary and letters to 'Mother' Oldershaw, the fact that her anger and greed *are* articulated positions *Armadale* within the genre of 'sensation', while *Wives and Daughters* exists as fiction which, as the *Spectator* reviewer stated, 'though not exciting reading, satisfies and rests the mind'.[36]

However, the 'restful' quality of *Wives and Daughters* is not entirely accurate. The novel's plot, as I suggested earlier, is based on the disruptive force of sexuality on middle-class life. Molly's depression stems from the oppressive nature of the secrets which motivate those around her. The idyllic calm of her childhood is shattered by her father's sudden remarriage, soon followed by her accidental knowledge of Osborne's secret marriage. Molly is 'troubled', and 'would never have guessed the concealed romance which lay *perdu* under that everyday behaviour.' (XI, 206) Osborne's secret is revealed to the reader long before Molly discovers the details, Gaskell choosing to reveal the secret through Osborne's thoughts, rather than a dramatic disclosure (in the usual style of sensation novels). Osborne thinks, 'What would my father say if he knew I'd married a Frenchwoman? [...] A Roman Catholic too! [...] I must keep it secret.' (XI, 340) It is secrets like this which are the stock-in-trade of sensation novels. However, while Collins or Braddon would have represented the French working-class woman as a devious adventuress intent on revenge or self advancement, Gaskell deliberately sets out to distort this convention (just as Collins sets out to distort many of the conventions of realist novels). Squire Hamley, when he hears of his French daughter-in-law after Osborne's death, imagines a 'chattering, dark-eyed, demonstrative, and possibly rouged' siren who, by 'female inveiglement' (XII, 533) has used Osborne to further her social ambitions. Aimée, when she does appear is far removed from the villainess of sensation fiction: she is a 'little figure in grey' (XII, 535) who 'looks like a gentlewoman' (XII, 537), displaying all of the feminine and maternal virtues so admired by the middle classes. Here Gaskell deliberately deflates the sensational potential of Osborne's secret.

Cynthia, like Osborne, finds life within the genteel family difficult, feeling a necessity to develop a secret life outside its constraints. From the moment Cynthia arrives from her French school, she and her mother harbour secrets, 'there were evidently hidden allusions in their seemingly commonplace speeches.' (XI, 209) Cynthia's secret turns out to be her early engagement to the land agent, Mr Preston, a relationship from which she now wishes to be free. Like Braddon's Aurora Floyd who, as an adolescent, made a disastrous runaway marriage with her father's groom,

Cynthia now finds her engagement to Mr Preston socially embarrassing, as well as personally odious. For much of the novel Gaskell keeps from the reader details of Cynthia's secret. In the final chapters, she reveals her engagement, having kept the secrets of Cynthia and Osborne simmering through many instalments, leaving readers in suspense for months. Suspense, of course, was a device associated with sensation novelists and condemned by critics for its power to keep readers in a state of nervous anticipation. It is significant that Gaskell was capable of employing this device in such a way as to make critics believe her incapable of devious plotting.[37]

Although she subscribed to literary realism, Gaskell is clearly aware of the possibilities of sensation fiction. She makes a covert reference to the sensation novel in Chapter 39 of *Wives and Daughters* which she calls 'Secret Thoughts Ooze Out'. Her use of the word 'ooze' succinctly suggests the repression needed to keep secrets hidden, as though the barriers her characters construct to contain secrets are easily breached. This title refers to Mrs Gibson's 'forbidden' and secret know-ledge (gained by eavesdropping on her husband's consultation with another doctor) that Osborne is ill and has not long to live. Using this secret knowledge, she schemes to promote Cynthia's engagement to Roger, the heir to Hamley Hall after Osborne's death. However, Mrs Gibson's secret plot is only part of a chapter bristling with secrets. There are also references to the mysterious disappearance of Cynthia's money (she is paying off a debt she contracted with Mr Preston) and her inexplicable annoyance when she discovers her engagement to Roger is no longer a secret. This chapter also shows Osborne attempting to uphold the secrecy surrounding his marriage, resorting to lies to appease his father who is now urging him to marry. Gaskell, like the sensation novelist, uses this chapter to expose the lies and secrets which lie *'perdu* under [...] everyday behaviour' (XI, 206).

Containing and exploiting sensationalism

While Gaskell shares Collins's desire to foreground secrets as a way of commenting on the tensions of middle-class domestic life and engineering a long narrative divided into instalments, the narrative techniques of both authors were intended to affect the reader in very different ways. As Patrick Brantlinger has said, by 'undoing narrative omniscience', the sensation novelist lets 'in kinds of knowledge that realistic fiction often excluded'.[38] An examination of an issue of *The Cornhill* containing instalments of both novels illustrates how these different narrative styles

worked. By focusing on two parallel instalments, it is possible to demonstrate how Gaskell's use of an omniscient narrator contains the sensational potential of her story, while Collins's inclusion of first person narrative accounts in the form of letters and diaries serves to generate sensation.

In the March 1865 instalment of *Armadale*, Collins's omniscient narrator for the first time appears to relinquish control. The instalment opens with the chapter 'Lurking Mischief', and introduces two new characters, Lydia Gwilt and Mother Oldershaw, through their letters. These letters are not framed for the reader by the commentary of the omniscient narrator; the villainesses 'speak for themselves'. The sudden loss of the narrator's guidance, coupled with the confusion as to who these women are, allows Collins to open up the novel's sensational potential by disorientating the reader. In one of her letters, Mrs Oldershaw refers to Lydia's 'money-grubbing in the golden Armadale diggings' (XI, 261), while Lydia's language is equally blunt; she writes, 'I am in one of my tempers tonight. I want a husband to vex, or a child to beat, or something of that sort' (XI, 266). Their violent, 'coarse' expressions indicate a lack of regard for respectable appearances (at least with each other), allowing readers immediate, direct access to the sensational heart of the novel: Lydia's criminal plots for self-advancement. No trusted narrative voice intervenes to either explain, excuse, or condemn. At the very moment when readers need to know how to 'place' these two women and gain more details about their mercenary plot, Collins withdraws his third person narrator, offering only the women's letters and a suggestive chapter title. The next chapter of this same March instalment, 'Allan as a Landed Gentleman', sees the return of the omniscient narrator, who makes no reference to the characters of the previous chapter. After the sensational epistolary dialogue between Lydia and Mrs Oldershaw, outlining their plans to plot against Allan, the mood swings abruptly towards a gentle domestic realism, where Collins's narrator dwells on the romantic comedy of Allan's first meeting with Neelie in the garden of Thorpe-Ambrose. It is in this chapter that *Armadale* ironically appears as a more lighthearted and untroubled text than the accompanying instalment of *Wives and Daughters*. This instalment of *Armadale*, with its violent juxtapositioning of genres and narrative styles mirrors the *Cornhill*'s own provision of contrasting novels in each issue.

However, the differences between *Armadale* and *Wives and Daughters* are not always pronounced. The March 1865 instalment of Gaskell's serial opens with Molly's confusion about her recent discovery of Osborne's

secret marriage. To Molly, his manner is that of a bachelor, which leaves him open to the matrimonial designs of mothers like Mrs Gibson:

> Molly was altogether puzzled by his manners and ways. He spoke of occasional absences from the Hall, without exactly saying where he had been. But that was not her idea of the conduct of a married man, who, she imagined, ought to have a house and servants, and pay rent and taxes, and live with his wife [...]. Perhaps in the rapid flow of conversation, these small revelations were noticed by no one but Molly; whose interest and curiosity were always hovering over the secret she had become possessed of [...]. (XI, 320)

The reader at this stage also knows of Osborne's 'secret' wife, but no details about her. Although Gaskell encroaches upon the territory of the sensation writer by focusing on secrets, her use of the distancing codes of domestic realism prevented readers being shocked and disorientated in the way of *Armadale*'s March instalment.

In *The Claverings*, Trollope also provides a plot based on secrets. However, he does not always share Gaskell's and Collins's mission to expose lies and secrecy as destructive aspects of genteel life. Indeed, his narrator frequently appears to collude with his characters' attempts to mask their emotions and cover their tracks in order to maintain a respectable and seemly façade. Harry Clavering, like Cynthia, has a tendency to desire many lovers, and although neither of them go so far as to consider a socially unacceptable path such as bigamy or adultery (a path chosen by many characters in sensation novels), both have difficulties settling on one marriage partner. Trollope's hero spends considerable time trying to conceal his illicit relationship with Julia. While sensation novelists offered an outlet for readers' fantasies of polygamy, Trollope (and to a lesser extent, Gaskell) allows characters to toy with the idea of multiple partners *before* marriage as a way of signalling the waywardness of sexual desire. This 'safe' method of representing an 'unsafe' concept did not go unnoticed by Victorian critics. Margaret Oliphant, after a scathing review of sensation novels in *Blackwood's*, goes on to praise Trollope's *The Claverings*, although she was uneasy about his 'favourite topic': the 'uncomfortable vacillation between two lovers'.[39] Despite this minor criticism, Oliphant approves of Trollope's rejection of sensationalism, saying that 'none of those fair women, none of those clean, honourable, unexalted English gentlemen, have any terrible secrets in their past that cannot bear the light of day'.[40] However, Harry's shortcomings, which reveal him to be less than 'honourable', are neatly

smoothed over by Trollope, who presents his dallying with a number of women as a minor flaw, rather than a problem which could spill over into adultery.

Even though Gaskell manages to be disapproving of Cynthia's inconstancy, both she and Trollope marry off their flirts respectably and that is seen as the end of the matter; the reader is not encouraged to guess how they subsequently contain their desires for other partners. While the domestic novel ends all such problems (almost invariably) with marriage as a closure which admits of no questions, the sensation novel's plots frequently begin with marriage: *The Woman in White*, *East Lynne*, and *Lady Audley's Secret*, for example, all use the unhappy or bigamous marriage as a basis for their sensational plots. *Wives and Daughters* and *The Claverings*, by contrast, present characters who invariably end up in 'safe' marriages, adopting a respectable path rather than risking social ostracism. Yet for many readers, the happy marriage closure of domestic fiction was clearly unsatisfactory, and sensation novels frequently filled in the gaps left by domestic realism.

Illustrating the sensational

Readers of *The Cornhill*, then, were offered an extraordinary opportunity to compare Collins's sensation novel with two domestic novels. This was complicated by the illustrations to all three novels which further blurred generic boundaries between sensationalism and domestic realism. The illustrated magazines of the 1860s were growing in popularity and many established artists, such as John Everett Millais, William Holman Hunt, and John Tenniel, were employed as illustrators. Stuart Sillars has discussed the style of sophisticated woodcut engravings which flourished throughout the 1860s which:

> stress dark, close textures caused by infinite variation of the spacing of engraved lines, often alternating with free and imaginative use of white paper to give the characteristic lighting effect referred to in the name of 'black and white art' by which it was also known. Add to this the intense emotional narrative effects of the second generation pre-Raphaelites, and it is clear that the 'sixties style' is a complex medium well suited to the presentation of dramatic incident and feeling.[41]

One of the main reasons for the 'flowering' of this style (which Sillars fails to mention) is the prevalence of sensation fiction during the decade, where (melo)dramatic plotlines called out to be illustrated visually.

Magazine editors recognized the potential selling power of using striking illustrations to accompany popular serial novels. *The Cornhill*, along with *Once A Week*, were among the major illustrated literary miscellanies of the 1860s, both proving influential in their foregrounding of 'black and white art'. *The Cornhill* always opened with a full page woodcut engraving representing an episode from the serial novel, along with a small accompanying vignette which (often playfully) incorporated the first letter of the first word of the text. Another full page illustration and vignette appeared alongside the second serial novel.

Although *The Cornhill* was not associated with the serialization of sensation novels, many of its illustrators chose to depict the more 'sensational' moments of the domestic serials. *The Claverings* was illustrated by Mary Ellen Edwards, a popular illustrator who worked for numerous periodicals, and her full page illustration for the novel's first instalment represents the wedding of Julia and Lord Ongar (see Plate 8). Trollope worked closely with Edwards and tended to select the episodes he wanted her to illustrate.[42] The initial illustration to a *Cornhill* serial was especially important because the reader encountered it *before* the written text and thus gained from it certain expectations of the novel. Edwards's illustration indicates that this wedding is no happy occasion; the bride's face is averted from her husband, who appears an unhealthy, even malevolent figure (the caption reads 'A Puir Feckless Thing, Tottering Along Like', which the reader later discovers is a servant's comment on the dissipated Lord Ongar). A face in the background looks anxiously towards the bride and groom, while the other guests and bridesmaids appear to ignore the central couple. The vignette which appeared on the adjoining page shows the bride talking to a man other than her husband, her head bowed while he, with open hands, appears to be entreating or explaining (see Plate 9). The juxtaposition of the two scenes, the major one depicting a haughty beauty and shrivelled man-of-the-world as a wedding pair, the smaller one showing the bride's apparent intimacy with another man, would have fostered readers' expectations of sensational events to come, for many sensation novels were based on failed marriages with suggestions of adultery or bigamy. However, the preliminary illustrations suggest more than the novel delivers, for the marriage of Lord Ongar and Julia forms only a minor part of the plot. He dies of his excesses a few instalments later, and the main focus becomes Harry Clavering's vacillations between the widowed Julia and the middle-class Florence Burton.

A later illustration by Edwards, which appeared alongside the October 1866 instalment, also invokes the themes of the sensation novel,

depicting Julia at a 'dangerous' moment of her life (see Plate 10). She sits
precariously on a rock jutting out over the sea, her eyes downcast. Behind
her stands a man with a top hat and fierce moustache (in the conventional
style of villany readers would have recognized from stage melodrama),
one of his hands stretched out to touch Julia. The caption reads 'Lady
Ongar, Are You Not Rather Near The Edge?', referring both to the physical
danger she faces of falling (or being pushed?) into the sea and, as the
reader of the novel understands, her danger of facing permanent
ostracism from 'polite' society. Edwards's illustration shows the sinister
Count Pateroff in his pursuit of the wealthy Julia, while she awaits Harry
in the hope that he will eventually marry her and bring about her
reincorporation into respectable society. Here, on this dangerous edge,
Julia is being blackmailed, the Count warning her that 'your character is in
my hands' (XIV, 385), as he reminds her of a rumour of adultery which
Lord Ongar had set in motion in an attempt to get a divorce and which he
hopes to profit by. Here the novel and its illustration come 'rather near the
edge' of domestic realism, referring to the darker aspects of gender
relations and social corruption which were associated with the sensation
genre. While Trollope allows Edward's illustrations to invoke expectations
of sensationalism in readers (will Pateroff push Julia over the cliff?; will
Julia give in to blackmail?) he plays this down within the novel.

This way of suggesting the sensational without developing it as a way of
exciting readers' expectations was also a feature of the illustrations to
Wives and Daughters by George Du Maurier. He had already learnt the
effectiveness of using dramatic 'sensational' scenes when he illustrated
Braddon's *Eleanor's Victory* in *Once A Week* in 1863. In one particular
illustration for Gaskell's serial, he drew upon readers' knowledge of other
visual texts in order to create a sense of the sensational (see Plate 11). This
depicts Osborne's 'secret' French wife, the working-class Aimée, who
faints into Molly's arms when she discovers that her husband is dead. This
image echoes a painting by Augustus Egg from his triptych, *Past and
Present* (1858) (see Plate 12), which depicts an adulterous wife prostrate on
the floor of her respectable middle-class home, her two children looking
on in bewilderment, while her husband holds a crumpled letter (evidence
of his wife's 'fall'). Du Maurier repeats many details of Egg's painting: the
respectable home as a background, the prostrate form of the woman, the
two children looking on (Molly is not a child, but Du Maurier's image
makes her appear so), and the crumpled piece of paper in the foreground.
At this juncture (the reader encountering the illustration at the beginning
of the serial's instalment), it is not known whether Aimée's marriage to
Osborne is a legal one. Readers familiar with Egg's painting may have been

led to expect that Du Maurier's illustration depicted a 'fallen' woman and her illegitimate child, anticipating sensational revelations in the accompanying instalment. However, as with Edwards's illustrations to Trollope's serial, the text undoes the sensational potential of the illustration. Aimée's marriage *is* legal, while the crumpled paper, so significant in Egg's painting, turns out to be only Molly's letter, written to warn Aimée of her husband's illness.

The illustrations to *Wives and Daughters* and *The Claverings* occasionally tease the reader with expectations of sensational incidents which fail to surface in the novels. George Thomas's illustrations to *Armadale*, however, are even more unstable, disorientating the reader's understanding of Lydia Gwilt by working against Collins's text. They often act as 'countervoices' which do not so much illustrate (in the sense of illuminate) the text, as assert contrary messages.[43] The problem with *Armadale*'s illustrations is that Collins and Thomas were not working together; indeed, Thomas's depictions of Lydia Gwilt were attempting to make a moral point about her wickedness which went beyond Collins's representations of her. This 'countervoice', however, is not even a consistent one, for sometimes Thomas follows Collins's text faithfully, while at othertimes he produces images which are decidedly at odds with what Collins is saying. The illustrations at times represent Lydia as a beautiful, demure young woman (see Plate 13), a vamp in the full-lipped Pre-Raphaelite style (see Plate 14), and a thin-lipped, malevolent harridan (see Plate 15). Perhaps the most overt example of Lydia's shape-shifting occurs in the illustrations to the February 1866 instalment (see Plate 16), where a full-length image shows a long-haired, graceful young woman, while the accompanying vignette depicts Lydia as much older, a wrinkled, witch-like figure hunched up in a railway carriage. This discrepancy was noticed (and approved of) by a *Spectator* reviewer, who considered Lydia to be 'a woman fouler than the refuse of the streets'; he referred to Thomas's illustrations of Lydia as more 'accurate' depictions than Collins's descriptions of her.[44] Presumably his point is that Collins's account of Lydia's beauty and charm cannot be 'real' because of her unfeminine criminal behaviour. Thomas, on the other hand, by working against Collins's descriptions of a beautiful woman, presents what reviewers considered a more 'accurate' image of her as 'ugly'.

This idea cannot be sustained, however much one may prefer to set up the illustrator as knowing 'better' than the novelist, because Thomas depicts Lydia as both ugly *and* beautiful, ageing *and* youthful, as though he is unable to overcome the problems of representation which Collins has set him. Collins states in *Armadale* that Lydia knows all of the

feminine arts of dress, and is skilful at making herself look younger than she is. Yet he is also careful to insist that it is only when Lydia is alone that she looks older (particularly after denying herself the laudanum that she depends on). Her public self, he stresses, looks charming and youthful. Thomas depicts Lydia in public as much older and unattractive. His unease about illustrating her suggests that the visual representation of deviant femininity was problematic; a ruthless, scheming woman could not, apparently, have an outwardly pleasing feminine appearance. The supposed disjunction between attractive women and 'bad' women meant that illustrators faced problems when imaging the *femme-fatale*. Sensation novelists like Collins and Braddon often foregrounded their 'bad' female characters as beautiful, yet while words could suggest the discrepancy between inner badness and outward charm, illustrators working within the context of the family magazine found badness and beauty unrepresentable.

Readers of *The Cornhill Magazine* had to negotiate the contradictory and misleading messages presented by the illustrations to Collins's, Gaskell's, and Trollope's serials. This form of intertextuality, along with occasional generic overlaps, complicated the reading of Collins's sensation novel and the two domestic novels. In his Preface, Collins later admitted that he had wished to shake the complacency of the comfortable middle classes by making *Armadale* a particularly controversial sensation novel. Patrick Brantlinger has argued that the sensation genre marked 'a crisis in the history of literary realism',[45] and this crisis can best be judged by an examination of *Armadale* and its first location in *The Cornhill*, uneasily sandwiched between the domestic novels of Gaskell and Trollope, where the fascinating hybridity of the sensation genre, its mixture of middle-class domestic realism and lowbrow melodrama, is brought into stark focus.

Conclusion: Victorian Novels and the Periodical Press

'From our present vantage point the nineteenth century begins to look like the great age of the periodical'.[1] So wrote R.G. Cox in an essay published in 1958 which offered a brief, but suggestive, overview of the genre. Since then there have been successive attempts to map out an extensive and diverse field. Nearly a decade after Cox's essay, Walter E. Houghton, in his introduction to the first volume of the invaluable *Wellesley Index to Victorian Periodicals, 1824–1900* (an index to what can only be a limited sample of the thousands of Victorian monthly and quarterly journals), emphasized the centrality of the periodical press to our understanding of nineteenth-century culture. The importance of Victorian periodicals, he stated, 'can scarcely be exaggerated'.[2] By 1982, scholars were demonstrating the range and significance of the archive in an important volume of essays, *The Victorian Periodical Press: Samplings and Soundings*, edited by Joanne Shattock and Michael Wolff. This marked an attempt to read the engagement between Victorian literature and culture and its periodicals, rather than use the archive as though it offered a passive mirror which unproblematically reflected the past.[3] In a stimulating essay published in this volume, Louis James stressed the inherent dialogism of the periodical form: 'The genre mediated to the era much of its finest fiction and non-fiction, and helped give both their vitality, their sense of being a dialogue between writer and reader'.[4] This view of the periodical press as an active cultural force has been developed further in numerous subsequent studies of Victorian periodicals, many of which have engaged with a variety of recent cultural and literary theories to encourage a bringing into sharper focus our perspective upon a complex period of literary and social history.[5]

By exploring the dialogic form of the periodical press it is possible to see how literature worked as a cultural force during the nineteenth century.

However, the most cursory examination of the Victorian periodical press alerts us to the fact that there was not one dialogue but many. The relationship between writers and readers which James identified as part of the 'vitality' of Victorian writing, is complicated by the fact that a periodical is in itself made up of different voices. It is possible to trace the various dialogues between editors and contributors, between fiction and non-fiction, as well as the dialogue between the different periodicals themselves. Like the internet today, where different voices compete for attention within an expanding media which defies boundaries and definitions, the Victorian periodical press was forever in a state of flux and transition as various discourses and genres established themselves (or sank into oblivion) through its pages. This refusal to be neatly classified indicates why the periodical press is impossible to approach satisfactorily from any one theoretical model, and new work in the field of Victorian periodicals illustrates the apparently endless possible approaches one can take.

An openness to the dynamic intertextuality of the periodical press helps to loosen the stubbornly fixed idea that the literature of the Victorian era was all about bulky three-decker novels, and any examination of Victorian periodicals emphasizes the fact that the golden age of the novel was not simply about books. The easy accessibility today of increasing numbers of Victorian novels as paperbacks obscures the important fact that for many Victorian readers novels were experienced as short fragments, the 'tantalizing portions' which Geraldine Jewsbury identified as part of the excitement of novel reading. Victorian novels in weekly or monthly parts, as Linda Hughes and Michael Lund have indicated in *The Victorian Serial*, were enjoyed by thousands of readers, and the implications of this different publishing practice on the form of the novel have only recently begun to be fully explored.[6] A considerable proportion of serial novels appeared as magazine serials, and these contexts have scarcely featured in most discussions of Victorian literature. Clearly, the uncharted regions of this territory need to be more fully explored and mapped. Yet, as a glance at the several volumes of *The Wellesley Index* indicates (remembering, of course, that this offers listings of only the more prestigious middle-class journals), the major problem facing the researcher today is where to begin when faced with the rich excess on offer: so many novels appeared serially in journals, so many different novelists produced these serials, so many genres emerged, so many articles, poems, short stories, and illustrations were published alongside the serial instalments.

The Sensation Novel and the Victorian Family Magazine has attempted to suggest one possible approach to this gloriously varied mass of texts we label 'Victorian periodicals'. I have tried to illuminate a section of

Victorian publishing history by examining one type of periodical (the middle-class family magazine), one literary genre (the sensation novel), throughout one decade (the 1860s). The conjunction of the magazine and sensation novel seems to me to offer a significant illustration of how the development of a literary genre through a popular publishing format could engage with, and provide a focus for, the cultural debates of the day. I have attempted to demonstrate how the idea of the middle-class family informed the working practices of contributors and editors of periodicals who attempted to provide cheap and entertaining reading. I have also attempted to show how sensation fiction was shaped and defined through its periodical publishing space, and the ways in which magazine editors, grateful for the enormous popularity of the new sensation genre, experimented with ingenious ways of supporting serials by adapting journalistic practices to suit the new discourse of middle-class sensation-alism. By approaching Victorian literture via the conjunction of popular middle-class magazines and sensation novels I have hoped to highlight not only the richness and complexity of Victorian literature as it appeared straight off the newsagents counters and railway stalls, but also to emphasize the numerous potential pleasures such magazines offered readers.

If we now fail to read novels as 'tantalizing portions' in the pages of magazines we also miss out on the pleasure of reading 'laterally', a form of reading which extended the boundaries of the serial novel by encouraging the reader's engagement with its accompanying texts.[7] I hope to have demonstrated that this invitation to Victorian magazine readers to participate in 'wider reading' helped to enhance the significance of the novel as a form of cultural discourse, even when those novels were condemned by Victorian reviewers as sensational stories based on plots of improbable excess.

Appendix

Publishing details of the serial novels discussed in the text

BRADDON, M.E., *Eleanor's Victory, Once A Week*, 7 March–3 October 1863.
COLLINS, W., *The Woman in White, All The Year Round*, November 1859–August 1860.
———, *No Name, All The Year Round*, 15 March 1862–17 January 1863.
———, *Armadale, The Cornhill Magazine*, November 1864–June 1866.
DICKENS, C., *Great Expectations, All The Year Round*, 1 December 1860–8 August 1861.
GASKELL, E., *Wives and Daughters, The Cornhill Magazine*, August 1864–January 1866.
OUIDA, *Granville de Vigne: A Tale of the Day, New Monthly Magazine*, January 1861–June 1863.
READE, C., *Very Hard Cash, All The Year Round*, 28 March–26 December 1863.
TROLLOPE, A., *The Claverings, The Cornhill Magazine*, February 1866–May 1867.
WOOD, E., *East Lynne, New Monthly Magazine*, January 1860–September 1861.

Notes

1 Tantalizing Portions

1. For discussions of Victorian working-class fiction see P. Brantlinger, *The Reading Lesson: The Threat of Mass Literacy in Nineteenth-Century British Fiction*; M. Dalziel, *Popular Fiction 100 Years Ago: An Unexplored Tract of Literary History*; and L. James, *Fiction for the Working Man, 1830–50*.

2. K. Tillotson, in her Introduction to *The Woman in White*, 'The Lighter Reading of the 1860s', discusses Collins's novel in the context of the sensation genre. A valuable introduction to the sensation novel can be found in W. Hughes, *The Maniac in the Cellar: Sensation Novels of the 1860s*.

3. Margaret Oliphant's contribution to the sensation genre was a mystery novel, *Salem Chapel* (serialized in *Blackwood's Magazine* from 1862 to 1863). For a discussion of the novel's links to the sensationalism of the 1860s see A. Trodd, *Domestic Crime in the Victorian Novel*. Charlotte M. Yonge's 'sensation novel' is *The Trial* (1863), a murder mystery story which forms an unlikely sequel to the domestic *Daisy Chain* (1856).

4. See N. Rance, *Wilkie Collins and Other Sensation Novelists*, 22–5.

5. Brantlinger, *The Reading Lesson*, 142.

6. Among the studies which discuss the subversive qualities of the sensation novel are: E. Showalter, 'Family Secrets and Domestic Subversion: Rebellion in the Novels of the 1860s' in A. Wohl (ed.), *The Victorian Family: Structures and Stresses*, and the chapter on Wilkie Collins in R. Barickman *et al.*, *Corrupt Relations: Dickens, Thackeray, Trollope, Collins, and the Victorian Sexual System*.

7. Tillotson, 'The Lighter Reading', xv.

8. *The Woman in White* first appeared serially in Dickens's magazine, *All The Year Round*, from November 1859 to August 1860. *East Lynne* was serialized in the *New Monthly Magazine* from January 1860 to September 1861. *Lady Audley's Secret* began serialization in the short-lived *Robin Goodfellow* in July 1861. However, the magazine ceased publication before the novel had completed its run. It began serialization again in the *Sixpenny Magazine* in January 1862, and was completed in December 1862.

9. G. Jewsbury, Unsigned review of *The Moonstone*, *Athenaeum*, 25 July 1868, 106, Cited in N. Page (ed.), *Wilkie Collins: The Critical Heritage*, 170–71.

10. Thackeray refers to novels as resembling raspberry tarts in one of his *Roundabout Papers*, 'On A Peal of Bells', originally published in *The Cornhill*. The phrase 'mental palates' is used by H. Stark in a review of *Middlemarch* in the *Daily Telegraph*, 18 June 1872, 6–7.

11. For an excellent discussion of historical analogies between novel reading and poison see Chapter 1 of Brantlinger, *The Reading Lesson*.

12. Unsigned review of M.E. Braddon's *Lost for Love*, *Spectator*, 17 October 1874, 1303–4.

13. L. Stephen, 'The Decay of Murder', *The Cornhill*, XX, 1869, 726.

14. H.L. Mansel, 'Sensation Novels', *Quarterly Review*, CXIII, 1863, 485.

15. See R.D. Altick, *Victorian Studies in Scarlet*, 67, along with Altick's *Presence of the Present: Topics of the Day in the Victorian Novel*, 59 and 80. See also Brantlinger, *The Reading Lesson*, 147.
16. Mansel, 'Sensation Novels', 502.
17. Constance Kent was suspected of murdering her brother in 1860; she confessed to the crime in 1865. See A. Trodd, Introduction to W. Collins, *The Moonstone*, for a discussion of the links between this case and Collins's novel. Madeline Smith's trial took place in 1862 and details of the 'not proven' verdict feature in W. Collins, *The Law and the Lady*. J. Bourne Taylor discusses the connection in her introduction to the Oxford University Press edition (1992). Rachel Leverson featured as Mother Oldershaw in W. Collins's *Armadale*. See M.S. Hartman, *Victorian Murderesses*, and Trodd, *Domestic Crime*.
18. See J.A. Sutherland, Introduction to W. Collins, *Armadale* (Harmondsworth: Penguin, 1995), for a discussion of the connections between the sensation novel and modern technology. See also N. Daly, 'Railway Novels: Sensation Fiction and the Modernization of the Senses', *ELH*, 66, 1999, 461–87.
19. A. Helps, quoted in W.E. Houghton, *The Victorian Frame of Mind, 1830–70*, 61.
20. Mansel, 'Sensation Novels', 485.
21. W. Collins, *Armadale*, serialized in *The Cornhill* from November 1864 to June 1866. The quotation is from volume XIII, April 1866, 576. Subsequent quotations from the novel are from the *Cornhill* serial and will be referenced in the text by volume and page numbers.
22. W.J. McCormack, *Sheridan Le Fanu and Victorian Ireland*, 60.
23. See Altick, *Presence*, 411–13, and K. Flint, 'Fictional Suburbia', in P. Humm et. al. (eds). *Popular Fictions: Essays in Literature and History*, See also K. Flint, *The Woman Reader*, for details of Victorian women's reading practices.
24. D.A. Miller, 'Cage aux Folles: Sensation and Gender in W. Collins's *The Woman in White*', in J. Hawthorn (ed.) *The Nineteenth-Century British Novel*, 95.
25. M. Butler, *Jane Austen and the War of Ideas*, 18.
26. Wilkie Collins and Charles Reade in particular used Prefaces quoting 'authorities' to justify improbabilities in their plots. Dickens also adopts this strategy in his Preface to *Bleak House*.
27. See Altick, *Victorian Studies in Scarlet*, 68, for a discussion of the enduring popularity of the gothic in nineteenth-century literature.
28. D. Masson, 'Politics of the Present, Foreign and Domestic', *Macmillan's Magazine*, 1, November 1859, 3.
29. Masson, 'Politics', 4. Masson's own emphasis.
30. The second Reform Bill was passed in 1867. See J. Loesberg, 'The Ideology of Narrative Form in Sensation Fiction', *Representations*, 13, 1986, 18–35, for a discussion which links calls for reform to the literary sensationalism of the 1860s.
31. See G. Beer, *Darwin's Plots: Evolutionary Narrative in Darwin, George Eliot and Nineteenth-Century Fiction* for the impact of Darwin's work on Victorian literary culture.
32. See *Illustrated London News*, volume XXXVII 7 July 1860, 21 July 1860, and volume XXXVIII 19 January 1861.

33. For discussions of sensation fiction as a form of catharsis see N. Rance, *Wilkie Collins and Other Sensation Novelists* – now Palgrave, 107, and K. Reynolds and N. Humble, *Victorian Heroines: Representations of Femininity in Nineteenth-Century Literature and Art*, 8.

34. Anon., 'Novels With a Purpose', *Westminster Review*, LXXXII, July 1864, 49.

35. R.C. Maxwell, 'G.M. Reynolds, Dickens, and the Mysteries of London', *Nineteenth-Century Fiction*, 32, 1977, 188.

36. This is the comment of the Radical Machester bookseller, Abel Haywood, quoted in R.D. Altick, *The English Common Reader: A Social History of the Mass Reading Public, 1800–1900*, 352, n. 6.

37. Maxwell, 'G.M. Reynolds', 191.

38. Maxwell, 'G.M. Reynolds', 198.

39. Dickens's *Oliver Twist* (1837–39) and *Barnaby Rudge* (1841) are well-known examples of the genre. Edward Bulwer-Lytton's *Eugene Aram* (1832) diverges from the Newgate novel formula in that it presents a 'respectable' criminal working within a genteel domestic setting, making it an early forerunner of the 1860s sensation novel. See K. Hollingsworth, *The Newgate Novel*.

40. For details of 'penny dreadfuls' and other working-class literature see Dalziel, *Popular Fiction 100 Years Ago*; and James, *Fiction for the Working Man*; and B. Kalikoff, *Murder and Moral Decay in Victorian Popular Literature*.

41. Anon., 'Popular Novels of the Year', *Fraser's Magazine*, LXVIII, August 1863, 262.

42. See Hughes, *Maniac*, 9.

43. For a discussion of the 'cult of domesticity' see C. Gallagher, *The Industrial Reformation of English Fiction: Social Discourse and Narrative Form, 1832–1867*, 126.

44. Anon., 'Female Sensation Novelists', *Littell's Living Age*, LXXXVIII, 22 August 1863, 353.

45. Daly, 'Railway Novels', pp. 464, 478.

46. For useful studies of developments in the Victorian publishing industry see J.A. Sutherland, *Victorian Novelists and Publishers*; N.N. Feltes, *Modes of Production in Victorian Novels*; and R. Hagedorn, 'Technology and Economic Exploitation: The Serial as a Form of Narrative Presentation', *Wide Angle*, 10, 1988, 4–12.

47. *Edinburgh Review*, 1864, quoted in Tillotson, 'Lighter Reading', xi.

48. The 'Scheherazade effect' is a reference to the storytelling princess of the *Arabian Nights*. Her ability to defer narrative closure and excite readers' curiosity as to what will happen next provides a model for serial writers.

49. See James, *Fiction for the Working Man*, 9–10.

50. Hagedorn, 'Technology and Economic Exploitation', 12.

51. See Feltes, *Modes of Production* for a wide-ranging analysis of the commodification of literature during the Victorian period.

52. J. Hayward, *Consuming Pleasures: Active Audiences and Serial Fictions from Dickens to Soap Operas*, 23, and 42.

53. Hayward, *Consuming Pleasures*, 21.

54. See K.M. Hughes and M. Lund, *The Victorian Serial*, 10; and L. Brake, ' "The Trepidation of the Spheres": The Serial and the Book in the Nineteenth Century', in *Serials and Their Readers*, R. Myers and M. Harris (eds), 88.

55. Also see A. Cruse, *The Victorians and Their Books*, and Flint, *The Woman Reader*, for general details of domestic reading practices.
56. See Hayward, *Consuming Pleasures*, 35.
57. Hughes and Lund, *Victorian Serial*, 8.
58. Hughes and Lund, *Victorian Serial*, 16.
59. *North British Review*, 3, May 1845, 85, quoted in Hayward, *Consuming Pleasures*, 26.
60. M. Oliphant, 'Sensation Novels', *Blackwood's Edinburgh Magazine*, May 1862, 568 (emphasis in the original).
61. C.H. Butterworth, 'Overfeeding', *Victoria Magazine*, November–April 1870, 503.
62. E.S. Dallas, review of *Great Expectations*, *The Times*, 17 October 1861, 6.
63. Dallas, review of *Great Expectations*, 6.
64. Tillotson, 'Lighter Reading', ix.
65. Quoted in W. Allingham, *A Diary*, 181.
66. For a discussion of the contents of these magazines see Dalziel, *Popular Fiction*.
67. *British Mother's Magazine* (1853) quoted in Dalziel, *Popular Fiction*, 53.
68. W. Collins, 'The Unknown Public', *Household Words*, 21 August 1858. Reprinted in *My Miscellanies*.
69. See G. Griest, *Mudie's Circulating Library and the Victorian Novel*.
70. *Household Words* cost twopence per issue. Working-class magazines usually cost one penny, sometimes even a halfpenny. See Altick, *English Common Reader*, 55.
71. Millais, Holman Hunt, Du Maurier and Tenniel all contributed illustrations to *Once A Week* and the *Cornhill* throughout the 1860s.
72. See Altick, *English Common Reader*, 356–7.
73. Quoted in Altick, *English Common Reader*, 359.
74. See for example Chapter 1 of M.W. Turner, *Trollope and the Magazines: Gendered Issues in Mid-Victorian Britain*.
75. J. Hannay, 'Bohemians and Bohemianism', *Cornhill*, XI, February 1865, 241.
76. Thackeray regularly addressed readers of the *Cornhill* from his position as editor through his *Roundabout Papers*. Dickens usually addressed readers of his magazines by means of short statements outlining his policies or distancing himself from the views of a guest novelists (as in the case of Charles Reade during the serialization of *Very Hard Cash*, when Dickens published a statement in the 14 November 1863 issue).
77. Anon., 'The Sensation Times: A Chronicle of Excitement', *Punch*, 9 May 1863, 193.
78. Exceptions are Altick, *Victorian Studies in Scarlet*, and Kalikoff, *Murder and Moral Decay*, both of whom discuss sensational journalism.
79. A. Blake, *Reading Victorian Fiction: The Cultural Context and Ideological Content of the Nineteenth-Century Novel*, 70.
80. During the early 1860s, M.E. Braddon edited *Temple Bar* and from 1866 *Belgravia*. Mrs Henry Wood contributed to the *New Monthly Magazine* before becoming editor of the *Argosy* from 1867. Collins worked as a staff member at both *Household Words* and *All The Year Round*.
81. A. Conan Doyle, *Study in Scarlet* (Harmondsworth: Penguin, 1982), 20.

82. C. Kent, 'The Editor and the Law' in *Innovators and Preachers: The Role of the Editor in Victorian England*, 106–7.

83. For discussions of the concept of intertextuality see the essays in M. Worton and J. Stills (eds), *Intertextuality: Theories and Practices*. For critics who have explored the role of intertextuality in the context of Victorian literary culture see Blake, *Reading Victorian Fiction*, and Turner, *Trollope and the Magazines*.

84. M.E. Braddon's literary mentor was the author Bulwer-Lytton. Wood and Ouida benefited (in a limited way) from the patronage of W. Harrison Ainsworth, editor of both *The New Monthly Magazine* and *Bentley's Miscellany*. Wilkie Collins benefited from his friendship with Dickens, collaborating with him on a number of literary projects.

85. Quoted in R.L. Wolff, *Sensational Victorian: The Life and Fiction of Mary Elizabeth Braddon* 324.

86. J. Rose, 'Rereading the English Common Reader: A Preface to a History of Audiences', *Journal of the History of Ideas*, 53, January–April 1992, 47–70.

87. Brantlinger, *The Reading Lesson*, 16–17.

88. M. Beetham, *A Magazine of Her Own?: Domesticity and Desire in the Woman's Magazine, 1800–1914*, 11.

89. Anon., review of A. Trollope's *Last Chronicle of Barset*, *Publisher's Circular*, 29, 1 November 1866, 650.

90. W.J. McCormack, ' "Never Put Your Name to an Anonymous Letter": Serial Reading in the *Dublin University Magazine*, 1861 to 1869', *Yearbook of English Studies*, 26, 1996, 115.

91. See A. Lorhli, Introduction to *Household Words: Table of Contents, List of Contributor and Their Contributions*, for details of Dickens's editorial policies in relation to *Household Words*.

92. See G. Storey, K. Tillotson and N. Burgis (eds), *Pilgrim Edition of the Letters of Charles Dickens*, VI, 50. Subsequent references to this edition of Dickens's letters will be cited as *Pilgrim*, followed by volume and page references.

93. See Sutherland, *Victorian Novelists and Publishers*, 167, for details of Dickens's break with Bradbury and Evans.

94. See Gallagher, *Industrial Reformation*, for a discussion of the social conditions which gave rise to the 'social problem' novel.

95. For an examination of *North and South* and *Hard Times* in the context of *Household Words* see Gallagher, *Industrial Reformation*.

96. *All The Year Round*, II, 29 November 1859, 95.

97. Dallas, review of *Great Expectations*, 6.

98. See Table 1.1 for further details of the make up of both magazines.

99. *All The Year Round* was considerably more popular than *Household Words*. See the relevant sections in A. Sullivan, *British Literary Magazines: The Victorian and Edwardian Age, 1837–1913*.

100. See Chapter 7 for a discussion of the serialization of *Very Hard Cash* in *All The Year Round*.

101. P.A.W. Collins, 'The Significance of Dickens' Periodicals', *Review of English Literature*, 2, 1961, 61.

102. Anon., review of C. Dickens and W. Collins, *House to Let*, *Saturday Review*, 25 December 1858. Reprinted in P.A.W. Collins, *Charles Dickens: The Critical Heritage*, 406.

103. See Sutherland, *Victorian Novelists and Publishers*, 166–8.

104. See G.A. Sala, *Things I Have Seen and People I Have Known* vol. 1, 80–1.
105. See D. Liddle, 'Salesmen, Sportsmen, Mentors: Anonymity and Mid-Victorian Theories of Journalism', *Victorian Studies*, 41, Autumn, 1997, 31–68; and O. Maurer Jr., 'Anonymity vs. Signature in Victorian Reviewing', *Studies in English*, 27, June 1948, 1–27.
106. B. Quinn Schmidt, 'Novelists, Publishers, and Fiction in Middle-class Magazines, 1860–80', *Victorian Periodicals Review*, 17, 1984, 145.
107. See Sutherland, *Victorian Novelists and Publishers*, 175.
108. *Great Expectations* was serialized from December 1860 to August 1861; *No Name* from March 1862 to January 1863; *A Dark Night's Work* from January to March 1863; and *The Moonstone* from January to August 1868.
109. S. Lonoff, *Wilkie Collins and His Victorian Readers*, 80.
110. See Sutherland, *Victorian Novelists and Publishers*, 175–8. See also J. Meckier, '"Dashing in Now": *Great Expectations* and Charles Lever's *A Day's Ride*', *Dickens Studies Annual*, 26, 1998, 227–60.
111. P.A.W. Collins, 'The *All The Year Round* Letter Book', *Victorian Periodicals Review*, 10, 1970, 27.
112. For details of *Once A Week* see S. Elwell, 'Editors and Social Change: A Case Study of *Once A Week* (1859–80)', in J.H. Wiener (ed.), *Innovators and Preachers*.
113. Prospectus, reprinted in Sullivan, *British Literary Magazines*, 287.
114. R.A. Gettmann, 'The Serialization of Reade's *A Good Fight*', *Nineteenth-Century Fiction*, 1, June 1951, 26.
115. Sullivan, *British Literary Magazines*, 287.
116. S. Brooks, 'Once A Week', *Once A Week*, I, 2 July 1859, 1–2.
117. Reprinted in R.C. Lehmann (ed.), *Dickens as Editor*, 269.
118. See J. Sutherland, '*Cornhill*'s Sales and Payments: The First Decade', *Victorian Periodicals Review*, 19, Fall 1986, 106, for details of Thackeray's salary. For details of Lucas's see Elwell, 'Editors and Social Change', 29.
119. W.E. Buckler, '*Once A Week* Under Samuel Lucas, 1859–65', *PMLA*, 67, 1952, 928.
120. Buckler, '*Once A Week*', 927–8.
121. See Elwell, 'Editors and Social Change', 25. Buckler, '*Once A Week*', 939, n. 49 argues differently, suggesting that the decline in sales began well before 1865.
122. Sullivan, *British Literary Magazines*, 290.
123. W.E. Houghton (ed.), *The Wellesley Index to Victorian Periodicals, 1824–1900* (5 vols) vol. I, 321.
124. Sullivan, *British Literary Magazines*, xvi.
125. M.W. Turner, 'Gendered Issues: Intertextuality and *The Small House at Allington* in *Cornhill Magazine*', *Victorian Periodicals Review*, 1993, 229.
126. Turner, *Trollope and the Magazines*, 12.
127. W.M. Thackeray, 'A Letter from the Editor to a Friend and Contributor', Prospectus announcing the publication of *The Cornhill*, 1 November 1859. Reprinted in G.N. Ray (ed.), *The Letters and Private Papers of W.M. Thackeray*, 160.
128. Reprinted in Ray (ed.), *The Letters of W.M. Thackeray*, 161.
129. Reprinted in Ray (ed.), *Letters of W.M. Thackeray*, 160.
130. Quoted in R.G. Cox, 'The Reviews and Magazines', in *The Pelican Guide to English Literature: The Victorian Age*, 195.

131. See Sutherland, '*Cornhill*'s Sales', 106–7.
132. See C. Peters, Introduction to W. Collins, *Armadale*, vii–viii.
133. Sutherland, '*Cornhill* Sales', 107.
134. See M. Elwin, *Victorian Wallflowers*, 168.
135. For a general introduction to the *New Monthly Magazine* see J. Sutherland, *The Longman Companion to Victorian Fiction*.
136. Sutherland, *Longman Companion*, 460.
137. Elwin, *Victorian Wallflowers*, 156.
138. C. Wood, *Memorials of Mrs Henry Wood*, 253–4.
139. Wood, *Memorials*, 206.

2 Wilkie Collins's *The Woman in White*

1. Mansel, 'Sensation Novels', op. cit. 482.
2. See Cruse, *Victorians and Their Books*, 322. See also Brantlinger, *The Reading Lesson*, 71, for details of the similar commercialization of Ainsworth's *Jack Sheppard* (1839–40), where among the souvenirs on sale were bags containing replicas of burglars' gear.
3. See C. Peters, *The King of Inventors: A Life of Wilkie Collins*, 167–8.
4. *The Dead Secret* was serialized from January to June 1857.
5. Quoted in Robinson, *Wilkie Collins*, 129.
6. Quoted in Robinson, *Wilkie Collins*, 130. Emphasis in the original.
7. Charles Reade and M.E. Braddon in particular drew upon Collins's narrative techniques in their sensation novels.
8. G.H. Lewes, 'Farewell Causerie', *Fortnightly Review*, VI, 1 December 1866, 894.
9. W. Collins, 'Vidocq; the French Detective', *All The Year Round*, III, 14 and 21 July 1860.
10. *The Perils of English Prisoners* was the *Household Words* Christmas number for 1857, while *House to Let* was the Christmas number for 1858. *The Lazy Tour*, was published in *Household Words* in four parts in October 1857.
11. C. Dickens, 'Hunted Down', *All The Year Round*, III, 4 and 11 August 1860.
12. W. Collins, *The Woman in White*, *All The Year Round*, III, 465. Subsequent volume and page references will be cited in the text.
13. Examples of this style of journalism in *All The Year Round* include: 'Down in the World', I, 10 September 1859, on families in the workhouse; 'Without A Name', II, 21 January 1860, on finding a home as a patient in Bedlam; and 'Happy and Unhappy Couples', III, 24 November 1860, on cases of bigamy.
14. Miller, 'Cage aux Folles', 101.
15. *The Woman in White*, according to Collins, originated in an actual case of a woman's false imprisonment in a lunatic asylum, outlined in Méjan's *Recueil des Causes Célèbres*. The origin of Hartright's midnight encounter with Anne Catherick is believed to have been Collins's own meeting with a 'woman in white' fleeing from a man who had imprisoned her in his villa. This is discussed in J.G. Millais's biography of his father, *The Life of John Everett Millais*, 2 vols.
16. Miller, 'Cage aux Folles', 96.
17. A. Trollope, *An Autobiography*, 257.

18. Miller, 'Cage aux Folles', 95. A short story which appeared during *The Woman in White*'s run, 'My Railway Collision' (II, 17 December 1859), also refers to premonitions of disaster in the context of an actual railway accident.
19. Oliphant, 'Sensation Novels', 566.
20. A. Vrettos, 'From Neurosis to Narrative: The Private Life of the Nerves in *Villette* and *Daniel Deronda*', *Victorian Studies*, 33, Summer 1990, 561.
21. J. Bourne Taylor, *In The Secret Theatre of Home: Wilkie Collins, Sensation Narrative, and Nineteenth-Century Psychology*, 33.
22. See Vrettos, 'From Neurosis to Narrative', 554–5 for a discussion of the mental health of 'Brainworkers'.
23. For details of Collins's poor health and laudanum addiction see Peters, *The King of Inventors*, 100. See also Robinson, *Wilkie Collins*.
24. 'The Breath of Life', *All The Year Round*, II, 17 March 1860, 484–8. Page references will be cited in the text.
25. Miller, 'Cage aux Folles', 97 also describes readers' responses to sensation fiction as 'hysterical'.
26. Taylor, *Secret Theatre of Home*, 69.
27. See Vrettos, 'From Neurosis to Narrative', 555.
28. Miller, 'Cage aux Folles', 114.
29. See M. Foucault, *Discipline and Punish: The Birth of the Prison*, trans. A. Sheridan.
30. Dickens, letter to W.H. Wills, 22 July 1855, reprinted in *Pilgrim Letters*, VII, 681. See also D. Wynne, 'Dickens's Changing Responses to Hereditary Insanity in *Household Words* and *All The Year Round*', *Notes & Queries*, 244, March 1999, 52–3.
31. Charles Reade was particularly keen to write on controversial topics. For an outline of his disputes with Dickens during the serialization of *Hard Cash* in *All The Year Round* see the chapter on Reade in J. Sutherland, *Victorian Fiction: Writers, Publishers, Readers*.
32. Anon., 'Without A Name', II, 21 January 1860, 291. Page references will be cited in the text.
33. Anon., 'The Black Tarn', *All The Year Round*, III 16 June–30 June 1860.
34. Anon., 'Life in Danger', *All The Year Round*, II, 24 March 1860, 506–8.
35. Anon., 'Man In!', *All The Year Round*, II, 21 January 1860, 293.
36. Trodd, *Domestic Crime*, 1.
37. See M. Foucault, (ed.) *I, Pierre Rivière, Having Slaughtered My Mother, My Sister, My Brother . . .* for discussion of an actual gallows speech.
38. Foucault, *Discipline and Punish*, 68.
39. Foucault, *Discipline and Punish*, 69.
40. H. James, 'Miss Braddon', *The Nation*, November 1865, 593–4.
41. F. Moretti, *Signs Taken for Wonders: Essays in the Sociology of Literary Forms*, 139.
42. See J.R. Reed, 'A Friend to Mammon: Speculation in Victorian Literature', *Victorian Studies*, 27, Winter 1984, 179–202.
43. The phrase 'universal struggle' is taken from Darwin's *Origin of Species* by Dickens and used in the first chapter of *Great Expectations*. *All The Year Round* published two articles in response to Darwin's theories, 'Natural Selection', III, 7 July 1860, and 'Species', III, 2 June 1860.
44. Darwin's *Origin of Species* also came out in November 1859.

45. J. Hollingshead, 'Convict Capitalists', *All The Year Round*, III, 9 July 1860, 202. Subsequent page references will be cited in the text.
46. J. Hollingshead, 'Very Singular Things in the City', *All The Year Round*, III, 14 July 1860, 35. Subsequent page references will be cited in the text.
47. For a recent discussion of *Self-Help* suggesting Smiles's ideology has been misunderstood see G. Day, 'Past and Present – The Case of Samuel Smiles' *Self-Help*', in G. Day (ed.), *Varieties of Victorianism*, 1–24.
48. Collins states his agreement with his character's views on crime in an interview with Edmund Yates. Reprinted in E. Yates, 'Mr Wilkie Collins in Gloucester Place', *Celebrities at Home*, 145–6.
49. Trodd, *Domestic Crime*, 7
50. See note 9.
51. See Trodd, *Domestic Crime*, 16.
52. See M. Booth, *English Melodrama*, 162.
53. An obvious example of a later super detective is Conan Doyle's Sherlock Holmes, with his enemy, the super criminal, Moriarty.
54. Quoted in Yates, 'Mr Wilkie Collins', 146.
55. Anon., 'Ardison & Co', *All The Year Round*, III, 7 July 1860, 299–301.
56. Among the articles on Italian issues which appeared in *All The Year Round* during this period are: 'The Sack of Perugia', I, 27 August 1859; 'The Northern Italians', I, 10 September 1859; and 'Italian Distrust', II, 26 November 1859.
57. Anon., 'Written in My Cell', *All The Year Round*, II, 14 April 1860, 21–4.
58. Anon., *The Black Tarn*.
59. See *Pilgrim Letters*, IX, 44, for details of Dickens's relationship with Wainewright.
60. See Sutherland, *Victorian Fiction*, 34.
61. C. Dickens, 'Hunted Down', 397. Subsequent page references will be cited in the text.
62. Oliphant, 'Sensation Novels', 567.
63. Lady Isabel Vane is the adulterous heroine of *East Lynne*. Aurora Floyd is the eponymous heroine of Braddon's second sensation novel, and Magdalen Vanstone is the heroine of Collins's *No Name*.

3 Ellen Wood's *East Lynne*

1. Quoted in Cruse, *The Victorians and Their Books*, 326.
2. For discussions of the dramatic versions of *East Lynne* see Booth, *English Melodrama*; E.A. Kaplan, *Motherhood and Representation: The Mother in Popular Culture and Melodrama*; and E. Hadley, *Melodramatic Tactics: Theatricalized Dissent in the English Literary Marketplace, 1800–1895*.
3. The most extensive study of the maternal melodrama in the context of *East Lynne* is chapter 5 of Kaplan's *Motherhood and Representation*. Other critics who discuss Wood's representation of motherhood include L. Langbauer, *Women and Romance: The Consolations of Gender in the English Novel*; A. Cvetkovich, *Mixed Feelings: Feminism, Mass Culture and Victorian Sensationalism*.
4. For discussions of *East Lynne* as specifically 'women's' fiction see S. Mitchell, 'Sentiment and Suffering: Women's Recreational Reading of the 1860s',

Victorian Studies, 21, 1977, 29–45; Cvetkovich's chapter on Wood's novel in *Mixed Feelings*, and Kaplan, *Motherhood and Representation*, 78.

5. *East Lynne, New Monthly Magazine*, volume CXX, page 266.
6. This section appears in the *New Monthly Magazine*, CXVII, 152, and comes immediately after the paragraph beginning, 'The word "business" always bore for Miss Carlyle one meaning, that of money-making.' Subsequent volume and page references to *East Lynne* will be cited in the text.
7. For example, both *Mrs Halliburton's Troubles* (1862) and *A Life's Secret* (1867) depict workers on strike. Wood's narrators' sympathies, however, are with the middle-class employers.
8. Bushby's *Why Is She an Old Maid?* appeared from June to August 1861. Ouida's *Granville de Vigne* was published from January 1861 to June 1863.
9. Wood's 'Seven Years in the Life of a Wedded Roman Catholic' appeared in the *New Monthly Magazine* in February 1851, 245–55.
10. Wood's 'Ensign Pepper' articles appeared from June to December 1854. For a discussion of these see D. Wynne, ' "See What a Big Wide Bed It Is!"': Mrs Henry Wood and the Philistine Imagination', in D. Duffy and E. Liggins (eds), *Feminist Readings of Victorian Popular Texts: Divergent Femininities*.
11. Wood, *Memorials*, 166.
12. See Sutherland, *The Longman Companion to Victorian Fiction* for details of Ainsworth's career.
13. Both Wood, *Memorials*, and E. Bigland in *Ouida: The Passionate Victorian*, claim that sales of the *New Monthly Magazine* increased during the serialization of Wood's and Ouida's novels.
14. Wood, *Memorials*, 234.
15. Wood, *Memorials*, 187.
16. Wood, *Memorials*, 314.
17. Wood, *Memorials*, 124–5.
18. Wood, *Memorials*, 96.
19. Wood, *Memorials*, 50.
20. Wood, *Memorials*, 141.
21. Wood, *Memorials*, 299.
22. Wood, *Memorials*, 227–8.
23. E. Showalter, *A Literature of Their Own*, 155.
24. For a discussion of this style of popular melodrama see M. Vicinus, 'Helpless and Unfriended: Nineteenth-Century Domestic Melodrama', *New Literary History*, 13, 1981, 132.
25. Kaplan, in Chapter 5 of *Motherhood and Representation*, does discuss *East Lynne*'s class theme; however, she sees the middle-class Carlyle as vulnerable rather than as hungry for power.
26. Kaplan, *Motherhood and Representation*, 78
27. Cvetkovich, *Mixed Feelings*, 98–9.
28. Cvetkovich, *Mixed Feelings*, 99.
29. Langbauer, *Women and Romance*, 177.
30. See in particular Wood's later novels, *Red Court Farm* (1868) and *Verner's Pride* (1862).
31. Wood, *Memorials*, 242.
32. S. Lucas, Review of *East Lynne, Times*, 25 January 1862, 6.

33. See Cruse, *Victorians and Their Books*, 324–6, for details of *East Lynne*'s popularity with Victorian readers.
34. M. Oliphant, 'Novels', *Blackwood's Magazine*, 94, August 1863, 170.
35. H. Michie, '"There is No Friend Like a Sister": Sisterhood as Sexual Difference', *ELH*, 56, Summer 1989, 407.
36. Pykett, *Improper Feminine*, 131.
37. Pykett, *Improper Feminine*, 118.
38. Hadley, *Melodramatic Tactics*, 169.
39. Kaplan, *Motherhood and Representation*, 78.
40. This tendency of the middle class to rise is most marked in *Mrs Halliburton's Troubles*, where Mrs Halliburton's sons, by means of self-discipline and self-education, raise themselves from their shabby genteel origins to gain wealth and political power.
41. Lucas, *The Times*, 6.
42. I will refer to the magazine serial as *Granville de Vigne*, although *Held in Bondage* became the novel's more widely known title.
43. For details of Ouida's life and work see Bigland, *Passionate Victorian*.
44. *Why is She an Old Maid?*, *New Monthly Magazine*, vol. CXXII, p. 206. Subsequent page references will appear in the text.
45. Kaplan, Cvetkovich, and Langbauer discuss Wood's invoking of the figure of the 'over-invested', or dangerously emotional, mother.
46. J. Fahnestock, 'Bigamy: The Rise and Fall of a Convention', *NCF*, 36, June 1981, 65.
47. Charles Dickens's 'Bound For The Great Salt Lake' is Essay XX in *The Uncommercial Traveller*. These essays were originally published in *All The Year Round* throughout the 1860s.
48. Anon., 'The Mormons and the Country They Dwell in', *New Monthly Magazine*, vol. CXXI, March 1861, 265. Subsequent page references will be cited in the text.
49. Mrs Henry Wood, *Verner's Pride*, 666.

4 Charles Dickens's *Great Expectations*

1. For a discussion of Dickens's relationship with Gaskell during the serialization of *North and South* see L.K. Hughes and M. Lund, *Victorian Publishing and Mrs Gaskell's Work*, 96–123.
2. See Sutherland, *Victorian Fiction*, 55–61 for a discussion of Dickens's relations with Reade.
3. See particularly Dickens's letter to Wills, 24 September 1858. Reprinted in *Pilgrim*, VIII, 669.
4. Dickens's addiction to giving public readings of his works during his last years indicates his ongoing dependency upon his readers' approval and loyalty.
5. L. Stephen, quoted in J. Don Vann, *Victorian Novels in Serial*, 7.
6. P. Hobsbaum, *A Reader's Guide to Charles Dickens*, 410; and P.W. Collins, 'The Significance of Dickens's Periodicals', 61.
7. See J. Meckier, '"Dashing in Now": *Great Expectations* and Charles Lever's *A Day's Ride*', *Dickens Studies Annual*, 26, 1998, 227–60. See also Sutherland,

Victorian Novelists and Publishers, 177–8; and A. Sadrin, *Great Expectations*, 3–17.

8. Sadrin, *Great Expectations*, 14.
9. See Oliphant, 'Sensation Novels', 574, for a review which argues that *Great Expectations* is a sensation novel.
10. Morel's *Traité des dégénérescences physiques, intellectuelles, et morales de l'éspéce humaine* was published in 1857, while Tours' *La Psychologie morbide* appeared in 1859. For the background to the reception of evolutionary theories in Victorian Britain see P. Morton, *The Vital Science: Biology and the Literary Imagination, 1860–1900*, and D. Pick, *Faces of Degeneration: A European Disorder c. 1848–1916*.
11. Anon., 'Natural Selection', *All The Year Round*, III, 7 July 1860, 297.
12. See Morton, *The Vital Science*, 122, and J. Oppenheim, *'Shattered Nerves': Doctors, Patients and Depression in Victorian England*, 279.
13. W.R. Greg, 'On the Failure of "Natural Selection" in the Case of Man', *Fraser's Magazine*, LXXVIII, September 1868, 353–62.
14. See in particular, Beer, *Darwin's Plots*; G. Levine, *Darwin and the Novelists: Patterns of Science in Victorian Fiction*, and P.A. Dale, *In Pursuit of a Scientific Culture: Science, Art, and Society in the Victorian Age*.
15. K. Flint, 'Origins, Species and *Great Expectations*', in D. Amigoni and J. Wallace (eds), *Charles Darwin's Origin of Species: New Interdisciplinary Essays*, 166–7.
16. G. Morgentaler, 'Meditating on the Low: A Darwinian Reading of *Great Expectations*', *Studies in English Literature*, 38, 1998, 708.
17. Morgentaler, 'Meditating on the Low', 709.
18. I have called the genre 'anxiety' fiction because of its anxious narrators who fear their 'unfitness'. There are no authorship details given for any of anxiety stories I discuss in E.A. Oppenlander's *Dickens' All The Year Round: Descriptive Index and Contributor List*.
19. Oliphant, 'Sensation Novels', 574–5.
20. Oliphant, 'Sensation Novels', 580.
21. See K.L. Spencer, 'Purity and Danger: *Dracula*, the Urban Gothic, and the Late Victorian Degeneracy Crisis', *ELH*, 59, 1992, 204.
22. Anon., 'The Family at Fenhouse', *All The Year Round*, IV, 22 December 1860, 260. Subsequent page references will appear in the text.
23. Anon., 'My Father's Secret', *All The Year Round*, IV, 9 March 1861, 517. Subsequent page references will appear in the text.
24. Anon., 'An Incident in the Tropics', *All The Year Round*, XVII, 5 January 1867, 31–4.
25. Anon., 'Out of the House of Bondage', *All The Year Round*, VII, 26 April 1862, 155–63. This story is discussed in detail in the next chapter.
26. Anon., 'Written in My Cell', *All The Year Round*, III, 14 April 1860, 21–4.
27. E. Miller Casey, 'Novels in Teaspoonfuls: Serial Novels in *All The Year Round*, 1859–95', Unpublished Ph.D. thesis, University of Winsconsin, 1969, 144.
28. C. Dickens, *Great Expectations*, *All The Year Round* (1 December 1860–3 August 1861) V, 51. Subsequent volume and page references will be cited in the text.
29. P. Brooks, *Reading for the Plot: Design and Intention in Narrative*, 340 n. 9.

30. Freud discusses his 'Wolf-Man' case more fully in his 'History of an Infantile Neurosis' (1918); 'Material From Fairytales in Dreams' was published in 1913. Both are reprinted in S. Freud, *Collected Papers*, trans. J. Riviere, vol. 4.
31. C. Ginzburg, *Myths, Emblems, Clues*, trans. J and A.C. Tedeschi.
32. For a discussion of the links between *Great Expectations* and Mary Shelley's *Frankenstein* see I. Crawford, 'Pip and the Monster: The Joys of Bondage', *Studies in English Literature*, 28, 1988, 625–48.
33. D. Trotter, *Circulation: Defoe, Dickens and the Economies of the Novel*, 133.
34. A. Sadrin, *Parentage and Inheritance in the Novels of Charles Dickens*, 96.

5 Wilkie Collins's *No Name*

1. Hughes, *Maniac in the Cellar*, 145.
2. Quoted in Robinson, *Wilkie Collins*, 147.
3. See V. Blain, Introduction to W. Collins *No Name*, xi.
4. Letter to Collins, 14 October 1862. Reprinted in W. Dexter (ed.), *The Letters of Charles Dickens*, III, 310.
5. Robinson, *Wilkie Collins*, 154.
6. Letter to Collins, 8 October 1862. Reprinted in Dexter, *Letters*, III, 307.
7. Blain, Introduction to *No Name*, x.
8. Anon., review of *No Name*, *The Reader*, I, 3 January 1863, 15.
9. H.F. Chorley, review of *No Name*, *Athenaeum*, 3 January 1863, 10.
10. A. Smith, review of *No Name*, *North British Review*, XXXVIII, February 1863, 184.
11. D. David, 'Rewriting the Male Plot in Wilkie Collins's *No Name*', in L. Pykett (ed.), *Wilkie Collins: Contemporary Critical Essays*, 137.
12. W. Collins, *No Name*, *All The Year Round*, VII, 363. Subsequent volume and page references will be cited in the text.
13. David, 'Rewriting the Male Plot', 143.
14. Mansel, 'Sensation Novels', *Quarterly Review*, 1863, 495.
15. W.R. Greg, 'Why are Women Redundant?', *National Review*, XIV, April 1862, 434–60; and F. Power Cobbe, 'What Shall We Do with our Old Maids?', *Fraser's Magazine*, LXVI, November 1862, 594–610.
16. Oliphant, 'Sensation Novels', 564–5.
17. A.A. Fisch, '"Repetitious Accounts so Piteous and so Harrowing": The Ideological Work of American Slave Narratives in England', *Journal of Victorian Culture*, 1, Spring 1996, 18.
18. Anon., 'Out of the House of Bondage', 156. Subsequent page references will be cited in the text.
19. E. Lynn Linton, 'Gone to Jail', *All The Year Round*, VII, 2 August 1862, 490. Subsequent page references will be cited in the text.
20. 'Granny Collis' may have been a model for Betty Higden, the old working woman who dreads 'imprisonment' in the workhouse in Dickens's *Our Mutual Friend*.
21. Readers finally discover Magdalen's innocence in the 8 November 1862 instalment, *All The Year Round*, VIII, 192.

22. F. Nightingale, 'Cassandra' (1852), reprinted in full in R. Strachey, *The Cause: A Short History of the Women's Movement in Great Britain*, 397.
23. E. Lynn Linton, 'The Girl from the Workhouse', *All The Year Round*, VIII, 8 October 1862, 132.
24. For an account of Urania Cottage and its inmates see Dickens's article, 'Home for Homeless Women', *Household Words*, VII, 23 April 1853, 169–74.
25. See R. Lewis, *Gendering Orientalism: Race, Femininity and Representation* for a discussion of Western Victorian representations of the harem.
26. Anon., 'Mrs Mohammed Bey "At Home"' *All The Year Round*, VII, 12 April 1862, 103. Subsequent page references will be cited in the text.
27. Bourne Taylor, *Secret Theatre of Home*, 137.
28. Madame Rachel was tried and convicted at the Old Bailey in 1867. See C. Peters, Introduction to *Armadale*, xiv; and Altick, *Presence of the Present*, 543–4.
29. Anon., 'Paint, and No Paint', *All The Year Round*, VII, 9 August 1862, 521. Subsequent page references will be cited in the text.
30. Quoted in Trodd, *Domestic Crime*, 38.
31. Anon., 'Worse Witches than Macbeth's', *All The Year Round*, 15 March 1862, 13.
32. Anon., 'The Polite World's Nunnery', *All The Year Round*, VII, 24 May 1862, 246.
33. David, 'Rewriting the Male Plot', 144.
34. Anon., 'Pinchback's Cottage', *All The Year Round*, VII, 22 March 1862, 31.
35. M. Oliphant, 'Novels', *Blackwood's*, August 1863, 168–83.

6 Mary Elizabeth Braddon's *Eleanor's Victory*

1. See in particular Buckler, '*Once A Week* Under Samuel Lucas'; F. Reid, *Illustrators of the 1860s*; D.P. Whiteley, 'George Du Maurier's Illustrations for *Once A Week*', *Alphabet and Image*, 5, September 1947, 17–29; and S. Elwell, 'Editors and Social Change: A Case Study of *Once A Week* (1859–80)', in J.H. Wiener (ed.), *Innovators and Preachers*.
2. G. White, *English Illustration: The 'Sixties* (1897), quoted in Whiteley, 'George Du Maurier's Illustrations', op. cit.
3. See Elwell, 'Editors and Social Change', 29.
4. Sullivan, *British Literary Magazines*, 290.
5. For a discussion of Bradbury and Evans's split with Dickens and the end of *Household Words* see Sutherland, *Victorian Novelists and Publishers*, 166–9.
6. See Buckler, '*Once A Week* Under Samuel Lucas', 924.
7. S.C. Robinson, 'Editing *Belgravia*: M.E. Braddon's Defense of "Light Literature"', *VPR*, 28, Summer 1995, 109–22.
8. See Wolff, *Sensational Victorian*, for a general analysis of the reception of Braddon's work throughout her career.
9. *Lady Audley's Secret* and *Aurora Floyd* have received attention from feminist critics. Perceptive discussions of these novels are made in Showalter's *A Literature of Their Own*; Trodd, *Domestic Crime*; Pykett, *Improper Feminine*; and Flint, *The Woman Reader*. Over her long career as a writer, from the late 1850s to the early twentieth century, Braddon produced 85 novels.

10. Quoted in Wolff, *Sensational Victorian*, 11. See also D. Wynne, 'Two Audley Courts: Tennyson and M.E. Braddon', *Notes & Queries*, 242, September 1997, 344–5.
11. Quoted in Cruse, *The Victorians and Their Books*, 327.
12. E. Miller Casey, 'Edging Women Out?: Reviews of Women Novelists in the *Athenaeum*, 1800–1900', *Victorian Studies*, 36, Winter 1996, 156.
13. Anon., 'Mrs Wood and Miss Braddon', *Littell's Living Age*, 18 April 1863, 99–103.
14. For details of Braddon's life and career see R.L. Wolff, *Sensational Victorian: The Life and Fiction of Mary Elizabeth Braddon*.
15. N. Cross, *The Common Writer*, 175.
16. See Altick, *English Common Reader*, 352, n.6, for further details of the male readership of penny dreadfuls.
17. James, 'Miss Braddon', *The Nation*, November 1865, 594.
18. James, 'Miss Braddon', 593.
19. Reprinted in R.L. Wolff, 'Devoted Disciple: The Letters of M.E. Braddon to Sir E. Bulwer-Lytton, 1862–73', *Harvard Library Bulletin*, 22, January 1974, 4.
20. Anon. review of *Eleanor's Victory*, *Saturday Review*, 19 September 1863, 397.
21. James, 'Miss Braddon', 594.
22. A. Trodd, 'Michael Angelo Titmarsh and the Knebworth Apollo', *Costerus*, 2, 1974, 63.
23. Reprinted in Wolff, 'Devoted Disciple', 14.
24. M.E. Braddon, *Eleanor's Victory*, *Once A Week*, 7 March–26 September 1863. Volume IX, page 19. Subsequent volume and page references will be cited in the text.
25. Braddon also refers to the Pre-Raphaelite Brotherhood in *Lady Audley's Secret*, where the portrait of Lady Audley in the Pre-Raphaelite style reveals her inner wickedness.
26. W.F. Ray, 'Sensation Novelists: Miss Braddon', *North British Review*, 43, 1865, 204.
27. Anon., 'Mrs Wood and Miss Braddon', *Littell's Living Age*, 99–100.
28. M.E. Braddon, *The Doctor's Wife* (London, 1864), 56.
29. Anon., Review of *Eleanor's Victory*, *Saturday Review*, 396.
30. Quoted in Wolff, 'Devoted Disciple', 10.
31. Flint, *The Woman Reader*, 283.
32. E. Traherne, 'Paul Garrett; Or, The Secret', *Once A Week*, IX, 27 June 1863, 1–8.
33. Anon., 'My Neighbour at the Theatre', *Once A Week*, VIII, 16 May 1863, 573. Subsequent page references will be cited in the text.
34. D. Cook, 'Lavinia Fenton', *Once A Week*, VIII, 6 June 1863, 651. Subsequent page references will be cited in the text.
35. Signed 'R.A.B.', 'The Celibate Consoled', *Once A Week*, VIII, 2 May 1863, 518.
36. Reprinted in Wolff, 'Devoted Disciple', 139.

7 Charles Reade's *Very Hard Cash*

1. M. Oliphant, 'Novels', *Blackwood's*, September 1867, 280.
2. F. Waddy, *Cartoon Portraits and Biographical Sketches of Men of the Day*, 62.
3. Quoted in Lehmann, *Dickens as Editor*, 303.
4. Oliphant, 'Novels', 280.

5. Waddy, *Cartoon Portraits*, 62.
6. See R.A. Gettmann, 'The Serialization of Reade's "A Good Fight"', *Nineteenth-Century Fiction*, 1, June 1951, 21–32. *The Cloister and the Hearth* appeared as a serial in *Once A Week* under the title, *A Good Fight*.
7. See Sutherland, *Victorian Fiction*, 60.
8. C. Reade, Preface to the 1863 edition of *Hard Cash*, 2 volumes, (Boston and New York: Colonial Press, n.d.).
9. See S.M. Smith, 'Propaganda and Hard Facts in Charles Reade's Didactic Novels: A Study of *It's Never Too Late To Mend* and *Hard Cash*', *Renaissance & Modern Studies*, 4, 1960, 135–49.
10. J.S. Bushnan, quoted in Preface to *Hard Cash*, 5.
11. Bushnan, quoted in Preface, 6.
12. *All The Year Round*, X, 14 November 1863, 265.
13. *All The Year Round*, X, 26 December 1863, 419.
14. Anon., Review of *Hard Cash*, *The Times*, 2 January 1864, 6.
15. Reade, Preface to *Hard Cash*, 3.
16. Sutherland, *Victorian Fiction*, 59.
17. Stang, *Theory of the Novel in England*, 29.
18. C. Reade, *Hard Cash*, II, 229. Subsequent volume and page references will be cited in the text.
19. Mansel, 'Sensation Novels', *Quarterly Review*, 1863 487.
20. The next chapter explores this further.
21. James, 'Miss Braddon', *The Nation*, November 1865, 593.
22. Anon., Review of *The Cloister and the Hearth*, *Saturday Review*, 12 October 1861, 381.
23. Miller Casey, 'Novels in Teaspoonfuls', 74.
24. Review, *Saturday Review*, op. cit. 381.
25. Letter to Wills, 23 November 1863, quoted in Sutherland, *Victorian Fiction*, 60. Emphasis in the original.
26. Reade, *Very Hard Cash*, *All The Year Round*, X, 3 October 1863, 124. Subsequent volume and page references will be cited in the text.

8 Wilkie Collins's *Armadale*

1. Hughes, *Maniac in the Cellar*, 37 and 4.
2. See P. Brooks, *The Melodramatic Imagination: Balzac, Henry James, Melodrama and the Mode of Excess*, ix.
3. Anon., Review of *Armadale*, *Saturday Review*, 16 June 1866, 726.
4. *Wives and Daughters* appeared in *The Cornhill* from August 1864 to January 1866. *Armadale* appeared from November 1864 to June 1866, and *The Claverings* was serialized from February 1866 to May 1867.
5. Examples of family magazines which specialized in specific types of fiction are *All The Year Round* with sensation novels, *Blackwood's* (particularly during its early years) with ghost stories, *Macmillan's* with the 'muscular Christianity' genre, and *Good Words* with religious fiction.
6. W. Collins, Preface to *Armadale* (April 1866), reprinted in the Oxford World Classics edition (1989).

7. George Smith was not so even handed in the payment of *The Cornhill* authors, Gaskell receiving considerably less than Collins and Trollope. See Sutherland, 'The *Cornhill*'s Sales', 106–8.
8. *Romola* was serialized in *The Cornhill* from July 1862 to August 1863.
9. H.F. Chorley, review of *Wives and Daughters*, *The Athenaeum*, 3 March 1866, 295.
10. H.F. Chorley, review of *Armadale*, *Athenaeum*, 2 June 1866, 732.
11. Anon., review of *Armadale*, *Saturday Review*, 16 June 1866, 726.
12. Anon., review of *Wives and Daughters*, *Manchester Guardian*, 1 May 1866, 7.
13. Anon., review of *The Claverings*, *Saturday Review*, 18 May 1867, 638.
14. Chorley, review of *Armadale*, 732.
15. Anon., review of *Armadale*, *London Quarterly Review*, XXVII, October 1866. Reprinted in N. Page (ed.), *Wilkie Collins: The Critical Heritage*, 152.
16. Anon., review of *Armadale*, *Saturday Review*, 726.
17. Anon., review of *The Claverings*, *Athenaeum*, 15 June 1867, 783.
18. Mitchell, 'Sentiment and Suffering', 32.
19. Mitchell, 'Sentiment and Suffering', 41.
20. Trollope, *An Autobiography*, 211.
21. It is interesting to note (although difficult to explain why) that the 'bad' women of all three *Cornhill* serials, Lydia, Julia, and Cynthia, have similar 'classical' names.
22. H. James, review of *Wives and Daughters*, *The Nation*, February 1866, 246–7.
23. Anon., review of *Wives and Daughters*, *Spectator*, 17 March 1866, 300.
24. Anon., review of *Wives and Daughters*, *Saturday Review*, 24 March 1866, 360–1.
25. Anon., review of *The Claverings*, *Spectator*, 4 May 1867, 639.
26. Anon., review of *The Claverings*, *Saturday Review*, 18 May 1867, 639.
27. M. Oliphant, 'Novels', *Blackwood's Magazine*, September 1867, 275–7.
28. Anon., review of *The Claverings*, *Saturday Review*, 639.
29. Barickman *et al.*, *Corrupt Relations*, 147.
30. C. Peters, Introduction, *Armadale*, xviii.
31. Hughes, *Maniac in the Cellar*, 158.
32. W. Collins, *Armadale*, *The Cornhill Magazine*, XIII, 339. Subsequent volume and page references will be cited in the text.
33. Showalter, 'Family Secrets', 104.
34. E. Gaskell, *Wives and Daughters*, *The Cornhill Magazine*, X, 129. Subsequent volume and page references will be cited in the text.
35. Brooks, *Melodramatic Imagination*, 4.
36. Anon., review of *Wives and Daughters*, *Spectator*, 300.
37. See A. Easson, *Elizabeth Gaskell: The Critical Heritage* 456–86 for a range of contemporary assessments of *Wives and Daughters*.
38. P. Brantlinger, 'What is "Sensational" about the Sensation Novel?', *Nineteenth-Century Fiction*, 37, June 1982, 26. An expanded version of this essay appears as Chapter 7 in Brantlinger's *The Reading Lesson*.
39. Oliphant, 'Novels', 276.
40. Oliphant, 'Novels', 276.
41. S. Sillars, *Visualization and Popular Fiction, 1860–1960: Graphic Narratives, Fictional Images*, 30–1.
42. N. John Hall, *Trollope and his Illustrators*, 103.

43. For a discussion of visual 'countervoices' working against a written text, see J.L. Fisher, 'Image versus Text in the Illustrated Novels of W.M. Thackeray', in C. Christ and J.O. Jordan (eds), *Victorian Literature and the Victorian Visual Imagination*, 61.
44. Anon., review of *Armadale* in *Spectator*, 9 June 1866, 640.
45. Brantlinger, *The Reading Lesson*, 161.

Conclusion

1. Cox, 'The Reviews and Magazines', 188.
2. Houghton, Introduction to *Wellesley Index*, xv.
3. See L. Pykett, 'Reading the Periodical Press: Text and Context', *Victorian Periodicals Review*, 22, Fall 1989, 100–8.
4. James, 'The Trouble With Betsy', 352.
5. Among the interesting studies to emerge in recent years on the Victorian periodical press are Beetham, *A Magazine of Her Own?*, L. Brake, *Subjugated Knowledges: Journalism, Gender and Literature in the Nineteenth-Century*, Hughes and Lund, *Victorian Publishing and Mrs Gaskell's Work*, and Turner, *Trollope and the Magazines*.
6. Hughes and Lund, *The Victorian Serial*.
7. See McCormack, 'Never Put Your Name', 115.

Bibliography

(For reasons of space and clarity I have not listed each article or review from nineteenth-century periodicals. These are cited in the footnotes.)

Allingham, W., *A Diary* (London: Macmillan, 1907)

Altick, R.D., *The English Common Reader: A Social History of the Mass Reading Public, 1800–1900* (Chicago and London: University of Chicago Press, 1957)

———, *Victorian Studies in Scarlet* (London: Dent, 1970)

———, *The Presence of the Present: Topics of the Day in the Victorian Novel* (Columbus: Ohio State University Press, 1991)

Barickman, R. S. MacDonald and M. Stark, *Corrupt Relations: Dickens, Thackeray, Trollope, Collins, and the Victorian Sexual System*, (New York: Columbia University Press, 1982)

Battiscombe, G., *Charlotte Mary Yonge: The Story of an Uneventful Life* (London: Constable, 1943)

Beer, G., *Darwin's Plots: Evolutionary Narrative in Darwin, George Eliot, and Nineteenth-Century Fiction* (London: Routledge, 1983)

———, *Arguing With The Past: Essays in Narrative from Woolf to Sidney*, (London: Routledge, 1989)

Beetham, M., *A Magazine of Her Own? Domesticity and Desire in the Woman's Magazine, 1800–1914* (London and New York: Routledge, 1996)

Bell, B., 'Fiction in the Marketplace: Towards a Study of the Victorian Serial', in R. Myers and M. Harris (eds), *Serials and Their Readers* (Winchester: St. Paul's Bibliographies, 1993)

Bigland, E., *Ouida: The Passionate Victorian* (London: Jarrolds, 1950)

Blain, V., Introduction to W. Collins, *No Name* (Oxford: Oxford World Classics, 1992)

Blake, A., *Reading Victorian Fiction: The Cultural Context and Ideological Content of the Nineteenth-Century Novel* (London and Basingstoke: Macmillan – now Palgrave, 1989)

Booth, M., *English Melodrama* (London: Herbert Jenkins, 1965)

Bourne Taylor, J., *In the Secret Theatre of Home: Wilkie Collins, Sensation Narrative, and Nineteenth-Century Psychology* (London: Routledge, 1988)

———, 'Obscure Recesses: Locating the Victorian Unconscious', in J.B. Bullen (ed.), *Writing and Victorianism* (London and New York: Longman, 1997)

Brake, L., '"The Trepidation of the Spheres": The serial and the book in the 19th century', in R. Myers and M. Harris (eds), *Serials and Their Readers* (Winchester: St. Paul's Bibliographies, 1993)

———, *Subjugated Knowledges: Journalism, Gender and Literature in the Nineteenth-Century* (London and Basingstoke: Macmillan – now Palgrave, 1994)

———, 'Writing, Cultural Production, and the Periodical Press in the Nineteenth Century', in J.B. Bullen (ed.), *Writing and Victorianism* (London and New York: Longman, 1997)

Brantlinger, P., 'What is "Sensational" About the "Sensation Novel"?', *NCF*, 37 1, June 1982, 1–28

———, *The Reading Lesson: The Threat of Mass Literacy in Nineteenth-Century British Fiction* (Bloomington, Indiana: Indiana University Press, 1998)

Brooks, P., *The Melodramatic Imagination: Balzac, Henry James, Melodrama, and the Mode of Excess* (New Haven: Yale University Press, 1976)

———, *Reading for the Plot: Design and Intention in Narrative* (Oxford: Clarendon Press, 1984)

Buckler, W.E., '*Once A Week* Under Samuel Lucas, 1859–65', *PMLA*, 67, 1952, 924–41

Butler, M., *Jane Austen and the War of Ideas* (Oxford: Clarendon Press, 1975)

Christ, C.T. and J.O. Jordan (eds), *Victorian Literature and the Victorian Visual Imagination* (Berkeley and London: University of California Press, 1995)

Collins, P.A.W., 'The Significance of Dickens' Periodicals', *Review of English Literature*, 2, 1961, 55–64

———, 'The *All The Year Round* Letter Book', *Victorian Periodicals Review*, 10, November 1970, 23–9

———, (ed.), *Charles Dickens: The Critical Heritage* (London: Routledge and Kegan Paul, 1971)

Collins, W., *My Miscellanies* (London: Chatto & Windus, 1875)

Cox, R.G., 'The Reviews and Magazines', in B. Ford (ed.), *The Pelican Guide to English Literature: From Dickens to Hardy* (Harmondsworth: Penguin, 1958)

Crawford, I., 'Pip and the Monster: The Joys of Bondage', *Studies in English Literature*, 28, 1988, 625–48

Cross, N., *The Common Writer: Life in Nineteenth-Century Grub Street* (Cambridge: Cambridge University Press, 1985)

Cruse, A., *The Victorians and Their Books* (London: Allen & Unwin, 1935)

Cvetkovich, A., *Mixed Feelings: Feminism, Mass Culture, and Victorian Sensationalism* (New Brunswick and London: Rutgers University Press, 1992)

Dale, P.A., *In Pursuit of a Scientific Culture: Science, Art, and Society in the Victorian Age* (Madison: University of Wisconsin Press, 1989)

Daly, N., 'Railway Novels: Sensation Fiction and the Modernization of the Senses', *ELH*, 66, 1999, 461–87

Dalziel, M., *Popular Fiction 100 Years Ago: An Unexplored Tract of Literary History* (London: Cohen & West, 1957)

David, D., 'Rewriting the Male Plot in Wilkie Collins's *No Name*', in L. Pykett (ed.), *Wilkie Collins* (London and Basingstoke: Macmillan – Now Palgrave, 1998)

Easson, A. (ed.), *Elizabeth Gaskell: The Critical Heritage* (London and New York: Routledge, 1991)

Elliott, J.B., 'A Lady to the End: The Case of Isabel Vane', *Victorian Studies*, March 1976, 329–44

Elwell, S., 'Editors and Social Change: A Case Study of *Once A Week*, 1859–1880', in J.H. Wiener (ed.), *Innovators and Preachers: The Role of the Editor in Victorian England* (Connecticutt and London: Greenwood Press, 1985)

Elwin, M., *Victorian Wallflowers* (London: Jonathan Cape, 1934)

Fahnestock, J., 'Bigamy: The Rise and Fall of a Convention', *Nineteenth Century Fiction*, 36, June 1981, 47–71

Feltes, N.N., *Modes of Production in Victorian Novels* (Chicago: University of Chicago Press, 1986)

Fisch, A.A., ' "Repetitious accounts so piteous and so harrowing": the ideological work of American slave narratives in England', *Journal of Victorian Culture*, 1, 1, Spring 1996, 16–34

Fisher, J.L., 'Image versus Text in the Illustrated Novels of W.M. Thackerary', in C.T. Christ and J.O. Jordan (eds) *Victorian Literature and the Victorian Visual Imagination* (Berkeley and London: University of California Press, 1995)

Flint, K., 'Fictional Suburbia', in P. Humm P. Stigant and P. Widdowson (eds), *Popular Fictions: Essays in Literature and History* (London and New York: Methuen, 1986)

——— *The Woman Reader, 1837–1914* (Oxford: Clarendon Press, 1993

———, 'Introduction' *Great Expectations* (Oxford: Oxford World Classics, 1994)

———, 'Origins, Species and *Great Expectations*', in D. Amigoni and J. Wallace (eds), *Charles Darwin's Origin of Species: New Interdisciplinary Essays* (Manchester: Manchester University Press, 1995)

Foucault, M. (ed.), *I, Pierre Rivière, Having Slaughtered My Mother, My Sister, My Brother ...* (Harmondsworth: Penguin, 1973)

———, *Discipline and Punish: The Birth of the Prison* (trans. A. Sheriden), (Harmondsworth: Penguin, 1977)

Freud, S., *Collected Papers* [trans. J. Riviere] vol. 4 (London: Hogarth Press 1949)

Gallagher, C., *The Industrial Reformation of English Fiction: Social Discourse and Narrative Form, 1832–1867* (Chicago and London: University of Chicago Press, 1980)

Gettmann, R.A., 'The Serialization of Reade's *A Good Fight*', *Nineteenth-Century Fiction*, 1, June 1951, 21–32

Ginzburg, C., *Myths, Emblems, Clues* (trans. J. and A.C. Tedeschi), (London: Hutchinson Radius, 1990)

Griest. G., *Mudie's Circulating Library and the Victorian Novel* (Bloomington: University of Indiana Press, 1970)

Grubb, G.G., 'The Editorial Policies of Charles Dickens', *PMLA*, 58, 1943, 1110–24

Hadley, E., *Melodramatic Tactics: Theatricalized Dissent in the English Marketplace, 1800–95* (California: Stanford University Press, 1995)

Hagedorn, R., 'Technology and Economic Exploitation: The Serial as a Form of Narrative Presentation', *Wide Angle*, 10, 1988, 4–12

Hall, N.J., *Trollope and His Illustrators* (London and Basingstoke: Macmillan – now Palgrave, 1980)

Hartman, M.S., *Victorian Murderesses: A True History of Thirteen Respectable French and English Women Accused of Unspeakable Crimes* (New York: Schoken, 1977)

Hayward, J., *Consuming Pleasures: Active Audiences and Serial Fiction from Dickens to Soap Opera* (Lexington: University Press of Kentucky, 1997)

Heller, T., *Dead Secrets: Wilkie Collins and the Female Gothic* (New Haven and London: Yale University Press, 1992)

Hobsbaum, P., *A Reader's Guide to Charles Dickens* (London: Thames & Hudson, 1972)

Hollingsworth, K., *The Newgate Novel* (Detroit: Wayne State University Press, 1963)

Houghton, W.E., *The Victorian Frame of Mind* (New Haven and London: Yale University Press, 1957)

———, (ed.), *The Wellesley Index to Victorian Periodicals, 1824–1900* (Toronto and London: University of Toronto Press & Routledge and Kegan Paul 1966–)

Hughes, L.K. and M. Lund, *The Victorian Serial* (Charlottesville & London: University of Virginia Press, 1991)

———, *Victorian Publishing and Mrs Gaskell's Work* (Charlottesville & London: University Press of Virginia, 1999)

———, 'Linear Stories and Circular Visions: The Decline of the Victorian Serial', in N.K. Hayes (ed.), *Chaos and Order: Complex Dynamics in Literature and Science* (Chicago and London: University of Chicago Press, 1991)

———, 'Textual/sexual pleasure and serial publication', in J.O. Jordan and R.L. Patten (eds), *Literature in the Marketplace: Nineteenth-Century British Publishing and Reading Practices* (Cambridge: Cambridge University Press 1995)

Hughes, W., *The Maniac in the Cellar: Sensation Novels of the 1860s* (New Jersey: Princeton University Press, 1980)

Hutton, L. (ed.), *Letters of Charles Dickens to Wilkie Collins* (London: Osgood, McIlvaine, 1892)

James, L., *Fiction for the Working Man, 1830–1850* (London: Oxford University Press, 1963)

———, 'The Trouble With Betsy: Periodicals and the Common Reader in Mid-Nineteenth Century England', in J. Shattock and R. Wolff (eds), *The Victorian Periodical Press: Samplings and Soundings* (Leicester: Leicester University Press, 1982)

Jordan, J.O. and R.L. Patten (eds), *Literature in the Marketplace: Nineteenth-Century British Publishing and Reading Practices* (Cambridge: Cambridge University Press, 1995)

Kalikoff, B., *Murder and Moral Decay in Victorian Popular Literature* (Ann Arbor, Michigan: UMI Research Press, 1986)

Kaplan, E.A., 'The Political Unconscious in the Maternal Melodrama: Ellen Wood's *East Lynne*', in D. Longhurst (ed.), *Gender, Genre and Narrative Pleasure* (London: Unwin, 1989)

———, *Motherhood and Representation: The Mother in Popular Culture and Melodrama* (New York and London: Routledge, 1992)

Kristeva, J., 'Word, Dialogue, and Novel', in T. Moi (ed.), *The Kristeva Reader* (Oxford: Blackwell, 1986)

Langbauer, L., *Women and Romance: The Consolations of Gender in the English Novel* (Ithaca and London: Cornell University Press, 1990)

Lehmann, R.C. (ed.), *Charles Dickens as Editor* (London: Smith Elder, 1912)

Levine, G., *Darwin and the Novelists: Patterns of Science in Victorian Fiction* (Chicago: Chicago University Press, 1988)

Lewis, R., *Gendering Orientalism: Race, Femininity and Representation* (London and New York: Routledge, 1996)

Liddle, D., 'Salesmen, Sportsmen, Mentors: Anonymity and Mid-Victorian Theories of Journalism', *Victorian Studies*, 41, Autumn 1997, 31–68

Loesberg, J., 'The Ideology of Narrative Form in Sensation Fiction', *Representations*, 13, 1986, 18–35

Lohrli, A. (comp.), *Household Words: Table of Contents, List of Contributors and Their Contributions* (Toronto: Toronto University Press, 1973)

Lonoff, S., *Wilkie Collins and His Victorian Readers: A Study in the Rhetoric of Authorship* (New York: A.M.S., 1982)

Lucas, J., 'Mrs Gaskell and the Nature of Social Change', *Literature and History*, 1, March 1975, 3–27

Martin, C.A., *George Eliot's Serial Fiction* (Columbus: Ohio State University Press, 1994)

Maurer Jnr., O., 'Anonymity vs. Signature in Victorian Reviewing', *Studies in English*, 27, June 1948, 1–27

Maxwell Jnr., R.C., 'G.M. Reynolds, Dickens, and the Mysteries of London', *Nineteenth-Century Fiction*, 32, 1977, 188–213

Mays, K.J., 'The Disease of Reading and Victorian Periodicals', in J.O. Jordan and R.L. Patten (eds), *Literature in the Marketplace: Nineteenth-Century British Publishing and Reading Practices* (Cambridge: Cambridge University Press, 1995)

McCormack, W.J., *Sheridan Le Fanu and Victorian Ireland* (Oxford: Clarendon Press, 1980)

————, ' "Never Put Your Name to an Anonymous Letter": Serial Reading in the *Dublin University Magazine*, 1861–1869', *Yearbook of English Studies*, 26, 1996, 100–15

Meckier, J., ' "Dashing in Now": *Great Expectations* and Charles Lever's *A Day's Ride*', *Dickens Studies Annual*, 26, 1998, 227–80

Meisel, M., *Realizations: Narrative, Pictorial, and Theatrical Arts in Nineteenth-Century England* (New Jersey: Princeton University Press, 1983)

Michie, H., ' "There is No Friend Like a Sister": Sisterhood as Sexual Difference', *ELH*, 56, Summer 1989, 401–21

Millais, J.G., *The Life of John Everett Millais* 2 vols. (London: Methuen, 1899)

Miller, D.A., *The Novel and the Police* (Berkeley and London: California University Press, 1988)

————, '*Cage aux Folles*: Sensation and Gender in Wilkie Collins's *The Woman in White*', in J. Hawthorne (ed.), *The Nineteenth-Century British Novel* (London: Edward Arnold, 1986)

Miller Casey, E., *Novels in Teaspoonfuls: Serial Novels in All The Year Round*, unpublished Ph.D. thesis (University of Wisconsin, 1969)

————, 'Edging Women Out?: Reviews of Women Novelists in the *Athenaeum*, 1800–1900', *Victorian Studies*, 36, Winter 1996, 151–71

Mitchell, S., 'Sentiment and Suffering: Women's Recreational Reading in the 1860s', *Victorian Studies*, 21, 1977, 29–45

Morgentaler, G., 'Meditating on the Low: A Darwinian Reading of *Great Expectations*', *Studies in English Literature*, 38, 1998, 707–21

Moretti, F., *Signs Taken for Wonders: Essays in the Sociology of Literary Forms* (London: Verso, 1983)

Morton, P., *The Vital Science: Biology and the Literary Imagination, 1860–1900* (London: Allen & Unwin, 1984)

Moynahan, J., 'The Hero's Guilt: The Case of *Great Expectations*', *Essays in Criticism*, 10, 1 January 1960, 60–79

Myers, R. and M. Harris (eds), *Serials and Their Readers* (Winchester: St. Paul's Bibliographies, 1993)

Nightingale, F., 'Cassandra' (1852), reprinted in R. Strachey, *The Cause: A Short History of the Women's Movement in Great Britain* (New York: Kennikat Press, 1969)

Nenadic, S., 'Illegitimacy, Insanity and Insolvency: Wilkie Collins and Victorian Nightmares', in A. Marwick (ed.), *The Arts, Literature and Society* (London: Routledge, 1990)

Oppenheim, J., *'Shattered Nerves': Doctors, Patients, and Depression in Victorian England* (New York and Oxford: Oxford University Press, 1991)

Oppenlander, E.A., *Dickens' All the Year Round: Descriptive Index and Contributor List* (New York: Whitston Publishing, 1984)

Ousby, I., *Bloodhounds of Heaven: The Detective in English Fiction, From Godwin to Doyle* (Cambridge, Mass. and London: Harvard University Press, 1976)

Page, N. (ed.), *Wilkie Collins: The Critical Heritage* (London: Routledge and Kegan Paul, 1974)

Peters, C., Introduction to *Armadale* (Oxford: Oxford World Classics, 1989)

————, *The King of Inventors: A Life of Wilkie Collins* (London: Minerva, 1991)

Pykett, L., 'Reading the Victorian Periodical Press: Text and Context', *Victorian Periodicals Review*, 22, Fall 1989, 100–8

————, *The Improper Feminine: The Woman's Sensation Novel and the New Woman Writing* (London: Routledge, 1992)

————, (ed.), *Wilkie Collins: Contemporary Critical Essays* (London and Basingstoke: Macmillan – now Palgrave, 1998)

Quinn Schmidt, B., 'Novelists, Publishers, and Fiction in Middle-class Magazines, 1860–80', *Victorian Periodicals Review, 17, 1984, 142–53*

Rance, N., *Wilkie Collins and Other Sensation Novelists* (London and Basingstoke: Macmillan – now Palgrave, 1989)

Ray, G.N. (ed.), *The Letters and Private Papers of W.M. Thackeray* (London: Oxford University Press, 1946)

Reed, J.R., 'A Friend to Mamon: Speculation in Victorian Literature', *Victorian Studies*, 27, Winter 1984, 179–202

Reid, F., *Illustrators of the 1860s* (1928, reprinted New York: Dover, 1975)

Reynolds, K. and N. Humble, *Victorian Heroines: Representations of Femininity in Nineteenth-Century Literature and Art* (Hemel Hempstead: Harvester Press, 1993)

Robinson, K., *Wilkie Collins: A Biography* (London: Davis-Poynter, 1974)

Robinson, S.C., 'Editing *Belgravia*: M.E. Braddon's Defence of "Light Literature"', *Victorian Periodicals Review*, 28, Summer 1995, 109–22

Rose, J., 'Rereading the English Common Reader: A Preface to the History of Audiences', *Journal of the History of Ideas*, 53, January–April 1992, 47–70

Sadrin, A., *Great Expectations* (Unwin Critical Library) (London: Unwin, 1988)

————, *Parentage and Inheritance in the Novels of Charles Dickens* (Cambridge: Cambridge University Press, 1994)

Sala, G.A., *Things I Have Seen and People I Have Known* (London: Cassell, 1894)

Schor, H., ' "If He Should Turn to and Beat Her": Violence, Desire, and the Woman's Story in *Great Expectations*', in J. Carlisle (ed.), *Charles Dickens: Great Expectations: Complete Authoritative Text* (Boston: Bedford Books, 1996)

Shattock, J. and M. Wolff (eds), *The Victorian Periodical Press: Samplings and Soundings* (Leicester: Leicester University Press, 1982)

Showalter., E., *A Literature of Their Own* (London: Virago, 1984)

————, 'Family Secrets and Domestic Subversion: Female Rebellion in the Novels of the 1860s', in A. Wohl (ed.), *The Victorian Family: Structures and Stresses* (London: Croom Helm, 1978)

Sillars, S., *Visualization and Popular Fiction, 1860–1960: Graphic Narratives, Fictional Images* (London and New York: Routledge, 1995)

Smalley, D., *Anthony Trollope: The Critical Heritage* (London: Routledge and Kegan Paul, 1969)

Smith, S.M., 'Propaganda and Hard Facts in Charles Reade's Didactic Novels: A Study of *It's Never Too Late to Mend* and *Hard Cash*', *Renaissance & Modern Studies*, 4, 1960, 135–49

Spencer, K., 'Purity and Danger: *Dracula*, the Urban Gothic, and the Late-Victorian Degeneracy Crisis', *ELH*, 59, 1992, 197–225

Stang, R., *The Theory of the Novel in England, 1850–70* (London: Routledge and Kegan Paul, 1959)

Storey, G., K. Tillotson and N. Burgis, (eds), *The Pilgrim Edition of the Letters of Charles Dickens* (Oxford: Clarendon Press, 1965–)

Sullivan, A. (ed.), *British Literary Magazines: The Victorian and Edwardian Age, 1837–1913* (Connecticutt and London: Greenwood Press, 1984)

Sutherland, J.A., *Victorian Novelists and Publishers* (Chicago: Chicago University Press, 1976)

————, '*The Cornhill*'s Sales and Payments: The First Decade', *Victorian Periodicals Review*, 19, Fall 1986, 106–8

————, *The Longman Companion to Victorian Fiction* (Essex: Longman, 1988)

————, *Victorian Fiction: Writers, Publishers, Readers* (London and Basingstoke: Macmillan – now Palgrave, 1995)

————, Introduction to W. Collins, *Armadale* (Harmondsworth: Penguin, 1995)

Tillotson, K., 'The Lighter Reading of the 1860's, Introduction to W. Collins, *The Woman in White* (Boston, Mass.: Dover, 1969)

Trodd, A., 'Michael Angelo Titmarsh and the Knebworth Apollo', *Costerus*, 2, 1974, 59–81

Domestic Crime in the Victorian Novel (London and Basingstoke: Macmillan – now Palgrave, 1989)

————, Introduction to W. Collins, *The Moonstone* (Oxford: Oxford World Classics, 1982)

Trollope, A., *An Autobiography* (Oxford: Oxford World Classics, 1992)

Trotter, D., *Circulation: Defoe, Dickens, and the Economies of the Novel* (London and Basingstoke: Macmillan – now Palgrave, 1988)

Turner, M.W., 'Gendered Issues: Intertextuality and *The Small House at Allington* in *Cornhill Magazine*', *Victorian Periodicals Review*, Winter 1993, 228–34

Trollope and the Magazines: Gendered Issues in Mid-Victorian Britain (London and Basingstoke: Macmillan – now Palgrave, 2000)

Vann, J.D., *Victorian Novels in Serial* (New York: Modern Language Association, 1985)

Vicinus, M., 'Helpless and Unfriended: Nineteenth-Century Domestic Melodrama', *New Literary History*, 13, 1981, 127–43

Vrettos, A., 'From Neurosis to Narrative: The Private Life of the Nerves in *Villette* and *Daniel Deronda*', *Victorian Studies*, 33, Summer 1990, 553–79

Waddy, F., *Cartoon Portraits: Men of the Day* (London: Tinsley, 1873)

Whiteley, D.P., 'George Du Maurier's Illustrations for *Once A Week*', *Alphabet and Image*, 5, September 1947, 17–29

Wolff, R.L., *Sensational Victorian: The Life and Fiction of Mary Elizabeth Braddon* (New York and London: Garland, 1979)

————, 'Devoted Disciple: The Letters of M.E. Braddon to Sir Edward Bulwer-Lytton, 1862–73', *Harvard Library Bulletin*, 22, 1 and 2, January 1974, 5–35, 129–61

Wood, C., *Memorials of Mrs Henry Wood* (London: Bentley, 1894)

Worton, M. and J. Stills (eds), *Intertextuality: Theories and Practices* (Manchester and New York: Manchester University Press, 1990)

Wynne, D., 'Two Audley Courts: Tennyson and M.E. Braddon', *Notes and Queries*, 242, September 1997, 344–5

———, 'Vidocq the Spy: A possible Source for Fosco in Wilkie Collins's *The Woman in White*', *Notes & Queries*, 242, September 1997, 341–2

———, 'Dickens's Changing Responses to Hereditary Insanity in *Household Words* and *All The Year Round*', *Notes and Queries*, 244, March 1999, 52–3

'"We Were Unhealthy and Unsafe": Dickens' *Great Expectations* and *All The Year Round*'s Anxiety Stories', *Journal of Victorian Culture*, 5.1, Spring 2000, 45–59

'"See What a Big Wide Bed It Is!": Mrs Henry Wood and the Philistine Imagination', in D. Duffy and E. Liggins (eds), *Feminist Readings of Victorian Popular Texts: Divergent Femininities* (Aldershot: Ashgate, 2001).

Yates, E., 'Mr Wilkie Collins in Gloucester Place', *Celebrities at Home* 3 vols. (London, 1879)

Index

accidents, 49
addiction, 5–6, 12–13, 153
advertising, 21, 38, 176 n2
Ainsworth, William Harrison, 9, 19, 21,
 35–7, 60, 62–4, 75, 76, 82, 174 n84,
 176 n2
 Jack Sheppard, 63
 Rookwood, 63
Allingham, William, 14
All The Year Round, 2, 13, 21, 22–8, 29,
 30, 33, 34, 37, 38–59, 82, 83–97,
 98–113, 115, 132–44, 174 n99, 185
 n5
 see also Dickens; Wills
Altick, Richard D., 16, 171 n15
American Civil War, 103–4
 see also slavery
anonymity, 25, 175 n105
anxiety, 3, 6, 8, 9, 10, 12, 26, 39, 43, 45,
 49, 51, 54, 57, 71, 84, 85, 86, 96,
 134
'anxiety' stories, 87–91, 94, 95, 97,
 103–5, 135, 143, 144, 181 n18
Arabian Nights, 11, 172 n48
Argosy, The, 15, 21, 65
Arnold, Matthew, 33
Athenaeum, The, 4, 100, 148
Austen, Jane, 118

Balzac, Honoré de, 2, 125
Barickman, Richard, 152
Beetham, Margaret, 20
Belgravia, 16, 115, 131
Bentley's Miscellany, 35, 63
Blackwood's Edinburgh Magazine, 12, 15,
 23, 34, 35, 87, 103–4, 160, 185 n5
Blake, Andrew, 18, 174 n83
Bourne Taylor, Jenny, 48, 109, 171 n17
Bradbury and Evans, 28–30, 115
Braddon, Mary Elizabeth, 10, 18, 31, 55,
 65, 115, 116- 21, 132, 136, 138,
 145, 173 n80, 174 n84, 183 n9, 184
 n25

as editor, 16, 115, 131
Aurora Floyd, 31, 115, 121, 129, 157,
 183 n9
Doctor's Wife, The, 123
Eleanor's Victory, 31, 37, 114–31, 163
Lady Audley's Secret, 4, 31, 59, 98, 113,
 115, 117, 120–1, 134, 138, 161,
 170 n8, 183 n9
Brantlinger, Patrick, 2, 19, 158, 165
Brooks, Peter, 93, 155
Brooks, Shirley, 28–9
Browning, Robert, 14, 129
Bulwer-Lytton, Sir Edward, 9, 19, 35, 97,
 99, 117–8, 119, 124, 131, 133, 172
 n39, 174 n84
Burdett-Coutts, Angela, 107
Bushby, Mary Ann, 62, 76–9, 179 n8
Bushnan, J.S., 133–4
Butterworth, C.H., 13, 21
Byron, Gordon, Lord, 123

Chorley, Henry F., 100, 148
circulating libraries, 1, 60, 70, 141, 142,
 154
class
 middle-class ambitions, 66–9, 72, 79
 middle-class respectability, 156, 159,
 160, 161, 168
 upper class, representations of, 4, 62,
 66–9, 70, 71, 72
 working-class culture, 9–10, 13,
 14–15, 114, 117, 118, 119, 120
 working class, representations of, 62,
 72–3, 75–6, 77, 80, 95, 105,
 111–12
 see also domesticity; readers; women
Colburn, Henry, 34
Collins, Charles Allston, 27
Collins, Philip, 24, 27, 84
Collins, Wilkie, 18, 21, 33–4, 65, 83, 98,
 136, 138, 145, 171 n26, 173 n80
 Armadale, 6–7, 19, 33–4, 37, 58, 59,
 109, 113, 144, 145–65, 171 n21

collaborations with Charles Dickens,
40–1, 99, 174 n84,
Dead Secret, The, 40, 43
Moonstone, The, 4, 12, 26, 175 n108
No Name, 19, 25, 26, 33, 98–113, 175
n108
'Unknown Public, The', 15
'Vidocq: The French Detective', 54–6
Woman in White, The, 2, 19, 24, 25,
26, 27, 33, 37, 38–59, 84, 98–9,
139, 161, 170 n8, 176 n15
Cook, Dutton, 128–9
Cook, Sir Edward, 33
Cornhill, The, 15, 17, 20, 21, 30, 31–4,
35, 37, 83, 115, 131, 144, 145–65,
186 n7
Cox, R.G., 166
crime, 4, 5, 6, 8, 9–10, 14, 18, 26, 38, 39,
50–8, 64, 82, 88, 89, 90, 92–3, 98,
105, 106, 118, 120, 152
detectives, 54, 55, 57, 58, 126, 141,
178 n48 and 53
forgery, 51–3, 55, 56, 58, 150
'gallows speeches', 50, 57
police, 54, 55, 56, 120
see also Vidocq; women
Cross, Nigel, 117
Cvetkovich, Ann, 67

Daily News, The, 133, 134
Dallas, E.S., 13, 24
Daly, Nicholas, 10
Darwin, Charles, 8, 85–7, 97, 177 n43
David, Dierdre, 101, 102, 112
degeneration, 84, 85–97, 142–3
dialogism, 101, 166–7
Dickens, Charles, 2, 9, 11, 19, 29, 38–9,
53, 99, 107, 132, 134, 139, 140, 172
n39, 173 n76, 180 n4
as editor of *Household Words* and *All
The Year Round* 17, 38–9, 45,
48–9, 53–4, 55, 57, 83–4, 85, 87,
134, 139
Barnaby Rudge, 64
Bleak House, 9, 171 n26
collaborations with Wilkie Collins,
40–1, 99, 174 n84
Great Expectations, 13, 24, 26, 83–97,
144, 175 n108

Hard Times, 23
'Hunted Down', 41, 51, 58
Our Mutual Friend, 110, 182 n20
Tale of Two Cities, A, 23, 24, 26, 39
Uncommercial Traveller, The, 27, 41, 80
Urania Cottage, 107
domesticity, 10, 61, 64, 65, 138–9
see also family; men; women
Doyle, Sir Arthur Conan, 18, 178 n53
Du Maurier, George, 16, 114, 127–8,
130, 163–4, 173 n71

Edinburgh Review, The, 11
editors (of family magazines), 1, 3,
16–17, 18, 30, 32, 35, 36, 38, 42, 59,
63–4, 81–2, 83–4, 131, 133, 134,
147, 162, 167, 168
see also Ainsworth; Braddon; Dickens;
Lucas; Thackeray; Wood
Edward, Prince of Wales, 60, 61
Edwards, Mary Ellen, 162–3
Egg, Augustus Leopold, 163–4
Eliot, George (Mary Ann Evans), 26, 30,
110, 115, 118, 132, 145
Romola, 34, 146, 147, 186 n8
'Englishness', 149, 151, 160
eugenics, 86
see also 'anxiety' stories; degeneration

Fahnestock, Jeanne, 79
fairytales, 91, 94–5, 123, 125, 155
see also wolves
family, the, 1, 10, 29, 32, 33, 64, 86, 89,
102–4, 106, 107, 110, 112, 117,
136, 146, 147, 149, 151, 152, 153,
154, 155, 157
children, 32–3, 77–9, 81, 94, 102,
121, 150, 155, 157, 163
see also readers, family magazines,
men, women
family magazines, 1–3, 6, 10, 14–22, 23,
29, 32, 35, 37, 42, 63, 64, 91, 114,
115, 133, 146, 165, 167, 168
feminization of, 32
'woman's' page, 35
see also All The Year Round; Cornhill;
New Monthly Magazine; Once A
Week
Fenton, Lavinia, 128

Féval, Paul, 122, 125
Fisch, Audrey A., 104
Flaubert, Gustave, 2, 123, 125
Flint, Kate, 87, 124–5
food, 4–6, 120
 see also addiction
Forster, John, 134
Fortnightly Review, The, 25, 40
Foucault, Michel, 50–1
Fraser's Magazine, 10, 15, 34, 86, 102
Freud, Sigmund, 94, 182 n30

Gaskell, Elizabeth, 32, 145
 and narrative, 155–8, 159–60, 161
 'Cage at Cranford, The', 139
 Cousin Phillis, 146
 Cranford, 139
 Dark Night's Work, A, 26, 175 n108
 North and South, 23, 83
 Wives and Daughters, 33, 34, 148, 149,
 150, 151, 152, 153, 154–8,
 159–60, 161, 163–4
Gettmann, R.A., 28
Ginzburg, Carlo, 94
Good Words, 185 n5
gothic fiction, 7, 8, 9, 19, 88
Great Exhibition of 1851, 8
Green, C., 126
Greenwood, Frederick, 146
Greg, William Rathbone, 86, 102

Hadley, Elaine, 71
Hagedorn, Roger, 11
Halfpenny Magazine, 117
Hannay, James, 17
Hayward, Jennifer, 11–12
Helps, Arthur, 6, 8
Hobsbaum, Philip, 83–4
Hogarth, William, 127–8
Hollingshead, John, 52–3
Hood, Thomas, 123
Houghton, Walter E., 166
Household Words, 2, 15, 20, 23–5, 28, 40,
 41, 48, 139, 173 n70
Hughes, Linda K., 12, 167
Hughes, Winifred, 10, 98, 145, 153
Hunt, Leigh, 35
Hunt, William Holman, 16, 125, 161,
 173 n71

illegitimacy, 10, 41, 58, 77, 98, 102,
 103–5, 107, 112, 117, 164
Illustrated London News, 8
illustrations, 16, 28, 29, 114, 115, 122,
 125, 126, 127–8, 130, 139–40,
 161–5
 as 'countervoices', 164, 187 n43
 'black and white art', 28, 161, 162
 see also Du Maurier; Edwards; Green;
 Thomas
Inman, Thomas, 46–7
insanity, 48–9, 86, 88, 89, 133–5, 141–3
internet, the, 167
intertextuality, 3, 19–21, 55, 87, 100,
 106, 139, 147, 165, 167

James, Henry, 51, 117, 119, 138, 151
James, Louis, 166, 167
Jerrold, Douglas, 55
Jewsbury, Geraldine, 4–5, 12, 22, 167
journalism, 2, 5, 9, 18, 26, 27, 38–9, 41,
 42, 51, 53, 54, 55, 57, 82, 84, 101,
 102, 117, 168
 see also newspapers

Kaplan, E. Ann, 67, 71, 179 n25
Kent, Christopher, 18
Kent, Constance, 6, 154, 171 n17
Kingsley, Charles, 135

Lancet, The, 86
Langbauer, Laurie, 67
Lever, Charles, 133
 A Day's Ride: A Life's Romance, 27–8,
 84
Leverson, Rachel, 6, 109, 171 n17
Lewes, G.H., 31, 40, 115
Lewis, 'Monk', 7
Linton, Eliza Lynn, 99, 105, 106, 107,
 110
Littell's Living Age, 116
Lucas, Samuel, 28, 29, 30–1, 70, 72,
 115
Lund, Michael, 12, 167

MacDonald, S., 152
Macmillan's Magazine, 15, 25, 30, 32, 35,
 185 n5
Mansel, H.L., 5, 6, 102, 138

marriage, 12, 64, 68, 79, 99, 102, 108, 135, 141, 145, 146, 150, 151, 153, 155, 157, 158, 160–3
 adultery, 10, 60, 64, 67, 76, 82, 98, 120, 121, 123, 160, 161, 162, 163
 as narrative closure, 161
 bigamy, 10, 64, 75, 76, 79–82, 121, 126, 160, 161, 162
 divorce, 5, 10, 18, 163
 Matrimonial Causes Bill (1857), 80
 polygamy, 80–1, 107–8, 130, 160
Martineau, Harriet, 28, 31, 33, 115, 131
Masson, David, 8
mass production (of literature), 6, 10–11, 16
maternal melodrama, 61, 67, 78, 121, 127–8, 178 n3, 180 n45
maternity, 62, 64, 71, 76–9, 81, 111, 121, 127
Maxwell, John, 117, 131
Maxwell, R.C., 9
McCormack, W.J., 7, 21
melodrama, 1, 8, 9, 14, 25, 31, 61, 62, 66–7, 76, 82, 84, 114, 118, 119, 120, 121, 122, 123, 124, 125, 127–8, 130, 135, 145, 149, 155, 156, 161, 163, 165, 179 n24
 see also maternal melodrama
men
 and cross-dressing, 56
 and violence, 141–3
 as family members, 16–17, 29, 68, 104–5, 110, 116, 121, 150, 160
 'Bohemians', 17, 117, 119
 'Brain workers', 44
 businessmen, 29, 61, 64, 66, 68, 71, 85
 celibates, 129–30
 male readers, 16–17, 29, 35, 60–1, 63, 117, 118, 129–30
 male writers, 117, 132–3
 masculinity, representations of, 56, 62, 69–74, 75
Meredith, George, 28, 30, 115
Michie, Helena, 70
Millais, John E., 16, 115, 125, 161, 173 n71
Miller, D.A., 7, 42
Miller Beard, G., 44, 45

Miller Casey, Ellen, 91, 138
Mitchell, Sally, 149
modernity, 6–7, 8, 10, 17, 44, 46, 51, 82, 85
Moreau de Tours, Jacques–Joseph, 85
Morel, Bénédict–Augustin, 44, 85
Moretti, Franco, 51
Morgentaler, Goldie, 87
Mormonism, 80–1

Nation, The, 119
National Review, The, 102
'nerves', 6–7, 38, 39, 43–50, 158
'Newgate' novels, 9, 35, 50, 63, 172 n39
New Monthly Magazine, 21, 34–7, 59, 60, 61, 62–4, 66, 70, 71, 73, 75, 76, 77, 81, 82, 146
newspapers, 16, 20
 see also journalism
Nightingale, Florence, 106
North British Review, 12, 100–1, 120

Oliphant, Margaret, 2, 10, 12–13, 43–4, 59, 70, 87–8, 93, 103–4, 113, 132, 152, 160
Once A Week, 15, 21, 24, 28–31, 33, 80, 114–31, 132, 133, 162, 163
Ouida (Marie Louise de la Ramée), 36–7, 174 n84
 Granville de Vigne (*Held in Bondage*), 36, 62, 74–6

Palmer, William, 58
Peters, Catherine, 153
Power Cobbe, Frances, 102
Pre-Raphaelite art, 31, 76, 119, 124, 161, 164, 184 n25
Publisher's Circular, The, 20
Pullinger, George, 53
Punch, 17, 115
Pykett, Lyn, 70–1

Quarterly Review, The, 5, 23, 102, 138

race, 85, 86, 90, 91, 99, 103–5
Radcliffe, Ann, 7
Ray, W.F., 120

Reade, Charles, 10, 21, 28, 65, 132, 171
 n26, 173 n76, 177 n31
 Cloister and the Hearth, The, 29, 30,
 132-3, 138, 143
 It's Never Too Late to Mend, 143
 Very Hard Cash, 24, 25, 37, 83, 132-44
Reader, The, 100
readers, 1-3, 5-7, 9, 12-16, 19-22, 23-4,
 26, 29, 32-4, 35, 40, 41-3, 54, 59,
 61, 70, 71, 75, 82, 83, 85, 88, 97,
 100, 104, 106, 115, 116, 118, 120,
 122, 124, 125, 131, 133, 135,
 136-8, 146-7, 153-4, 155, 156,
 159, 160, 161, 162, 163, 164-5,
 166, 167, 168
 'common' reader, the, 19, 43
 family readerships, 1, 9, 14-22
 letters from, 17, 49
 middle-class, 1, 14, 15
 working-class, 9, 13, 14-15, 24, 29,
 117-8, 120, 153
 see also family magazines; men;
 suspense; women
realism, 101-2, 105, 132, 134, 135-40,
 149, 155, 165
 domestic realism, 7, 8, 9, 10, 25, 26,
 33, 34, 42, 57, 58, 59, 102, 137-8,
 141, 144, 145, 154, 162, 163
Redpath, Leopold, 52-3
reform, 8, 23, 171 n30
 of newspaper taxes, 16
Rémy, Jules, 80-1
Reynolds, G.W.M., 9, 117
Ritchie, Anne, 33
Robin Goodfellow, 115
Robinson, Kenneth, 99
Robinson, Solveig C., 115
Rose, Jonathan, 19
Ruskin, John, 33

Sadrin, Anny, 84, 96
Sala, George Augustus, 15, 25
Saturday Review, The, 118, 124, 138,
 148
scandal, 5-6, 51, 54
Schmidt, Barbara Quinn, 26
Scott, Sir Walter, 19, 125
self-help, 50-4

sensation fiction, 1-10, 18, 26, 30-1,
 33-4, 36-7, 38, 40, 114, 132, 145,
 146, 158, 168
 and fictionality, 121-31
 and secrets, 154-8, 163
 as a commodity, 11, 38
 compared to domestic realism, 146-9,
 157-60, 161, 162, 163, 165
 see also addiction; readers; suspense;
 women
serialization, 1-3, 4-6, 10-14, 26, 40, 84,
 100-1, 106, 133, 135, 136, 138,
 140-44, 147, 148, 154, 158, 167, 168
 see also food; readers; suspense
Shattock, Joanne, 166
Shelley, Mary,
 Frankenstein, 95
Sheppard, Jack, 56, 64, 125
Sheridan, Richard B., 112
Showalter, Elaine, 66, 154
Sidgwick, Henry, 116
Sillars, Stuart, 161
Sixpenny Magazine, The, 115
slavery, 103-5
 see also race
Smiles, Samuel,
 Self-Help, 51-3, 178 n47
Smith, Alexander, 100-1, 102
Smith, George, 15, 31-2, 33, 146, 186
 n7
Smith, Madeline, 6, 110, 154, 171 n17
Spectator, The, 27, 164
spies, 54-7, 153
Stang, Richard, 135
Stanley, Arthur Penryn, 60, 61
Stark, M., 152
Stephen, Leslie, 5, 83
Stevenson, Robert Louis,
 *Strange Case of Doctor Jekyll and
 Mr Hyde, The*, 88, 91
Stoker, Bram,
 Dracula, 88, 91
Stowe, Harriet Beecher, 32
suburbs, 7
Sullivan, Alvin, 22, 29, 115
Surtees, R.S.,
 Mr Sponge's Sporting Tour, 63
suspense, 4, 6, 11, 12, 26, 40, 41-2, 100,
 133, 135-8, 141, 154, 158

see also readers; sensation fiction;
 serialization
Sutherland, John, 135
Symonds, J.A., 33

Temple Bar, 15, 35
Tenniel, Sir John, 16, 115, 161, 173 n71
Tennyson, Alfred, Lord, 116, 119, 121,
 124, 125, 129
Thackeray, William Makepeace, 35, 55,
 115, 129, 132, 170 n10, 173 n76,
 187 n43
 as editor of *The Cornhill*, 15, 17, 31–3,
 35
 Lovel the Widower, 32
 Vanity Fair, 152
Thomas, George, 164–5
Tillotson, Kathleen, 4, 14
Times, The, 13, 24, 28, 30, 70, 72, 134
Tinsley's Magazine, 16
Tinsley, William, 16
Traherne, Emma, 125–6
Trodd, Anthea, 54, 119
Trollope, Anthony, 55, 145, 162
 Autobiography, An, 43, 149–50
 Claverings, The, 33, 147–152, 154,
 160, 161, 162–3
 Framley Parsonage, 32, 146
 Small House at Allington, The, 146
Trotter, David, 96
Turner, Mark W., 32
typography (of magazines), 24, 139–40

Victoria Magazine, 13
Victoria, Queen, 116
Vidocq, François-Eugène, 41, 54–8
violence, 17, 27, 39, 64, 78, 86, 87, 88,
 89–91, 93–4, 104–5, 110, 117, 124,
 133, 135, 136, 138, 141, 142–4,
 149, 159

Waddy, Frederick, 132
Wainewright, Thomas Griffiths, 58
Watts, Walter, 52
Welcome Guest, The, 117
*Wellesley Index to Victorian Periodicals,
 The*, 22, 166, 167
White, Gleeson, 114

Wills, William Henry, 39, 99, 132
Wolff, Michael, 166
wolves, 93–4, 123, 143
'Wolf-man', the, 94
 see also fairytales; Freud
women, 32, 33, 34, 48, 61, 62–4, 66, 67,
 69–71, 77, 80, 96–7, 100, 118, 145
 and anger, 156–7
 and cosmetics, 109–10
 and crime, 6, 106, 146, 150, 164
 and cross-dressing, 65
 and domesticity, 49, 66, 105, 106,
 107, 108, 110, 130, 139
 and femininity, 152, 153, 154, 157,
 164, 165
 and harems, 103, 107–8
 and hysteria, 48
 and insanity, 48–9
 and jealousy, 81
 and pregnancy, 90
 and prostitution, 107, 109, 152
 and revenge, 62, 70–1, 75–6, 77, 96,
 121, 124, 125, 127, 130, 157
 and work, 102, 103, 111–12, 116
 and workhouses, 98, 102, 105, 106–7,
 110
 as actresses, 98, 108–9, 111, 112, 116,
 121, 127, 128
 as 'fallen' women, 163–4
 as *femme-fatales*, 75, 157, 164–5
 as nuns, 103, 111
 as 'outsiders', 99, 100, 103, 105, 107,
 152
 as prisoners, 103, 105, 106, 107, 110
 as readers, 5, 16–17, 32–3, 35, 61, 63,
 70–1, 75, 77, 82, 118–19, 122–5
 as 'redundant', 102, 112, 126
 as witches, 103, 110–11
 'sensation' heroines, 19, 34, 98–113,
 123, 127–8, 134, 146, 147, 149,
 150–8, 186 n21
 see also Braddon; Bushby; class;
 domesticity; Eliot; family;
 Gaskell; maternal melodrama;
 maternity; Ouida; Wood
women's writing, 35–7, 62–6, 74–82,
 98, 115–17, 118–21
 see also Braddon; Bushby; Eliot;
 Gaskell; Linton; Ouida; Wood

Wood, Charles, 35–6, 64–6, 70, 176
 n138
Wood, Mrs Henry (Ellen), 5, 10, 15, 18,
 21, 35–7, 113, 116, 132, 138, 145,
 173 n80, 174 n84
 as editor, 15, 65
 as journalist, 63
 Danesbury House, 36, 63
 East Lynne, 4, 36, 37, 59, 60–82, 98,
 113, 116, 146, 161, 170 n8
 'Ensign Pepper', 63, 179 n10
 'Johnny Ludlow', 63

Life's Secret, A, 179 n7
Mrs Halliburton's Troubles, 179 n7,
 180 n40
Red Court Farm, 179 n30
'Seven Years in the Life of a Wedded
 Roman Catholic', 63
Shadow of Ashlydyat, 36
Verner's Pride, 31, 80, 179 n30

Yates, Edmund, 16
Yonge, Charlotte M., 2, 21, 170 n3